Museums in

MUSEUMS IN THE GERMAN ART WORLD
From the End of the Old Regime to the Rise of Modernism

JAMES J. SHEEHAN

OXFORD
UNIVERSITY PRESS
2000

OXFORD
UNIVERSITY PRESS

Oxford New York
Athens Auckland Bangkok Bogotá Buenos Aires Calcutta
Cape Town Chennai Dar es Salaam Delhi Florence Hong Kong Istanbul
Karachi Kuala Lumpur Madrid Melbourne Mexico City Mumbai
Nairobi Paris São Paulo Shanghai Singapore Taipei Tokyo Toronto Warsaw

and associated companies in
Berlin Ibadan

Published by Oxford University Press, Inc.
198 Madison Avenue, New York, New York 10016

Oxford is a registered trademark of Oxford University Press.

Library of Congress Cataloging-in-Publication Data
Sheehan, James J.
Museums in the German art world from the end of the
old regime to the rise of modernism / James J. Sheehan.
p. cm.
Includes bibliographical references and index.
ISBN 0-19-513572-5
1. Art museums—Germany—History. I. Title.
N2210.S54 2000
708.3'09—dc21 99-053648

9 8 7 6 5 4 3 2 1

Printed in the United States of America
on acid-free paper

To Peggy

Ad pulcritudinem tria requiruntur,
integritas, consonantia, claritas.
—THOMAS AQUINAS

ACKNOWLEDGMENTS

This book owes its existence to two magnificent institutions. I began my research at the Wissenschaftskolleg in Berlin, an ideal setting for any kind of serious work and perhaps especially for starting a new project. I am grateful to its rector, Wolf Lepenies, to his gracious and accommodating staff, and to all of my colleagues at Kolleg who provided me with good company and intellectual companionship. Monika Steinhauser deserves special mention for her valiant efforts to teach me something about art history. Most of the book was written with the support of a Research Prize from that model of institutional flexibility and generosity, the Alexander von Humboldt Foundation. My debts to my German hosts, Hans-Ulrich Wehler at the University of Bielefeld and Josef Becker at the University of Augsburg, are too numerous to count. More important, Renate and Uli Wehler and Ruth and Josef Becker have nourished and sustained me for years with their love and hospitality. They represent for me the Platonic ideal of friendship.

I want to thank the many friends and colleagues who read the manuscript, untied the knots of error, tamed unruly syntax, and suggested fruitful new lines of analysis. Whatever its remaining faults, this is a better book because of Paula Findlen, Kathleen James, David Kennedy, Fritz Stern, and Rudy Weingartner. Thomas LeBien forced me to tell the story I wanted to tell, which is exactly what an editor should do. Kevin Repp, Myong Lee, Karin Hall, Chad Bryant, and Ron Davies helped at various stages of the research and writing; all of them made the author's life easier.

Finally, I am grateful to Margaret Lavinia Anderson for her integrity, harmony, and radiance—and for much else besides.

Berkeley, California　　　　　　　　　　　　　　　　　　　　　　　　J. J. S.
November 1999

Picture Credits

Figure 1. Courtesy of Deutsche Verlags-Anstalt GMBH, Stuttgart.

Figure 3. Courtesy of Bayerische Verwaltung der staatlichen Schlösser, Gärten und Seen. Munich.

Figure 4. Courtesy of Bildarchiv preussischer Kulturbesitz.

Figure 5. Courtesy of Staatliche Museen Kassel.

Figure 6. Courtesy of Bildarchiv preussischer Kulturbesitz.

Figure 7. From Oswald Hederer, *Leo von Klenze. Persönlichkeit und Werk*. Munich: Callwey Verlag, 1964.

Figure 8. Courtesy of Munich Stadtmuseum.

Figure 10. Courtesy of Deutscher Kunstverlag, Munich and Berlin.

Figure 11. Courtesy of Deutscher Kunstverlag, Munich and Berlin.

Figure 12. Courtesy of Deutscher Kunstverlag, Munich and Berlin.

Figure 13. Courtesy of Deutscher Kunstverlag, Munich and Berlin.

Figure 14. Courtesy of Bildarchiv preussischer Kulturbesitz.

Figure 15. Courtesy of Städelsches Kunstinstitut und Städtische Galerie, Frankfurt.

Figure 16. Courtesy of Munich Stadtmuseum.

Figure 17. Neue Pinakothek, Munich. Bayerische Staatsgemäldesammlungen München.

Figure 18. Courtesy of Landesbildstelle Berlin.

Figure 19. Courtesy of Staatliche Kunstsammlungen Dresden.

Figure 21. From Peter Böttger, *Die alte Pinakothek in München*. Munich: Prestel Verlag, 1972.

Figure 23. Neue Pinakothek, Munich. Bayerische Staatsgemäldesammlungen München.

Figure 24. Courtesy of Sächsische Landesbibliothek/Staats- und Universitätsbibliothek Dresden. Dezernat Deutsche Fotothek.

Figure 26. Courtesy of Kunstmuseum Düsseldorf.

Figure 27. Christoph Hölz, Zentralinstititut für Kunstgeschichte, Munich.

Figure 28. Courtesy of Plansammlung der Universitätsbibliothek der Technischen Universität Berlin.

Figure 29. Courtesy of Bildarchiv preussischer Kulturbesitz.

Figure 30. From Mortimer G. Davidson, *Kunst in Deutschland, 1933–45*, volume 3. Tübingen: Grabert Verlag, 1995.

Figure 31. James Stirling, Michael Wilford and Associates. Courtesy Michael Wilford and Partners Limited.

CONTENTS

INTRODUCTION

Art museums teach us what to see when we look at art. As the guardians of the world's artistic treasures, they provide opportunities to see things that might otherwise be lost or forgotten; they encourage public appreciation of art, preserve essential scholarly skills, and foster historical research. But museums create as well as conserve. They establish the explanatory frames within which individual objects can be understood; they affirm artistic significance—indeed, they help us to decide what is and is not art. As the conservators and creators of artistic value, museums are also expressions of power—the political and economic power of those who build them, the professional power of those who define their mission and shape their collections, and the social power of those upon whom they depend for sustenance and support. Museums everywhere have certain things in common, but they are also shaped by their historical settings; they have, in other words, histories of their own besides the manifest narrative that their collections are organized to impart.[1]

This book traces the history of art museums in the German states from the second half of the eighteenth century to the beginning of the twentieth. My purpose is to examine the relationship between German museums and their historical context, especially the relationship between the development of museums and changes in artistic theory and practice. I have sought to approach the museum at a middle level of analysis, between the general surveys and the individual case studies that make up most of the large and expanding literature on the history of museums.[2] I hope that this level will provide a perspective from which we can learn something both about art and museums in general and about their distinctive place in German politics, culture, and society.

The book's organization is roughly chronological. Chapter 1 examines the intellectual and institutional origins of German art museums in the court culture and public discourse of the eighteenth century. Chapter 2 focuses on the ways that German intellectuals and civil servants deployed museums as part of their efforts to confront the cultural and political crises of the revolutionary era. Chapter 3, which is devoted to the middle decades of the nineteenth century, traces how the development of museums reflected and influenced historicism's problematic triumph in aesthetic theory and artistic practice. Chapter 4 treats the response of museums to changes in the

world of art at the end of the nineteenth century, changes that challenged many of the museum's foundational assumptions at the same time that they reaffirmed its place as a source of artistic value and meaning.

The four chapters have the same tripartite structure. Each begins with a discussion of ideas about art, both in the work of a few influential thinkers (Kant, Schiller, Hegel, Nietzsche) and in the writings of less well-known scholars, critics, and journalists. We then turn from ideas to institutions; the second section of each chapter examines the relationship of museums to their social and political context, and also the organizational development of the museums themselves. Each chapter concludes with a discussion of specific museum buildings whose design and decoration reflected contemporary ideas about art's nature and purpose and art's institutional place in politics and society. Although the chapter sections might be read chronologically (rather than sequentially) as intellectual, institutional, and architectural histories of art museums, the book's primary purpose is to demonstrate how these ideas, institutions, and structures worked together.

Finally, I should say a word about the concept of an art world, which serves as my central analytical category. I use *art world* in two ways. First, following Arthur Danto, I use it to mean the theories, assumptions, and historical experiences that shape the way we see art as art.[3] But even in its most abstract formulations, this theoretical art world is connected to patterns of behavior; aesthetic theories, like ethical principles, always imply certain kinds of practice. I also use *art world*, therefore, in Howard Becker's institutional sense, to refer to "the network of people whose cooperative activity, organized via their joint knowledge of conventional means of doing things, produces the kind of art that [the] art world is noted for."[4] In short, my notion of an art world assumes the persistent interaction of aesthetic ideas and artistic institutions, without granting priority to either.

Because the art world is embedded in its historical context, its ideas and values are inseparable parts of the wider culture; its institutions, of the larger social, economic, and political realm. The story of the art world is therefore also the story of political institutions and the rise of a "public" culture, of national aspirations and social upheaval, of academic disciplines and bureaucratic ambition, of established elites and new money. There is a distinctively German version of this story, even though Germans were influenced by, and in turn influenced, developments in Europe and America. The reader will find here some familiar German themes: the persistence of monarchical authority, the importance of bureaucratic institutions, the close link between culture and nationalism, the social and cultural preeminence of academic elites, and the increasing fragmentation of the middle classes.

Philosophy and scholarship, wealth and power, the organization of society and state all played their parts in creating and sustaining the art world within which museums grew. But although art is not, and never can be,

autonomous, neither is it merely a reflection of some deeper reality. It is always a mistake to "explain" art (or, for that matter, any other significant historical phenomenon) by making it disappear into something else. To understand the art world, we must grasp not only its connections to other ideas and institutions but also its own conventions, values, and structures. The best place to begin, therefore, is with the idea of art itself.

Museums in the German Art World

1

EIGHTEENTH-CENTURY
ORIGINS

Art museums rest on three fundamental assumptions that took shape within the eighteenth-century art world. Most obviously, the museum assumes that there is such a thing as art. Otherwise, its Attic vases, medieval altarpieces, and dynastic portraits would have nothing in common; they were, after all, made in different ways and designed to serve different ends. Only because they can all be regarded as "art" can the museum's diverse contents occupy the same physical space and share the same matrix of meaning. Because they are art, they can all be experienced "aesthetically": that is to say, as things valuable for their own sake, without practical purpose. But museums are not without a social purpose; their claim to public resources and private support depends on the belief that aesthetic experience is somehow beneficial to individuals and society. This is the second foundational assumption: that separating art from the everyday world creates a setting in which visitors can comprehend the connections between art, truth, and morality. Museums, therefore, are supposed to promote beauty, virtue, and enlightenment. Finally, museums also rest upon an awareness of historical movement, which celebrates the value of past art and recognizes the need to protect and conserve it for the future. Among museums' most important sources of influence is the historical meaning and the promise of permanence they offer to the treasures they contain.

In the eighteenth century, these ideas about the aesthetic, ethical, and historical value of art were joined with another of the museum's foundational convictions, that its contents should be open and accessible to the public. Like the other public institutions that emerged in the eighteenth century, museums were the result of profound changes in the way culture was created and experienced, changes in what it meant to be an artist, and in how art was perceived. In German Europe, these changes took place in two distinct but overlapping institutional settings: first, in what is now thought of as "the public sphere," within which people viewed, heard, read, and discussed art, music, and literature; second, in the princely courts, which remained significant sites for both the production and display of the visual and performing arts. The reciprocal relationship of court and public was architecturally expressed

by the first art galleries and museums, in which princes opened their collections to their subjects.

I. Art, Morality, and History

In his influential work *Allgemeine Theorie der schönen Künste* (Universal theory of the fine arts [1771–1774]), Johann Georg Sulzer defined *aesthetics* as a "new term, which was invented to describe a branch of knowledge that has only existed for a few years. It is the philosophy of the fine arts."[1] Like economics, which emerged at about the same time, aesthetics readjusted epistemological boundaries by gathering into a single discipline a series of issues that had previously been examined separately. Both the science of aesthetics and its subject, what Sulzer called the "fine arts," were eighteenth-century inventions.

As Paul Kristeller showed in his seminal essay "The Modern System of the Arts," the use of the term *art* to include only painting, sculpture, architecture, music, and poetry is of relatively recent provenance. Not until the Renaissance were the visual arts of painting, sculpture, and architecture severed from the crafts with which they had been associated; equally important, in the fifteenth century, Italian humanists sought to enhance the prestige of painting by stressing its similarities to literature. Painters, like poets, could now lay claim to a special status, markedly superior to that of the artisans who wove tapestries, hammered gold, or made pottery. The final step in the creation of *art* was taken in the first half of the eighteenth century, when music was added to literature and the three visual arts. Thereafter, it became common to assume that these activities required skills and talents different from those of handicrafts and that they produced sorts of knowledge and experience different from those of the sciences.[2] Thus began what M. H. Abrams has called the "Copernican revolution" in the definition of art: the creation of "art as such," a distinctive kind of activity with its own purpose, meaning, and history.[3]

The Primacy of Perception

Museums are places where art is seen, not created. Their emergence was part of a transformation in the art world which Abrams describes as a shift from "the maker's" to the "perceiver's stance."[4] This shift was essential for the invention of art as art. After all, from the viewpoint of the musician, poet, painter, sculptor, and architect, the ways of making art—composing a fugue, writing a sonnet, painting a picture, carving a statue, designing a building— constituted quite different kinds of creative activity. It was possible to suppose that music, poetry, pictures, statues, and buildings were alike only when one turned from how they were made to the responses they evoked in their listeners, readers, or viewers. The new philosophy of art, therefore, was

primarily concerned not with the nature of artistic objects or the skills nec-
essary to produce them but rather with art's subjective effects on those who
experienced it. From the start, aesthetics was closely associated with the
analysis of perception, cognition, and imagination.[5]

Throughout the eighteenth century, artists and writers were concerned
with the psychological origins and effects of artistic experience. Consider,
for example, two prints by Daniel Chodowiecki (fig. 1).[6]

These were part of the series "Natürliche und afectierte Handlungen
des Lebens" (Natural and affected modes of behavior), which appeared, with
text by Georg Christoph Lichtenberg, in *Göttinger Taschen-Calender* in 1779
and 1780. Each print depicts two young men in front of a statue of Flora. In
the "affected" form of art appreciation, the observers seem more interested
in each other than in the statue; their gestures and attitude are social and
expressive rather than private and contemplative. In its "natural" counter-
part, they stand in quiet appreciation of the object. Here, art is not part of a
social scene with conventionalized responses; it is a subjective, spiritual,
individual experience. Only through this "natural" approach can an authentic
connection with the work of art be established—as Chodowiecki shows by
having Flora now respond to her natural connoisseurs with a subtle but know-
ing smile.[7]

The philosophical study of aesthetic responses began in England and
France, but it was given its most elaborate formulation in Germany. The
first important German philosopher of art, and the first person to use the
word *aesthetics* philosophically, was Alexander Gottlieb Baumgarten.[8] In
many ways, Baumgarten was a transitional figure whose philosophical train-
ing and style, like the Latin in which he wrote, remained closely tied to the
conventions of seventeenth-century German rationalism. His point of depar-
ture was the expansion of rationalist epistemology to include sense percep-
tion. In the lectures that he delivered first at Halle, then at Frankfurt/Oder,
and in his *Aesthetica*, parts of which were published in 1750 and 1758 but
which remained unfinished at his death in 1762, Baumgarten developed the
idea that aesthetics, "the science of sense cognition," was logic's younger
sister, with a secondary but significant place in the household of intellect.
At the same time, he identified aesthetic truth with artistic beauty. Aesthet-
ics, he stated at the very beginning of his treatise of 1750, is "the art of thinking
beautifully," and he defined its goal as "the perfection of sense cognition as
such, by which is meant beauty."[9]

By associating beauty, perception, and perfection, Baumgarten set into
motion a powerful philosophical project that conceived of art as the expres-
sion of a special kind of truth, with deep roots in our cognitive faculties. As his
student and disciple G. F. Meier put it: "The beautiful sciences invigorate
the whole man. . . . [They provide] the way for truth to gain access to the
soul."[10] Moses Mendelssohn, in an essay on "the sources and connections of
the fine arts and sciences," published in 1757, expanded on Baumgarten's
analysis of art's psychological roots: "Poetry, eloquence, beauty in shapes

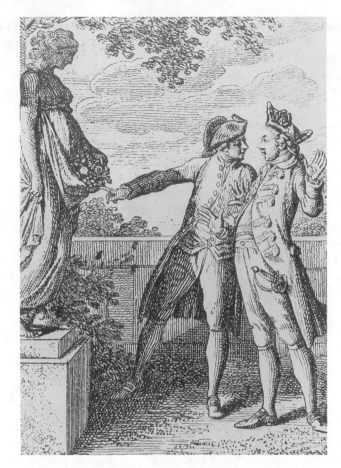

FIGURE 1 (*above and facing page*). Daniel Chodowiecki, *Connoisseurship* (1779-1780).

and sounds penetrate through the various senses to our souls and rule over all our dispositions." How, Mendelssohn asked, do these diverse experiences please us? Why do we regard them as "beautiful"? Because they all provide what he called that "sensuous expression of perfection" which is beauty's common source.[11]

Beauty and Virtue

In these phrases by Baumgarten, Meier, and Mendelssohn about beauty, perfection, and the soul, we glimpse a preliminary formulation of the association of beauty and virtue which would play a persistently significant part in the German art world and especially in the theory and practice of German art museums. Of course, as Robert Norton has recently pointed out, the idea that there is a special affinity between beauty and goodness has a long history in

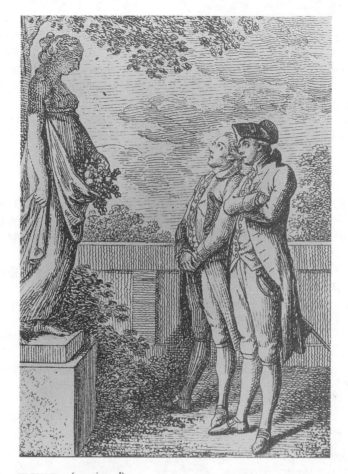

FIGURE I *(continued)*.

European culture. But in the eighteenth century, concern for the connection between them intensified.[12] In part, this was because moral philosophy, like the philosophy of art, shifted its focus from the realm of action to the realm of subjective experience. Just as aesthetics defined its subject as the psychological sources of beauty, so ethics came to be concerned with the psychological sources of goodness.[13] During the last third of the eighteenth century, therefore, philosophers and artists tried to discover how goodness and beauty might be joined in what some of them called "the beautiful soul."

An early and widely read example of this enterprise can be found in the work of Johann Georg Sulzer (1720–1779). Born in Switzerland, Sulzer spent most of his adult life as a teacher and member of the reorganized Prussian Academy of Sciences in Berlin. Although deeply influenced by Baumgarten and acquainted with Meier, Sulzer's range of reference and experience was broader and more varied than that of these early writers on aesthetics.

Sulzer's most important work was his *Allgemeine Theorie der schönen Künste*, first published in 1771 and 1774 and often reprinted thereafter; excerpts from it appeared (without Sulzer's knowledge) in a supplementary volume of the *Encyclopédie*.[14] Organized as a lexicon with 870 entries, the *Allgemeine Theorie* ranged from technical issues, such as the nature of ornament or allegory, to general discussions of aesthetic theory.

Art, Sulzer argued, has its origins in our inherent desire to beautify the world in which we live. But art can also be a form of moral education: "The judicious use of the fine arts can bring to his full potential the man whose imaginative powers point him toward feeling beauty and whose heart points towards a feeling of goodness."[15] In art, beauty and goodness are inevitably joined, since every work of art worthy of the name must have moral power. This moral power has given art a central role in the long history of mankind from barbarism to enlightenment: "Reason and morality are the first requisites for those who would lift themselves out of the dust and elevate their nature, but this rising is consummated by taste, which completes both reason and morality. . . . Taste leaves nothing of man's natural rawness, but makes him sensitive to all goodness." On this vision of art's historical role Sulzer based his belief in its social utility and political significance. Because art can make humans more virtuous and therefore better citizens, Sulzer maintained, "the cultivation of taste is . . . a great national concern."[16] The experience of beauty, valuable in itself and as a source of individual virtue, could also help to produce a better civil order.

Kant and the Knowledge of Beauty

The single most powerful philosophical examination of the relationship between beauty and virtue is to be found in Kant's *Critique of Judgement*. Published in 1790, at the end of the extraordinary decade of creativity in which Kant produced his critiques of pure and practical reason, the *Critique of Judgement* tried to establish the foundations of the knowledge of beauty, just as the first two critiques had sought to ground the knowledge of experience and morality. At the same time, this third critique returned to themes from Kant's work in the 1760s, when he had explored at some length the relationship between beauty and goodness, taste and virtue.[17]

Like most eighteenth-century writers on aesthetics, Kant was concerned with the psychological experience of beauty, not its outward form or nature. His first task was to clarify the difference between this experience and other kinds of pleasure. "Taste," he wrote in a famous passage at the end of the book's first section, "is the faculty of estimating an object or mode of representation by means of a delight or aversion apart from any interest. The object of such a delight is called beautiful."[18] The pleasure we take in "agreeable" things is inseparable from what Kant calls our "interest" in them. In order to enjoy the pleasures of a ripe peach, we must be able to taste it. But we can

take delight in beauty for its own sake; we are able to admire a painting of a bowl of fruit without any concern for how the fruit might taste or whether we can eat it.

Once Kant had stated the subjectivity and autonomy of aesthetic experience, he then proceeded—in a typically Kantian move—to find grounds for a belief in its universality and connectedness. One need not follow the whole labyrinthine path of his argument to find two elements in Kant's aesthetics that had a lasting impact on the art world in which museums would develop.[19]

First, we must not misunderstand what Kant meant by the autonomy of aesthetic experience. Although he certainly believed that such experience is disinterested, he did not see it as without purpose; it can and should both instruct and delight. Beauty expresses the moral order by bringing it into the sensory realm, thus making it more accessible: "The beautiful is the symbol of the morally good" (para. 59, p. 223). When we acquire taste— that is, the ability to apprehend beauty—we are able to approach morality along the even, level path of our senses: "Taste makes . . . the transition from the charm of sense to habitual moral interest possible without too violent a leap" (para. 59, p. 225). Kant dismisses art that seeks only to thrill or amuse. When art is not somehow combined with moral ideas, when its aim is "merely enjoyment," it "renders the soul dull, the object in the course of time distasteful, and the mind dissatisfied with itself and ill-humoured" (para. 52, p. 191). Appreciating art, therefore, is at once an aesthetic and a moral act; genuine taste is possible only "when sensibility is brought into harmony with moral feeling" (para. 60, p. 227).

Second, Kant insisted that just as aesthetic experience can be both autonomous and purposeful, so it is at once subjective and universal. He rejected the notion that each individual has his own taste. Taste, he insisted, is a kind of *sensus communis*, the product of a public process in which opinions are openly expressed and exchanged. And because the experience of beauty is necessarily collective, the appreciation of beauty is possible only in a society where it can be nourished and shared (para. 41, p. 155). In fact, by developing our taste, we intensify our social identity because we become aware that others make the same judgments. At the same time, a taste for art enhances our ability to share our feelings and sensations. Art, although an end in itself, "has the effect of advancing the culture of the mental powers in the interests of social communication" (para. 44, p. 166).

Wrapped in these hard-edged abstractions is the vision of art as a source of the individual virtue and social cohesion which Kant, like many of his contemporaries, believed was necessary for progress and enlightenment in the modern world. As we shall see in chapter 2, in the 1790s, when revolutionary upheavals made the need for virtue and commmunity yet more urgent, this vision of art's moral and political purpose would play an important part in the formation of the first art museums.

Winckelmann and the Classical Ideal

Kant's vision of a community enriched by the fusion of taste and virtue was also a central element in that admiration of ancient art and culture which is conventionally referred to as *neoclassicism*. Chronologically, the emergence of neoclassicism in German Europe roughly coincided with the development of philosophical aesthetics from Baumgarten to Kant. But whereas the philosophers discovered the connection between beauty and goodness in the operations of the mind, the classicists found it in the historical example of Greece, which, after midcentury, replaced Rome as the chief source of inspiration from antiquity. Neoclassicism had two ingredients of lasting significance for the development of German museums: first, it provided a set of stylistic values that guided the early museums' style and contents; second, it encouraged the conviction that solutions to aesthetic problems were to be found in the history of art.

The key figure in the creation of German neoclassicism was Johann Joachim Winckelmann, who, in Goethe's famous tribute, resembled "a new Columbus" because he too rediscovered a land "that had once been known but then had been lost again."[20] The Greece that cast its spell over German culture was the land Winckelmann discovered or, more accurately, the one he created from his private longings and cultural experience. We will encounter Winckelmann often in the story of art museums; there is perhaps no more significant figure in their development or, for that matter, in the intellectual history of the German art world from the end of the eighteenth century to the beginning of the twentieth.[21]

Born in 1717 in the Prussian village of Stendal, Winckelmann was one of a handful of eighteenth-century intellectuals who were able to overcome the obstacles of poverty through natural talent, hard work, and good fortune. On this long and difficult journey, he stubbornly pursued his own, often eccentric interests, avoiding such natural refuges as theology in favor of literature and Greek, for which he developed an early passion. Winckelmann began as an autodidact, briefly attended the University of Halle (where he heard Baumgarten's lectures on aesthetics), worked as a private tutor, and then, for five miserable years, was a schoolmaster. Finally, he was lucky enough to get a job as the librarian for Count Bünau, a well-to-do amateur scholar who was writing a history of the Holy Roman emperors. This position gave him access not only to the count's excellent library but, more important, to the vibrant art scene in nearby Dresden, where the Saxon electors had accumulated an extraordinary collection of art. In 1754, Winckelmann left the count's service, moved to Dresden, and succeeded in acquiring the patronage necessary to finance a study trip to Rome. He lived there from 1755 until 1768, when he was murdered by a thief in a hotel in Trieste.

In Rome, to supplement his small pension from the Saxon court, Winckelmann had entered into the service first of Cardinal Archinto, the papal secretary of state, then of Cardinal Albani, one of the great Italian

connoisseurs of the eighteenth century. In 1763, Winckelmann was named prefect of antiquities and given a post in the Vatican library. He spent his days reading, visiting the Roman collections, guiding visitors around the city, and occasionally traveling south to see the ancient sites around Naples. He seems to have known everyone: visiting royalty such as the prince of Dessau, prominent foreigners such as John Wilkes, artists such as Anton Raphael Mengs (with whom he lived for a time), Angelika Kaufmann (who painted his portrait), and a host of others. Winckelmann became a famous figure on the Roman scene; his writings were translated and discussed throughout Europe; his influence remained powerful long after the specifics of his work had been corrected or rejected.

Winckelmann was thirty-eight years old when he published his first book, *Gedanken über die Nachahmung der Griechischen Wercke in der Malerey und Bildhauerkunst* (Thoughts on the imitation of the Greeks in painting and sculpture), which appeared in an edition of fifty copies just before he left Dresden in 1755. In Rome, he wrote a series of essays on various antiquities, a book on ancient architecture, and a catalogue of Baron von Stosch's art collection; in 1764, he produced his masterpiece, *Die Geschichte der Kunst des Altertums* (The history of art in antiquity). Although he produced other books after 1764, including a two-volume work on ancient monuments, *Die Geschichte* continued to occupy his attention: he published notes and additions to it in 1767 and at the time of his death had almost completed a revised edition, which eventually appeared in 1776. Despite everything else he had to do—his obligations to his various patrons, formal duties as librarian and informal service as a tour guide for visiting dignitaries, an active social life, and extensive correspondence—Winckelmann accomplished an extraordinary amount in his thirteen years as a publishing scholar. In essence, his diverse and wide-ranging works were all parts of a single, unfinished project of seeking to understand the nature of art by connecting the particular and the general, objects and ideas, history and theory, and—most important of all—the ancient world and the present.

The Greeks, Winckelmann was convinced, represented the timeless ideals according to which artistic beauty and cultural health must be judged. Only by striving to emulate these ideals in their own art could moderns find the inspiration and instruction necessary to save themselves. In the famous passage from the opening section of his first published work, he proclaimed that "the only way for us to become great, indeed, if it is possible, to become inimitable, is to imitate the ancients."[22] Although such proclamations of the classical ideal were not uncommon in the eighteenth century, Winckelmann presented an uncommonly rich and elaborate account of the Greeks' achievements, which he firmly rooted in an analysis of their historical condition.

Winckelmann belonged to that great era of intellectual integration during which historiography was transformed from a disconnected series of stories about individuals and episodes into a unified account of processes—the transformation, in Reinhart Koselleck's phrase, from "histories into history."[23]

Unlike the great Giorgio Vasari, whose *Lives of the Artists* had retained its exemplary status for two centuries after its publication in 1550, Winckelmann did not regard the history of art as the collective biography of famous artists. The protagonist of his history was art itself, as it had been defined in the early eighteenth century: that is, art as a category of activities transcending the work of particular individuals and the differences among various media. But although art had its own history, its evolution was inseparable from the physical and spiritual world in which it developed. This was especially true of Greek art, which was based "in part on the influence of the Greek sky, in part on the constitution and government, and on the modes of thought that they had shaped."[24] Everything in the Greeks' world nourished their art: the warmth of their climate, the purity of their light, the grace of their bodies, the character of their institutions, and the quality of their religion and literature. To create his masterpieces, the Greek artist had only to look around him; his art shared and reflected the unsurpassed beauty of his life.

The beauty of the Greeks' art, Winckelmann believed, was inseparable from their virtues, especially their love of freedom: "Like a noble branch from a healthy trunk, the thought of the entire nation sprang from freedom."[25] Freedom enabled the Greeks to develop their genius and provided the basis for a society in which greatness was possible; it was the precondition and the substance of the Greek achievement. There is something deeply moving about these words of praise for freedom from a man so tethered by obligations: to practice a religion in which he did not believe, to conceal his homosexuality, to serve patrons less talented than himself, and to live dependent upon the offerings of the rich and powerful. Perhaps these daily confrontations with dependence gave special power and poignancy to his image of a community of free men joined in the common pursuit of beauty.[26]

Winckelmann's ideas about art were grounded not only in his general reflections about the past but also in his close observation of specific objects. "I came to Rome," he wrote his friend Konrad Friedrich Uden in 1756, "only to look."[27] Winckelmann had the good fortune to be in Rome at a time when there was more art to be seen than ever before. New excavations, such as those at Herculaneum and Pompeii (begun in 1738 and 1748), were uncovering important works from the ancient world, and a number of private collections had only recently become accessible to visitors. The active art market, in which his patron Cardinal Albani was vigorously involved as both buyer and seller, brought an increasing number of objects out into the open, where they could be inspected and evaluated. The treasures of antiquity, as Goethe wrote, "passed before his eyes, strengthened his inclinations, stimulated his taste, and extended his knowledge."[28]

Like the eighteenth-century physicians who emphasized the importance of observation for the diagnosis of disease, Winckelmann helped to establish the eye as the primary organ for the analysis of art. His commitment to the careful examination of artistic detail, which he attempted to record and analyze, was among his most important legacies. Winckelmann, Hegel once

remarked, created "in the realm of art a new organ for the spirit, a wholly new way of looking."[29] But Winckelmann wanted to do more than observe. Just as eighteenth-century botanists sought to construct a taxonomy of the natural world by examining individual specimens, he believed that his study of individual pieces could illuminate the larger world of classical art and also the idea of beauty itself. Significantly, he imagined the best foundation for such a project as an ideal museum containing all the works of Greek art; after each object had been examined "by the eye and understanding," it would be possible to establish the nature of beauty once and for all.[30]

In order to be seen, Winckelmann insisted, objects not only had to be physically accessible; they also had to be properly displayed and preserved. He was critical of those contemporary collections, such as the elector's antiquities that he had visited in Dresden at the end of 1754, where the pieces were crowded together and badly illuminated. Such precious objects should be arranged in an orderly manner, well lighted, and made visible from all angles so that the observer could examine each significant detail.[31] Furthermore, as Winckelmann wrote in 1767, the viewer should be able "to distinguish the old from the new, the authentic from the renovation." He was not opposed to restoring statues—among his closest associates in Rome was Bartolomeo Cavaceppi, a leading craftsman in the field—but he did insist on being able to tell what was original and what had been added later. If it was to be done at all, restoration had to be done carefully, honestly, and with restraint.[32]

The Paradoxes of Historicism

Winckelmann's insistence on the autonomy and authenticity of the past broke with the long-established habits of using yesterday's objects to meet today's needs. For most of European history, people had never hesitated to add on to existing buildings, fill out a broken relief, put heads or limbs on statues, or touch up faded pictures with new colors in order to create more finished and beautiful objects. Through this collaboration between ancient and contemporary artists, some of the past's art was lost forever, but some of it became a part—in the case of architecture and sculpture, quite literally a part—of the art of the present. By insisting on the necessary distinction between the two, Winckelmann asserted not only the significance of the past but also its pastness, its essential separation from the art of the present.

This separation between past and present produced an underlying tension in Winckelmann's thought, the tension between Winckelmann the historian, who sought to root the distinctive character of the Greek achievement in its circumstances, and Winckelmann the classicist, who proclaimed the immutable value of this achievement as an aesthetic ideal. The very success of his historical analysis of the Greeks, therefore, seemed to call into question their relevance for the modern age. This tension is, as Michael Podro has pointed out, a recurrent problem in the history of art: "the more firmly you attached a work of art to the concerns and purposes of the society in which

it was produced, the firmer the separation from the purposes and concerns of those elsewhere."[33]

Winckelmann himself was painfully aware of this tension. Indeed, the very concept of *Nachahmung*, imitation, reveals our distance from the Greeks; what we must self-consciously strive to acquire through research and analysis was simply, directly theirs: "Much that we would want to imagine as ideal," he noted sadly, "was natural for them."[34] However hard we try to emulate them, he sometimes seemed to realize, the Greeks will always lie just beyond our reach. In the closing passage of *Die Geschichte der Kunst des Altertums*, he summarized the relationship of his contemporaries to Greece with this elegiac metaphor: "We are like a maiden on the shore, who follows her beloved with tear-filled eyes as he departs forever and believes that she can still see his image in the ship's distant sail. Like her, we are left with no more than the shadowy outline of our desires."[35]

For many poets and painters in the eighteenth and nineteenth centuries, the figure of Iphigenia, who was forced to live in unhappy exile from her Greek homeland, came to symbolize the sense of loss that was always an element in classicism. For example, in Goethe's *Iphigenie auf Tauris*, which he finished in Rome in 1786, the heroine laments what she has lost:

> Alas, the sea separates me from those I love.
> I spend long days upon the shore,
> Seeking with my soul the land of Greece,
> But the waves only answer my sighs
> With their own dull roar.[36]

Like many of those who visited Italy in the second half of the eighteenth century, Goethe was struck by the contrast between the glories of the past, as reflected in its monuments and treasures, and the endemic misery of its present condition. "Everything is in ruins," he wrote from Rome, "and yet no one who has not seen these ruins can have any conception of greatness. So the museums and galleries are only golgothas, charnel houses, chambers of skulls and torsos— but what skulls."[37] Deep convictions about the past's greatness, together with the knowledge of its vulnerability to time's passage and men's changing fortunes, produced the muted sense of loss that was never far from classical sensibilities. But equally important was the impetus to preserve what was left— to study and describe, uncover and protect all that remained of ancient glory. This recognition that the treasures of the past had to be preserved and protected would remain an essential part of the museum's history.

II. Court and Public

The emergence of aesthetics as a discipline was inseparable from changes in the institutional art world; like the new science of economics, aesthetics at once reflected and shaped patterns of behavior. As we should expect from

our discussion of aesthetic theory, the most important innovation had to do with how art was experienced rather than how it was made, with perception rather than creation. Throughout the eighteenth century, as the first important theoretical statements on aesthetics were being published by Baumgarten, Sulzer, and Kant, institutional settings were created within which art could be perceived in new ways: theaters and concert halls, galleries and museums, scholarly associations and literary societies, and, most important of all, an expanding network of published materials. Since Jürgen Habermas's influential work, this collection of institutions has been thought of as "the public sphere," the realm of *Öffentlichkeit*, within which ideas and images, instruction and entertainment, could be transmitted to a new kind of audience—to a "public."[38]

Like the concept of the "fine arts," *public* brings together a number of different activities. In his widely used dictionary, for example, Johann Christoff Adelung distinguished between the audience attending a play and the dispersed world of readers, but he regarded them both as examples of what he termed "a critical public."[39] What did sitting in a theater with a crowd of people and reading a book by oneself have in common? How could they both be expressions of the "public"? In the first place, unlike court entertainments or village festivals, theaters and books were, at least in theory, accessible to everyone. This openness made them "public." But reading and theatergoing also offered the same kind of experience of art in that the members of an audience, like individual readers, experienced art privately—in isolation from one another. However much these experiences might become an occasion for sociability and communication, they were originally internalized and isolated in a way that the traditional oral cultures of court or community usually were not. Recall that the priority of private perception was the message of Chodowiecki's portrayal of the "natural experience of art," which extolled the same kind of quiet, individual attentiveness that was required in both theater audiences and readers.[40] The public sphere, therefore, institutionalized both accessibility and subjectivity, essential characteristics of aesthetic experience in the art world within which museums developed.

Courtly Publics

Since the eighteenth century, the idea of a public has had powerful ideological resonance. Kant, for instance, emphasized its progressive, enlightened character; he regarded *Öffentlichkeit* as an instrument of critical reason that eventually would triumph over the forces of superstition and unreason. Others compared the openness and universality of the public sphere to the closed, status-driven world of the court aristocracy. To a remarkable degree, historians have appropriated this normative image of the eighteenth-century public, which they conventionally link to the progressive social forces that supposedly promoted the triumph of the middle classes [*Verbürgerlichung*] in German culture. "The 'great' public that formed in the theaters, museums, and concerts," Habermas argued, "was bourgeois in its social origins."[41]

The close association of public and *Bürgerlichkeit* seems to me to force the complexities of eighteenth-century culture and society into an oversimplified, excessively dualistic model. There was, in fact, nothing necessarily *bürgerlich* or progressive about the public sphere, in which many members of traditional elites actively participated and where quite unprogressive ideas and values were vigorously propagated. Moreover, the divisions between the new public and the traditional court were always porous; individuals frequently lived in both realms or moved easily from one to the other. In this regard it is worth noting that Chodowiecki's pictures of the "natural" and "affected" ways of experiencing art portray the same two figures, whose dress and swords identify them with the nobility. The difference between the two poses is in the men's sensibilities, not their social position. Nor is it surprising that Chodowiecki's own work, which is justly famous for its portrayal of enlightened values and bourgeois life, was avidly collected by princes such as Franz Friedrich Anton, the duke of Saxe-Coburg.[42] To understand the German art world at the end of the old regime, therefore, we must examine the coexistence and interaction of new and traditional forms of culture.

Everywhere we look in eighteenth-century culture, we find a blend of court and public. Consider, for instance, Winckelmann's career. Without patronage—first from Count Bünau and then from the Saxon court—he would not have been able to produce the works that made him famous. Even in Rome, Winckelmann, like almost all the other German artists and intellectuals living there, depended on pensions from some patron or other. His increasing fame as a writer did not enable him to support himself, but it did help him to improve his position in the courtly world. Cardinal Albani employed him not simply because he enjoyed his company but because his reputation was growing in the public sphere. As Winckelmann himself realized, Albani wanted him "not for the service I could perform, but in order to be able to say that I am his."[43] To the cardinal's household, and to his collection of ancient art, Winckelmann brought his expertise as a scholar and his prestige as a well-known writer. All of this was especially useful to someone like Albani, who was eager to legitimate both his purchases and his sales. Winckelmann's ideas about the relationship between art and freedom belonged to the realm of enlightened opinion; his life remained enmeshed in the traditional world of patronage and dependence.

A more prominent example of the interaction of court and public interacted is the career of Winckelmann's great admirer, J. W. Goethe. The stunning speed with which Goethe's fame spread after the publication of *The Sorrows of Young Werther* in 1774 indicated the German reading public's newly acquired vigor and receptivity. Virtually overnight, the young author became a celebrity in whose reflected glory everyone wanted to bask—including young Duke Carl August of Weimar, who sought him out during a brief stop in Frankfurt at the end of 1774. There is no doubt that Goethe's reputation made him a valuable ornament to the duke's court. But why did Goethe allow himself to become first the duke's favorite, then a hardworking

member of his government? Unlike Winckelmann, Goethe was not without resources and alternatives; he did not need a patron in order to survive. Certainly, he enjoyed his sometimes strenuous friendship with the duke as well as the pleasures of courtly life. But most of all, he was attracted by the court's blend of political power and cultural authority, which he recognized as sources of personal influence and artistic inspiration. Of course, Goethe was also aware of the tensions between the imperatives of art and the demands of courtly life, which he explored so powerfully in *Torquato Tasso* and from which he fled to Italy in 1786. Nevertheless, two years later he returned to Weimar and thereafter devoted his life and his art to both court and public. The great achievement of Goethe's later career, Nicholas Boyle has written, was "to create an art which aspired to the intimate relation with the reading public characteristic of his Frankfurt years, but which drew equally on the forms and values of court and officials."[44]

Perhaps the most successful institutional synthesis of princely authority and public culture was achieved in the state of Dessau-Anhalt during the reign of Prince Leopold III Friedrich Franz, who was born in 1740 and ruled from 1758 to 1817. An astute student of enlightened thought, a fervent Anglophile, and an admirer of Rousseau, the prince had spent six months being shown around Rome by Winckelmann in 1766. Together with his friend and architect Friedrich Wilhelm von Erdmannsdorff, Franz turned Dessau into a model of progressive government and cultural vitality. He built schools, formed learned societies, collected scientific specimens and classical antiquities, and entertained the leading intellectuals of his day. At his country seat in Wörlitz, Franz constructed a home in the English Palladian manner, whose simple, classical lines reflected his enlightened conception of princely rule; set in an English garden, filled with shrines to enlightened ideas and places for quiet contemplation, Wörlitz, like many of his other properties, was accessible to everyone. As Rudolf Braun and David Gugerli remark, Dessau-Wörlitz "makes apparent how difficult it is to fix sociologically what *bürgerlich* means."[45]

Although rarely with the creative harmony possible in so small a state as Dessau, everywhere in German Europe the growth of the public sphere led princes to redefine their cultural role. In 1742, for instance, Frederick the Great built an opera house in Berlin which had both courtly and public features. Originally, admission was free but required an invitation. In 1789, Frederick William II had the building redesigned; its boxes were converted into a gallery, and tickets could be purchased by anyone who could afford them. In the course of the century, more and more princes patronized opera companies, theater groups, and orchestras that performed for the public.[46] At the same time, they opened the grounds of their palaces or even, as in Munich in 1789, constructed new gardens for their subjects' enjoyment. Libraries and collections, once closed within the court, became more easily available to artists, scholars, and casual visitors.

Like the military uniforms the princes began to wear and the state papers over which they labored, their role as patrons of public culture was part of a

structural transformation in the way dynastic authority was exercised and imagined. But this new involvement in the public sphere was also a natural extension of the prince's traditional role as a patron of the arts, as well as of the court's traditional function as a means of communicating values to its own members and to the world at large.[47] To be sure, the prince's position had changed: he no longer was, as in the world of the baroque court, the symbolic center and ultimate expression of all authority. Nevertheless, as the source of patronage and personification of taste and values, he retained a significant position at the cultural intersection of court and public.

Both as the object of princely patronage and as an essential ingredient in courtly modes of communication, the visual arts had always occupied a special place in early modern courts. Most employed a variety of artists to prepare settings for courtly rituals, celebrate the prince's achievements, and create monuments to dynastic glory. Such courtly art remained important throughout the old regime; indeed, some of its greatest achievements, such as Giambattista Tiepolo's frescoes in the episcopal palace at Würzburg and François Cuvilliés's hunting lodge at Nymphenburg, are from the middle decades of the eighteenth century. In many places, traditional patronage remained much the same throughout the century. At the court of Zweibrücken, for instance, where Johann Christian Mannlich was court painter, artists worked exclusively for princely patrons, upon whose continued favor their livelihoods depended. When their patron died or his taste or fortunes changed, they could easily find themselves without a source of support.[48]

Even the most successful eighteenth-century artists found it difficult to live without some kind of patronage; nowhere in Germany was the art market robust enough to guarantee a reliable income. Anton Graff, for example, who was perhaps the most renowned German portrait painter of his day, was Saxon *Hofmaler* at the same time that he did a thriving business painting the portraits of clients from throughout central Europe. Like Winckelmann, Graff used his growing public reputation to improve his patronage position; in 1788, the elector of Saxony agreed to raise his salary and appoint him to the Dresden Academy so that he would not accept an offer to move to Prussia.[49] The interaction of court and public in the careers of artists such as Graff was institutionalized in many of the royal academies of art that were formed throughout central Europe in the eighteenth century. On the one hand, academies offered their members the prestige and privileges of an official position, under the patronage of the court. On the other hand, academies helped artists to sell their work through regular exhibitions that served the growing German art market.[50] Here too, court and public coexisted, each shaped by and dependent on the other.

Princely Collections and the Public

For the development of the museum, the most significant interaction between public and court was in the organization and display of princely collections. From these collections came not only many of the objects that would end up

in nineteenth-century museums but also many of the ideas about how these objects should be arranged and exhibited. The development of art museums, therefore, helps to substantiate Martin Warnke's argument that the origins of the modern art world are to be found in the princely courts.[51]

At least since the Renaissance, collecting things had been an important part of being a prince. At the end of the sixteenth century, for example, Francis Bacon listed among the necessary attainments of every learned gentleman a "goodly, huge cabinet" filled with natural and manmade wonders. The possession of rare and valuable things was a source of pride and prestige, and also a means of exhibiting the discriminating taste and easy learning regarded as so becoming in the rich and powerful. Collections provided the settings for the ceremonial display that was at the center of courtly life, as well as places of contemplation and repose into which the prince might retire.

Some of the great early-modern collections of natural and artificial things were elaborately arranged to represent the world, and thus to provide a microcosm over which the prince could claim authority. In 1565, Samuel Quiccheberg called the *Kunstkammer* established in Munich by Duke Albrecht V a *Theatrum Sapientiae*, an appropriate appellation for a collection that included books, graphics, maps, works of art, weapons, religious relics, wax figures, scientific instruments, miraculous pieces of corn that had fallen from the sky, a malformed calf's head, and much more.[52] Another famous collection was assembled in the 1560s and 1570s by Archduke Ferdinand II in his castle at Ambras. Four buildings on the castle grounds were devoted to collections: three to arms and armor (the archduke's special interest), and one to an all-purpose *Kunstkammer* whose contents were organized according to their raw material. This system of classification was carried out with such consistency that in the cupboard containing items made of bone, among the antlers and the ivory carvings, was to be found the arm of a Habsburg ancestor—an early expression of the museum's ability to transform even the most sacred object into a thing like any other.[53]

A few early-modern collectors, such as the Habsburg Archduke Leopold Wilhelm (1614–1662), specialized in fine paintings and sculpture, but most of them assembled a variety of objects deemed to have value: ancient coins, unusual feathers, beautiful seashells, stuffed animals, old armor, and whatever else seemed rare, curious, or beautiful. In the collection as microcosm, pictures and statues sometimes occupied an important but not unique position as transitional objects, at once natural and manufactured, creations of God and man.[54] But they were not regarded as "art" in the eighteenth-century meaning of the term, nor were they singled out for special treatment. To the Bavarian elector, for example, who organized the contents of his collections according to the material from which they were made, it seemed quite reasonable to put his master of linens in charge of his picture gallery—paintings are, after all, made of cloth.[55]

Gradually, early-modern collections became less inclusive and more specialized—in large part because once some things were regarded as art,

they seemed to have nothing in common with such curiosities as unusually large antlers and stuffed alligators. Art's primary value come to depend less on its rarity or the costliness of its materials than on its moral and intellectual effect—which is why painting and sculpture began to be more highly prized than intrinsically more valuable objects such as tapestries or jewelry. Because of its special status, art had to be treated with appropriate reverence, properly displayed and carefully studied. It also had to be accessible to all those who might be edified by its moral value or instructed by its historical message.

By the mid-eighteenth century, efforts to make art public were apparent throughout Europe. Like most aspects of public culture, the practice of opening collections began in France and England. In 1750, the Luxembourg gallery in Paris was open to the public for three hours, two days a week; by the time it was closed in 1779, plans were already under way for a larger and more generally accessible national museum in the Louvre. In 1753, the British House of Commons approved the creation of a museum that would give "free access . . . to all studious and curious persons." When the British Museum opened six years later, an elaborate set of restrictions ensured that those whom one trustee called "ordinary people of all ranks and denominations" did not endanger the museum's possessions or excessively annoy its staff.[56] In no German state were there programs as ambitious as those of Paris or London, but rulers almost everywhere began to make their art more publicly available.

Access to art collections was especially important for artists, whose training frequently involved copying the works of old masters. Sulzer regarded what he called "the public use" of galleries for artistic education as their most important function; galleries, he argued, are for artists what libraries are for scholars.[57] In most states, it became standard practice to allow students and connoisseurs free access to the ruler's collections. For example, in 1786, the first year of his reign, Prussia's King Frederick William II decreed that all his collections should be available to students; four years later, the new statutes of the Academy of Art recommended the appointment of a gallery inspector who could provide instruction as well as oversee the royal collection. By 1800, the curriculum of the Berlin Academy scheduled thirty-two hours a week for gallery work.[58]

In the course of the eighteenth century, almost every important German art collection was opened to the public. To inform people about what was worth seeing, J. G. Meusel included a list of all the major German collections in his *Teutsches Künstlerlexikon*, which was first published in 1778 and then appeared in an enlarged edition between 1808 and 1814.[59] Sometimes it was necessary to acquire tickets ahead of time or apply to the gallery director for permission to enter. Guided tours of the Braunschweig Kunst- und Naturalienkabinett were available several times a week; advanced booking guaranteed a ticket. Other collections were simply open at set hours on certain days of the week: Munich's Hofgarten gallery, for example, could be visited from nine to twelve and one to four every weekday. "Who is not pleased,"

Joseph von Rittershausen wrote about his visit there in 1788, "that the gallery is now open to everyone?"[60]

When Rittershausen spoke of "everyone" (*alle Menschen*), he did not, of course, have in mind every inhabitant of Munich who might show up at the gallery door. Access to a gallery, like participation in public culture as a whole, was limited by an elaborate set of rules and preconditions: one had to have the money to buy theater tickets, the ability to read in order to have access to books, and the right appearance to be welcome in literary societies. Restrictions on visiting galleries were both formal and informal, stipulated in the regulations or left to the discretion of whoever was in charge. In 1792, access to the imperial gallery in Vienna was limited to those with clean shoes—not a trivial matter in a city with lots of horses but no sidewalks. In his guidebook to Berlin, published in 1769, Friedrich Nicolai gave the address where permission to visit the royal collections could be obtained. "Everyone is allowed," he added, "to view these rarities, and it is to be understood that what is customary and conventional [*üblich und gebrauchlich*] in other places will also be enforced here."[61] This remark reminds us not only that collections were restricted to those who knew the rules, but also that, by the end the 1760s, visiting collections had become common enough practice among Germans that Nicolai could simply allude to these rules without having to spell them out. He could assume that "everyone" would understand what was "customary and conventional"—that is to say, everyone who was likely to be reading his book. In practice, therefore, the number of people who actually visited a gallery tended to be small: in the 1750s, for example, only about thirty visitors a month entered the electoral gallery in Dresden.[62]

As art was transformed from an ornament of the courtly world into a source of public edification, the role of the prince changed but did not disappear. The great collections still belonged to him, just as the best artists still had some connection to the court. Moreover, the prince's collections continued to be a way of communicating his glory, although now it was communicated to the public at large, not just the closed society of the court.

Among the first things confronting a visitor to the new gallery that opened in Vienna in 1728 was a painting by Francesco Solimena which showed the director of the imperial palaces presenting to Emperor Charles VI an inventory of the works assembled and preserved, while the goddess Fame proclaimed the excellence of the emperor's taste to an appreciative world. A similar message appeared in the print that opened the 1778 catalogue for the electoral gallery in Düsseldorf: in a common form of secular apotheosis, a winged female carries a medallion of the Elector Karl Theodor toward glory; classical figures grouped around the easel recall his contributions to the arts; and the elector's palace, shown just above the captured weapons and standards of his enemies, stands as an enduring monument to his earthly triumphs. But although both pictures celebrate the prince as patron, an important difference between them reflects the changing role of the prince in the century's middle decades: in Solimena's tribute to Charles, the emperor

dominates the scene, and his generous act is the focus of attention; in the Düsseldorf print, the elector is not only less visually prominent but not actually present except as a work of art.[63]

Within the public galleries, both the nature of art and its relationship to the prince were transformed. The objects on display—paintings, sculpture, perhaps some artifacts from the ancient world—were no longer the luxurious ornaments of courtly life; they had been changed into *art*, with all the moral power conveyed to it by the new aesthetics. Although still belonging to the prince, they were thus effectively sheltered from the ideological attacks on luxury that had become increasingly widespread as the century progressed. As art, the primary purpose of these objects was not to proclaim the prince's glory; instead, prince and public joined to celebrate their beauty and power.

A good expression of this new relationship of prince, public, and art appears in Schiller's "Brief eines Reisenden Dänen," first published in 1785, which describes a visit to the collection of antiquities in Mannheim:

> Today [writes the fictional Dane] I had an inexpressibly pleasant surprise, which has enlarged my whole heart. I feel nobler and better. I have come from the Hall of Antiquities. . . .
>
> Every native and foreigner has the unlimited freedom to enjoy these treasures from antiquity because the clever and patriotic elector has brought them from Italy, not to add to his glory by possessing one more rarity nor, like many other princes, to provide the casual traveler with something to admire. He made this sacrifice for *art* itself, and a grateful art will forever praise his name.[64]

The prince was to be honored, therefore, not because he owned these things but rather because he was willing to share them with the public. By making art accessible to all, the prince associated himself with its moral power.

Intermediaries

A prince's art collection was usually supervised by a court artist, who might have the additional title of *Galerieinspektor* or—like Court Painter Nicolas Guibal in Stuttgart in 1760—gallery director. These artists advised the prince on what to buy, were in charge of maintaining and restoring his pictures, and helped to prepare inventories and catalogues. At some courts, the *Galerieinspektor* was an important figure; Mannlich, for one, had close access to the prince and considerable influence over how his collections were organized and displayed. Elsewhere, he was little better than a custodian, happy to earn pocket money by selling tickets to the collections or showing visitors around.[65]

As their art collections became more public, some princes hired experts to help them acquire, organize, display, and publicize their art. These experts were the vanguard of what would become an increasingly important sector of the modern art world, the talented and ambitious individuals who act as

advisers and intermediaries for wealthy and powerful collectors. Just as the objects on display in todays's art museums often originated in princely collections, so modern museum administrators can trace their ancestry back to eighteenth-century intermediaries such as Christian Ludwig von Hagedorn and Christian Mechel.

The son of a Danish official who had died young and poor, Hagedorn (1712–1780) studied law and then joined the Saxon diplomatic corps, in which, as a representative to various states, he specialized in matters of court etiquette, ritual, and precedence.[66] He was deeply interested in art, a frequent visitor to various princely collections, and the friend of many artists. From his artistic connections and through careful purchases on the auction market, he began to build a private collection, to which he devoted much of his free time and limited resources; in the end, he is reported to have owned 225 oil paintings. After his retirement from government service in 1754, Hagedorn became a full-time connoisseur; he contributed articles about art to periodicals, published books, and made prints. In his major work, *Betrachtungen über die Mahlerey* (Observations on painting), which appeared in 1762, he combined his firsthand grasp of artistic techniques with an impressive knowledge of aesthetic theory.

Like Winckelmann, whom he knew in Dresden and whose works he had read and admired, Hagedorn used his literary accomplishments to enhance his value to the court. In 1763, the elector made him his adviser on artistic affairs and then general director of the arts in Saxony, with responsibility for all the dynastic collections and galleries and for the Academy of Art as well. Armed with this authority, Hagedorn set out to strengthen the ties between art and society. He tried to make the academy serve the common good by cultivating taste and improving craftsmanship, as well as by training painters and sculptors. At the same time, he sought to improve the pedagogical mission of galleries by making them into schools of art history as well as sources of good taste and public virtue.

Christian Mechel (1737–1817) entered the eighteenth-century art world from a different direction.[67] The son of a prosperous Basel craftsman, he began as an apprentice to a printmaker in Augsburg. In 1757 he went to Paris, where he became associated with the most successful German engraver of the time, Johann Georg Wille, in whose workshop several generations of young German artists learned their craft.[68] After acquiring a little capital, Mechel returned to Basel and set himself up as an art dealer. In 1766, he spent an important few months in Rome, where, like so many other visitors, he met Winckelmann and was impressed both by his ideas and by his place in the Roman art world. From Winckelmann he learned new ways of looking at and talking about art, which he used to expand his business as printmaker and agent. For the next several years, Mechel was one of the most successful art dealers in Europe, with ties to the small German courts and his own thriving "academy" that turned out prints, small folios, and a few large works, among them the Düsseldorf gallery catalogue.

Mechel's big opportunity came in 1777, when the Emperor Joseph II stopped by his workshop to look at his prints. The next year, Joseph called him to Vienna to supervise the installation of the imperial collection in the Belvedere. Mechel returned from Vienna with gifts, honors, and special privileges. For the next few years, his business flourished; he traveled throughout Europe, moved in the highest circles, and sold his prints at a healthy profit. For Mechel, as for so many other purveyors to courtly life, the French Revolution was a disaster. He went bankrupt in 1805 and spent the last decade of his life as a pensioner of the Prussian king, desperately and unsuccessfully trying to recoup his fortune.[69]

Both Hagedorn, the diplomat and expert on courtly ritual, and Mechel, the artisan and merchant, moved across the eighteenth-century art world, buying and selling in the expanding art market, participating in the public discussion of art's history and purpose, and establishing those ties with the courts necessary to influence the way art was displayed. Like their more famous contemporaries—Winckelmann, Goethe, Graff—they were able to succeed because of their ability to use the opportunities provided by both court and public.

Collections and the Literary Public

Among the most important tasks assigned to intermediaries such as Hagedorn and Mechel was publicizing the prince's collections. Since the Renaissance, collectors had assembled inventories and printed descriptions of their hold-ings, but these were usually records of ownership rather than modes of public communication. The earliest known attempt to bring a German collection "in black and white to the light of day" was made at the beginning of the eighteenth century by the Viennese gallery inspector, Christoph Lauch, who hired the painter and printmaker Jakob Männl to produce an illustrated cata-logue of the emperor's paintings; both men died before the project was finished. The first catalogue exclusively devoted to a German gallery was produced in Düsseldorf in 1719. Thereafter, as galleries became more accessible and visiting them more popular, the public's demand for useful descriptions grew, as did the desire of princes to have their collections publicly recognized. In 1778, for example, Mechel collaborated with Nicolas de Pigage to produce a complete catalogue of the Düsseldorf gallery, show-ing its contents wall by wall. Since this catalogue was too large and expen-sive to serve as a guidebook, a more compact edition was produced five years later. Mechel also supervised the production of a guide to the Vienna collec-tion, published in both a French and a German edition, which not only identified and located individual works of art but also indicated which ones were especially worthy of attention.[70]

Catalogues were intended to encourage visitors by displaying what each collection had to offer. "It is impossible to page through these descriptions and illustrations," J. H. Merck wrote about the Düsseldorf catalogue, "with-

out feeling the strongest urge to travel to Düsseldorf and view these treasures for one's self."[71] At the same time, they were designed to encourage the kind of aesthetic experience that was becoming associated with the fine arts, an experience involving recognition of the moral function of beauty and the necessity of a discriminating taste. In the preface to the catalogue of the Dresden collections, for instance, readers were told that this was a book not for the "simple traveler, who strolls through the galleries," but rather for the "true connoisseur who studies them, and who, after having experienced their beauty . . . reflects on why he prefers one work to another."[72]

In addition to these catalogues, a growing number of periodicals helped to spread information about collections to the German public. At first, they tended to discuss art in connection with other kinds of collections—precious gems, rare or odd natural specimens, and other curiosities—but after 1750, as the modern system of the arts took hold, periodicals began to treat art as a separate category. At the same time, more specialized journals focused on painting and antiquities. In 1779, J. G. Meusel began to publish the *Miscellaneen artistischen Inhalts*, which was reprinted under various titles until 1808. As its original title suggests, the *Miscellaneen* was a mélange of scholarly articles, biographical sketches of artists, prices and market information, and other items of interest gathered by a team of fifty collaborators throughout central Europe.[73] Equally important as a source of public information about visual images were reproductions of famous artworks, which were turned out in large quantities by the thriving German printmaking trade. Sulzer viewed the growing availability of these reproductions as "a great advantage of the new age over the old," because it brought the work of "the great artists, whose originals are locked up in the palaces of the great, into the homes of ordinary citizens."[74]

The visual arts also found their way into people's homes in literary accounts of gallery visits, which became a recognized genre that blended personal experience, theoretical reflections on art and beauty, and descriptions of individual pictures and statues. An important early example was Wilhelm Heinse's "Über einige Gemählde der Düsseldorf Galerie," first published in *Der Teutsche Merkur* in 1776–1777. Heinse (1746–1803), like so many of his contemporaries, served both public and court: a man of letters, journalist, and translator, he held a sinecure at the elector's court in Mainz until he was driven out by the French Revolution. His gallery description used an epistolary form which allowed him to take a personal, informal tone in his responses to what he had seen. Like Winckelmann, Heinse wanted to make public his subjective responses to individual works and thereby to extend and embellish the experience of art available to those who visited galleries themselves.[75]

Gallery descriptions like Heinse's, together with catalogues, art periodicals, and the reproductions of famous works, helped to develop an audience for the visual arts within the small but significant literary public that had begun to remake German culture in the eighteenth century. From these publications about art, individuals acquired a surrogate experience of the gallery in the privacy of their homes—just as visiting a gallery demanded an

individualized private response in a public place. Seen together, therefore, art publications and art galleries blended the public and private elements that were at the core of the new art world.[76]

The best-known description of an eighteenth-century gallery is Goethe's account of his visit to Dresden in 1768, which appears in book 8 of *Dichtung und Wahrheit* and touches on many of the themes in this chapter:

> The hour when the gallery was to be opened appeared, after having been expected with impatience. I entered into this sanctuary, and my astonishment surpassed every conception which I had formed. This room, returning into itself, in which splendour and refinement reigned together with the deepest tranquillity; the dazzling frames, all nearer to the time in which they had been gilded; the polished floor, the spaces used by spectators rather than for work—imparted a unique feeling of solemnity which much resembled the sensation with which one enters a church, as the adornments of so many temples, the objects of so much adoration, seemed to be displayed here only for art's sacred ends.[77]

Goethe's account is obviously written from the spectator's point of view; the gallery does not exist for us until he enters it. Everything appears to us through his eyes; indeed we have a more vivid sense of his response to the gallery than of the space itself. He comes into the gallery not from the palace, as a courtier or confidant of the prince, but from the outside, as a member of the public, who knows what he will see from published descriptions. Nevertheless, he immediately makes his readers aware of the princely origin of the collection, seen in the splendor of the space containing the paintings, even in the very frames that surround them. But to this courtly elegance is added Goethe's sense that art has a sacred character; royal magnificence is overlaid with spiritual meaning. The gallery may belong to a prince, but it is now a sanctuary set aside from ordinary life, a public temple dedicated to art; across its polished floors move those who have come to see, to worship with their eyes. Architecturally, the gallery has lost its function within the palace: as Goethe puts it, the room turns back into itself—a reference not only to the particular structure of the Dresden gallery but also to the fact that its purpose is self-contained.

Courtier and public figure, energetic connoisseur and creative artist, Goethe is an appropriate figure with which to conclude our discussion of the German art world at the end of the old regime. With his appreciation of the Dresden gallery in mind, let us now examine more closely the spaces within which eighteenth-century princes made their art available to the public.

III. Princely Spaces

Spiro Kostof has defined architecture as "the material theater of human activity," adding that "its truth is in its use."[78] Kostof's metaphor guides my discussion of museum architecture throughout this book, but it seems

especially appropriate to the spaces devoted to housing princely collections in the early modern court. Nowhere was the theatrical deployment of space more manifest than in the baroque court; its truth was in its use as a setting for the grand drama of princely authority. The layout of the palace's grounds, the arrangement of its buildings, the decoration of its rooms were all designed to express the prince's glory. Here were enacted the symbolic representations of royal power, pageants of arrival and departure, rituals of birth and marriage and death, theatrical displays of festivity and pleasure and abundance.[79]

Within this courtly world, the ruler's collections had a well-established place. As evidence of his knowledge and taste, they were expressions of what Paula Findlen has called the "self-conscious connections between possession and power, display and self-display," which had preoccupied Italian elites and, following their example, princes everywhere in Europe.[80] Because these collections were meant to be displayed, they cannot be thought of as private in today's sense of the word; access to them as to the rest of the court, however, depended on the ruler's will. To be invited to share with the prince the pleasure of his possessions was a sign of special favor or part of some ceremony of recognition or honor.[81] Collections, therefore, were the background to, and sometimes the occasion for, those rituals of carefully regulated contact with the prince around which the life of the court was organized.

Cabinets and Galleries

As early as 1704, Leonhard Christoph Sturm published a sketch of an ideal museum, which he imagined as a simple three-story structure with separate spaces for different kinds of objects; although most of the museum was devoted to natural history, Sturm did propose to set aside one room solely for art. In 1742, Count Algarotti, an Italian art expert with strong ties to the courts of both Saxony and Prussia, described an ideal museum for August III, which he imagined as a striking combination of spaces arranged around a large courtyard.[82] In the second half of the eighteenth century, European architects and connoisseurs became increasingly interested in the problems of building museums. For its Prix de Rome, in 1753, for example, the Académie d'Architecture specified plans for a gallery connected to a palace; in 1754, for a "Salon des Arts"; in 1778, for a museum of art and natural history, with a print room and library. Five years later, in 1783, Etienne-Louis Boullée sketched as his ideal museum a massive structure with a great central rotunda and imposing porticos on all four sides. Boullée's plan was the basis for the museum depicted in Durand's *Précis des leçons* of 1802–1809, which in turn inspired the first generation of German museum builders.[83]

During the first two-thirds of the eighteenth century, however, not many separate buildings were constructed to house collections; most of each prince's possessions remained, physically and symbolically, within the court itself. There, collections could be found in many different sorts of spaces, but two arrangements seem to have been especially prevalent: the cabinet

(*Kammer*) and the gallery. In various forms and combinations, these two kinds of space would continue to dominate museum architecture throughout the nineteenth century, thereby underscoring the museum's origins in the princely collections of the early-modern court.[84]

We can get some idea of what a collector's cabinet may have looked like from Lorenz Beger's *Thesaurus Brandenburgicus*, a survey of the Hohenzollern collections, which he published between 1696 and 1701 while he was serving as "counselor and librarian" to the Brandenburg Elector (later King) Frederick. Encouraged by his sovereign's cultural ambitions, Beger had expanded the royal collections, especially of antiquities but also of the usual mementos, curiosities, and natural objects. A print from the *Thesaurus*, (fig. 2) shows a richly appointed room where structure and decoration are fused in a characteristically baroque manner. The room is full of things, but it is well appointed and large enough to retain an air of calm and repose. Although it is not clear just how the antiquities were supposed to be arranged, the largest and most important pieces seem to have been placed on table surfaces, less complete or less valuable ones on the floor. But the room is intended to store objects as much as to display them. The cupboards and drawers contain parts of the collection that can be removed when its owner wishes; they are there for him and his companions to touch or talk about—not for casual visitors to see.[85]

If the cabinet is regarded as a "theater of activity," what is the drama to be enacted there? Beger's picture gives two alternatives: the figure sketching beside the window suggests the solitary study that the room's restful atmosphere makes possible; the quiet conversation that two men are having about an object represents the learned discourse that collections were meant to inspire. The picture emphasizes the coexistence and compatibility of the two kinds of activity; in the cabinet's tranquil spaces, isolated contemplation and civilized sociability are equally possible.

Unlike the cabinet, which offered a setting for quiet study and edifying conversation, the gallery invited movement and sociability. Like that other characteristic baroque structure, the formal staircase, the gallery was originally intended to extend and connect spaces; it was meant for ceremonial arrivals and departures, processions and receptions. In its most elaborate form, such as the Hall of Mirrors at Versailles, we must visualize the gallery filled with people, color, and light. It was exactly the sort of setting through which might pass the "moving observer," who represented the ideal viewer of baroque architecture.[86] But galleries were also well suited to the display of certain kinds of objects, especially large paintings and statuary. One of the first and most influential galleries to be used in this way was built by Bramante around 1510 to display Pope Innocent VIII's collection of classical art; in the 1570s, the Uffizi in Florence was renovated to create an art gallery; ten years later, Vespasiano Gonzaga had a 300-foot-long gallery constructed for his statuary at Sabbioneta. The Grand Gallery of the Louvre, which would play such a prominent role in the history of museums, was built in 1610.

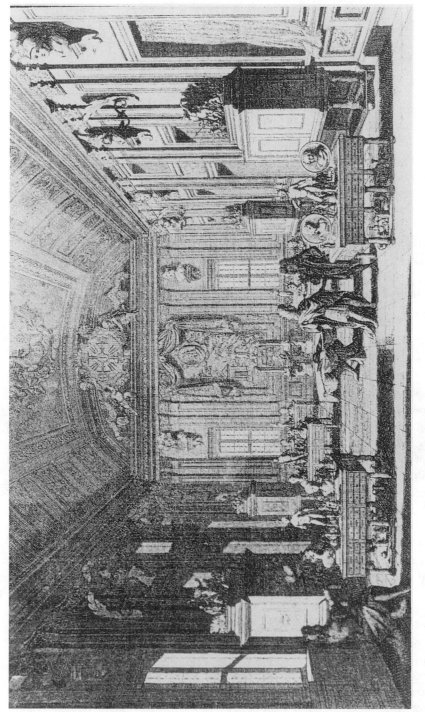

FIGURE 2. Lorenz Beger, *An Idealized View of an Antiquities Cabinet.*

The most important German gallery in the sixteenth century was the Antiquarium in Munich, built by Duke Albrecht V of Bavaria between 1569 and 1571 to house his large collection of classical statues and modern copies, then altered soon after his death in 1579.

The Antiquarium (fig. 3) is a long, barrel-vaulted space, divided into a series of bays; on both sides, its walls were broken by niches and pedestals. A stunning combination of architecture, painting, and sculpture, the entire space was intended to proclaim the glory of the ruling dynasty: the busts of emperors displayed along the sides associated them with the imperial majesty of ancient Rome; the walls pictured their territories and recorded their virtues. Although it was built to display objects, the Antiquarium's contents and structure were inseparable; they reinforced each other to create a unified work of art.[87]

After 1700, more and more German princes, alert as always to trends west of the Rhine and south of the Alps, constructed galleries to display their art, usually by converting parts of their palaces. In 1707, for example, King Frederick of Prussia's new architect, Johann Friedrich Eosander von Göthe, installed a long, gallery-like space on the second floor of the Berlin palace. In Vienna and Dresden, the royal stables were converted into galleries for the prince's art collections. Eventually, the association between gallery and court became close enough for a well-informed Dresden collector to believe that the term should be used to refer only to the collection of a sovereign prince.[88]

An early example of a German art gallery was the extension to his palace at Salzdahlum built by Duke Anton Ulrich of Braunschweig in 1701. Visitors entered the complex of rooms through the so-called grand gallery, a long, splendid hall with two rows of ancient and modern statues; its ceiling was decorated with allegorical frescoes celebrating the arts; a mirrored wall at one end visually extended its space. At a right angle to the grand gallery was a slightly longer and much narrower gallery that had paintings on one wall, windows on the other. At the near end of this second gallery were two cabinets where smaller pictures were displayed. The far end opened into an eight-sided cabinet where a few pictures were illuminated by windows in the upper walls. Architecturally and spiritually, this "sanctum sanctorum" was the culmination of the gallery, in which the visitor could contemplate the finest, most inspiring works in the collection.[89]

The Düsseldorf gallery, opened in 1710, was built by the Palatine Elector Johann Wilhelm (1658–1716) to house the paintings from his own collection and from that of his second wife, the daughter of Grand Duke Cosmo III of Tuscany. The building was U-shaped, with three long rooms connected by two smaller cabinets; in the long rooms, paintings hung on one wall which were lit by windows opening to the court; next to the windows were movable screens to which small pictures were attached. In 1756, the gallery was reorganized by Lambert Krahe, a local painter who had worked for many years in Rome. Instead of using the paintings merely as an extension of the architecture, Krahe gave equal emphasis to the objects themselves. Abandoning

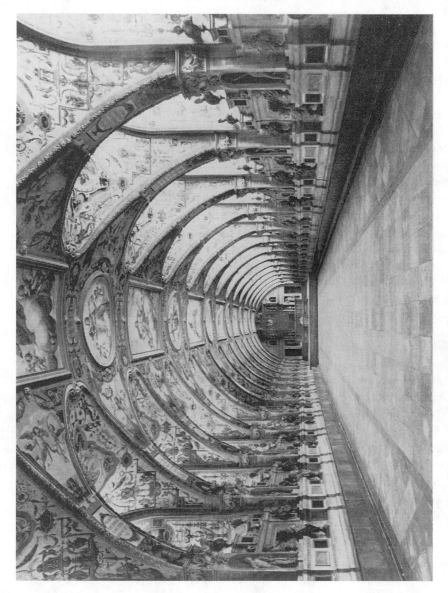

FIGURE 3. Interior of the Antiquarium in Munich from the northwest.

the conventional practice of covering the walls completely, he removed some of the less important works and tried to display the rest in a way that would suggest their relative artistic quality. He also divided the gallery's contents into schools: the visitor entered first the "Saal der vlämischen Meister," which held Flemish paintings from the seventeenth century; next, a cabinet with smaller genre scenes; then the Italian Hall, with a few genuine treasures and a great many copies; then the second cabinet devoted to a local artist, Adriaen van der Werff; and finally, the great Rubens Hall, whose forty-six paintings were presented as the high point of the collection.[90]

As their collections expanded and became more specialized, princes everywhere in German Europe built new spaces to house them. Nowhere was this more necessary than in Saxony, whose rulers had been avid collectors of all sorts of things since the middle of the sixteenth century. August the Strong (1670–1733, elector from 1694, king of Poland from 1697) not only added to these collections but also began to reorganize them so that they might be better preserved and displayed. It was August who was responsible for the Zwinger complex, designed in 1711 by Matthias Pöppelmann to be a setting for court entertainments and to house some of the royal collections, including an assortment of exotic plants. August also shifted his print collection out of the palace's all-purpose *Kunstkammer* into separate rooms, displayed his bronzes and jewelry in the so-called Grüne Gewölbe, and began to move the best of his enormous collection of paintings out of the palace proper and into a gallery constructed in the royal stables.[91]

August's son, August III (1696–1763, elector from 1733), shared his father's love of precious objects but had a more focused interest in the "fine arts." It was during his reign that many of the treasures of the Dresden collection were acquired, including the Sistine Madonna, which he bought in 1754. August III also presided over the extensive remodeling of the art gallery in 1745–1747. The newly created exhibition space was divided into two parallel galleries, one lit by windows facing the courtyard, the other by windows looking out into the Neumarkt. Public access to the gallery was through a fine double staircase, added to the Neumarkt facade in 1729–1730. The Dresden gallery became one of the most famous art museums in Europe, often visited and much admired by connoisseurs and travelers—including, as we have seen, Winckelmann and Goethe.[92]

The princely galleries constructed in the first half of the eighteenth century had strong stylistic ties to their baroque models. They continued to be splendidly decorated, and, as in the Antiquarium, their contents were usually designed to blend with the structure in order to create a unified visual impression. Nevertheless, the gallery was no longer simply a setting for courtly life; it had its own spatial organization, which, as in Salzdahlum, led the visitor along an aesthetically defined path that culminated in the collection's finest works. No longer a transitional space through which people moved from one part of the palace to another, galleries became self-contained struc-

tures with their own rhythms and purposes—as Goethe said of the Dresden gallery, "places used more for viewing than for work."

Galleries still retained their structural connections with the court and their symbolic dependence on the prince. At Salzdahlum, for example, the grand gallery was linked to the rest of the palace by a mirrored antechamber, and two galleries enclosed the duke's garden, into which visitors exited at the end of their tour. No one who visited any of these collections could doubt that they belonged to the prince. But they also had a public face: the Düsseldorf gallery, which was adjacent to the elector's palace, had a separate, outside entrance. Local nobles, civil servants, and artists apparently had unrestricted access; foreigners could obtain admission tickets from the *Hofmarschall*. In Dresden, the gallery was still joined to the palace complex by a slender passageway, but the main entrance was obviously the staircase into the Neumarkt, whose architectural prominence underscored the building's role as what Carl Heinrich von Heinecken, the author of the first catalogue, called an *école publique*.

Public and Private Spaces

Around the middle of the century, the growing penetration of public culture into the life of the court began to affect not only the design of galleries but also the construction of theaters, opera houses, libraries, and similar buildings. In these projects, we can see the first signs of that slow, uneven process of architectural specialization through which the functional and symbolic centrality of the court would eventually give way to a fragmented series of public offices and institutions, eventually housed in separate quarters.[93]

The same forces that pulled some of the court's activities into the public sphere encouraged princes to reserve some spaces for their own private use. Unlike Louis XIV, into whose royal apartments at Versailles courtiers would be invited to bask in the warmth of the king's proximity, princes now wanted separate quarters where they could find relief from their duties and enjoy the comforts of a private life. In the course of the eighteenth century, therefore, princes built a variety of retreats—pleasure palaces [*Lustschlosser*], hunting lodges, garden houses—which were removed from both the ceremonial publicity of the traditional court and the universal accessibility of the new public areas. At Wörlitz, for example, where so much was open for the public's delight and enlightenment, some spaces were set aside only for the prince and his familiars.[94]

A good example of how princes began to think about private space is Sanssouci, the palace designed by Frederick the Great and his court architect, Georg Wenzeslaus von Knobelsdorff, and built near Potsdam between 1745 and 1748. Sanssouci was not, of course, without a certain representational quality; it was, after all, a king's palace, carefully placed on formal terraces amid splendid surroundings. But the long, low structure of the origi-

nal palace made no claim to grandeur or symbolic centrality; its elegant rooms were primarily intended for private living and recreation rather than cere-monial display. The realities of power, Frederick believed, were to be found around the conference table or on the battlefield, not in the rituals of king-ship so highly regarded by his grandfather, Prussia's first King Frederick, whom he regarded as "great in trivial affairs, but trivial in great ones."[95] Sanssouci was an elegant refuge from the harsh realities of public affairs, a place to enjoy art and music, intelligent conversation and refreshing solitude. When Frederick wanted to indulge his taste for additional buildings, he did so not by adding to the original palace but rather by scattering other struc-tures about the grounds. The result was a complex that had neither a sym-bolic center nor an overall design; the various structures reflected Frederick's various moods and inclinations.[96]

Among Frederick's first constructions after the completion of the palace itself was a picture gallery, designed by Johann Gottfried Büring, who had become the king's chief architectural adviser after Knobelsdorff's death in 1753. Because of the Seven Years' War, the gallery, begun in 1755, was not finished until 1763. Sited on a terrace next to but slightly lower than the palace, it matched Knobeldorff's Orangerie on the opposite side. Like these buildings, the gallery was a low, one-story structure, without an elevated pedestal or elaborate entrance. The design was straightforward: two wings extending from a central dome, with small cabinets at either end. The gallery could be entered in two ways: at one end, a small private entrance was reserved for the king; other visitors used the doors in the facade, which opened directly to the terrace. The facade was divided by a central pavilion, its roof heavily decorated and crowned with a square lantern, and by two smaller, plainer risalits, one on each side. The main decorative work on the exterior was done by a series of sculpted urns and statues depicting allego-ries of the arts and sciences and famous artists (fig. 4). These elements were purely decorative; they were neither tied to the building itself nor part of a cohesive symbolic system—a clear sign of the flagging integrative power of Büring's rococo.

The interior of the gallery was richly decorated but structurally simple. According to the usual practice, the paintings were hung along one wall and lit by the windows facing them; the marble floor also served as a source of reflected light. The central dome contained a set of Corinthian columns that were repeated at both ends of the wings. Otherwise, the interior space was both unified and varied by its decorations, by the high quality of its material, and, of course, by the paintings themselves, which covered the walls with-out interruption.

As about most things, Frederick had strong views about art; he always knew what he liked. But it would be a mistake to overestimate either his knowledge of or his interest in the visual arts. Frederick seems to have thought of his gallery as a unity, in which structure and contents had equal weight: he had, for example, been willing to cut Antoine Watteau's last masterpiece,

FIGURE 4. Gallery at Sanssouci from the west.

L'enseigne de Gersaint, in half to fit the decorative scheme in his gallery at Charlottenburg.[97] For the gallery at Sanssouci, Frederick simply bought enough pictures—mainly large historical and mythical scenes—to fill the walls. As he wrote to his sister, "The painting foolishness [*Bildernarrheit*] won't occupy me for long, because as soon as I have what I need, I will stop buying."[98] He was not prepared to overspend. Some princes might be willing to levy new taxes in order to buy great art, but Frederick had more important things to do with his subjects' sparse resources. Nor, it must be said, was he always well advised by his art experts and agents; a number of copies and inferior pieces found their way to Potsdam. But once the walls were covered, the king seemed satisfied.

Frederick's gallery was not intended to be an *école publique*. Like everything else at Sanssouci, it was primarily a setting for the king's private moments rather than for public enlightenment or court festivities. This atmosphere of privacy and isolation is beautifully captured in Adolf Menzel's picture of the old king standing in front of his paintings, accompanied only by his dogs, whose presence underscores the absence of human companions.[99]

Although Frederick built Sanssouci for himself, he recognized his duty to share his possessions with his subjects. He hired Matthias Oesterreich from Dresden (whom Winckelmann regarded as a "great ass and a confidence man") to prepare a catalogue, which appeared in 1764. Five years later, Friedrich Nicolai's guide to Berlin contained a detailed account of the gallery and its contents. Evidently, anyone could ask to visit the collection, where they would be shown around by Oesterreich or, after his death in 1778, by a custodian.[100] The gallery at Sanssouci, therefore, had both a private and a public character. Unlike the traditional court, where the division between public and private was always fluid and indistinct, Sanssouci could be either public or private, depending on the king's needs and desires.

There was a somewhat different combination of public and private spaces in the building most often cited as the first separate museum in a German state: the Museum Fridericianum in Kassel, which was constructed between 1769 and 1779 to contain the collections and library of Landgrave Frederick II. Best known to American historians for allegedly having supplied Hessian mercenaries to the British during the Revolutionary War, Landgrave Frederick was in fact a relatively enlightened prince who, in characteristic eighteenth-century fashion, combined a desire for self-aggrandizement with a commitment to public culture and social improvement.[101] In addition to building palaces, seeking military glory, and supporting an extravagant court, Frederick subsidized scholarly projects (for one of which he unsuccessfully attempted to hire Winckelmann in 1761), established a Société des Antiquités, and built libraries, hospitals, and other public works. In his building projects, Frederick worked with Simon Louis du Ry (1726–1799), a member of a family of French Protestants which had provided architects to the landgraves for three generations. Multilingual, well traveled, having had formal training in Paris and a prolonged period of study in Italy, du Ry belonged

to that international elite of artists who served princely patrons through-
out old-regime Europe.[102]

Du Ry's most important assignment was to supervise the reconstruc-
tion of Kassel, which had been occupied and badly damaged during the Seven
Year's War. Since the war had demonstrated the uselessness of Kassel's for-
tifications, Frederick and du Ry decided to expand the city by linking its
original urban core with the Oberneustadt, a Huguenot settlement that had
grown up outside the old walls. The key elements in du Ry's plan were three
enclosed spaces: the Königsplatz, a circus in the west of the old city; the
Friedrichsplatz to the southwest; and, farther south, the Paradeplatz, into
which was incorporated the old racecourse.

The Friedrichsplatz was anchored by the Museum Fridericianum (fig. 5).
The museum's facade, eighty meters long, was divided into nineteen bays,
separated by Ionic pilasters. Its most dramatic element was a majestic por-
tico whose six unfluted Ionic columns supported a pediment, behind which
rose a heavy attic bearing statues that represented architecture, philosophy,
painting, sculpture, history, and astronomy. The museum was flanked on
one side by the Palais von Jungken, the stately home of a cabinet minister,
and on the other by St. Elisabeth's Catholic church, which du Ry designed
to balance the ensemble. In the original plan, the spaces between these build-
ings were filled with trees, which effectively closed off the northeastern side
of the square.[103]

Together with the palace at Wörlitz, on which construction also began
in 1769, the Fridericianum marked the arrival of English neo-Palladianism
in the German world. By setting his building low to the ground, du Ry
emphasized its strong horizontality, which was only slightly moderated by
the extension of the entablature with a balustrade topped with urns. The
articulation of the building's different elements—most obviously the sepa-
ration of the portico from the body of the building—showed an inclination
toward clearly defined architectural components, contrasting sharply with
the baroque architect's desire to downplay or mask the divisions within a
building.[104]

Behind the facade of the Fridericianum were two wings, one connected
to a medieval watchtower that had been converted into an observatory. Like
the British Museum, whose arrangement may have influenced the landgrave
during his visit to London, the Fridericianum included a library as well as
collections of several kinds. Much of the ground floor was devoted to classi-
cal statues and modern plaster casts. The first floor contained the library and
collections of natural history specimens, scientific instruments, clocks,
weapons, and wax figures. The museum was, therefore, a transitional building,
combining elements of the early-modern curiosities' cabinet with enlighten-
ment science and classical art.

The Fridericianum's architecture and organization proclaimed it to be
both a princely and a public institution. It dominated the Friedrichsplatz as
a palace would dominate its courtyard; the facade bore its founder's name,

FIGURE 5. G. W. Weise, *The Friedrichsplatz in Kassel* (1789). From a print by J. W. Kobold.

and after 1783, his statue faced it from the square. Frederick was in the habit of visiting his collections almost every day, usually just after he had reviewed his troops. In his private study, he met with scholars, consulted his books, and enjoyed his possessions. Nevertheless, as the museum's broad portico and lack of a high pedestal suggested, the Fridericianum was also a public structure, easily accessible to visitors; it was, in fact, open to everyone four days a week, from nine to ten in the morning and two to three in the afternoon. Places in the library were reserved for visiting scholars. And the library and the collections were supervised not by a court official but by a committee of four experts who represented the interests of the scholarly republic of letters.

The Belvedere Gallery

The Habsburgs were Germany's greatest princes and among its most important collectors of art. From the 1720s to the 1770s, the best of their remarkable collection of paintings were displayed in the Stallburg in Vienna, which, like its counterpart in Dresden, had been constructed in the stables adjoining the palace. In many ways, the Stallburg was a typical early eighteenth-century gallery: its pictures were set in curved gilt wainscoting, where they blended with the architecture; when necessary, they had been cut or enlarged to fit their assigned spaces. And although visitors were usually allowed, the Stallburg remained a princely gallery, designed and decorated to celebrate the glory of the emperor, whose patronage of the arts was memorialized in the picture by Francesco Solimena (described above). Within a few years, the Stallburg became overcrowded and uncomfortable; in 1773, when Empress Maria Theresa decided to allow artists to use the gallery to copy pictures, its total inadequacy was apparent, and a decision was made to find a new site.[105]

The Upper Belvedere, into which the pictures were moved, was part of a complex of buildings built by Johann Lucas von Hildebrandt for Prince Eugene of Savoy between 1714 and 1723.[106] The property had come into the possession of the ruling house and been given the name Belvedere in 1752. Situated outside the old city, the new gallery stood at the top of a formal set of terraces on what was said to be the site of the grand vizier's tent during the siege of Vienna in 1683. The Belvedere had been designed as a summer palace; with its beautiful gardens, tranquil location, and stunning views, it resembled a French *maison de plaisance* or one of those classical villas into which the Italian elites had sought refuge from the fast pace and crowded conditions of urban life. To some contemporaries, this seemed to be a perfect setting in which the public could experience the allied beauties of art and nature.[107]

Compared with the usual gallery, in which the ways of hanging paintings were limited, the Belvedere's complex spaces posed a major organizational challenge. The first attempt to order the pictures was made by the court painter Josef Rosa, who had been brought to Vienna from Dresden in 1772

to supervise the imperial collections. His plan was rejected. In 1778, on the basis of his excellent work in Düsseldorf and his growing reputation as an art expert, Christian Mechel was given the assignment, on which he spent the next three years. Following the practice that he and his collaborators had used in Düsseldorf, Mechel first divided the paintings into schools, then did his best to arrange the works of each school in a roughly chronological order. The imperial collection, Mechel wrote in the catalogue he published in 1781, was remarkable not only for its size and value "but also for the contributions to the history of art which it so richly offers."[108]

Within the baroque grandeur of Prince Eugene's summer retreat, therefore, the first historically organized exhibition of painting gradually took shape. Here, from his introduction to the catalogue, is Mechel's statement of what he had in mind:

> The purpose of all our endeavors was to use the numerous separate spaces of this beautiful building so that the whole arrangement as well as the individual pieces would be, insofar as it was possible, a visible history of art. This kind of public collection, which was designed more for instruction than for transitory pleasures, was rather like a well-stocked library, in which the curious visitor might find works of all sorts and from every age, not just perfect and pleasing but contrasting works, which he could observe and compare—the only way to expertise—and thus become a true connoisseur.[109]

To emphasize this pedagogical mission, Mechel hung all the paintings in simple, uniform frames and provided each with an identifying label. This was to be neither a place for princely display and courtly rituals nor a source of idle pleasure and relaxation; the purpose of Mechel's gallery was to present the history of art as an object of study and reflection.

By suggesting that a gallery should be like a library, arranged to instruct as well as to delight its visitors, Mechel introduced that tension between pedagogy and aesthetic pleasure which would remain a persistent part of the museum's history.[110] Some of his contemporaries were outraged that he was prepared to sacrifice beauty for instruction, thus creating what one artist contemptuously called a "sampler card of pictures [*Bildermusterkarte*]." Christian Mannlich, for example, saw no reason for most gallery visitors to want a historical organization: "Why should the art lover, the true connoisseur of the good and beautiful, care about the chronological order of the master artists or the differences between the schools?" Mannlich's ideal, as attested by visitors to the gallery he arranged in Munich, was to provide aesthetic pleasure for visitors and technical instruction for art students, not a "visible history of art." Even in Vienna, Mechel's plan was undermined by Josef Rosa, who, after his rival had departed, removed the labels and altered some of the arrangements.[111]

In the long run, however, Mechel's chronological approach prevailed. Eventually, most museum officials proceeded on the assumption that art objects should be seen and understood historically, as individual expressions

of a cohesive narrative that would give them order and meaning. As visible histories of art, museums existed to display this narrative and underscore its lessons. To move through a museum was to walk a path that traced the trajectory of art's development over time. "On the first floor of the building," wrote one visitor to the Belvedere in 1783, "which contains the Italian and Dutch pictures, I was in the golden age of art. When I mounted the stairs, I entered the silver and iron ages with the old Dutch and Germans."[112] In this remark we can see that Winckelmann's view of art as having a single history not only was institutionalized in the arrangement of the Belvedere's paintings but also had been absorbed into its visitors' assumptions about artistic progress and decline. If, as Ludmilla Jordanova once remarked, "all museums are exercises in classification," some version of the historical method would remain the art museum's most important principle of classification, from Mechel's day to our own.[113]

The historical arrangement of pictures was particularly important for the museum's future because it introduced a principle of organization that was independent of the building's architectural design or ornamentation. Although the full effects of this change would not be felt for several decades (even Mechel's arrangement had not totally ignored decorative consideration), the intrusion of history would eventually transform the relationship between a collection's contents and its setting. An early-modern gallery such as the Antiquarium was a unified work of art in which objects and architecture were essentially fused; in the nineteenth century, the connections between objects and architecture would loosen. After 1900, many museums would become neutral settings whose primary purpose was to provide the necessary light, space, and information for their collections. In this conception of the museum's role, the picture frames (and statue pedestals) lost their function as architectural elements that linked objects to the building and instead became visual aids that separated objects from their environment and thus connected them to the viewer.[114]

By the last decades of the eighteenth century, many of the princely spaces in which art was displayed had been reshaped to fit a new set of ideas and assumptions about art's nature and purpose. Most obviously, the objects defined as art were separated from the other things in the prince's collection; art no longer shared space with natural curiosities and handicrafts, which were seen to have a different sort of meaning and significance. At the same time, the objects on display began to be separated from their architectural setting so that they could be experienced for themselves and not just as part of a unified beautiful structure. New entrances, such as the stairway into the gallery in Dresden, underscored that the experience of art was not just for the prince and his guests but for the public at large, for whom it would provide both aesthetic pleasure and moral edification. And finally, at the Belvedere and elsewhere, historical categories had begun to be the basis for the organization of the collections, thus initiating the association between art

history and the museum which would remain essential to both in the century to come. Taken together, these developments—the specialization of princely collections, their increasing public accessibility, and their historical arrangement—would provide the intellectual, institutional, and architectural foundations upon which the German art museum would be constructed.

Despite these important changes in the way collections were organized and displayed, only a few new museums were actually built in the eighteenth century. Except for those in the Fridericianum and the Museo Pio-Clementino (which was added to the Vatican in 1773–1780), most important collections, such as the ones in the Belvedere and the British Museum, were installed in existing structures or, like Frederick's at Sanssouci, in buildings constructed according to well-established models. This tendency to use buildings from the old regime to create new public spaces points once again to that intersection of court and public where the art museum began. In the German states as in the rest of Europe, the great age of museum building did not come until the first decades of the nineteenth century, after the intellectual and institutional legacies of the old regime's art world had been transformed by the experiences of the revolutionary era.

2

MUSEUMS AND THE AGE OF REVOLUTION, 1789–1830

LIKE EVERY OTHER ASPECT OF GERMAN LIFE, THE ART world was deeply affected by the French Revolution and its aftermath. From 1792, when the revolutionary government in Paris declared war on Austria and Prussia, until Napoleon's defeat in 1815, the German lands were caught up in an uninterrupted series of upheavals: princes were driven from their thrones, boundaries redrawn, institutions transformed, and vast resources mobilized either to assist or to combat France's drive for European hegemony. In many small German courts, especially along the Rhine, artists suddenly found themselves without patrons when their princes fled to avoid the French menace. Even in states large enough to survive the revolution's onslaught, there were no funds for the sort of projects that had once provided employment for painters, sculptors, and architects.

Revolution spared neither persons nor things. The French looted art collections everywhere they went, sending the choicest objects back to Paris; as a number of smaller German states disappeared, their treasures were dispersed or transplanted; when hundreds of ecclesiastical foundations were secularized, their collections were seized, sold, or destroyed. Revolutionary upheavals increased people's sense of art's fragility and of the need to protect it from the destructive forces of change.[1] At the same time, they created a buyer's market for art, which enabled some individuals to assemble collections of remarkable size and quality. These new collections and the need to preserve them helped to set in motion the great age of German museum building which began in the 1820s. Equally important for the development of museums were two other legacies from the revolutionary age: first, the new ideas formulated in the 1790s about art's social role; second, the new cultural institutions created as part of a larger process of political renewal in the German states after the turn of the century.

I. The Ideal of an Aesthetic Community

John Zammito has aptly termed Kant's *Critique of Judgement* the "conduit through which the most important ideas and ideals of the German eighteenth

century passed to the generation of Idealism and Romanticism."[2] There is no doubt that Kant's ideas about beauty and morality provided the point of departure for many who tried to deploy art to meet the crisis of the revolutionary era, but the new generation of German intellectuals gave them greater emotional intensity and a heightened urgency. After 1789 the austere logic of Kant's arguments, like the cool abstraction of his style, seemed inadequate in a historical situation so filled with social instability and spiritual uncertainty. Kant, Friedrich Hölderlin wrote at the end of the 1790s, "is our Moses; he has led us from our Egyptian slumbers into the free, lonely desert of his speculations and brings us vigorous laws from the holy mountain." The implications of Hölderlin's biblical metaphor are clear: however necessary Kant might have been to lead Germans from the captivity of old ideas, other prophets would be needed if they were to reach the promised land beyond the present's discontents.[3]

Schiller and the Healing Power of Art

Among the first and most influential responses to the revolutionary crisis was Friedrich Schiller's "On the Aesthetic Education of Man" ("Über die ästhetische Erziehung des Menschen"), which he wrote in the form of letters to his patron, the duke of Augustenburg, and initially published in *Die Horen* in 1795. Schiller was thirty-six years old in 1795. From the beginning of his career, he had been concerned with ethical questions and especially with the moral function of art and the moral responsibilities of the artist. Like Enlightenment aestheticians, he believed that beauty brought a special kind of knowledge by using sensory experience to teach goodness. In his long philosophical poem of 1789, "Die Künstler" (The artists), Schiller told humankind that "only through beauty's gate, can you penetrate the land of knowledge." On his deathbed sixteen years later, Schiller affirmed this connection between beauty and truth by quoting two lines from the same poem: "What we have here perceived as beauty, will then come to us as truth."[4]

"On the Aesthetic Education of Man" was the most significant product of Schiller's long struggle to define the moral purpose of art.[5] Like the rest of his philosophical work from the 1790s, the essay can be read as a prolonged dialogue with Kant, whose ideas, Schiller said in 1796, had cost him twenty years—ten to understand them and ten to overcome them. The essential elements in Kantian aesthetics were present in Schiller's essay but recast to meet the deep crisis of the modern spirit that Schiller saw fully manifested in the situation in France, whose political deterioration provided the immediate context for his aesthetic meditations.[6]

Unlike many German intellectuals, Schiller had never been entranced by the French Revolution's emancipatory potential; in early 1793, as the intensity of revolutionary violence grew, he wrote that he was "sickened" by the "abominable butchers" who had executed Louis XVI. A few months later, he told the duke of Augustenburg that the revolution has "plunged not only

that unhappy nation itself, but a considerable part of Europe and a whole century, back into barbarism and slavery."[7] At the source of these political catastrophes Schiller perceived a spiritual malaise, which he variously defined as the triumph of materialism, as the spread of savagery among the masses and lethargy among the elite, and most fundamentally, as the rise of social fragmentation and cultural disharmony. Clearly following Winckelmann, he illuminated this spiritual crisis by contrasting his age to the ancient world, whose distinctive blend of harmony and freedom was modernity's antipode.

Schiller was perfectly sincere when he called his essay on aesthetic education a "profession of political faith." He was convinced that the experience of beauty would heal the modern spirit and thus re-create the cultural harmony upon which true political liberty ultimately must depend: "If man is ever to solve that problem of politics in practice he will have to approach it through the problem of the aesthetic, because it is only through Beauty that man makes his way to Freedom" (2.5, p. 9) For Schiller, art was neither a flight from political reality nor a response to political powerlessness; it was the only cure for what he regarded as an essentially spiritual malady.

The key to art's pedagogical power is its autonomy; art's connection to our deepest and most practical needs comes from what Kant called its disinterestedness. The history of human culture, Schiller argued, begins with play and ornamentation, whose very superfluity marked mankind's liberation from the realm of necessity. Because art, the highest form of play, is not part of the realms of physical sensation or moral judgment, it can create a third realm in which sense and reason, necessity and choice, reality and ideals can find harmony. From this harmony, he said, we learn to overcome the fragmentation of our culture without falling victim to either of modernity's great perils, savage sensuality or lifeless intellectuality: "By means of beauty, sensuous man is led to form and thought; by means of beauty, spiritual man is brought back to matter and restored to the world of sense" (18.1, p. 123). The experience of beauty liberates us without alienating us from the physical world in which we must live. Art and life do not become one; instead, art teaches us how to live in freedom and harmony.

Schiller's essay is devoted to the aesthetic education of the individual, for "man" (*des Menschen*), not "men" (*der Menschen*) or "humanity" (*der Menschheit*). But although that education begins with the individual, it should end with the reconstruction of the community: "Taste alone brings harmony into society, because it fosters harmony in the individual." Art, therefore, has a special role in the creation of a cohesive society. According to Schiller, we are compelled to live together by our needs; reason can teach us the principles of social life; only beauty makes us true social beings. "The dynamic state" makes society possible, and the "ethical state" makes it "morally necessary," but "the aesthetic state alone can make it real, because it consummates the will of the whole through the nature of the individual" (27.10, p. 215). Just a few lines later, in the final paragraph, Schiller seems to draw back from this utopian vision of the aesthetic state when he asks where such

a state may be found. His answer: "like the pure Church and the pure Republic, only in some few chosen circles," in circles "where men make their way, with undismayed simplicity and tranquil innocence" (27.12, p. 219). He leaves a lingering uncertainty, then, about the scope of art's transformative potential: can it remake society as a whole, or will only a small elite be able to grasp the meaning of beauty for human life?[8]

The generation of Germans who read his work against the backdrop of the revolution's political and spiritual crisis took to heart Schiller's ideal of a community that could be created by the experience of beauty and nourished by the power of art. Even those who had doubts about his ideas often ended up using them for their own purposes. This was so because Schiller vividly expressed two convictions that came to be widely shared among German intellectuals in the late eighteenth and early nineteenth centuries: first, that modern society and culture—particularly when compared with the ideal of the ancient world—are fragmented and divided against themselves; second, that art can provide a new source of spiritual harmony and social cohesion. Both of these convictions had been part of eighteenth-century aesthetics, but Schiller, under the impact of the revolution's cultural and social convulsions, gave them new power and urgency. He was among the first to recognize that, as Friedrich Schlegel wrote in 1795, "the right moment for an aesthetic revolution" had arrived.[9]

A characteristic expression of the belief that art offered an answer to the crisis of the age can be found in a text conventionally known as "Das älteste Systemprogramm des deutschen Idealismus." Dating from 1796 or early 1797, this brief document is in Hegel's handwriting, although scholars have suggested that it may have been composed by Friedrich Schelling or perhaps by Schelling in collaboration with Hölderlin. These three had been fellow students at the Tübingen seminary, were sometime residents of Jena, and during the late 1790s were would-be collaborators in a project to renew their nation's spirit. That a plausible case can be made for any one of them as the author of the "Systemprogramm" enhances the document's representative character.[10] Like Schiller's essay, it is a response to the political and cultural challenge of the revolution. Since neither the state nor philosophy can meet this challenge unaided, the document argues, philosophy must join with art to lead mankind to salvation. After proclaiming a belief in that familiar eighteenth-century fusion of goodness and beauty, the text proposes an aesthetic mythology that clearly belongs to a new generation of intellectuals: "A higher spirit, sent down from heaven, must establish this new religion among us; it will be the last and greatest human accomplishment."[11] This utopian promise of a new religion embracing both reason and art reverberated in the work of young men such as Hegel, Hölderlin, and Schelling around the turn of the century.[12]

To the first generation of German Romantic artists and writers, art was not simply *like* religion; it was, in and of itself, a religious act, an evocation of sacred beauty, a source of salvation.[13] Caspar David Friedrich, for instance,

tried to recapture the spiritual power of Christian icons not only by painting religious subjects but also by infusing secular subjects with spiritual meaning. One of Friedrich's admirers, was right, therefore, when she noted in 1808 that his *Kreuz im Gebirge* "affected everyone who entered the room as if they stepped into a church."[14] And it is not surprising that some of Friedrich's contemporaries were perplexed by pictures that seemed to violate conventional distinctions between the secular landscape and the sacred icon. His work, they believed, was too spiritual for a secular setting but too aesthetic for a conventional place of worship.[15]

Galleries as Chapels of Art

For many of those who adopted the new aesthetic religion, museums became sacred spaces, shrines to the cult of art, sites for the rituals through which a faith in beauty might be spread. Consider, for example, the characterization of art galleries in Wilhelm Wackenroder's *Herzensergiessungen eines kunstliebenden Klosterbruders* [Outpourings from the heart of an art-loving monk], which was written about the same time as the "Systemprogramm."[16] *Herzensergiessungen* takes the form of a series of reflections by a pious monk, through whom the author presents his own views on art and artists. The core of the book is Wackenroder's conviction that art and religion are similar enterprises: they represent, he wrote, "two wonderful languages," one the language of nature through which God reveals "His being and attributes," the other the language of art, which "through similar dark and mysterious ways . . . also has a marvelous power over the heart of man" (p. 119). Like the author of the "Systemprogramm," Wachenroder believed that from art— as from nature—we will learn things that philosophy cannot teach us; words appeal only to our brains, but the language of beauty engages our entire being, bringing truths that transcend speech. The artist, therefore, is like a priest, who serves as an intermediary between the human and the divine. Indeed, Wackenroder seems at times to suggest a parallel between divine and artistic creativity, that is, between God and the artist: "Art represents for us the highest human perfection. Nature, to the extent that a mortal eye sees it, resembles fragmentary oracular decrees from the mouth of the deity. However, if it is permissible to speak thusly of such things, then one would perhaps like to say that God may, indeed, look upon all of Nature or the entire world in a manner similar to the manner in which we look upon a work of art" (p. 120).

Although *Herzensergiessungen* is often called a *Künstlerroman*, a novel about an artist, it has more to do with the reception than the creation of art; it is essentially a perceiver's rather than a maker's novel. But while Wackenroder followed the great tradition of Enlightenment aesthetics by examining the psychology of art appreciation, the tone and emphasis of his analysis were quite different from those of Baumgarten, Sulzer, or Kant. Once again, the key to understanding this difference is Wackenroder's compari-

son of art and religion. The enjoyment of art resembles prayer, he argued, and both require the proper state of mind. Neither can be accomplished amid the hurly-burly of ordinary life. Like prayer, the appreciation of art requires the proper setting, in which one can be properly receptive to the spiritual nourishment it provides. Art galleries, therefore, "ought to be temples where, in peaceful and silent humility and in heart-lifting solitude, one might admire the great artists as the most lofty among mortals and, with long, uninterrupted contemplation of their works, might warm oneself in the sunshine of the most charming thoughts and sensations" (p. 126). Wackenroder's vision of the museum as a temple in which to contemplate sacred objects, together with Hölderlin's notion of the "aesthetic church" and many other Romantic images, deeply affected the way the first art museums were imagined and constructed.[17]

Like those of many of his contemporaries, Wackenroder's aesthetic ideas were directly connected to his experience in art galleries. Most of his novel was composed during the summer of 1796, while he and his friend and collaborator, Ludwig Tieck, were in Dresden viewing the elector's art. Two years later, August Wilhelm Schlegel—together with his wife, Caroline, his brother Friedrich, and other young artists and intellectuals—spent several weeks examining the Dresden collections. This visit became the basis for "Die Gemälde," originally published in the second volume of the *Athenäum* in 1799. Like Wackenroder's novel and a great many other contemporary writings about art, "Die Gemälde" used the observation of specific artworks as the occasion for reflections on larger aesthetic issues. Just as art needs religion, Friedrich Schlegel wrote in 1804, so "the theory of art can not be separated from contemplation [*Anschauung*] without degenerating into willful fabrications or empty generalities."[18] Without the opportunity provided by public galleries to see and analyze a wide range of great works of art, this characteristic combination of direct observation and general reflection would not have been possible.

"Die Gemälde" belongs to the genre of gallery descriptions represented by Wilhelm Heinse's *Briefe aus der Düsseldorfer Gemäldegalerie* (Letters from the Düsseldorf gallery) (1776–1777).[19] But it is important not to miss the difference between Heinse's letters and Schlegel's dialogue: the former, by pretending to be communications from a gallery visitor to an absent friend, affirm the gallery visit's role as an occasion for communication between writer and reader within the public sphere; the latter, by presenting a dialogue among three observers who are gathered at a carefully defined time and place, suggests how the direct experience of art might create what one of the participants calls a feeling of "community and social interaction."[20] In these conversations on the banks of the Elbe, where the free exchange of ideas and impressions forged ties of authentic affection among the three friends, one finds in microcosm the aesthetic community for which so many of the Romantics yearned.

Schlegel's hopes for an aesthetic community, the young philosophers' call for a new mythology in their "Systemprogramm" and Wackenroder's

statement of art's religious nature were all expressions of that widespread longing for what Schlegel had called an "aesthetic revolution." To produce a truly spiritual art, to effect a new synthesis of beauty and truth, to take their rightful place alongside the great masters of the past required a new kind of art world in which the artists' relationship to their community would not be restrained by either patronage or markets. In the late 1790s, therefore, most advocates of an aesthetic revolution believed that it would somehow be connected to radical changes in German public life.

They were, of course, disappointed. After the turn of the century, at the same time that their own youthful hopes for independent careers began to evaporate, the political situation in central Europe lost much of its apparent flexibility. A few of the aesthetic revolutionaries kept on struggling for a radically new kind of art world, which usually meant living a life of frustration and isolation. Many more eventually found a place within the establishment yet sought to defend some version of their old ideals. Thus, even after the first fervent hopes for a new aesthetic community waned, the ideal continued to resonate—not only among German intellectuals but also among some of the political reformers who tried to reshape German political and cultural institutions in response to the challenges of the revolutionary age. It was these reformers who created the institutional art world within which the first German museums were built.

II. Art and the Civic Order

To understand how the ideal of an aesthetic community influenced the men who built the first art museums in German Europe, we must turn our attention from the writings of German intellectuals to the political developments that were at the heart of the revolutionary experience.

The revolution affected European politics in two closely connected ways: first, it seemed to increase people's engagement in the life of their states and thus demonstrated the power, possibilities, and dangers of democracy; second, at the same time, it greatly expanded governments' capacity to mobilize popular loyalties and social resources and thus demonstrated the power, possibilities, and dangers of modern states. Because art could be used to express and celebrate both the democratization of public life and the expansion of state power, the first museums reflected both dimensions of revolutionary politics: they were supposed to promote better citizenship and to affirm the authority of monarch and state.

Paris

In the definition of new relationships between art and politics, as in so much else about the revolutionary era, France provided the model. The leaders of the French Revolution swiftly recognized art's importance as an instrument

of political reform and social reconstruction.[21] From this conviction about art's political purpose came the creation of a national museum in the Grand Gallery of the Louvre. In August 1789, the French National Assembly passed a decree expressing the importance of establishing such a museum, which was finally opened on August 10, 1793, as part of the revolutionary festival of national unity. The great art treasures, wrote the Abbé Grégoire, "which were previously visible to only a privileged view . . . will henceforth afford pleasure to all . . . [and] the property of the people will be returned to them." But it was not enough for the people to know that art now belonged to the nation; it was essential that it be used to teach the virtues essential to the citizens of a free society. In his contribution to a report calling for a more systematic organization of the collection, Jacques Louis David argued that the Louvre should be not "a vain assemblage of frivolous luxury objects that serve only to satisfy curiosity" but "an imposing school."[22]

The Louvre may have begun as a school for patriots, but it quickly became a means to demonstrate the power of the revolutionary state. In 1794, the government sent a commission of experts to France's newly conquered Belgian territories to select works of art, which were then brought to Paris for study and display. The same policy was enthusiastically applied in Italy by General Bonaparte, whose aesthetic interests were limited but who instinctively grasped the value of art as a trophy of victory. In the treaties he imposed on the Italian states, Bonaparte included provisions that gave him the right to ship selected art objects to France. As the scope of French conquests grew, so did the French collection of artistic loot: "Rome n'est plus dans Rome," went a popular refrain of 1798, "elle est tout à Paris." People flocked to the Louvre to admire what their victories had brought, while Napoleon used these treasures to magnify his own glory. It was in the Grand Gallery, surrounded by the artistic treasures he had seized from Europe's ancient dynasties, that the emperor celebrated his acquisition of another valuable trophy, the Habsburg Princess Marie Louise, whom he married in 1810.[23]

In a sense, of course, France's acquisition of conquered art was part of a process as old as war itself: conquerors had always taken what their enemies valued most, leaving behind them looted palaces and empty shrines. But this was old-fashioned looting in the new age of museums, driven by the ancient impulses of victorious warriors but guided by the modern art world's aesthetic theories and historical assumptions. An important part of the appeal of these revolutionary acquisitions, therefore, was the care with which they were chosen, packed, and transported. That these precious things arrived undamaged was a source of great popular satisfaction, as were their skillful restoration and well-designed public display. Presiding over this extraordinary enterprise was Dominique Vivant-Denon, Napoleon's chief artistic adviser, who was in charge of all the Paris museums. A Balzacian figure of prodigious talent and energy, he was responsible for the artistic quality and historical scope of the French acquisitions. Under his leadership, the French assembled the largest, best-organized collection of art in the world.[24]

In the Louvre's Grand Gallery, art was transformed from an old-regime luxury, traditionally associated with conspicuous consumption and social privilege, into national property, a source of patriotic pride and an instrument of popular enlightenment.[25] Equally dramatic was the transformation of the religious and royal art displayed in the Museum of French Monuments, which was established in the former cloisters of the Petits-Augustins. This collection consisted of objects that had been stripped from churches and monuments because the revolutionary regime regarded them as ideologically reprehensible. Originally scheduled for destruction, they had been saved, catalogued, and eventually exhibited by Alexandre Lenoir.[26] Under his direction, altarpieces and statues of dead monarchs lost their connection to discredited cults and fallen dynasties; no longer symbols of superstition and tyranny, these things became objects of historical interest—carefully labeled and preserved but safely separated from the everyday world of culture and politics. In the foyer of Lenoir's museum stood a bust of art history's patron saint, Johann Joachim Winckelmann.

Those for whom such objects were still living symbols decried their museumification. After Napoleon's reconciliation with the church in 1802, Catholic leaders demanded that the museum's religious exhibits be returned to their original devotional purpose. This demand was supported by critics such as Antoine Quatremère de Quincy, who believed that the museum "kills art to make [art] history"—a charge that would become a persistent theme in the long history of museum criticism. Lenoir's collection did not survive Napoleon's defeat; in 1816, it was dissolved, and some, if by no means all, its contents were returned to their former sites.[27]

Many Germans were outraged by the French looting of Europe's art. Schiller, for example, warned that no French Pygmalion would be able to bring these stolen statues to life.[28] Karl August Varnhagen von Ense, who spent some time in Paris in 1810, loved the art he saw there but objected vigorously to its display in a "victory monument" rather than an artistic shrine. Nor was he much impressed by the collection's public accessibility; watching the boisterous and irreverent crowd of "fishwives, soldiers, and peasants in wooden shoes" move past the great masterpieces hanging in the Louvre convinced him of the wisdom of Goethe's line: "Works of the mind and art are not for the mob." Like Quatremère, Varnhagen also condemned Lenoir's exhibit for tearing sacred objects "from their connection to life and location in order to possess them as mementos and registered objects in the narrow realm of a museum."[29]

Most German visitors, however, were deeply impressed by the art treasures on display. Wilhelm von Humboldt, who was to play an important part in the development of German museums, appreciated the unique opportunities to view great art during his stay in Paris between 1797 and 1801. He recognized that the only way Lenoir had been able to save the objects in his care was by turning them into art: "As soon as they ceased being valued as historical monuments or devotional objects," he wrote in 1798, "only the

protection of art could preserve them from future abuse."[30] Others were similarly dazzled by their experiences in Paris; as Sulpiz Boisserée recalled from his visit in 1803, "we didn't have enough eyes" to see what was there.[31] Throughout the revolutionary period, hundreds of German artists and writers traveled to the French capital in order to admire its collections, which they described or reproduced for their fellow countrymen. A generation of architects, collectors, and scholars—among them Georg von Dillis, Karl Friedrich Schinkel, Haller von Hallerstein, Gustav Waagen, and Johann Passavant—returned from the French capital with a new understanding of how art exhibitions should be organized and displayed. "The order—systematic arrangement of every genre—[and] unlimited access, the cheerfully accommodating efforts to satisfy the aspirations of both connoisseurs and artists, deserve universal admiration," noted Dillis in his diary during his stay in 1806. "This should be the model for all such arrangements."[32]

Precisely as Napoleon had intended, the accumulation of Europe's greatest art collection in Paris demonstrated to every visitor the Continent's subordination to the French imperium. For German patriots, the forcible removal of the best pieces from their own collections was a particularly humiliating indication of their impotence; they wanted to reconquer these lost trophies and to display them as symbols of their own recovered authority. Among the many lessons to be learned from the French, therefore, was the power of art to express state power. But although this, like other painful lessons France taught the world about the new nature of political power, was important everywhere in German Europe, its application varied from state to state. In what follows, we will limit our discussion to Prussia and Bavaria, two states that were particularly important for the development of the nineteenth-century German art world and especially for the emergence of the first German museums.

Berlin

In 1795, after having taken part in the initial military campaigns against revolutionary France, Prussia signed a peace treaty that enabled it to spend a decade on the periphery of the political storms raging across central Europe. From this perspective, a number of Prussian political leaders and intellectuals tried desperately to find answers to what they recognized as a continent-wide crisis. The result was a period of intense cultural creativity, often mixed with profound political frustration. Those who hoped to effect practical political and social reforms had very limited success, but an impressive number of people—from the army officers in Gerhard von Scharnhorst's military society to young Berlin literary figures such Wackenroder and Tieck—produced deeply original theoretical responses to the revolutionary challenge.[33]

A characteristic expression of the cultural ferment in fin de siècle Berlin was Friedrich Gilly's proposal for a monument to Frederick the Great (fig. 6), which was exhibited at the Academy of Art in 1797. Only twenty-

FIGURE 6. Friedrich Gilly, "Design for a Monument to Frederick the Great" (1797).

five years old in 1797, Gilly belonged to the same generation as Schelling, Hegel, and the Schlegels. Like their dreams of an aesthetic community, Gilly's project displayed extraordinary intellectual ambition and a boundless faith in the power of art. To be sited on the Leipziger Platz, just south of the Brandenburg Gate, Gilly's monument would have dominated the urban environment. He imagined an elevated Doric temple—surrounded by a sacred space and approached through a massive gateway—built on an extravagant scale and sternly geometrical lines. His plan recalls the work of French architects such as Claude-Nicolas Ledoux and Etienne-Louis Boullée, whose grandiose designs also sought to evoke deep feelings. Following these French practitioners of a style Anthony Vidler has called "the public sublime," Gilly wanted to celebrate the power of the state and to instill a sense of civic community with an architectural vocabulary that transcended religious or dynastic sources of authority.[34] Like Wackenroder and many other talented young people of his generation, Gilly died young, his precocious promise unfulfilled and his monument never built. Nevertheless, his work had a significant impact on Leo von Klenze and Karl Friedrich Schinkel, the builders of the first two German art museums.

On September 25, 1797, a few months after the display of Gilly's plans, Alois Hirt marked the birthday of King Frederick William II with an address to the Berlin Academy of Art in which he called for the establishment of a public museum that would bring together the best works from all the royal collections. Born in 1759, Hirt, like Winckelmann, was an autodidact who had used his knowledge of classical art and literature to acquire friends in high places. From 1782 to 1796, he had supported himself by guiding tourists—including Goethe—around the monuments in Rome.[35] In 1796, Hirt was given an appointment at the Prussian Academy of Art—perhaps through the influence of Countess Lichtenau, the king's favorite, who had used his services as a cicerone the year before.

In his September address, Hirt marshaled every possible argument in favor of a Prussian museum, from grand historical theories about the connection between artistic and political achievement to practical proposals for improving public taste through an exposure to the fine arts. His strongest and clearest argument was based on the fact that each of the other major states already had a public collection in which art could be visited, copied, and discussed; should not Berlin be on a list that included Dresden, Vienna, Munich, Mannheim, Düsseldorf, and many lesser capitals? It is also worth noting what Hirt did not say: there is nothing in his speech about the spiritual power of art or its role as a source of social cohesion. When listing the future beneficiaries of his plan, he spoke not of the nation as a whole or of some ideal aesthetic community but rather of people like himself and his fellow academicians. By age and intellectual disposition, therefore, Hirt belonged to the pre-Romantic generation; he was interested in practical instruction, political prestige, and popular taste, not in the reconstruction of society through art.[36]

Frederick William II died just a few weeks after Hirt's speech. In December, Minister Karl Friedrich von Heinitz, in his capacity as head of the Academy of Art, wrote to the new king, who reigned as Frederick William III, to remind him of Hirt's suggestion and to repeat that it would be desirable to have a museum in which to display the masterpieces "that belong to the fatherland"—a phrase that reveals how fully assumptions about the public nature of royal collections had been absorbed by both princes and their advisers.[37] Frederick William III expressed some highly qualified interest in Hirt's ideas and asked for more details, which Hirt provided in a memorandum to the curatorium of the academy in September 1798. This document contained specific recommendations on the organization of the collections: "A gallery must be seen as a school for taste and therefore proper order in the display of art objects is its first rule." Hirt proposed an organization by subject matter for the antiquities and by epoch and school—following Mechel's example in Vienna—for the paintings. The collection would be open all day in the summer to students and visiting artists and two mornings a week for everyone. The museum staff would consist of a director, two curators, and four service personnel.

Among the venues that Hirt suggested for his museum was a new building to be erected alongside the Royal Arsenal on Unter den Linden. His description of this proposed structure once again reveals the restrained, un-Romantic character of his vision: it was to have two stories, the first rusticated in the Renaissance fashion, the second with engaged columns between the windows. "Thereby" he wrote, "the exterior acquires the appearance and attendant solidity of a public building." Except for a terse reference to the monarch on the facade, there would be neither aesthetic nor symbolic ties to the traditional court or royal gallery. Simple, straightforward, businesslike, the building might be an administrative office or a school. The style and tone of its design perfectly expressed the academic, pragmatic functions that Hirt expected his museum to perform.[38]

Like most of the reforms proposed during this period, Hirt's museum project was never realized. Frederick William III, who was naturally indecisive and rightly concerned about Prussia's fiscal situation, refused to approve any new expenditures for public buildings.[39] Nevertheless, the royal collections remained a subject of discussion for several years. In 1803, the king wrote that Hirt's proposed building was unnecessary because he himself had "determined an appropriate location"—though exactly what the monarch had in mind remains a mystery. A year later, Jean Henry, the king's librarian and curator of his Berlin collections, began a sustained campaign to get a higher salary and greater authority to reorganize and display art and natural-history materials in a suitable location. "What more splendid monument could a peace-loving monarch create," Henry wrote his sovereign, "than such a temple dedicated to art and nature."[40] But nothing had come of these plans when Prussia's disastrous military defeat at the hands of Napoleon in 1806 changed the direction of Prussian political life.

Needless to say, artistic matters were not foremost on the minds of the men who took over the Prussian government after the debacle of 1806; they knew that greater administrative efficiency, military effectiveness, and economic productivity were necessary to move Prussia away from the brink of catastrophe. Still, many of the reformers also believed that the new civic order had a necessary cultural dimension. In order to develop the kind of citizenry necessary for the political order that the reformers imagined, they needed to find ways of forming opinions, improving morals, and spreading civil responsibility. For this task, education, scholarship, and art all had a role to play. Indeed, the virtues to be instilled by the experience of beauty, which had been promised by Kant and his contemporaries during the Enlightenment, seemed all the more necessary in the new world of reform and revolution.

In September 1807, for example, at the very beginning of the reform process, Freiherr von Altenstein underscored the spiritual importance of the fine arts and scholarship for the life of the state. Everyone acknowledged the practical uses of art and science, Altenstein wrote, but their ethical value was even more significant:

> If it is the purpose of the state to bring to humanity the best things in life, then this can only be done through the arts and scholarship. Only they can create an active and energetic existence and an aspiration to higher things. Needless to say, we are talking about genuine scholarship and the authentic fine arts, not pseudo-scholarship and art.

Altenstein went on to develop a set of proposals through which the state could fulfill its ethical duties by enriching the intellectual, moral, and religious life of its citizens.[41]

As part of the administrative reorganization that marked the first step in revitalizing the Prussian state after the defeat of 1806, the reformers established a department in the Ministry of the Interior with jurisdiction over public health, educational and religious institutions, the academies of arts and sciences, the royal library, state-supported theaters, and the censorship of all nonpolitical publications. The gathering of these various activities into one administrative agency reflected the reformers' aspiration to increase the state's role in "all institutions that influence the general formation of culture [*allgemeine Bildung*]," which was defined broadly enough to include everything from religion to recreation.[42] The first man chosen to lead this enterprise was Wilhelm von Humboldt, who was then serving as Prussian envoy in Rome.

Humboldt represents the strongest personal link between the aesthetic theory discussed previously and the practical implementation of cultural policy. Born in 1767 to an influential and wealthy Berlin family, Humboldt, as one of his biographers wrote, had "the good fortune to be the contemporary of his nation's greatest men."[43] He seems to have known everyone worth knowing from the Prussian court to the salons of Berlin, from Jena and

Weimar to the artistic colony in Rome, from revolutionary Paris to Georgian London. Deeply influenced by Kantian ethics and Winckelmann's idealization of the Greeks, he was closely associated with Schiller and had personal ties to Goethe and many other leading artists and intellectuals. His own work, though often fragmentary and undeveloped, touched his age's most important ideas about art, education, and culture.

Humboldt shared Kant's conviction that art made moral ideas accessible to our senses and thus helped to harmonize our sensual natures with society's ethical imperatives. "The purpose of all art," he wrote in an unpublished fragment from 1788 or 1789, "is moral in the highest sense of the word"; indeed, aesthetic experience is essential to bridge "the momentous gap" between savagery and "moral cultivation [*moralische Bildung*]."[44] He further developed these views on the harmonizing effects of art in an essay on the amelioration of morals which he published in the *Berlinische Monatsschrift* of November 1792: "Nothing exercises such a widely diffused influence on the whole character as the expression of the spiritual in the sensuous—of the sublime, the simple, the beautiful in all the works of nature and products of art which surround us."[45] Humboldt thus assigned art a distinctive role in that essential process of *Bildung* through which both individual character and the national community were to be formed.[46]

Like Schiller, Humboldt derived art's usefulness from its autonomy: "Were it not for his feeling for the beautiful," he wrote in 1792, "man would cease to love things for their own sake." Neither art nor scholarship were to be directed by the state; both needed to be free from external restraint so that they could advance knowledge, encourage morality, and deepen culture. In Hermann Lübbe's useful formulation, in the realm of art and scholarship *Selbstzweck* was *Staatszweck*—that is, by being ends in themselves, art and scholarship were fulfilling the ends of the state.[47] This was precisely the relationship of art and society upon which Schinkel based his design for the Berlin museum.

Like many other German intellectuals, Humboldt was drawn into the service of the state by the revolutionary crisis. During his brief tenure in office, he helped to transform Prussian culture by establishing the University of Berlin, introducing changes in the school system, reorganizing the academies of arts and sciences, issuing new regulations for the royal library, and reforming several other institutions under his authority. These innovations were accompanied by a brief but intense flowering of cultural activity in Berlin, including Johann Fichte's lectures at the academy (which would later be famous as "Reden an die deutsche Nation"), Achim von Arnim's and Clemens Brentano's political journalism, and the 1810 exhibition of paintings and sculpture at the academy in which Caspar David Friedrich's masterpiece *Monk at the Sea* caused a minor sensation.

Within this atmosphere, discussions about the creation of an art museum began once again. After Frederick William III had been compelled to watch the French conquerors remove some of his best artworks to Paris, he ordered

a complete inventory of what was left. Assisting in this process was Christian Mechel, who was then living in the Prussian capital on a small stipend as the queen's librarian. Mechel, deeply in debt and down on his luck, may have hoped that he could become the leading force in creating "a public and well selected art collection in beautiful Berlin." Humboldt supported this project but requested that "in order to avoid unpleasant confrontations," Mechel be placed under the direct supervision of his department. The king agreed in a decree of May 1810, which also called for a permanent exhibition of artworks in the university buildings; the final decision about what was to be displayed would remain the king's.[48] Humboldt's departure from Berlin (he became the Prussian ambassador in Vienna in June 1810), the sudden death of Queen Luise in July 1810, and the growing pressures of international affairs delayed the completion of these plans until after Napoleon's defeat.

Munich

Unlike Prussia, which managed to remain on the sidelines during the first decade of France's assaults on the European order, Bavaria stood directly in the path of the Napoleonic juggernaut. After sharing Austria's disastrous defeats during the War of the Second Coalition, the Bavarian elector became France's ally in 1805, in return for which Napoleon gave him a royal title, a leading role in the Rhenish Confederation, and a variety of lands once held by ecclesiastical authorities, imperial nobles, and minor principalities. Together with the other German states that enjoyed the mixed blessings of Napoleon's patronage, Bavaria faced the formidable task of integrating its new territories and extracting from them the resources demanded by the French to support their unending military adventures. There was, therefore, no real alternative to the drastic innovations that were carried out under the leadership of Max von Montgelas, who reorganized the administration, dismantled social restrictions, secularized church property, and reformed such other institutions as schools, academies, libraries, and archives.[49]

Prominent among these reforms was an effort to redefine the monarch's political position. The Bavarian constitution of 1808 affirmed the king's primacy but did so by linking his authority to the institutions of the state, giving him the right to appoint ministers, countersign laws, and represent the state symbolically. His power over dynastic affairs, including the rights of succession, were clearly defined but implicitly limited, thus effecting what Eberhard Weis called a "fusion of monarchical authority and state power [*Verstaatlichung des Herrscherrechts*]." Equally important, the reformer tried to distinguish between dynastic and public property. According to a document issued in October 1804, the entailed possessions of the ruling house were transferred to the state; the ruler retained private sources of income and could expect support from state funds, but he could no longer look upon his territories as his own possessions. The final version of the constitution, issued by royal decree in 1818, contained a list of items described as "state

property (*Staatsgut*)", which included archives, public buildings, the contents of the royal residences, and "all the collections for the arts and sciences."[50] Thus began the long and complicated process of distinguishing which art objects belonged to the crown and which belonged to the state.

Bavaria's first king, Maximilian I Joseph—the former duke of Pfalz-Zweibrücken—was a dutiful but not particularly dynamic sovereign who usually went along with the policies initiated by his ministers. Max Joseph had a genuine if rather narrow interest in art; he assembled a private collection of first rate genre paintings and landscapes, most of which were sold at auction after his death. For the royal gallery, however, he was willing to leave purchasing decisions in the hands of such men as Johann Christian von Mannlich, who served as director of the royal art galleries, professor of drawing at the academy, and chairman of the king's committee of artistic advisers.[51]

Like Hirt in Berlin, Mannlich was a transitional figure in the history of German museums. He was smart and alert enough to recognize that the era of the ornate princely gallery, like the one he had helped to create in Zweibrücken, was past, but he did not share the younger generation's vision of art as a source of spiritual salvation and moral reform. Nor did he approve of Mechel's historical organization of the paintings at the Belvedere gallery. Paintings, Mannlich believed, should be organized according to a "well-ordered, complete design based on their relative beauty"; such a design would lead to the "formation of taste and the definition of sound judgment."[52] His plans for the Bavarian collections, he envisioned simple, intimate settings in which works could be enjoyed by the public and studied by young artists. For Mannlich, as for Hirt, the proper goals of the state's cultural policies were the spread of good taste and sound judgment among the population and the creation of a well-trained corps of artists.

Much closer to the spirit of the age were the ideas of F. W. J. Schelling, who had come to Munich in 1806 as director of the Academy of Sciences. In the preceding decade, Schelling had moved away from the aesthetic radicalism so passionately expressed in the "Systemprogramm," but he had not totally abandoned his belief in art's civic power. In the well-attended and widely discussed address that he delivered in 1807 to celebrate the king's name's day, Schelling once again asserted the importance of art as a source of meaning and community. This time, however, he linked art directly to monarchical patronage. Artistic creativity, he acknowledged, can arise only "from the vital movement of inner feeling and spiritual power, from what we call enthusiasm," but individual enthusiasm is not sufficient; each individual's efforts must be infused in public life, as in the days of the Medicis or Pericles. This collective spirit, he added, is better protected "by the mild authority of a patriarchal ruler than by a democratic government." Schelling concluded his remarks by emphasizing the national basis of art—which he illustrated with the example of "our great Albrecht Dürer," who was both "distinctively German" and closely tied to the achievements

of the Italians—and expressing his high hopes for Bavaria, his "immediate fatherland," whose sublime ruler had preserved "the living seeds of past art" and "the renowned sites of old German art."[53]

In the reorganized Bavarian Academy of Art, whose constitution he drafted in 1808, Schelling attempted to use monarchical authority to "increase the beneficial influence of the fine arts on the nation as a whole" and thus to employ "this mighty educational instrument [*Bildungsmittel*]" to raise the level of ingenuity among the people, as well as to "ennoble them spiritually and morally." This will happen because—and here, of course, Schelling followed a well-worn path in German aesthetics—there is a connection between the experience of beauty and the attainment of goodness: "The love of proportion and decorum that flows from art will enter into life and teach us how we can also find there what is proper and well-formed."[54]

Among those who heard Schelling's address in 1807 was Prince Ludwig, King Max Joseph's twenty-one-year-old son and heir, who would soon be the dominant figure in the Bavarian art world and eventually become one of the nineteenth century's most important patrons of the arts. Although Schelling does not seem to have had much direct influence on Ludwig, the two men clearly breathed the same cultural air and shared a belief in art's collective basis and ethical power. When, in the closing lines of his speech, Schelling mentioned "the young prince who has recently received the loud applause of a grateful nation," he described exactly the image that Ludwig hoped his patronage of the arts would enable him to obtain.

Born in 1786, Ludwig belonged to the generation whose youth was shadowed by war and revolution.[55] He was educated by private tutors and, following a relatively new fashion in princely education, also attended lectures at the universities of Göttingen and Landshut. But none of these educational experiences influenced the young prince as much as the months he spent in Italy in 1804 and 1805, where he developed his lifelong passion for art. As he toured Italy's ancient monuments and enjoyed the Roman nobility's cultivated, confident sociability in their art-filled villas, he discovered a captivating world of unlimited pleasure and satisfaction. For Ludwig, who was physically awkward and had poor hearing and impaired speech, this was a world that he could master. It was, moreover, an especially welcome refuge during the years when his dynastic duties forced him to cooperate with Napoleon, whom he loathed, and also to endure those frustrated ambitions that seem to be an heir apparent's inescapable fate.

Art for Ludwig was always more than a way of passing time or compensating for his personal deficiencies and political frustrations. Art provided, as Heinz Gollwitzer once wrote, another realm over which he ruled, a parallel kingdom to which he devoted enormous time, energy, and resources.[56] As both crown prince and king, Ludwig used the art he collected and commissioned to represent his most fundamental values: a deep if unreflective Christian faith, a patriotic attachment to German culture, an unwavering belief in the state's educational mission, and, last but by no means least, a

commitment to preserve and enhance the prestige of the Wittelsbach dynasty. What success in war was to Frederick the Great, patronage of the arts was to Ludwig: something of value in itself, a contribution to the welfare of his state, and a guarantee of his own place in history.

Ludwig's interest in art invites comparison with that of the great baroque patrons who had dominated the art world of the seventeenth and early eighteenth centuries; in fact, some of his projects—such as the series of battle scenes he had Wilhelm von Kobell paint or the portraits of beautiful women, the so-called Gallery of Beauties, he displayed in his palace—had baroque prototypes. But the differences between Ludwig and his princely predecessors are more instructive than their similarities. In the first place, art did not serve to express Ludwig's personal glory directly or to provide a setting for the ritual enactment of his power. Second, though a demanding and obstinate patron, Ludwig did not imagine himself to be above the art world; he was at once its master and disciple, the leader and colleague of the artists with whom he worked. This relationship is expressed in Franz Ludwig Catel's well-known portrait of the crown prince ordering wine for a group of artists in a Roman tavern.[57] It is difficult to imagine a baroque prince portrayed in such a modest setting or, for that matter, coming to meet with artists on their home ground. Four decades later, Wilhelm von Kaulbach made the same point in his mural for the Neue Pinakothek, which shows the king stepping down from his throne to join the artists gathered around him.[58]

The range and diversity of Ludwig's interests and enthusiasms reflected the eclecticism that was so characteristic of nineteenth-century art. He shared his contemporaries' special regard for classical antiquity and retained a lasting affection for all things Italian, but his collections spanned most of Western art history from ancient Greece to his own time. He commissioned works on widely different subjects, from the mythological frescoes in the Glyptothek to scenes from recent Bavarian history. He built churches and national shrines, royal residences and libraries, museums and monuments. Everything he bought, from fragments of Greek temples to paintings of recent battles, was important to him not because of its subject matter or its connection with his own life but rather because of its intrinsic value and special status as art. Only this value and status made his diverse collection a source of his own prestige and of public enlightenment. It is perfectly appropriate, therefore, that sooner or later most of his art would end up in a museum.

Although Ludwig had begun to dream of grand artistic projects while he was still in Italy and had managed to acquire some important artworks, he could not begin to fulfill his plans until Napoleon had finally been defeated. In 1814, the crown prince started a campaign to raise funds for the Walhalla, the shrine in praise of German culture that he would eventually build near Regensburg. At the same time, he set in motion an architectural competition for a building to house his collection of antiquities. During the summer of 1815, Ludwig was in Paris supervising the selection and shipment of art to be returned to Munich. He used this opportunity to buy some important

pieces from impoverished aristocratic families who could not afford to have them transported back home. Often using his personal funds, Ludwig and his agents took full advantage of the buyer's art market that had been created by the upheavals of war and social dislocation. Among his purchases were some pieces that had once belonged to Winckelmann's old patron, Cardinal Albani, which thereby found their way to the world of German art, where Winckelmann's influence was still very much alive.

III. The First Museums

By 1815, both Crown Prince Ludwig and King Frederick William III had decided to build museums in which their art collections could be displayed to the public. In both cases, however, the planning and construction process lasted a long time. What came to be called the Altes Museum in Berlin and the Glyptothek in Munich were finally finished in 1830 and opened within ten weeks of each other, the former on August 3, the king of Prussia's birthday, the latter on October 13, the queen of Bavaria's name day. By the time the two museums opened their doors, the world had changed dramatically. In July, the people of France had once again driven their monarch from his throne; revolutionary ferment then swiftly spread across the Rhine, evoking scattered outbreaks of political violence and social unrest in a number of German states as well as an armed insurrection in Russia's Polish territories. These immediate crises seemed to underscore the growing recognition among many Germans that they were entering a new historical era. But the buildings themselves had been planned and constructed in a different political and cultural climate. Their design and decoration, therefore, still expressed the reform era's aspirations for an aesthetic community and the Romantics' belief in the healing power of art.

The Glyptothek

The Glyptothek belonged to Prince Ludwig. When, shortly after the building was finished, an ill-advised local publisher offered him the chance to subscribe to an edition of prints based on the museum's frescoes, Ludwig sharply replied that "since the frescoes in the Glyptothek, like the entire building, are my property," no such pictures could be made without his approval.[59] The prince had been involved in every step of the construction process, from the invention of the museum's pseudo-Greek name to the selection of the architect and the approval of his plans. Engaged with the countless questions of detail that always arise in such a complex project, Ludwig was perfectly capable of appearing at the building site and, if he found something not to his liking, simply countermanding the architect's instructions.[60]

Ludwig did not, however, have a totally free hand. In the first place, he always needed money. Even after his marriage in 1810 gave him some measure

of financial stability, he was still dependent on his father for funds. More-over, many of his artistic collaborators were civil servants, who usually had to get the king's permission to carry out the prince's orders. When Ludwig inherited the throne in 1825, he acquired more autonomy, but he could not escape the constitutional limits on monarchical power, including parliamen-tary approval of the civil list from which he supported most of his artistic ventures.

Other limitations on Ludwig's freedom of movement were self-imposed. Because he did not view himself simply as a patron who gave orders to his artists as he might to his tailors or his cooks but, instead, wanted to be an active participant in the process of creation, he had to work with and some-times in opposition to his strong-willed artistic advisers. For example, he exchanged nearly five hundred letters with Leo von Klenze on various struc-tural and aesthetic questions; J. M. Wagner, Ludwig's agent in Rome, inter-vened at several critical moments to press for changes in the museum's design and decoration; the selection of the temperamental and contentious Peter Cornelius to do the interior frescoes increased the potential for conflict among all those concerned. The building of the Glyptothek, therefore, was an extra-ordinarily long, complex, and strife-ridden process. And like many other patrons before and since, Ludwig consistently underestimated the time it would take to realize his plans: in March 1815, he wrote to Georg von Dillis from Vienna that his museum, although not yet begun, might be finished by 1817; his estimate turned out to be thirteen years off.[61]

All the sculpture in the Glyptothek had been acquired by Ludwig. His purchase of a number of important classical pieces, especially his acquisi-tion of the magnificent sculptures from the newly excavated temple at Aegina in Greece, shaped the collection. Ludwig used his own (or his father's) money to buy these things, but the transactions were not entirely private. For example, Wagner, who acted as his principal agent in these matters, lived on a pension from the state. Furthermore, the prince was prepared to use his dynastic connections and political authority to help him buy and trans-port what he wanted; in order to get permission to bring the so-called Barberini Faun from Rome to Munich, he had his sister, the Austrian empress, intervene directly with the pope.[62]

Ludwig had begun to think about a site for his museum as early as 1809, when Karl von Fischer, a professor of architecture at the Bavarian Academy of Art, prepared a comprehensive urban design for Munich. Four years later, the prince asked Karl Haller von Hallerstein, a participant in the excava-tions at Aegina, for suggestions about what the museum should look like. Finally, in early 1814, Ludwig directed the Academy of Art to coordinate a competition, which was to be decided in January 1815. When Ludwig found none of the submissions acceptable, the deadline was extended another year. Characteristically, the prince, too impatient to follow his own procedures, asked Fischer to prepare drawings outside of the regular competition, and when these did not please him, he solicited ideas from Leo von Klenze, whom

he had met in Paris the year before. At one point, Haller, Fischer, and Klenze each thought that he was the prince's preferred choice. In the end, after various changes and counterproposals, Ludwig gave the job to Klenze. But even when the museum's cornerstone was laid in April 1816, the final plans were still not finished.[63]

It may have been because he was not exactly sure what he was looking for that Ludwig had trouble finding an acceptable design. Early in 1816, when he was still uncertain about which alternative to choose, he asked Wagner to send him some plans for a sculpture museum from "a famous sixteenth-century architect." There were no historical models, Wagner replied, since the first museums had been built no more than eighty years earlier.[64] In fact, the few models on which a new museum might have been based seemed to have little relevance for what Ludwig had in mind. Among German museums, neither a royal gallery like Sanssouci nor a multipurpose building like the Fridericianum would suit Ludwig's needs; nor were the great foreign museums, such as the Louvre and the Pio Clementino, of much use.

Perhaps the most important prototypes for Ludwig's architects, and later for Schinkel in Berlin, were the designs produced in France around the turn of the century, and especially the one published in Jean-Nicolas-Louis Durand's *Précis des leçons d'Architecture données a l'École Polytechnique* (1802–1805). Durand had worked as a draftsman for Etienne-Louis Boullée, who in the 1780s had been among the first to imagine an art museum as the basis for a new kind of civic culture, without connections to dynasty or church. Clearly following Boullée's lead, Durand designed a somewhat subdued version of the "public sublime": a massive square structure built around central courts, with dramatic colonnades on all four sides and a central rotunda.[65]

Neither Fischer, who borrowed heavily from Durand without fully comprehending the spirit of his designs, nor Haller, whose extravagant proposals recalled Friedrich Gilly's unbuilt and probably unbuildable monument to Frederick the Great, was able to overcome the lack of well-established and usable precedents. Far better than his competitors, Klenze grasped the central purposes of the museum and, equally important, understood how to present his design persuasively to Ludwig. Thus Klenze mastered the two tasks that all major architects would have to confront in the nineteenth century: first, the need to use the historical vocabulary of architecture to solve unprecedented problems, and the need to establish a satisfactory working relationship with a variety of difficult and demanding clients.

Klenze was thirty years old when he was first introduced to Prince Ludwig in 1814.[66] He had studied architecture with David Gilly in Berlin between 1800 and 1803; one can see in his work, as in that of his fellow student Schinkel, some of the same aspirations that moved David Gilly's son, Friedrich, to imagine his monument to Frederick the Great. After leaving Berlin, Klenze studied in Paris and then managed to acquire a position at the court of Napoleon's brother, Jerome, the king of the newly created state

of Westphalia. Klenze clearly learned a lot during his time in Westphalia. Although young and without practical experience as an architect, he was involved in several major building projects; equally important, he acquired the courtier's skills he would need in dealing with the contentious crowd of alleged allies and real competitors who had gathered around Prince Ludwig.[67]

Like many of his contemporaries, Klenze shared Winckelmann's conviction that the classical style remained art's abiding ideal. But Klenze's classicism was qualified by the characteristic nineteenth-century assumption that one should select whatever historical style best suited the task at hand. "As models and techniques," he wrote, "contemporary architecture has access to all the achievements of the past. A skillful builder will bring to bear on the problems of the present the architectural forms of the classical, as well as the Romantic, Gothic, and Romanesque. . . . Shouldn't it thus be possible to find a new architectural style, just as the Renaissance once did by using the styles known at the time?"[68] In his original submission to Ludwig, therefore, Klenze proposed museums in three different styles: classical Greek, Roman, and Renaissance.

The Glyptothek was built on the Königsplatz, the site selected by Fischer in his urban development proposals of 1809–1810. This square was an element in the Wittelsbachs' plans to create a royal city outside of, and as an alternative to Munich's old urban core around the Rathaus and Frauenkirche. Within this larger urban scheme, the Königsplatz was neither a focal point, as it might have been in a baroque design, nor a means of tying together different parts of the city, as du Ry's system of squares and circuses in Kassel had been. The Königsplatz was a destination in itself, one among several alternatives offered by the loosely arranged array of new public buildings constructed after 1815. Fischer had originally proposed that in addition to the museum, the Königsplatz should contain the Walhalla, the monument to German culture that Ludwig eventually would construct overlooking the Danube. Klenze, however, had hoped that there would be a church opposite the Glyptothek, thus affirming the spiritual parallels between art and religion.[69]

Klenze's conception of the Glyptothek followed a simplified form of the museum designed by Durand (and Fischer): it is a square building constructed around a central court. The main facade, on the south side facing the Königsplatz, is dominated by a portico with eight unfluted ionic columns, a decorated pediment, and a pitched roof extending back across the width of the wing into the courtyard (fig. 7).

The gabled portico, of course, evoked a Greek temple, which, in a characteristically Palladian move, was attached to the main structure—as in the Fridericianum and the palace at Wörlitz. The Glyptothek, however, had an even stronger horizontality than either of those buildings; only the portico itself had vertical thrust. Klenze attempted to integrate the portico with the rest of the structure by a careful reckoning of its proportions, a three-step pedestal extending across the entire facade and wrapping around the eastern and western wings, and a cornice around the entire building. A second row

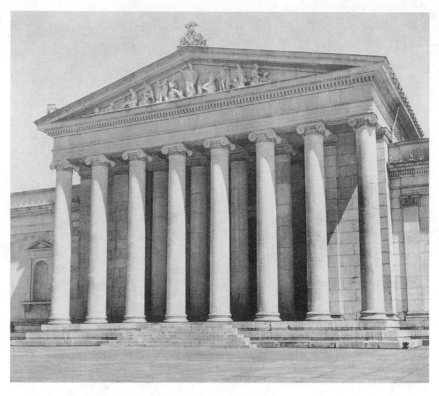

FIGURE 7. Glyptothek in Munich: portico.

of four columns inside the portico helped to provide a transition into the main building.

In the middle of the museum's northern elevation, facing the park, was a porte cochere to be used for festive occasions and court functions. Here the building's royal patron and his guests could alight from their carriages and directly enter the museum. With its pedimented portico and Ionic columns, this entrance is meant to be the structural counterpart of the main entrance on the facade. But the unmistakably analogous character of the two entrances served to emphasize the differences between them: the north portico wais much smaller, its pediment empty, the capitals of its four columns less elaborately decorated. The relative size and splendid articulation of the main entrance, therefore, expressed the importance of the museum's public face and civic purpose.

One of the many disagreements between architect and patron was over the question of whether to have niches with statues in the exterior walls. Ludwig was worried about the absence of Greek precedents, but Klenze finally convinced him that it was aesthetically necessary to break the flat surface of the walls. Eighteen niches in all, six each on the south, east, and west sides, held statues of gods, artists, and ancient rulers, whose presence suggested the intertwined classical and artistic motifs represented by the

building as a whole. The gable pediment on the south portico showed Pallas Athena at the center, surrounded by artists, who drew their inspiration from her divine power. Appropriately, the goddess was portrayed rather abstractly; the artists' humanity was indicated by a more realistic rendering of their bodies and features.[70]

Klenze did not put windows in three of the exterior walls; only the north side has two large windows, which illuminate and visually extend the space of the side wings. In the rest of the building light comes either from high windows facing the inner courtyard or, in the rooms on the northeast and northwest corners, from the roof. Essentially closed off from the outer world, the Glyptothek demanded its visitors' total attention as it led them through a series of rooms, each with a different decorative design (fig. 8).

The rooms' principal structural feature was a sequence of domes and arches recalling Roman public buildings. Klenze used these elements to create divisions in the interior space, which he then reinforced by varying the designs of the floors and of the decorations stretching above the cornices across the ceilings. Unlike the gallery at Sanssouci, where the decorative motifs are intended to unify a large open space, in the Glyptothek decoration enhanced the distinctions between the various stages through which visitors passed.

In the northern wing, on either side of a small vestibule, were two rooms decorated with frescoes by Peter Cornelius. Born in 1783, a painter's son, Cornelius had begun studying art at the Düsseldorf Academy of Art but, like many artists of his generation, had to abandon his studies when the revolution uprooted the audience for whom he had been trained to paint. Eventually, he made his way to Rome, where he became associated with the German painters usually known as the Nazarenes.[71] Cornelius's career uneasily combined fierce personal independence, an abiding disdain for academic discipline and convention, and the passionate desire to create and express truly German art. This great national goal, he believed, could best be pursued with the fresco, which, in addition to its rich historical association with medieval Christian art, necessarily had a public place and purpose. In November 1814, Cornelius tried to persuade Joseph Görres, then a leading propagandist in the struggle against Napoleon and a man who had access to influential statesmen, to help him revive the fresco. Encouraging this kind of painting, Cornelius assured Görres, would make it possible to defeat academic sterility and "negative eclecticism," to achieve the art Germany's new national vitality clearly required, and to "reconcile the lord our God with his people."[72] It is not surprising that Cornelius's blend of artistic ambition, national enthusiasm, and Christian piety was attractive to Prince Ludwig when the two men first met in Rome in 1818.

Although the rooms in the northern wing which contained Cornelius's frescoes were to be used for royal festivities, the paintings enhanced the appreciation of Ludwig's art rather than the celebration of his personal power.[73] The subjects were all classical: in the central vestibule, Prometheus and Pandora; on one side, in the so-called *Göttersaal*, an ensemble of ancient

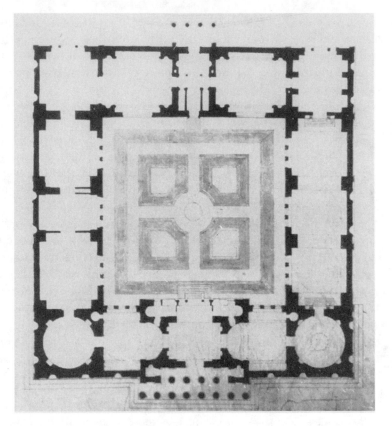

FIGURE 8. Glyptothek in Munich: floor plan.

deities; and on the other side, in the Trojan Room, a series of scenes from Homer. The figure of Prometheus, who brought light to mankind and then paid a fearsome price for his generosity, symbolized the majesty as well as the tragedy of art. In the dome of the vestibule, Prometheus, with the help of Minerva, was shown shaping a man; this was meant to suggest that human creativity can achieve its final goal only with the help of divine wisdom. The larger rooms on either side—especially the room devoted to Homer—presented the powerful, destructive forces that threaten all human activities—a theme that also appeared in Schinkel's museum in Berlin.

Cornelius, who thought of himself as a deeply Christian artist, apparently was disappointed that his first major German commission was to paint scenes from pagan myths. Perhaps, as some commentators have argued, he tried to link this classical material with his Christian convictions by drawing on Schelling's ideas about the unity of religious aspirations. But one does not sense that the frescoes—that is to say, the reproductions that remain—have much religious feeling of any sort, pagan or Christian; they are no more than artful but lifeless illustrations of ancient myths and contemporary ideas. If, as Jean Seznec once argued, Nicolas Poussin painted gods whose age has

passed, Cornelius portrayed gods who had never existed—except as subjects in the history of art, to which he self-consciously contributed.[74]

The frescoes, like the rest of the Glyptothek's decorations, were located above the cornices, so that the separate artworks on display stood in front of plain walls, where they could be seen without distraction. Most of the objects were elevated on small platforms or pedestals; the larger pieces stood alone, usually in the center of the room. The art, therefore, had no structural connection to the building. The relationship between the Glyptothek and its contents was iconographical rather than architectural; each room in the southern, eastern, and western wings had a decorative motif appropriate for the objects it contained.

Despite his efforts to subordinate the decorations to the contents, Klenze's interior design still seemed much too elaborate to Wagner, who urged Ludwig to keep the surroundings simple so that the art could be experienced directly. "No one goes to a museum," Wagner tartly remarked, "to see marble floors."[75] But for the prince and his architect, the beauty of the building was an important contribution to the experience of the art—and it was, of course, *their* contribution, a constant reminder of Ludwig's largesse and Klenze's skills.

Wagner also protested Ludwig's plan to use the building as a place to entertain; such blasphemy, he told his princely patron, "would turn these masterpieces into a sort of furniture." He was especially outraged by Ludwig's enthusiasm for holding torchlight receptions in the museum: "The antiquities do not need such a forced source of stimulation; on the contrary, I believe that this kind of light is alien to the sublime grandeur of art."[76] Again, Ludwig was unmoved by Wagner's protests; he wanted a space in the Glyptothek where he could re-create those glamorous evenings he had experienced in the villas of the great Italian collectors. Even before it was finished, the Glyptothek became the setting for various royal festivities, such as the musical evening held in October 1823 to celebrate the engagement of Crown Prince Frederick William of Prussia and Princess Elizabeth. In addition to being a national institution, therefore, the Glyptothek was also a royal institution, rather like one of those Palladian villas it somewhat resembled, to which the monarch might retreat to escape the pressures of courtly life.

Probably the most important argument that Wagner lost was about how the art should be arranged. Instead of a chronological order, he wanted a thematic organization that would direct the visitor's attention to individual objects and their aesthetic relationship to one another. From the start, however, Klenze recognized the advantages of a historical approach whereby "the visitor follows the development of art, sees there its rise and decline, and always experiences the expectation of the next step and the memory of the last under the impression of the present."[77] This view prevailed. Beginning with a room devoted to the Egyptians and ending with a room containing contemporary neoclassical sculpture, the visitor was offered what Mechel had called a visible history of art. The beginning and end of this history re-

sembled each other, not only because of their parallel positions on either side of the main entrance hall but also because these two rooms did not seem organically tied to the classical art that made up the collection's core. By suggesting the problematic relationship of pre- and postclassical art to the classical ideal, the design of the Glyptothek revealed the same tension between historical development and transcendent ideals that was present in Winckelmann's history of Greek art a half-century before.

We can summarize our analysis of the Glyptothek by considering what critics from the Ecole des Beaux-Arts would have called its *marche*: that is, "the imaginary experience of walking through a plan in the mind's eye and ultimately [of] the building itself. . . . [It is] perceived as a sequence of architectural images, a highly ordered series of tableaux."[78] The Glyptothek's *marche* began in the great portico, which dominated the entire structure and announced the building's aspiration to be what Klenze called "an institution for the nation." Once inside, separated from the ordinary world by solid walls, visitors were invited to move past a series of tableaux that displayed the history of classical art from its Egyptian prelude to its contemporary coda. As they moved along, visitors could lift their eyes from the objects themselves to gaze at a richly decorated environment worthy of the museum's treasures. The arrangement was primarily designed for the interested amateur rather than for artists or scholars. Indeed, one reason Ludwig chose the odd neologism *Glyptothek* was that he thought "*museum*" too closely associated with scholarship rather than with disinterested appreciation.

And where did Ludwig fit into this *marche*? Although there was never any doubt that the Glyptothek was his, the king's symbolic presence was limited to a simple inscription (in Latin rather than Greek, so that more people could understand it) and a modest statue in the hall of modern sculptures. Of course, he sometimes took full possession of the museum and used it for courtly celebrations. But there were also times when he opened up his palace so that the public might enjoy his private collections; according to a guidebook published in 1834, "The king has made his residence into a monument of the literary and visual arts."[79] In Ludwig's mind, the line between museum and palace was indistinct; both were part of that aesthetic realm over which he reigned, the realm where monarch and nation could be united by their common experience of beauty.

Schinkel's Berlin Museum

In Berlin, Napoleon's final defeat revitalized the art policies that had been dormant during the difficult and eventful years after 1810. The Prussian authorities, like their counterparts in other German states, demanded the return of the artworks taken to France in 1807. When these pieces were brought back to Berlin, their homecoming became part of the victory celebrations held in the fall of 1815. Treated with the reverence due to recaptured national treasures, the most important works were displayed in the

Berlin Academy of Art, together with General Gerhard von Blücher's collection of captured French art—a combination of objects that emphasized art's patriotic significance. Proceeds from the sale of tickets were distributed to the disabled veterans of the wars against Napoleon.[80] In November 1815, while the exhibition was attracting enthusiastic crowds, Frederick William III commanded that the stables attached to the academy building be converted into a museum. He intended to pay for this project out of his own funds.[81]

A diffident, somewhat melancholy man, Frederick William did not like to spend money and had little personal interest in art. But however reluctant a patron, the king nonetheless recognized that the support of artistic projects was one of his monarchical duties.[82] He attended the exhibitions of contemporary works regularly held by the Academy of Art and (without much enthusiasm) directed his adjutant to buy a few paintings and other objects. More important, the king approved two major purchases that would provide the foundation for the Berlin museum's collection: in Paris in 1815, he acquired the Giustiniani family's collection of Italian art; six years later he bought 3,000 paintings that had belonged to Edward Solly, an English businessman who had made his fortune in Germany.[83]

The museum project itself got off to a slow and rocky start. In 1820, after it had become clear that Friedrich Rabe, the court architect in charge of construction, was simply not up to the job, work was temporarily halted. In March 1822, the king established a blue-ribbon commission to review the plans and at the same time agreed to add 700,000 taler to the 300,000 he had already invested in the project. Karl Friedrich Schinkel, a member of this commission, drew up new plans for the academy renovation. But while these were still under consideration, he developed a totally new concept that involved shifting the site from the academy to the Lustgarten, just opposite the royal palace. Schinkel presented this proposal in a brilliantly argued memorandum, which was endorsed by the king soon after he returned from the Congress of Verona in January 1823.[84]

Born in 1781, in the garrison town of Neuruppin in Brandenburg, Schinkel and his family moved to Berlin soon after his father died from injuries suffered in a fire that destroyed most of the town.[85] As a gymnasium student, Schinkel became enthralled by Friedrich Gilly's proposed monument to Frederick the Great. Although Schinkel was always open to new ideas and subject to many different influences, his work continued to be marked by the values and ambitions of Gilly's generation.[86] Like Gilly—and many other German intellectuals around the turn of the century—Schinkel combined a devotion to the classical style with a Schillerian faith in art's moral power and civic purpose. Art, he once wrote, portrays "the condition of a beautiful soul," and from this experience of beauty comes moral improvement and ethical behavior: "Men educate themselves in beauty so that their motives and deportment can be beautiful."[87]

Schinkel studied under David Gilly, Friedrich's father, initially at his private architectural school and then as part of the first class of the new state-

sponsored Building Academy established in 1799. After this formal train-
ing, Schinkel spent two years in Italy, where he formed close ties to the circle
of artists and intellectuals around Wilhelm von Humboldt, who was to play
an important part in Schinkel's career. When the young architect returned
to Berlin in 1805, there was virtually no work available. In addition to
designing stage sets, he supported himself by painting the large panoramas
that were then a popular form of entertainment. It was at one of these that,
early in 1810, he met King Frederick William and Queen Luise.

A few months later, Schinkel was appointed to the Technische Oberbau
deputation with the rank of assessor; thereafter, he rose steadily through the
administrative ranks to become Oberbaurat, Oberbaudirektor, and in 1838,
two years before his death, Oberlandesbaudirektor.[88] But although he
occupied a place in the bureaucracy, his social connections and court influence
remained essential to his career. He probably owed his initial appointment
to Wilhelm von Humboldt. His close relationship with the crown prince,
later Frederick William IV, was useful to him on several occasions; the
prince seems to have been instrumental, for example, in helping him obtain
the king's approval of his museum plans. Moreover, even though Schinkel
was not a court architect in the traditional sense, many of his most important
projects, beginning with his design for Queen Luise's tomb after her death
in 1810, were done for the royal family. Nor was he exempt from assisting
with courtly festivities, such as the *tableau vivant* that he prepared for a ball
in honor of Grand Duke Nicholas in 1821 and the decorations for the Festival
of the White Rose that he designed in 1829.[89]

Unlike the construction of the Glyptothek, which was largely determined
by Ludwig and his advisers, the planning and building of the Berlin museum
was enmeshed in the administrative institutions of the Prussian state. One
can trace its development through ministerial documents, not in private
letters to and from the building's royal patron. The funds were administered
by a state financial department; the contents were selected by a commission
that included Kultusminister Karl von Altenstein; and the construction itself
was supervised by Staatsminister Viktor Hans von Bülow. Nevertheless, even
though Frederick William did not play the kind of part in the construction
of his museum that Ludwig had in building the Glyptothek, the final deci-
sions were always his. The project began when he approved Schinkel's plans
in January 1823; it continued because he accepted the final budget a year later.
In 1827, after Schinkel returned from a trip to France and England with some
expensive new ideas about decoration, the king refused his request for more
money; eventually, though reluctantly, he did grant a much smaller addi-
tional allowance. Legendarily terse, the king felt no need to explain his
decisions; he once indicated his negative reaction to one of Schinkel's pro-
posals simply by drawing two lines across the page.[90]

Schinkel's first, decisive contribution to the museum project was to shift
the site from the academy to the northern end of the Lustgarten, which, in
1823, was damp, uneven ground on which stood a few shabby buildings.

Schinkel had been concerned with this part of the city since the spring of 1817, when he had prepared a plan—now apparently lost—for a reorganization of Berlin's entire core. In 1819, he designed the Schlossbrücke over the Kupfergraben, which linked the island with Unter den Linden and thus established a line of public buildings (including his own guardhouse [*Neue Wache*]) extending westward toward the Brandenburg Gate.[91] Placing the museum in the Lustgarten enabled Schinkel to unify the space around the palace, which he accomplished by relating the building to its neighbors through a series of visual references and analogies, as well as by carefully designing the surrounding landscape. Furthermore, the site allowed him to make a powerful statement about the significance of art. By setting his museum in an ensemble of buildings—the palace, the cathedral, the arsenal (fig. 9)—he asserted art's centrality, indeed suggested its claim to equal status with dynasty, church, and army: those three fundamental pillars of the Prussian state.

The museum's monumental facade expressed this aspiration (fig. 10). Its combination of breadth and weight—a line of eighteen columns based on an elevated foundation and supporting a heavy entablature—conveyed an impression of great dignity and strength. Moreover, its strong horizontality emphasized the structural parallels with the palace and thus its implicit claim to symbolic parity.

The shape of the site enabled Schinkel to concentrate his design on the main facade—the sort of cost-containing measure that always appealed to his frugal royal master. The other three elevations were unadorned and linked to the building as a whole through the skillful repetition of a few subdued elements such as the corner pilasters and the molding course that articulated the two stories. The building's base, which appeared as a pedestal for the main facade, became a genuine ground floor, with windows, on the other three sides.

Schinkel's museum was firmly rooted in its urban environment. Although some scholars refer to it as a "temple" of art, it was actually based upon a stoa, more precisely, on the *stoa poikile*, the covered colonnade in the agora of Athens. The contemporary buildings it most resembles—the Paris Bourse, begun in 1808; the Treasury Building in Washington, D.C., begun in 1836; and the Palais de Justice in Lyons, begun in 1835—are all secular structures. From the outside, therefore, the museum presents a resolutely worldly face. It is also a shrine, of course, but its sacred spaces are inside, concealed and protected from the external world. This combination of a secular exterior and a sacred interior is best understood when we look at the museum's entrances.

Since entrances at once separate and join a building's interior and its environment, they often convey a message about how the building is intended to relate to the outside world. That entrances might have a special significance for the new aesthetics was clearly seen by Goethe, who named his periodical devoted to the arts the *Propyläen*, thus alluding to the gateway to the Acropolis, which was in his words "stairway, gate, entrance, vestibule,

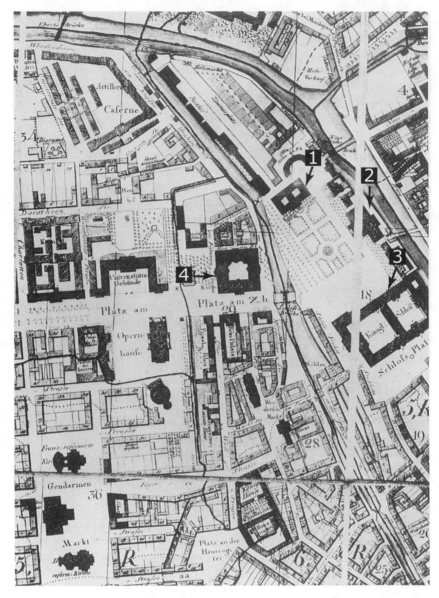

FIGURE 9. Map of Berlin, 1833: (1) museum, (2) cathedral, (3) palace, (4) arsenal.

the space between the internal and external, the sacred and the profane." A youth, Goethe went on, believes that he can rush into the sanctuary; an adult recognizes that he remains in the anteroom.[92] Thus the image of the gateway allowed Goethe to raise once again the question posed by art's alleged autonomy: how does one approach art and connect it to the world? With the entrances to his museum, Schinkel tried to suggest an answer to this question.

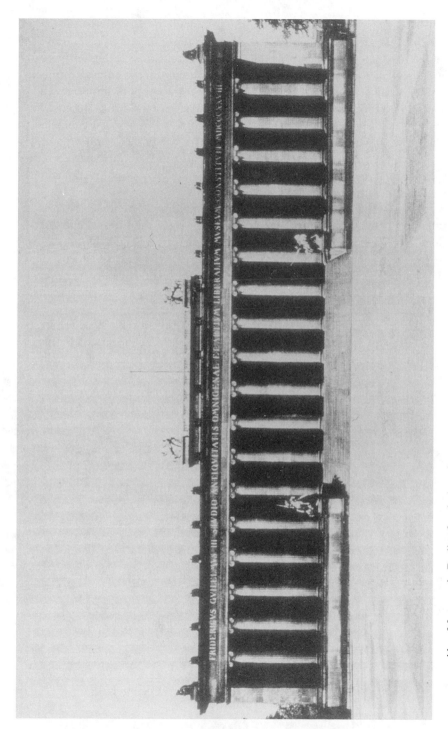

FIGURE 10. Altes Museum in Berlin: facade (1934).

The main entrance opens from the colonnade into a rotunda (fig. 11), which evokes the Pantheon and the Pio Clementino, as well as Durand's design of a model museum. Shielded from the outside by a high attic and largely isolated from the rest of the interior, the rotunda is entered through a rather small doorway that serves to amplify the impact of its imposing scale and rich decoration. When Hirt criticized the idea of a rotunda because he thought such a grand setting would detract from the art works it contained, Schinkel replied that his building had to have "a dignified central point." Here, he went on, "the perception of a beautiful and sublime space makes [the visitor] receptive and creates a mood of enjoyment and understanding for what the building contains."[93]

In some notes for an essay on "religious buildings," Schinkel described the rotunda as the basic form of religious architecture and thus the foundation for architecture as a whole. That idea is clearly expressed in his museum, where the rotunda is a sacred space designed to evoke past spiritual traditions and to associate the building with religious experiences—very much in the tradition of Romantic writers such as Wackenroder, for whom museums were places for devout contemplation.[94]

These aspirations are apparent in a drawing of the rotunda that Schinkel made while the museum was being built (fig. 12). In it, the space is empty, while a single, isolated individual is entering from outside. The prevailing mood is silent, contemplative, reverential. Here is a place of preparation, where the visitor can free himself from the cares of the everyday world and get ready to approach what Schiller would have called the third realm, the

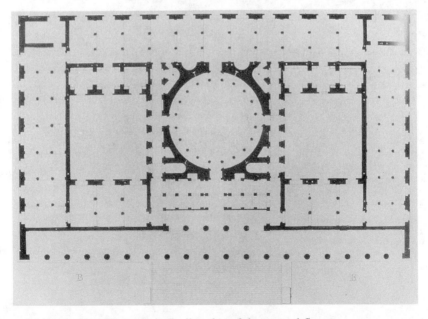

FIGURE 11. Altes Museum in Berlin: plan of the ground floor.

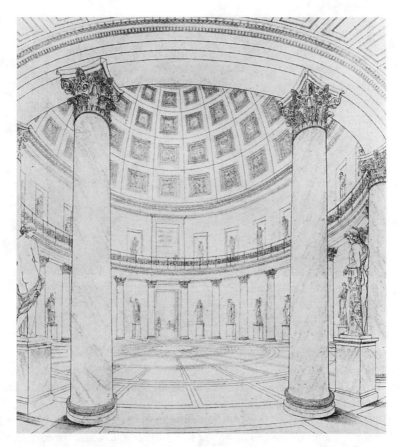

FIGURE 12. Karl Friedrich Schinkel, "View of the Rotunda" (1829).

realm of play, beauty, and freedom. To fulfill this function, the rotunda must be set apart from the outside world, just as art itself must be autonomous in order to be socially useful.

The museum's second entrance points in the other direction: it is a staircase that leads from the colonnade to an open porch on the second floor. In contrast to the rotunda, which is enclosed within the building, the staircase remains outside, a link to the social world.[95] Once again, Schinkel has left a drawing that hints at its part in his larger design (fig. 13). Unlike his portrayal of the rotunda, which is shown as empty and sublime, his rendering of the staircase and porch has them busy with visitors. This is a space for conversation and sociability, where people can discuss what they will see or have seen as they come and go between the museum and society—the exterior world into which the figure leaning over the railing at the left is looking. Rotunda and staircase are like the opposite ends of a bridge between interior and exterior, between private experience and social life, between art's separation from and its connection to the civic order.

FIGURE 13. Karl Friedrich Schinkel, "View of the Outer Staircase" (1829).

The monarchical presence in Schinkel's museum was originally restricted to a conventional tribute written by Hirt and inscribed across the facade. Otherwise, the building clearly belonged to the public: there was no ceremonial entrance, no festive space, no trace of art's origins as an embellishment of courtly life. Instead, the building was designed to reinforce the role of art as a source of virtue as well as enlightenment, of morality and delight, civic improvement and individual cultivation. Like Kant and Schiller, who linked art's moral function to its autonomy—and like Humboldt, who believed that scholarship could fulfill its political function only by being free from partisan controversy—Schinkel maintained that art could be at the core of public life only if it could be protected from the distractions of the everyday world.

Schinkel fully subordinated the decoration of the museum to its architectural design. The coffers in the dome of the rotunda, for example, were beautifully rendered and set off with a carefully selected color scheme, but they carried no important iconographical weight; similarly, the handsome detailing in the first-floor columns was discreet enough not to distract from the art. There were no frescoes inside the building, nor were there any of the elaborate decorative motifs that Klenze built into his museum.[96] On the exterior front of the attic surrounding the dome, Schinkel placed statues of the Dioscuri, figures whom he regarded as bringing "protection and salvation."[97] He had thought of having contrasting figures representing destruction on the back of the attic but eventually abandoned the plan. After his death, however, his idea for an interplay of protection and destruction was realized when the statue of a horseman struggling with a lion and one of an

Amazon—conventionally regarded as a symbol of unpredictable and disruptive energy—were placed on either side of the front stairs.

Besides these statues, the main decorative element on the outside was a series of frescoes, sketched by Schinkel but not realized until after his death, when they were painted by Cornelius and some associates. As in Cornelius's own work for the Glyptothek, the theme of Schinkel's fresco designs is the tension between creativity and destruction. For the walls of the colonnade, he designed two friezelike paintings that contrast the ideal "realm of the gods" with "human life." The former proceeds from darkness to light, from Saturn's triumph over the Titans to an apotheosis of the sun god; the latter moves in the opposite direction, from morning/springtime/youth to night/winter/age. For the walls of the second-floor porch at the top of the staircase, Schinkel planned two depictions of violence in human life, one in nature, one in war, both emphasing the fragility of human efforts to stand against the forces of disorder and devastation. The visitor, therefore, is supposed to carry away a sense of art's splendor but also of its vulnerability.[98]

The selection and arrangement of the collections was a great deal more complicated in Berlin than in Munich. Whereas Klenze could organize the spaces and design the decorations of the Glyptothek with a particular body of work in mind, Schinkel had to create a setting for art and antiquities without knowing exactly what was to be displayed. As early as his plans for the academy renovation, he had imagined sculpture on the first floor, paintings on the second, and this division remained the basis of the Lustgarten museum's original organization. In addition to expressing the foundational character of classical art, putting the paintings on the upper floor improved the lighting, and thus helped to resolve a structural problem that would continue to plague museum architecture until the invention of effective artificial light. The basement (which Schinkel had once considered renting out as a source of income) was used to house coins, vases, medallions, and other small antiquities, plus a library and a work area for the museum staff. But within this rough division of space, there were countless details to be worked out. In order to learn more about museum practices elsewhere, Schinkel made two long study trips, one to Italy in 1824, another to France and England two years later.[99] In 1829, as the building neared completion, Frederick William appointed Wilhelm von Humboldt to chair a committee to make the final selection of objects and to make recommendations about how the museum should be administered.[100]

The long and complicated deliberations about the organization of the Altes Museum reflected some basic disagreements among the leaders of the German art world. The primary source of controversy was Hirt, who had been the first to raise the question of a museum for Berlin. Although he wanted the museum to be publicly accessible, Hirt had assumed that it would be primarily devoted to the training of artists and the advancement of scholarship—an assumption expressed in his inscription, which stated that the king had constructed his museum to promote "the study of antiquities and the

liberal arts."[101] Furthermore, in addition to his objection to the rotunda, which he regarded as a pretentious and inefficient use of space, Hirt wanted to base the final selection of paintings on historical rather than aesthetic grounds; he believed, in other words, that the museum should strive for coverage rather than exemplary quality. Schinkel, with the support of Gustav Waagen and Carl-Friedrich von Rumohr, argued for an aesthetically excellent collection that would, as Schinkel and Waagen put it in 1828, "first delight, then instruct." Hirt's defeat in this debate led to his resignation from the committee. Humboldt's final report endorsed Schinkel's conviction that the museum's most important purpose was to teach people about beauty rather than the history of art. This was why, for example, he rejected the idea of using plaster casts to fill in the historical gaps in the museum's collection of classical sculpture.[102]

According to the catalogue of 1836, the rotunda and four halls of the first floor of the museum contained 451 statues, many of them heavily restored. Like Klenze, Schinkel separated the objects to be displayed from their architectural context: the statues had no structural tie to the building but were set on individual columns, each one designed to match its object's proportions. The antiquities were thematically rather than chronologically organized, thus suggesting the timeless beauty of classical art. On the second floor, almost 2,000 paintings were arranged according to a mixture of historical and aesthetic criteria that had been worked out by Schinkel, Waagen, Rumohr, and—most significantly—Humboldt in a series of compromises.[103] The space was divided into a series of rooms with walls designed to use the light as effectively as possible. As a result, visitors experienced the paintings in isolated but interconnected units that showed what Schinkel regarded as "the great historical whole in its full splendor."[104]

This, then, was the Berlin museum's *marche*: from a public space surrounded by palace, arsenal, and cathedral, visitors ascended the building's central steps and, having passed through its great columned hallway, entered the rotunda, whose sacred shape and splendid embellishments prepared them for the aesthetic experience ahead. On the ground floor, they could walk among the monuments of the ancient world, which formed the basis of all artistic achievement; on the floor above, visitors followed a more or less chronological path, marked by the greatest examples of Western painting, with particular emphasis on the work of the Italian masters who had recaptured the classical tradition for European art. From this unfolding experience of art's enduring ideals as they developed through time, visitors were prepared to reenter the outside world by contemplating frescoes that reminded them of history's potentially destructive power—and therefore of the museum's essential goal of preserving the treasures of the past.

Woven into the architectural fabric of these first two German art museums were many of the themes considered in this and the preceding chapter. The museums' style and contents expressed the classical ideal and the sense of

history that had been so important to Winckelmann and succeeding generations of German intellectuals. At the same time, the buildings proclaimed the sacred nature of art, to which the Romantic generation had looked for spiritual nourishment and moral improvement. Both buildings were also connected to the new sense of political power that had developed during the revolutionary era; even as they promised greater community, the Glyptothek and the Altes Museum also celebrated the significance of the monarch, the state, and, potentially at least, the nation. They recalled Wackenroder's artistic shrine, Napoleon's monument to his conquests, and—perhaps most of all—the public sublime of Friedrich Gilly's design for a monument to the great Frederick.

Although the two buildings were similar in style and message, they each emphasized different aspects of the museum's intellectual and institutional origins. The Glyptothek was closer to the world of the court; like the Fridericianum in Kassel or the gallery at Sanssouci, its origins and character were inseparable from the personality of its founder. In its festive spaces, the Glyptothek evoked memories of the baroque gallery though which courtiers had ceremonially paraded. The dynastic ties of the Berlin museum were substantially weaker; it was shaped more directly by Romantic aesthetics and the cultural ambitions of administrative reformers such as Altenstein and Humboldt. One cannot imagine torchlit festivities in its austerely grand spaces. It belonged entirely to the world of *Bildung*, not the court.

The Glypothek and the Berlin museum were among the earliest German *Bildungsbauten*, those characteristic nineteenth-century structures built to serve as museums, theaters, opera houses, and libraries. Such buildings were supposed to be public; they were designed, in theory if not in practice, to make culture accessible to a large segment of the population. At the same time, they all encouraged private, individualized experiences; museum visitors, concertgoers, and readers remained isolated while they were viewing, listening, or reading. As the "material theater of human activity," therefore, museums were supposed to be settings for the enactment of *Bildung*'s twin aspirations: to celebrate and nourish the community, and to edify and improve the individual.

3

THE MUSEUM AGE, 1830–1880

IN THE YEARS AFTER THE FIRST GERMAN MUSEUMS OPENED in 1830, art museums were built all across central Europe. In Munich, Crown Prince Ludwig had secured his father's permission to build a new gallery for paintings even before the Glyptothek was finished; the cornerstone of the Alte Pinakothek, also designed by Leo von Klenze, was laid in 1826, and construction was finally finished in 1842. A museum for modern art, the Neue Pinakothek, was begun in 1846 and opened in 1853, five years after Ludwig's abdication. In Berlin, which eventually became Munich's chief rival as Germany's artistic center, a new museum to house the Hohenzollern collection of Egyptian antiquities and plaster casts was constructed just to the north of Schinkel's masterpiece; it was finished in 1855. Twenty years later, the National Gallery, devoted to modern art, was built nearby. Cultural competition, which had been so important for the spread of princely galleries in the eighteenth century, encouraged the construction of new museums in every German capital. In Stuttgart, for example, the king acceded to pressures from the Württemberg Landtag and approved plans for a museum that was completed in 1843. The grand duke of Baden constructed the Karlsruhe Kunsthalle between 1840 and 1846; Dresden added the Gemäldegalerie to its complex of museums in 1855; Hanover acquired the Museum für Kunst und Wissenschaft in 1856, Weimar a museum for art in 1869. Museums, Gustav Klemm wrote as early as 1837, had become "political necessities [*notwendige Staatsbedürfnisse*]."[1]

Museums were also founded by nonprincely patrons of the arts such as Johann Friedrich Städel, a wealthy Frankfurt merchant and avid collector, who bequeathed his fortune to establish a public museum and art school. After an eleven-year legal battle with Städel's heirs, the gallery and school were opened in 1829. A new museum building was constructed in Frankfurt between 1874 and 1878. In Cologne, Ferdinand Wallraf left his collection to the city when he died in 1824; thanks to a legacy from another local patron, Johann Heinrich Richartz, a museum to house the collection was built in 1861. The Germanisches Nationalmuseum, founded in 1852 and moved to its permanent home in a former monastery in Nuremberg five years later, was the result of the generosity and drive of Hans Freiherr von Aufsess, who

regarded collecting German art and artifacts as a contribution to the nation's cultural identity. In some German cities, the impetus for building a museum came from local citizens. In Bremen, for example, an art association founded in 1828 developed a permanent collection—largely as the result of bequests from its members—which became the basis for the Kunsthalle, built in 1849. Similarly, citizen groups organized and helped to fund museums in Leipzig (1855–1858), Kiel (1856–1857), and Hamburg (1863–1868).

In this chapter we will examine why German princes, governments, and eventually the public came to regard art museums as indispensable sources of prestige and essential instruments for the spread of culture and enlightenment. We will begin with the growing importance of historical modes of understanding in the German art world. We will then turn to the institutional dimensions of the art world and follow the changing relationships of museums to their traditional royal patrons, as well as to a newly organized and politically engaged public. As in the preceding chapters, we will conclude by suggesting how these ideas and institutions helped to shape the design, decoration, and spatial arrangement of museum buildings.

I. Past and Present

As the official repositories of history's treasures, guardians of traditional values, and sites of scholarly research, museums were among the principal beneficiaries of the nineteenth century's belief in the significance of the past for the present. "History and the historical observation of the world," Jacob Burckhardt told his students in 1851, "permeate our entire cultural formation [*Bildung*]."[2] Aesthetic standards, artistic genres, and the disciplines of philosophy, theology, economics, and even the natural sciences were influenced by historical examples and historical modes of understanding. In popular periodicals, scholarly associations, and political assemblies, the way people thought about the issues of the day was shaped by their conviction that knowledge of the past was essential to finding one's way in the contemporary world.

In the nineteenth century, when the destructive forces of change were everywhere apparent, the need to preserve and protect the threatened residues of the past became a cultural imperative. History was a barrier against the ravages of time, a way of remembering what would otherwise be forgotten, of retaining what might be lost. People formed organizations to collect and publish ancient texts and medieval manuscripts; amateur anthropologists went into the countryside to record folktales and peasant rites; governments assumed responsibility for protecting historically important buildings. Burckhardt, who felt with particular poignancy the disappearance of ancient treasures, recognized that it was only thanks to "our unfulfilled longing for the past [that] . . . so many fragments have been saved and set into a historical context through tireless scholarship."[3]

But the importance of history was also emphasized by the urge to con-
nect, to build bridges linking the present to the past. History was a guide to
what was valuable and important, a source of legitimacy for political authority,
an inspiration for artistic creation. Public buildings were constructed accord-
ing to the stylistic canons of the past; kings were crowned in what were sup-
posed to be ancient ceremonies; painters and poets sought their subjects in
the sites and scenes of bygone ages. The same forces of change that made
preservation seem so imperative created the need for orientation, identity,
and meaning.

From the ubiquitous significance of history in nineteenth-century
culture, therefore, came the art museum's most important mission as well
as its greatest challenge: to preserve the artistic legacy of the past and to make
this legacy meaningful for the present.

Art as Monuments, Monuments as Art

"A true work of art," Schinkel once wrote, "must in some way be a monu-
ment; that is, it should contain the products of a transcendent human spirit
that will survive as long as its materials retain their shape."[4] Schinkel saw
himself as moving in the stream of time; for him, the purpose of art was to
add to the great accomplishments of the past by providing monuments for
the future. Like most contemporary architects, Schinkel aspired to create
buildings similar to those he most admired: the public buildings of the ancient
world, whose remains he had studied in Italy, or the medieval cathedrals that
were the subjects of some of his finest paintings. This did not mean that he
simply wanted to imitate the past—for Schinkel, "art is nothing if it is not
new"—but it did mean that he wanted to be great in the same way that past
masters had been great, and thus to prepare for the future what his prede-
cessors had bequeathed to the present.

Schinkel illustrated these aspirations in *Blick in Griechenlands Blüte*,
which he painted in 1825, while he was still hard at work on the Berlin
museum (fig. 14).[5] In this picture of a busy building site set in a classical
cityscape, Schinkel obviously meant to express his enduring commitment
to classical antiquity; even the elongated format seems to evoke the frieze
being put into place on the temple. At the same time, the picture is full of
references to the present. The column of men who are apparently marching
off to battle, for instance, is an allusion to the Greek struggle for indepen-
dence which had recently captured the imagination of many Europeans.
Moreover, *Blick in Griechenlands Blüte* certainly refers to Schinkel's museum
project, whose double row of columns might have served as a model for the
Greek structure's most prominent architectural feature. Schinkel's paint-
ing, therefore, both pays tribute to the past and asserts his own connection
to it.

Schinkel's title alerts us to another aspect of his historical self-
consciousness. *Blick* ("view," but also "glance") and *Blüte* ("flowering,"

FIGURE 14. Karl Friedrich Schinkel, *Blick in Griechenlands Blüte* (1825).

but also "blossom") both have temporal connotations; both suggest moments that will swiftly pass. If Schinkel associates the flourishing of classical culture not with a finished building but rather with the process of construction, then we must suppose that once the final stone is in place, a process of decline will begin. Just as blossoms wither and fall away, so the fragmented columns and uncompleted roof, which Schinkel paints when they are teeming with life and creative energy, will eventually reappear as ruins—empty, abandoned, slowly reclaimed by the forces of nature. "Nations decline and fall," Schinkel wrote in 1810, "since all things human last only for a time, but they leave behind monuments of art and knowledge, which deserve reverence and remain exemplary."[6]

This painting is a vivid illustration of historicism's two dimensions: first, an empowering sense of connection with the past; second, the sober recognition that the accomplishments of the present, like those of the past, will eventually decay. From the tension between these perceptions came the historical questions that would absorb the nineteenth century art world. What is the place of the present in the history of art? What will be its monumental legacy for the future? How will this legacy compare with the monuments from the past? In the art museum, these questions were posed with particular force and clarity.

Hegel and the Necessity of Mediation

One of the most intellectually powerful and influential attempts to define the historical place of contemporary art can be found in Hegel's lectures on aesthetics, which he delivered in 1820–1821, 1823, 1826, and 1828–1829 at the University of Berlin—just a few blocks away from the Lustgarten, where Schinkel's museum was under construction.[7]

By the 1820s, Hegel's ideas about art had changed a great deal since his collaboration with Schelling and Hölderlin on the "Systemprogramm" of 1797. Like most of his generation, he had abandoned his emotionally charged, quasi-religious conviction that art might serve as the source of a unifying myth for the modern world. Nevertheless, he remained deeply interested in aesthetic theory and art history. Hegel believed, first of all, that art was an important source of knowledge about the past; in their monuments, "nations have deposited their richest inner conceptions and representations."[8] But art was also a source of contemporary pleasure and edification. Hegel himself knew a number of artists in Berlin, several of whom were actively involved in the museum. He belonged to the local art association, or *Kunstverein*, in which various artistic issues were regularly discussed. When he received a travel grant from the Prussian government, he spent it on trips to visit the great collections in Dresden, Vienna, Paris, and the Netherlands. Among Hegel's several claims to our attention, therefore, is the fact that he experienced art in much the same way as his educated contemporaries did—as a student of art history, active participant in learned societies and scholarly discussions, and enthusiastic cultural tourist.[9]

Hegel's aesthetics proceeds from the conviction that art must be understood historically, as part of a larger context of thought and feeling. Every work of art, he wrote, belongs to "its time, its nation, its environment." Moreover, like Winckelmann and many others, he regarded the classical age as the high point of art history. For him, its greatness could be explained in terms of Greek life itself—not the physical beauty of the Greeks, which had so engaged Winckelmann's imagination, but rather the distinctive character of their culture and especially of their religion. In classical Greece, Hegel believed, the World Spirit—the driving force of history that he variously identified with God and Reason—had reached a stage where art was its most appropriate expression. Greek art and Greek religion were perfectly suited to one another; indeed, "Greek religion is the religion of art itself." In contrast to both the terrifying abstraction of Egyptian deities and the individualized humanity of Christian saints, the gods of Greece were the perfect source of art, subjects in which spirit and flesh, the universal and the individual, symbolic power and particular experience could find harmony and reconciliation.[10]

This conjunction would never come again, Hegel believed, because in the postclassical era, Spirit and art had moved in different directions. The Spirit having made its long and painful way toward ever greater self-realization—first in Christianity, then in philosophy—the world-historical purpose of art had diminished, and the quality of art had necessarily declined. In the modern age, therefore, art had lost its power to reveal the World Spirit's true nature; as Hegel famously put it, art "in its highest determination [is and will remain] for us a bygone thing." Against this condition, there was no antidote: "One can perhaps hope that art will develop more and more and fulfill itself, but its form no longer meets the spirit's highest needs. We can still find the representation of Greek gods magnificent and can still see God the Father, Christ, and Mary portrayed fully and with reverence, but that does not help us; we will no longer genuflect before them." For Hegel, the autonomy of art, which Kant and Schiller had identified as the basis of its moral power, was a symptom of its loss of spiritual primacy; autonomous art, what he called "art as such," could never claim our deep devotion. And because there was no way to reverse the direction of the spirit's journey, those who sought to regain art's ability to evoke devotion by emulating the styles and subjects of the past were bound to fail.[11]

The permanent and irreversible separation of art and Spirit had profoundly altered the way people experienced works of art. "In our day the intellectual approach to art [*die Wissenschaft der Kunst*] is much more necessary than when art itself was fully satisfying. Now art invites us to thoughtful observation, not in order to appropriate it once again but rather to understand intellectually what art is."[12] Because it was no longer the immediate expression of the culture's central truths, art had to be approached indirectly, as mediated through history and theory. For the Greeks, said Hegel, art was religion; for us, it has become scholarship and philosophy. They approached

their statues carrying sacrificial offerings; we come with monographs and guidebooks. They built temples; we build museums.

Art and the History of Art

What Hegel called the *Wissenschaft der Kunst* seems very similar to Arthur Danto's idea of an "art world": that is, the intellectual context necessary to define something as art.[13] For Hegel, as for most other nineteenth-century artists and critics, historical knowledge was the most important element in this art world, the essential source of inspiration, information, and value. In applying for a position at the Berlin museum, Hegel's student Heinrich G. Hotho, the editor of his lectures on aesthetics, wrote that his "highest scholarly purpose" was "to treat aesthetics only in the closest connection to the history of art and thus to base aesthetic principles on the historical development of the arts."[14] History, to borrow an image from Hans Belting, had become the frame within which art was perceived, interpreted, and understood. And like a frame, history both contained and excluded things; by shaping the museums' decisions about what to display, history helped to determine what belonged to the art world and what did not, what should be seen and what could safely be ignored.[15]

Although the intellectual foundations of art history were laid by Winckelmann and others in the eighteenth century, its disciplinary character was established during the middle third of the nineteenth, when a growing number of scholars assembled information about artists, catalogued their works, identified styles and periods and techniques, and developed methods for settling problems of attribution. Beginning in the 1820s, a series of important scholarly works on particular artists and movements appeared, such as Gustav Waagen's pathbreaking study of the van Eycks (1822) and Carl Friedrich von Rumohr's *Italienische Forschungen* (1827–1830).[16] This research was consolidated and made more generally accessible in important reference books, among them K. O. Müller's *Handbuch der Archäeologie der Kunst* (1835), Franz Kugler's *Handbuch der Kunstgeschichte* (1842), and Carl Schnaase's *Geschichte der bildenden Künste bei den Alten* (1843). The work of these pioneers was sustained by a network of societies devoted to the study of art, such as the Wissenschaftlicher Kunstverein, to which Hegel belonged in Berlin, and by periodicals such as the *Berliner Kunstblatt*, which regularly published articles about new scholarly discoveries.[17]

Many of the early art historians were amateurs who had been drawn to the subject by happenstance or personal enthusiasm. Rumohr, for instance, was a wealthy landowner who also wrote novels, scientific treatises, and a famous cookbook. But though private scholars would remain important for the development of the discipline (one thinks, for example, of Konrad Fiedler or Aby Warburg), in the course of the century, art history became increasingly professional and academic. At first, it occupied a marginal position as an ancillary field within classics or history or as part of the curriculum at art

academies; gradually, however, art history became a separate academic discipline and in 1860 acquired the essential mark of disciplinary legitimacy when Anton Springer became a full professor of art history at the University of Bonn. By the end of century, art history was an accepted part of Germany's thriving academic culture and had representatives at several major universities.[18]

From the start, there was an elective affinity between art history and the museum. A number of the first art historians—Gustav Waagen, Johann David Passavant, H. G. Hotho—were employed on a museum staff. Franz Kugler, whose handbook on the history of painting was a landmark in the discipline's evolution, also wrote an important guide to the Berlin museum's collection. Other scholars served museums in advisory capacities; almost all did some of their work in museum collections, which quickly became the most convenient and accessible places to view paintings and sculpture.[19] This close association between museums and scholarship was confirmed at the Kunstwissenschaftliche Kongress, the first professional meeting of art historians, which was held in Vienna in September 1873; at least half of its sessions were devoted to the preparation of accurate museum catalogues and improvements in restoration and conservation techniques.[20] After 1870, scholars rather than artists were usually selected to head museums. In Munich, for example, the painter Philipp Foltz was replaced by the historian Franz von Reber in 1875; seven years later, Julius Hübner reluctantly surrendered the directorship of the Dresden gallery to Karl Woermann, who held a doctorate in art history.

Art historians had the specialized knowledge necessary to determine and preserve the authenticity of art objects. Although experts who specialized in identifying the provenance of individual works had been part of the European art world since the Renaissance, until the nineteenth century their procedures remained unsystematic, their ability to establish authenticity limited. Apparently, a number of collectors had been willing to accept the authenticity of what they bought without much question. As noted in chapter 1, Frederick the Great, in his rush to cover the walls at Sanssouci, bought many doubtful works. Even the electors of Saxony, who were more knowledgeable and discriminating collectors than the Hohenzollern, ended up with a significant number of copies and forgeries; when Woermann became the director of the Dresden gallery in 1882, he discovered that no more than half of the pictures acquired by his predecessors were accurately attributed. Similarly, only three of the fifteen "Giottos" in the Wittelsbach collection turned out to be the work of the master himself.[21]

"The notion of authenticity," Charles Smith has recently argued, "lies at the heart of all museum activity." Historical authenticity was, of course, important to every participant in the nineteenth-century's expanding art market, in which value was directly dependent on the integrity of the work, but it was particularly important to museums, whose contents had to have the sacred aura of genuine art.[22] In response to these economic and cultural pressures, there arose an international elite of experts who attempted to

formulate a scientific set of procedures for testing the accuracy of attribu-
tions. To avoid painful embarrassment, museum collections had to withstand
the careful scrutiny of these experts, men who delighted in demonstrating
their skills by uncovering an inferior copy or incorrectly labeled work hang-
ing in some major public gallery.[23] It was no longer enough that an object
seemed old or interesting or even beautiful. Art now had to meet the demands
of scholarship; indeed, in the *Wissenschaft der Kunst*, the first term was no
less important than the second.

At the same time that one set of experts was developing the science of
attribution, another had begun to establish higher standards for the restoration
and conservation of artworks. Here too we find evidence of the century's
growing absorption with historical authenticity. It had once been thought
perfectly permissible to do whatever was necessary to make damaged or
incomplete works of art more beautiful. Crown Prince Ludwig, for example,
had insisted that Bertel Thorvaldsen use marble rather than plaster to "restore"
the sculpture in the Glyptothek; his object was to make the final product as
harmonious and graceful as possible.[24] Such a procedure had become un-
thinkable by the middle of the century, because people were convinced that
the historical object should be conserved rather than improved. If some kind
of restoration was unavoidable, then it should be done with the maximum
possible restraint—though precisely how this could best be accomplished
was a matter of intense controversy among critics and museum workers.[25]

The museum, always seen as the guardian of artistic treasures, now
became also the guarantor of historical authenticity, the institution respon-
sible for the careful preservation and proper restoration of artworks. Here
art received the reverent attention its historical significance demanded; here
it would be safe from the perils of ordinary life, protected from the ravages
of time. The critic Friedrich Pecht even went so far as to suggest that valu-
able paintings should be transported from churches to museums, where they
could be preserved for the appreciation of cultivated viewers, for whom "aes-
thetic pleasure" (*Kunstgenuss*) was the modern equivalent of divine worship.
Bright copies of the originals, he said, might be left for the edification of those
naive enough to associate spirituality and religion. After all, such pious but
uncultivated people did not require authentic art to assist them in their quaint
devotions.[26]

Art historians not only authenticated and preserved the individual works
of art in a museum's collection; they also articulated the master plot around
which a collection was organized. The eighteenth-century foundation of this
organizing narrative had been formulated by Winckelmann and then used
by Christian Mechel at the Belvedere. In the nineteenth century, no one
doubted that the museum should be a "visible history of art." Humboldt,
for example, was clearly thinking of the Berlin collection as the representa-
tion of a unified historical narrative when he argued that the museum's
acquisitions policy should be designed to "fill genuine and significant gaps";
in order to identify such gaps, of course, one had to be able to imagine a

whole.[27] In the description of the Berlin museum first published in 1838, Franz Kugler wrote that because the collection's "arrangement follows the laws of the historical development of painting," visitors were able to experience both "the development of art by stages, its flourishing and decline," and "at the same time, something of higher and more universal interest, the perceptive powers, the sensibility, and emotions of a bygone day."[28] As Kugler's statement shows, the organization of the nineteenth-century museum blended an explicit concern for the past with the implicit assumption that there were ideals according to which progress and decline might be plotted. The purpose of the museum, like the purpose of art history, was both descriptive and normative: to impart information about the past, and to convey values valid for all times.

This same blend of description and evaluation was evident in the concept of the "epoch," with which scholars tried to understand how art was related to its historical context. Every epoch, it was widely assumed, had its own distinctive way of expressing its most significant ideas and values: "Art," wrote Carl Schnaase in 1843, "is the central activity of nations, in which every endeavor and emotion, spiritual, moral, and material, is combined and restrained."[29] From this perspective, the concept might have become the basis for aesthetic relativism, according to which each epoch finds its appropriate means of artistic expression, and thus—to borrow Leopold von Ranke's phrase—all become equal before God. But few historians believed in the equality of artistic epochs. Instead, they usually agreed with Winckelmann that artistic achievement was a sign of cultural strength; artistic decline, of cultural decadence. Even Jacob Burckhardt, whose views on the relationship of art and culture were subtle and complex, could not resist asking whether "a formal decline in poetry and representational art always impl[ies] a people's national decline." His answer, at least with regard to the age of Constantine, was that "anyone who has encountered classical antiquity, if only in its twilight, feels that with beauty and freedom there departed also the genuine antique life, the better part of the national genius."[30]

Beauty and freedom, artistic achievement and cultural vitality were regarded as the common characteristics of every great artistic epoch. Throughout the nineteenth century, classical Greece retained its privileged place among history's great epochs of artistic achievement. The special significance of classical languages and literature was institutionalized in the gymnasium; classical subjects and styles continued to appeal to artists; historical images of the ancient world engaged the imagination of generations of thinkers from Schiller to Nietzsche. Still, even those who admired the ancient world recognized the creative accomplishments of other epochs. Some revered medieval art for its harmonious blend of religious devotion and aesthetic excellence; others regarded the Middle Ages as significant because they believed that the Gothic was a "German" style, with enduring relevance for the origins and development of Germans' cultural identity.[31]

In the course of the century, more and more scholars recognized the fifteenth and sixteenth centuries as a distinctive epoch, which they came to call the Renaissance. As usual, the concept had both historical and normative significance. Franz Kugler, for example, wrote in his authoritative *Handbuch der Geschichte der Malerei* that Italy in the early sixteenth century was "one of the rare highpoints in human cultural development. . . . The great works from this period are of eternal value, undiminished worth; they bear the mark of their own time, but are created for eternity."[32] Eventually, other scholars extended Kugler's vision to include northern Europe as well as Italy and architecture as well as painting. The result was an image of the Renaissance as a historical epoch, which, as we will see, had particular importance for the design and decoration of nineteenth-century art museums.

In theory, nineteenth-century historians emphasized the significance of artistic epochs, but in practice, their research often had to do with individual artists, especially those geniuses whose work dominated and at the same time transcended the epoch in which they lived. After midcentury, the practice of art history became increasingly biographical, with the publication of such landmark studies as Herman Grimm's works on Michelangelo (1860) and Raphael (1872), Alfred Woltmann's on Holbein (1867), and Carl Justi's on Velázquez (1888).[33] Popular enthusiasm, like scholarly interest, usually focused on past masters, and especially on those, such as Albrecht Dürer, whose artistic greatness could be linked to national values. The Dürer festival so vividly described in Gottfried Keller's *Der grüne Heinrich* was a celebration of art's past and present, of German artists' historical accomplishments, and of German culture's enduring qualities.[34]

Closely connected to the image of the genius was the concept of the masterpiece, which was of particular importance for the organization of many museums. The masterpiece was not only a major work of art; like the individual genius, the masterpiece both expressed and transcended history.[35] In the Dresden Gemäldegalerie, for example, Raphael's *Sistine Madonna* was hung in a room of its own, reflecting both its place as the culmination of the gallery's Italian collection and its status as a timeless artistic achievement. Reverently displayed, carefully guarded, frequently reproduced, and eventually familiar to educated people everywhere, masterpieces were the most prominent features of a landscape mapped by art historians and represented by the museum's collection. Their identification and exhibition provided particularly vivid examples of the museum's role as the arbiter of artistic value.

Museums and the Art of the Present

While almost everyone in the nineteenth century believed that museums should be visible histories of art, there was less agreement about their relationship to contemporary art. Should they be, as Hegel's views might lead one to think, closed depots of ancient works, whose only function was to

preserve for posterity the artistic residues of vanished cultures? This assumption shaped both Munich's Glyptothek and Berlin's Altes Museum, where modern works played a marginal role; their collections, like the story of art to be found in Kugler's handbooks, tended to taper off as they reached the early eighteenth century. Even among those who did not share Hegel's view of modern art as inevitably inferior to art of the past, many believed that only those works which had stood the test of time should have a place in the museum; contemporary art belonged in annual exhibitions or in auction houses, not in a permanent collection. Ernst Curtius argued in 1870 that "museums should connect us with the past and protect us from being too one-sidedly modern."[36] There were other critics and artists, however, who believed that museums should not be closed off from the art being created in the world around them and that there was room in them for the creative works of the present as well as the treasures of the past.

Of course, museums had always been important for living artists; the art academies' desire to use royal collections for artistic education was among the pressures that opened them to the public in the first place. Throughout the nineteenth century, ambitious young artists spent long hours studying and copying original works by past masters. For example, as art students in Vienna at the beginning of the century, Franz Pforr and Friedrich Overbeck had been inspired by the works of medieval German and Italian painters in the Belvedere. Other artists, including such well-known figures as Franz Lenbach, Anselm Feuerbach, and Hans von Marées, supported themselves during their early years by painting reproductions of great works, usually at the behest of some wealthy patron.[37] Even after art historians began to assume more and more responsibility for museum management, artists continued to work in the technical departments and to influence acquisitions policy. During the first era of museum construction, when frescoes and statuary were important parts of the buildings' decorative programs, museums were also a significant source of commissions for major artists.

As they had since the late eighteenth century, museums shaped the conventions with which artists defined their tasks. In the first place, the prominence of museums obviously helped to create and sustain that historical self-consciousness which, from the eighteenth to the early twentieth century, was European art's most striking characteristic.[38] By making available and affirming the significance of a wide range of different styles and subjects, the museum encouraged the pluralism associated with artistic historicism in all its forms. Moreover, the importance of museums further undermined the genre hierarchy, which had already begun to dissolve in the eighteenth century. On the museum's walls, portraits, still lifes, landscapes, and religious scenes were all hung together; all shared a certain equality as works of art.[39] And finally, as visible histories of art, museums created new possibilities of artistic identity and new criteria for aesthetic judgment. Individual artists saw themselves not as the products of a particular atelier or as pupils of an individual master but rather as figures within the established canon of Western

art, which began with the Greeks and reached into the eighteenth century. The history of nineteenth-century art, therefore, is filled with painters and sculptors who self-consciously associated themselves with the artistic geniuses from the past by imitating their styles (in life as well as art) and even by taking their self-portraits as models for their own.

Artistic excellence, Friedrich Pecht argued in 1877, was best measured by what he called *Galeriefähigkeit*: that is, worthiness to hang in a museum with the old masters. More than the patronage of a great person or the commission to create a significant work of art, a place on a museum's walls became the aspiration of the century's greatest artists. "Sometimes my life is like a dream," Anselm Feuerbach once wrote, "in which, a hundred years from now, I wander through the galleries and see my own works hanging in quiet gravity on their walls."[40] But could artists really be expected to defer the recognition of their monumental status for a hundred years and, in the meantime, enjoy it only in their dreams? Wasn't it possible to join the ranks of the great artists of the past, to be recognized as having created masterpieces, like Dürer or Raphael? There seemed no better way to answer this question that to have one's work hanging in a museum and thus to be monumental in Schinkel's sense, a part of the future's past. Only in that way could living artists be assured a place in art's history and thus a kind of parity with the masters whose work they had studied, revered, perhaps emulated.

There were practical reasons why so many nineteenth-century artists viewed the museum as the ideal destination for their work. Museums promised permanence and preservation; they also provided immediate recognition and material rewards, improving an artists' market value while shielding them from the indignities of commerce. Museums carried the prestige of official, even royal patronage, but at the same time they were instruments of public culture, accessible to everyone. They seemed to allow the freedom and autonomy for which artists yearned; they placed no limits on size or subject matter. They offered settings large enough for the enormous canvases that were so popular in the middle of the century—where else, one wonders, could pictures as large as Carl Friedrich Lessing's *Hus at the Council of Constance* (308 × 455 cm), Friedrich Overbeck's *Triumph of Religion in the Arts* (392 × 392 cm), or Philipp Veit's *Introduction of the Arts into Germany by Christianity* (854 × 192 cm) possibly have found a place? Museums were equally suitable for all the kinds of paintings popular in the century's middle decades, not only the Nazarenes' religious themes but also historical panoramas, genre paintings, landscapes, and still lifes. To an institution devoted to art as such, nothing was inappropriate, everything equally acceptable.[41]

There was, of course, one fundamental difference between the museum's historical works and its contemporary acquisitions: whereas the new works were often created with the museum in mind, the old ones had all been intended for some other venue. Contemporary artists' aspirations to become part of a museum's collection at once joined them to the past and revealed the gap separating them from those for whom such aspirations would have

been unimaginable. Historical consciousness, therefore, retained that paradoxical combination of connection and alienation that we first saw in Winckelmann. "To be sure," Wilhelm von Schadow wrote toward the end of his life, "we continually evoke the name of Raphael. But what is there of Raphael in us? Perhaps an atom of his graceful beauty. A thousand roses bloomed for him, while for us scarcely a single bud will open." No wonder, as Frances Haskell once remarked, "the spector of the museum haunts [nineteenth-century] art" like a ghost that is "at times welcoming and benevolent, at times hostile and threatening."[42]

A good example of a nineteenth-century painter's aspirations to monumentality is Friedrich Overbeck's *Triumph of Religion in the Arts*, on which he worked for almost ten years before it was finally installed in the gallery of Frankfurt's Städel Kunstinstitut at the end of October 1840 (fig. 15).[43] Overbeck, a convert to Catholicism and former associate of the Nazarenes in Rome, expressed here his belief in the necessary connection between art and religion, whose many-sided relationship is the painting's central theme. He also affirmed his own connections to the history of art, not only by using past models (especially Raphael's masterpieces, the *Disputa* and *The School of Athens*) but also by placing himself, together with his friends Philipp Veit and Peter Cornelius, in the picture itself (they are the figures barely visible on the left-hand margin, just behind the representation of Dante), in the company of Europe's greatest artists from the past. As though to illustrate Hegel's point that art could no longer be approached directly but had to be mediated through a *Wissenschaft der Kunst*, Overbeck wrote a long essay to explain his painting; in it he tried to demonstrate that "the arts can bring salvation to humanity only if, like the wise virgins, they come with the lamps of faith."[44]

Not all of Overbeck's contemporaries were impressed by either his pious intentions or his extensive explanations. In the long essay on Overbeck he published in 1842, Friedrich Theodor Vischer argued that *Triumph* was no more than an illustrated "lecture on the history of art," such as no old master would have tried to paint; with no trace of the divine, no living faith, no expression of genuine piety, it was essentially self-referential, art that "turns back upon itself and makes itself into the subject."[45] To modern eyes, Vischer seems to have been right: Overbeck's Virgin appears to be an attractive human being, but she does not evoke devotion. Before her, in Hegel's phrase, we are not inclined to fall upon our knees. Nor should we be expected to, since the picture was, after all, painted not for a church but rather for a museum, where kneeling is not encouraged.

Like Overbeck, Wilhelm von Kaulbach was unwilling to wait a hundred years for the opportunity to associate himself with past greatness. All his major works, in which the history of art and the significance of the museum are clearly manifest, aspire to monumental import. For instance, Kaulbach conceived his *Destruction of Jerusalem by Roman Troops under Titus* as the

FIGURE 15. Friedrich Overbeck, *Triumph of Religion in the Arts* (1840).

modern counterpart to Rubens's *Last Judgment*, one of the Alte Pinakothek's most prominent masterpieces. Kaulbach's subject, like Rubens's, is a great climactic event, although, in keeping with the spirit of his age, Kaulbach took his theme from history rather than theology; he rendered the unfolding of the divine within human history, not the end of historical time. The painting's size, style, composition, and epic subject all reinforced Kaulbach's self-conscious claim to a place in the history of art. *The Destruction of Jerusalem*, like Overbeck's *Triumph of Religion*, was destined for a museum. Purchased by King Ludwig in 1841, it eventually hung in the central room of the Neue Pinakothek, where it occupied a position similar to that of Rubens's *Last Judgment* in the Alte Pinakothek.[46]

At the laying of the Neue Pinakothek's cornerstone in 1846, Ludwig made clear both his own historical self-consciousness and his building's monumental intentions. The new museum, he said, was intended for paintings "from the present and future centuries." The high art of painting had once been extinguished but had "risen again like a phoenix from its ashes"—

this time in Germany, where all the visual arts were undergoing a rebirth. "My great artists," the king concluded, "bring me pride and joy. After the statesmen's work has long been forgotten, their achievements will continue to delight."[47] Ludwig did everything possible to establish parallels between his two painting galleries; he even commissioned an altarpiece that went from the artist's studio directly into the museum without ever having been near a church—a path that would surely have amused Hegel. August von Voit's design for the Neue Pinakothek also called attention to the similarities between the two galleries: on a site just north of the older museum, he erected a two-story, rectangular building with a series of cabinets along the north elevation and skylights for the large central galleries and the smaller rooms on the south side (fig. 16).[48]

Ludwig commissioned Kaulbach to design murals for the Neue Pina-kothek's exterior to depict the achievements of contemporary German art and of Ludwig's role as a patron. The result was an extraordinary set of frescoes in which history, allegory, and satire uneasily coexisted. In the first of the series, for example, titled *Struggle against Pedantry* [*Der Kampf gegen den Zopf*], Kaulbach presented a mean-spirited caricature of his contemporaries— including his teacher Cornelius and the king—and himself (fig. 17).[49]

Kaulbach's work was not popular. Most of his contemporaries believed that he had violated the sacred purpose of art, which was, as Julius Schnorr von Carolsfeld wrote in a scathing attack on the frescoes, to serve as a "memorial tablet of the past." Moritz von Schwind, Kaulbach's colleague and rival in Munich, remarked that "King Ludwig has spent millions in order to make German art great and then thousands more so that he could be ridiculed for doing so."[50] As a memorial in honor of art's past greatness and as an expression of its patron's generosity and good taste, the monumental museum should have evoked reverence and respect, not irony and amusement.

II. Museums as Public Institutions

"Art should not be seen as a luxury," King Ludwig declared when he laid the cornerstone for the Neue Pinakothek in 1846. "It expresses itself in everything, it flows into life—only then is it what it should be."[51] Most of Ludwig's contemporaries agreed that art should be connected to life, but they imagined these connections in many different ways. Whereas Ludwig himself regarded art as an expression of his personal taste, national aspirations, and dynastic glory, civil servants saw it as part of the state's educational mission; members of the *Bürgertum* believed that it was a necessary source of individual cultivation and refined sociability; patriots were convinced that art expressed the nation's true identity; and for artists, of course, art was at once a distinctive vocation and a way of making a living. These various views of art's purpose shaped the complex role of the museum in the institutional art world between the 1830s and the 1880s.

FIGURE 16. Neue Pinakothek in Munich from the southeast (1865).

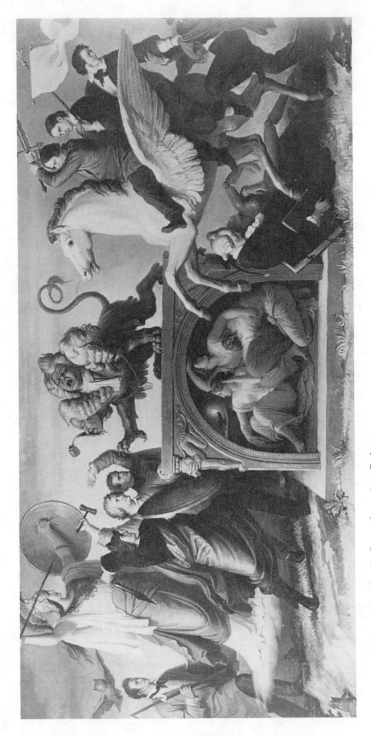

FIGURE 17. Wilhelm Kaulbach, *Struggle against Pedantry.*

Monarchical Patronage: Persistence and Limitation

Throughout the nineteenth century, the courts continued to play a leading role in the German art world. As they had for centuries, rulers built palaces, erected statues of themselves and their ancestors, commissioned official portraits, and in various other ways used art to express and embellish their position as personifications of the state. For some monarchs, patronage helped to fill the spaces left by the gradual seepage of the court's political functions to other governmental agencies. In much the same way as other wealthy individuals, monarchs also patronized art by using their private funds to collect the works of artists they admired. And, of course, monarchs could use their political power to push art policies in the direction of certain individuals and organizations: they could influence appointments, and determine how and where public projects were carried out. In its variety and extent, therefore, rulers' engagement with the art world reflected the complex of new roles that they had begun to play in the postrevolutionary world.[52]

Perhaps the best way to begin analyzing the relationship between rulers and nineteenth-century art museums is to examine the issue of property. Who owned the objects that were on display in public galleries and museums? During the old regime, most of these things were part of the dynasty's personal property. In the course of the eighteenth century, some rulers and their advisers began to refer to these dynastic art collections as some sort of national possession, even though their legal status had not changed. Nevertheless, princes could still dispose of their contents as they wished. If a ruler changed states, as Max Joseph did when he inherited the Bavarian electorate, he simply took his art with him as he did the rest of his possessions. In the nineteenth century, however, most people believed that art should not only be accessible to the public but legally belong to it as well; this was why the city of Düsseldorf engaged in a prolonged (and ultimately unsuccessful) legal battle with the Wittelsbachs to get back what Max Joseph had carted off in 1805.[53]

During the revolutionary era, the legal status of art was affected by reform governments' efforts to establish a clear distinction between dynastic and public property, as in the Bavarian constitution of 1818, which declared the royal collections to be "state property." Nevertheless, the line between dynastic and state property remained indistinct. Max Joseph, for instance, referred to "our painting and art collections" when he approved Georg von Dillis's appointment as gallery director in 1822.[54] Moreover, as crown prince and as king, Ludwig acquired art with both state money (from the civil list, as well as directly from the budget) and his own private funds. In 1828, the Landtag amended the constitution to ensure that artworks bought with the king's own money would remain his personal property, even if they were displayed as part of a public collection. Throughout the life of the monarchy, the status of the Wittelsbach collections remained complex: the Glyptothek was dynastic property; the Alte Pinakothek was built with state money and contained both public and dynastic art; in the Neue Pinakothek, which was

built with Ludwig's funds and contained his private collection of modern art, the state "borrowed" space for pictures bought with public money and administered by its own curator. In 1914, the state of Bavaria bought the Neue Pinakothek from the royal family for a million marks, but the exact status of the other collections was not finally settled until after the revolution of 1918–1919.[55]

In almost every German state, the question of artistic property was equally complicated and potentially contentious. The Saxon constitution of 1831, which, like its Bavarian counterpart, converted most dynastic properties into *Staatsgut*, also established an entailed royal trust, which included the art collections and whatever might be added to them. The collections themselves were administered by the state rather than the court, but the royal family retained a say in their disposition.[56] In Hesse-Darmstadt, Grand Duke Ludewig issued a decree in 1820 establishing his collections as state property and opening them "for the entertainment and instruction of the public," though the objects themselves remained in the royal palace for the next eighty years. In the 1890s, when the Hessian Landtag was asked to approve funds for a new building to house these collections, the question of who actually owned them was very much on the delegates' minds. They were understandably reluctant to use public funds on behalf of collections that did not belong to the state.[57]

In Prussia, where there was no constitution until 1848, the separation of dynastic and state properties had been effected by a law governing public debts, decreed in January 1820, which transferred the Hohenzollern landed estates to the state and guaranteed the royal family an income of 2.5 million Reichstaler from an entailed fund. In addition to this income, the Prussian kings had a private fortune, which they could spend as they wished.[58] It was from this latter source that Frederick William III purchased Edward Solly's extensive collection of paintings in 1821; they remained his private property, as did many of the works that made up the core of the Berlin museum's holdings.[59] And even though the Hohenzollern had a long tradition of making their art accessible to the public, they sometimes had occasion to make its actual ownership clear. In 1872, for instance, when Crown Prince Frederick William, together with officials from the Berlin museum, compiled a list of paintings from the royal palaces that they wanted to display publicly, his father rejected the proposal out of hand.[60]

During the first two-thirds of the nineteenth century, many German rulers personally appointed the court artists who managed their collections. King Ludwig chose men who were close to him, first Dillis and then, after 1846, Clemens von Zimmermann (1788–1869)—a court painter and a professor at the academy, who had worked with Cornelius on the Glyptothek. In Württemberg, the royal gallery was run by Philipp Hetsch (1758–1838), a court musician's son, who—like Dillis and Zimmermann in Bavaria—was eventually ennobled for his service to the crown. In the early 1820s, however, Hetsch was summarily demoted by the king despite his protest that he

"should be treated as a free, independent artist, subordinate to no one."[61] He was replaced by Johann Heinrich Dannecker (1758–1841), a sculptor whose rise from poverty (his father had worked in the royal stables) to European prominence had been made possible by royal patronage.[62]

Sometimes rulers hired nationally known artists, who could bring prestige as well as artistic expertise to their museums. In 1846, the king of Saxony convinced Julius Schnorr von Carolsfeld (1794–1872), who had spent almost twenty years working for King Ludwig, to leave Munich and become director of the Gemäldegalerie and the Academy of Art in Dresden, where he served until 1871.[63] In 1858, the grand duke of Baden replaced Carl Ludwig Frommel (1789–1863), a local artist who had directed the Karlsruhe gallery since 1830, with Karl Friedrich Lessing (1808–1880), whose painting *Hus at the Council of Constance* had been a cause célèbre when it was purchased by the Städel in 1842. Lessing's reputation as a militant Protestant gave his appointment political as well as artistic meaning in Baden's confessionally divided and increasingly acrimonious public life.[64]

Despite the court's continuing significance for the art world in general and museums in particular, monarchical authority was everywhere affected by the political transformations that had occurred during the revolutionary era. In the formation of artistic policy, as in their other political activities, monarchs had to act with, through, and sometimes against a bureaucracy that developed its own expertise and interests in the administration of artistic affairs. In most states, rulers also had to face the scrutiny of and often the restrictions imposed by representative institutions. Moreover, constitutional limits on monarchs' financial resources meant that they either had to seek parliamentary approval for their artistic projects or had to finance them out of their own funds.

Even King Ludwig—who dressed his court artists in uniforms, dismissed them at will, and had once declared that "I, the king, am art in Munich"— could not transcend the institutional limitations imposed by the constitution. Although he attempted to preserve his independence by paying for most of his projects from his own pocket, he was often subjected to harsh parliamentary criticism. In the stormy political climate following the Revolution of 1830, for instance, the Landtag refused to approve all the funds necessary to complete the Alte Pinakothek; we must turn our backs on art, one delegate said, "when art builds its temple with the nation's emergency funds [*Notpfennigen*]."[65] After Ludwig's forced abdication in 1848, his son, Maximilian II, was usually willing to leave art policy in the hands of officials from the ministry of religious and educational affairs, who operated through advisory committees. Maximilian's successor, the unfortunate Ludwig II, ultimately failed to get the money he needed for his grandiose schemes; indeed, the financial difficulties caused by his extravagance produced the final crisis of his reign.[66]

Some combination of monarchical, bureaucratic, and parliamentary influence on artistic policies could be found in other states as well. In Baden,

for example, the decision to build a new museum was the product of consultations involving the grand duke, the ministry, and the Landtag, which had to approve all major expenses. When Moritz von Schwind was hired to provide frescoes for the museum, his contract was approved by the court, but later on, the artist had to turn to the state's finance ministry for additional funds.[67] In Saxony, where the art collection continued to belong to the dynasty but was administered by the state, decisions about museum personnel and acquisitions were made jointly by court and bureaucracy. Thus, in 1855, when Hermann Hettner was being considered for the post of director of the royal collection of antiquities, he was interviewed by members of the royal household as well as officials of the Interior Ministry. Eventually, authority over Saxony's art was moved to the Kultusministerium, but major acquisitions still had to have the king's approval.[68]

Administering the Berlin Museums

The administrative structure of the Berlin museums is of particular interest, not simply because of their major role in the German art world but also because in their development we can see with particular clarity forces that would eventually affect art museums everywhere.

There is a certain irony in the fact that Frederick William III of Prussia, who must rank among the least artistic of monarchs, had more autonomy as a patron than the ruler of any other major German state. This was true in part because he was restrained by neither a constitution nor a state parliament; the public debt law of 1820, which regulated dynastic property, said nothing about art or the dynasty's other personal possessions. Less obvious but equally important, until the 1840s the king did not have to compete with a bureaucratic agency charged with making and administering art policy. During the era of reform, Altenstein had hoped that the state would play an active role in artistic affairs, but when the Kultusministerium was established in 1817, its functions were limited to ecclesiastical and educational matters.[69] In this institutional vacuum, the king and his advisers were primarily responsible for establishing Prussian art policy in the years before and immediately after Schinkel's museum opened in 1830. The king, who had made the critical decisions during the building process itself, continued to be involved, often reluctantly, in the museum's operations, especially those that required extraordinary expenditures; he was, for example, consulted about Gustav Waagen's repeated requests for a higher salary.[70]

Some of Frederick William's advisers were afraid of giving anyone absolute and unchecked power over the museum. In a memorandum that he prepared for the king in December 1830, Wilhelm von Humboldt argued that the museum must be protected "from the personal caprice [*Willkür*] and contingency of its various leaders." Although he was writing about the museum's administrative head, Humboldt may well have been thinking about the monarch himself: *Willkür* was often the term constitutionalists used to

complain about the arbitrary character of princely absolutism. In any event, Humboldt urged the king to issue what he called a *Grund-Verfassung*, a set of statutes that would permanently define the museum's internal organization and its relationship to other institutions. Having failed to persuade Frederick William to grant a constitution for the state, Humboldt hoped that he could at least avoid "caprice and contingency" in the operations of the museum.[71]

After considerable debate and discussion, the museum's statutes were decreed on January 15, 1835.[72] The head of the royal collections was called the general intendant, a title that suggested parallels with the head of the royal theaters, who was also a court official responsible directly to the monarch.[73] The general intendant's task was, among other things, to represent "the museum at court and in the highest social circles."[74] Under his authority were several departments—painting, prints, sculpture, antiquities, and, outside of the museum itself, the Egyptian collection and the *Kunstkammer*—each of which had its own director and assistant curator. Policy matters, including decisions about acquisitions, were in the hands of an artistic committee composed of the general intendant, the various department heads, and an advisory group of artists that originally included Schinkel, the sculptor C. D. Rauch, the painter Karl Wilhelm Wach, and Jacob Schlesinger, the museum's chief restorer. The general intendant chaired this committee, but its decisions were taken on the basis of a majority vote.

Debates about the Berlin museum's organization included one of the first sustained discussions of the relative importance of scholarly expertise and artistic judgment, an issue that remained a source of disagreement among museum officials for the remainder of the century. That "scholarly education and thorough knowledge [*eine wissenschaftliche Bildung und gründliche Kenntnis*]" were essential for the museum's department heads had been vigorously argued by Schinkel and Hirt in 1826 and by Altenstein four years later.[75] Humboldt, however, was rather less sympathetic to the unqualified claims of scholarship. Just as he believed that art should be displayed with both historical and aesthetic values in mind, he was convinced that "purely artistic issues" should be decided "by real artists."[76]

In the end, the leadership of the Berlin museum included both artists and scholars. The first director of the painting department was Gustav Waagen, who had been involved in planning the museum since 1823 and would establish himself as one of Europe's leading experts on the display and administration of collections.[77] Waagen's assistant was Heinrich Hotho, the art historian who edited Hegel's lectures on aesthetics. The director of sculpture was Friedrich Tieck (brother of the poet Ludwig Tieck), an accomplished artist with extensive connections in German intellectual circles. Konrad Levezow, professor of mythology and archaeology at the Academy of Art, became director of antiquities; Wilhelm Eduard Schorn was in charge of the print collection, which became a separate department in 1832. Of these five, Waagen, Tieck, and Levezow had all been recommended to the king by Schinkel and Hirt in their 1826 memorandum.[78]

The first general intendant was Count Brühl, the grandson of a promi-
nent Saxon statesman, son of a Prussian officer, a former chamberlain at the
Prussian court, and, from 1815 to 1828, the director of the royal theater in
Berlin.[79] Although well connected to court society and an experienced cul-
tural administrator, Brühl had no particular interest in or knowledge of the
visual arts. Furthermore, by 1830, poor health forced him to spend much of
his time away from Berlin, either on his estate or at some spa. During his
seven years in office, therefore, Brühl's efforts to shape museum policy were
sporadic and largely unsuccessful. In effect, the most important decisions
were taken by the artistic committee, which was led by Schinkel.[80]

After Brühl's death in 1837, Altenstein persuaded the king to have the
head of the museum—renamed "general director"—report directly to the
Kultusministerium rather than the court. Six years later, Friedrich von
Eichhorn, Altenstein's successor, established in the Kultusministerium a new
department responsible for all aspects of artistic policy. Its first head was
Franz Kugler, the art historian, publicist, and author of path-breaking hand-
books on art.[81] Both the assignment of the general director to the ministry
and the creation of an art department would have important long-range
consequences for the governance of Prussian museums; nevertheless, for the
next three decades, the king and his entourage retained much of their tradi-
tional influence on museum policy and personnel.

In 1837, there was considerable disagreement about who should replace
Brühl. Crown Prince Frederick William strongly recommended Josias von
Bunsen, a diplomat, amateur scholar, and art patron who had guided the
prince during his brief visit to Rome. In many ways, Bunsen seemed an ideal
candidate, but he was vigorously opposed by Altenstein, as well as by Waagen,
Schinkel, and Rauch, who questioned his artistic judgment and may have
been worried that he would have undue influence at court when the crown
prince succeeded his father. Their candidate, who was also supported by
Alexander von Humboldt, Wilhelm's brother and the king's chief adviser
on cultural matters, was Ignaz von Olfers, a physician by training and a former
diplomat who occupied a middle-level post in the Kultusministerium. After
a two-year conflict that clearly revealed the mix of bureaucratic maneuvering
and court politics driving Prussian art policy, Olfers was appointed general
director of Prussia's museums.[82]

Olfers surprised his supporters by having his own ideas about how the
museum should be run. Since he was particularly interested in the museum's
scholarly mission, he set out to improve the library and expand the archae-
ology department; he also spent a good deal of money on plaster reproduc-
tions of important statues in order to increase the historical range of the sculp-
ture collection. After consolidating his position with Frederick William, who
became king in 1840, Olfers increased his authority at the expense of both
the department heads and the artistic committee. The new arrangement was
codified in a revised set of statutes issued in December 1854.[83] Olfers's
subordinates, especially Waagen, were outraged by this assault on their

autonomy and by the director's frequent interference in their operations. Matters came to a head in 1866 when Olfers, during one of Waagen's frequent trips abroad, ordered the restoration of a painting by Andrea del Sarto, which turned out badly. The result was a flurry of activity directed against the general director: the usual bureaucratic and court politics, angry newspaper articles, and critical speeches in the Prussian Landtag.[84] In May 1868, Prince William (who had succeeded his brother in 1858) issued a new museum statute that reasserted the authority of the minister and restored the power of what was now called the technical committee over acquisitions and restoration.[85] Olfers's authority was essentially broken; he resigned in 1869.

The general director's position was still open when, after his return from the victorious campaign in France in 1871, King (and now also Emperor) William appointed Crown Prince Frederick William as the protector of the royal museums. Although the appointment was intended to limit the prince's political influence by keeping him away from more important state business, Frederick took his task seriously. He had all communications from the museum staff to the Kultusministerium forwarded through him and received copies of the ministry's replies. Furthermore, his active role in museum affairs included the preparation of a long memorandum in 1883 calling for a more aesthetically pleasing arrangement of the collections.[86] The crown prince and his entourage were primarily responsible for the selection of Count Guido von Usedom, a former diplomat who had been forced from office by Bismarck, to be Olfers's successor.[87]

As even Usedom's supporters quickly realized, the new director lacked the energy and administrative ability necessary to run so complex an organization as the Berlin museums had by then become. Soon he was involved in an ongoing battle with his department heads, especially with Waagen's successor as director of paintings, Julius Meyer. Usedom's opponents in the museum attacked him on three fronts: first, they bombarded the ministry with complaints and requests for assistance; second, they used their influence with the crown prince to undermine Usedom's position; and finally, they rallied their allies in the press and parliament to raise critical questions about the way he was managing the museum.[88] These prolonged polemics and intrigues produced yet another revision of the museum statutes, issued by the crown prince in November 1878 (while his father was recovering from the attempt on his life earlier in the year), which substantially strengthened the authority of the department heads and established a monthly meeting at which they could discuss general policy questions. In place of the technical committee for the museum as a whole, each department was to have its own advisory committee for acquisitions, restoration, and other artistic decisions. These changes were obviously a repudiation of Usedom, who resigned in 1879.[89]

The emperor next offered the directorship to Count Pourtales, another courtier. When he declined, the position went to Richard Schöne, who had been in charge of the art department of the Kultusministerium since 1872.

Unlike Brühl or Usedom or, for that matter, Olfers, Schöne did not come from an influential family; his grandfather had been a small farmer, his father a schoolteacher. Moreover, Schöne had a long-standing interest in art and impressive scholarly credentials. After receiving a doctorate in philosophy, he had studied art and archaeology and had held a teaching post at the University of Halle before joining the ministry. Thus, he owed his job to his scholarly accomplishments and administrative experience, not to his relationship with the monarch. Indeed there were still some—including Wilhelm Bode, a rising star in the Berlin museum world—who looked upon Schöne's lack of court connections as a serious drawback.[90]

The shift from men like Brühl, Olfers, or Usedom to a cultural bureaucrat such as Schöne underscored the fact that running a museum had become a full-time job, best given to a professionally trained expert rather than a confidant of the monarch, a retired diplomat, or some other amateur. The need for administrative skills was especially apparent in the Berlin museums, which were major beneficiaries of the government's growing investment in public culture after the formation of the German Empire in 1871. Following its victories in battle, Adolf Rosenberg wrote in *Die Grenzboten*, the German-Prussian government had gone from triumph to triumph in the cultural realm, which included "making all its collected treasures available to everyone for free study and unlimited pleasure."[91] As befitted the capital of a powerful and prosperous nation, Berlin increased its museum budget from 20,000 to 103,000 talers in the 1870s, with special subsidies for new acquisitions.[92] By the time Schöne took over as general director in 1880, he was responsible for several large collections spread across a growing number of buildings.

As museums grew larger and more complex, then, the standards for administrative performance were raised; procedures that had seemed perfectly adequate at the beginning of the century now appeared amateurish and embarrassing. In the last section, we saw how the demands for more accurate attribution and more careful conservation were part of the increasing professionalization of art history. We can now examine how these demands were supported by vocal members of the educated public, who claimed proprietorship over the museum's treasures in the name of the *Volk*.

Museums and the Volk

In 1872, as the Prussian museums were beginning to enjoy a new era of expansion, Herman Grimm, professor of art history at the University of Berlin, published "A Series of Perspectives on Our Public Institutions for the Enhancement of Art," which was a characteristic statement of how art policy— and, by extension, all public policies—should be made. Grimm began with the premise that the *Volk* was now the source (*Urheber*) of policies governing the maintenance and encouragement of art. But the *Volk* had to act through its representatives, "the officials appointed by the emperor and the

parliamentarians elected by the emperor's subjects," who were in turn "moni-
tored [*controlirt*] by the intellectual power of those whose talent and learn-
ing qualified them for the task." Since the eighteenth century, Grimm
pointed out, scholars interested in art history had provided more and more
of this guidance, not because the government favored them but rather because
both artists and the public increasingly accepted their authority. Now that
public collections were so large and diverse, the art historian had become
indispensable.[93]

About the same time that Grimm offered this vision of modern art policy,
Reinhard Kekulé published an article on the current controversy over how
the Berlin museum's extensive collection of plaster reproductions of classical
statues should be displayed. A private collector, Kekulé wrote, was free to
arrange his possessions without regard for historical principles; he needed
only to please himself. The Berlin museum, however, was not a private
operation but "a magnificently conceived and magnificently funded insti-
tute of the state, founded and perpetuated for the good and benefit of scholar-
ship, and, through and with scholarship, for universal cultivation." It was
unthinkable, Kekulé concluded, "that the exhibit of casts should continue
to violate the historical principles which are the only justification for the
Berlin museum's existence."[94] What was at stake here obviously transcended
the question of whether these objects should be displayed in chronological
order; behind this particular debate was the much more significant question
of what sort of expertise, and therefore what sort of expert, should control
public collections.

Issues of the kind that inspired Kekulé's article were frequently the occa-
sion for discussion and debate among the educated public. Art critics, scholars,
journalists, and political leaders wrote about the accuracy of museums' cata-
logues, the way their works were labeled and displayed, and the overall quality
of their collections.[95] Essays on art policies, museum acquisitions, and spe-
cial exhibitions were regular features not only in specialized art periodicals
but also in general-interest publications such as the *Grenzboten* and *Preussische
Jahrbücher*. Friedrich Pecht, for instance, a prominent author and the editor
of *Kunst für Alle*, was a persistent critic of the Alte Pinakothek, whose col-
lections he regarded as poorly arranged, dimly lighted, and insufficiently
explained.[96]

A good example of the public's engagement with artistic matters was
the long and heated debate in the late 1860s and early 1870s over the correct
attribution of two paintings of the Madonna, both supposedly by Holbein
the Younger. One of these pictures had been in Dresden since the 1740s,
where it was revered as the "German" counterpart of the collection's most
famous masterpiece, Raphael's Sistine Madonna. In the 1820s, a strikingly
similar picture came on the market, was purchased by Prince William of
Prussia, and eventually ended up in the grand ducal collection in Darmstadt.
Soon after its discovery, this picture was judged by most scholars to be the
authentic Holbein, a claim vigorously contested by admirers of the Dresden

version. After the debate became increasingly heated in the 1860s, an exhibition of the two works was held in Dresden in 1871, which was widely discussed in art journals and elsewhere. A few writers, such as the psychologist Gustav Fechner, tried to argue that since both pictures were beautiful, the question of attribution was not of great interest. But most of the historians and museum officials involved in the controversy jumped at the chance to display their professional expertise. When the Darmstadt version was finally accepted as an authentic Holbein, the legitimacy of the experts' claims to control over museum policies seemed vindicated. Putting an artist rather than a scholar in charge of a museum, remarked Alfred Woltmann, a leading participant in the controversy, was like making a pregnant woman rather than a physician head of a maternity clinic.[97]

In some instances, public dissatisfaction with museum management led to hostile parliamentary interrogations. The director of the Dresden gallery was taken to task in the Saxon Landtag because he had not bought a work by the highly popular historical painter Carl Piloty. Clemens von Zimmermann was harshly criticized in 1846 for selling off some 1,500 paintings from the Pinakothek's collections, including a few major works.[98] And, as we have seen, both Olfers and Usedom were attacked in the Berlin press and the Prussian Landtag for their various administrative and aesthetic errors. Museums, in short, while continuing to be run by a combination of court and state, now had to carry out their affairs in the light of public scrutiny and, on occasion, in the face of organized political protest. This certainly encouraged those responsible for museums to hire scholars upon whose competence and credentials they—and the artistically aware public—could rely.

The Campaign for a National Gallery

The German public had a particularly intense interest in the development of contemporary art. Although a few intellectuals may have accepted Hegel's bleak assessment that art's greatest days were gone forever, most educated Germans regarded the art of their day as culturally and perhaps even politically significant. As Rudolf Marggraff wrote in 1838, "The work of art not only reveals, it also stimulates and enlivens the spirit of the *Volk*, and thus becomes . . . a means of cultivating [*Bildungsmittel*] the national spirit."[99] To encourage German art in both its past greatness and present manifestations was to celebrate German culture and thus to encourage national consciousness, an essentially important step toward greater unity. Like music, literature, and other forms of culture, the visual arts helped Germans experience a national community whose political dimensions were still fluid and uncertain.

In the first half of the nineteenth century, the institutional basis for the public's involvement in the art world substantially expanded, especially through the creation of art associations (*Kunstvereine*), the era's most characteristic form of artistic organization. These associations, wrote Jacob

Burckhardt in 1843, "bring together friends of art to create more vital artistic interests and, at the same time, to provide artists the opportunity to display their work and also to support talented people with systematic artistic purchases." They had become, Burckhardt believed, "the most significant material support for painting."[100] Like the many other associations that began to appear in the 1820s, they provided an organizational basis for Germans' cultural aspirations, affirmed their social connections, and sometimes expressed their inchoate political ambitions.

The social composition and aesthetic emphasis of the various *Kunstvereine*—and here too they were like other contemporary *Vereine*—differed from place to place. The Bremen organization remained limited to fifty members of the city's elite until 1849; the one in Berlin was dominated by civil servants and professors and other notables, including the Humboldt brothers, Hegel, Schinkel, and Waagen; in Düsseldorf, the *Kunstverein* was closely associated with the Academy of Art, whose interests and tastes it helped further, the Munich association was more diverse and popular, with two to three thousand members by midcentury. Almost everywhere the *Kunstvereine* celebrated the universal value of art as a means of personal edification and social improvement; among their goals were the dissemination of knowledge about art, the elevation of popular taste, and the support of worthy artistic projects.[101]

Kunstvereine were frequently involved in the activity of museums—indirectly in cities such as Berlin, where their membership included museum officials as well as other opinion leaders, or directly in those urban centers where the association itself took the lead in establishing a museum. In Bremen, for example, the art museum was run by a local art dealer who lived on the ground floor of the *Kunstverein*'s headquarters, a handsome house in which its collection was displayed. The city fathers of Hamburg, whose desire not to fall behind other cities had led them to build an art museum in the 1860s, hired someone to take care of the practical details but left responsibility for policymaking in the hands of a committee comprising two representatives from the senate, city council, and *Kunstverein*. Both the Bremen and Hamburg museums were filled with the work of local artists and assorted gifts from association members.[102]

In the 1840s, the need to support contemporary German art became all the more pressing because artists seemed to be suffering the same structural crisis of oversupply that was affecting so many other social and economic groups. Cries for help from artists and their advocates were amplified by various national organizations whose members regarded the purchase of German art as both a patriotic duty and an essential contribution to the protection of the artistic community from proletarianization, the evil that contemporaries called *Künstlerpauperismus*.[103] In Düsseldorf, an association for the creation of an art gallery, founded in 1846 with the close cooperation of members of the local art academy, declared its intention of acquiring art "with lasting value and especially the works of modern German masters." The

Leipzig *Kunstverein* established the Museum der bildenden Künste to display contemporary works from its own collection.[104] Bavaria's King Ludwig, as noted earlier, also devoted increasing attention to modern art in the early 1840s, first by buying Klenze's important collection of contemporary paintings, then by beginning work on the Neue Pinakothek. At the same time, King Frederick William IV of Prussia, a much more enthusiastic patron of the arts than his father, established a small museum of contemporary art in the Schloss Bellevue in Berlin.[105] In 1843, Franz Kugler, head of the new art department in the Prussian Kultusministerium, prepared a long memorandum suggesting measures to relieve the current crisis in artistic production; among them, he proposed a "national gallery" of contemporary German art.[106]

During the Revolution of 1848, a group of German artists demanded a national gallery both to improve their economic position and to decrease their dependence on the direct patronage of the courts. A gallery devoted to the promotion of German art, they believed, would provide them with official recognition and state support, but its acquisition policies should be determined by a committee of artists and officials, not by a king and his advisers.[107] These aspirations were incorporated in a new memorandum that Kugler drafted in 1849, in which he reiterated the state's responsibility for encouraging art and protecting artists. "The formation and systematic expansion of a national gallery that would collect the works of the fatherland's contemporary masters," Kugler continued, should guarantee artistic autonomy and provide public support; in addition to reflecting current trends, it should also eventually attain what he called "monumental significance."[108]

The desire for a national gallery survived the revolution's defeat. Indeed, the failure of the revolutionaries to create a political foundation for German nationhood made the encouragement of German art seem all the more important. In the words of the men who organized an exhibition of German artists in 1858, "We want to establish in German art the unity that the fatherland cannot yet provide us. We want a national art and in it, national unity."[109] Many artists were convinced that a gallery devoted to German art would be a vital contribution to the development of national unity, and the project was officially endorsed by the Deutsche Kunstgenossenschaft, the new nationwide organization of artists founded in 1856. Over the next several years, artists and their supporters petitioned their governments to provide funds for a museum of contemporary German art.[110]

In the end, however, a German national gallery was created neither by reform bureaucrats such as Kugler nor by popular organizations such as the Kunstgenossenschaft but rather by a combination of private philanthropy and royal patronage. In 1861, Johann Heinrich Wilhelm Wagener, a prosperous Berlin merchant, bequeathed 262 paintings to the Prussian monarch, who, according to Wagener's will, was free to decide whether the collection should "develop into a national gallery that could display the full development of modern painting." King William, who had just formally succeeded his brother and was still enjoying the warm political climate of the "new era," accepted

Wagener's gift and had the paintings installed in the Berlin Academy of Art, where they remained while a new building was planned and constructed.[111]

Eventually, the National Gallery, designed by August Stüler and completed under the direction of Heinrich Strack, was built on what King Frederick William IV had planned as a forum behind Schinkel's Altes Museum. The building's axis pointed it directly toward the Rittersaal in the palace across the Lustgarten.[112]

Work on the gallery began in 1866, the year of Prussia's victorious war against Austria, and was completed in 1876, five years after the defeat of France and the formation of the German Empire. The gallery's inscription, "Der deutschen Kunst MDCCCLXXI," proclaimed both its dedication to German art and the link between national art and political unification. The central figure on the pediment portrayed Germania as patron of the arts; at the top of the ceremonial stairs on the facade was an equestrian statue of Frederick William IV (fig. 18). Inside, there was a frieze depicting German contributions to the arts. And in addition to the best works from Wagener's collections, the gallery displayed a number of pictures with patriotic themes, battle scenes, and portraits of important historical personages. In other words, every feature of the building was meant to celebrate the fusion of national culture, patriotism, and dynastic power which formed the ideological core of the German Empire.[113]

But the National Gallery was not only a shrine to German culture; it was also supposed to confer monumental status on contemporary artists. Its "principal task," wrote Karl Scheffler in his "critical guidebook" of 1912, "was to be for the art of the present what historical art museums are for the art of the past."[114] As Scheffler knew, this was easier to state than to accomplish; historical art museums, though by no means free from controversy, could base their decisions about what to buy and display on a well-established canon, whereas modern museums were subject to the shifting currents of contemporary taste, as well as to pressures from living artists and their patrons. From the beginning, those responsible for art policy in Berlin recognized that the National Gallery had to have a governance structure different from that of other Prussian museums. Consequently, its director (from 1874 to 1895, Max Jordan, an art historian) did not report to the general director of museums but was directly responsible to the Kultusministerium. Further, the gallery's acquisitions policy was determined by the *Landeskunstkommission*, an advisory committee formed in 1859 and dominated by representatives from the three Prussian academies of art. By the 1890s, these institutional connections with the artistic establishment would contribute to a series of bitter conflicts about the gallery's proper role in the formation of artistic policy (see chapter 4).[115]

Museums and Bildung

In the middle decades of the nineteenth century, the art museum became one of Germany's "representative organizations": that is, it organized objects,

FIGURE 18. National Gallery in Berlin from the southwest (1902)

people, and spaces to represent society's fundamental values, norms, and modes of behavior. Like the century's other representative cultural organizations—the concert hall and the university, for example—museums were closely tied to the theory and practice of *Bildung*, an untranslatable word whose range of meanings includes (and combines) formal education, aesthetic cultivation, and character formation. Rooted in the introspective sensibility of seventeenth-century German pietism, *Bildung* never entirely lost its spiritual overtones. In the course of the century, however, its connotations tended to become less spiritual and moral and more pedagogical and scholarly.

We can see this evolution in people's attitudes about the purpose of art museums. In 1835, Franz Kugler clearly imagined art's goal as moral when he wrote that viewing "the pictorial representations of worthy subjects" should lead "the *Volk* to a higher vision of life." Gustav Waagen believed that "the museum's primary and most important purpose" was "to advance the spiritual education of the nation through the experience of beauty"— the same aspiration that Schinkel had tried to express in his Berlin museum.[116] Increasingly, however, those responsible for museums began to focus on their educational mission. Max Jordan, for example, emphasized their historical task: "Even artworks that are meant to give us pleasure require that we be instructed by them." By their formation and organization, he believed, museums could teach their visitors how to compare works of art, see how artists expressed the views of different times, and understand their distinctive craftsmanship.[117] In 1875, Herman Grimm also talked about instruction (*Belehrung*) when he tried to define the museum's primary purpose: its "systematically arranged collections should be for the instruction of the *Volk* and the advancement of scholarly work."[118] To historians such as Jordan and Grimm, museums would contribute to *Bildung* not by giving people a sublime sense of beauty but by teaching them about the art of the past.

Bildung was a cultural category that had to do with morality and learning, but it was also a social category that had to do with the distribution of status and power. In all its various meanings, therefore, *Bildung* manifested that tension between universality and exclusiveness which lay at the core of nineteenth-century culture and society—the tension between the aspiration to have institutions that would be open to everyone and the structural inequalities that made these institutions inaccessible to all but a minority of the population.

Consider, for example, the social composition of the *Kunstvereine*, which were a characteristic institutionalization of *Bildung*. On the one hand, these organizations celebrated the universal value of art as a means of personal edification and social improvement; among their goals were the dissemination of knowledge about art and the elevation of popular taste. On the other hand, membership in a *Kunstverein* required material and cultural resources— money, leisure time, proper clothes and manners—which were available only to a small sector of society. The *Vereine*, therefore, offered members both the satisfaction of acting on behalf of universal ideals and the pleasure of being

with people like themselves, people with a similar style of life, values, and aspirations. The associations thus institutionalized "taste," which Pierre Bourdieu has defined as "what brings together things and people that go together."[119]

We find this same blend of universality and exclusiveness in nineteenth-century art museums, whose offer to provide public access to the treasures of the past was an example of what Bourdieu once called the "false generosity" of cultural institutions: supposed to be open to everyone, they were in fact limited to those who, "endowed with the ability to appropriate the works, [had] the privilege of using this privilege and who [found] themselves consequently legitimized in their privilege."[120]

As we have seen, the first museums attempted to formalize and broaden the public accessibility that had already been introduced in many eighteenth-century galleries. The Berlin museum, Altenstein wrote the king in 1830, must "provide an opportunity to experience art to the general public, without regard to social status or education." At about the same time, King Ludwig proudly wrote to Wagner that "the Glyptothek is now open to the people." Through an awakened sense for art, he believed, even "the dullest among the masses" could be enlightened and ennobled. One of the advocates of a new museum in Stuttgart told the Württemberg Landtag in 1833 that such an institution would benefit "artists, connoisseurs, and even the masses [*dem grossen Haufen*]." Many museum officials gave the public character of their mission a decidedly populist emphasis. Gustav Waagen, for example, believed that museums should provide an "aesthetic education" for the lower classes of society.[121]

We can see these aspirations in Karl Louis Preusser's 1881 painting of the Dresden *Gemäldegalerie* (fig. 19). Preusser depicts a socially diverse set of visitors enjoying the paintings on display in one of the large rooms in the Dresden gallery's east wing. The group includes men and women, adults and children, couples, families, and individuals; there are well-dressed members of the middle classes (such as the man and woman seated confidently on the central sofa), a military officer in one corner, and a woman in peasant costume in another. Two artists, one instructing a student, the other copying Murillo's *Madonna and Child*, underscore the enduring significance of the museum's treasures for contemporary art. Although they are viewing the works as individuals or in small groups, all the persons in Preusser's painting (except perhaps the uniformed guard on the stairs) are united by the common experience of art.

In practice, however, most museums did not live up to these populist aspirations. Visiting hours, for instance, were limited almost everywhere. Until the 1870s, the Berlin collections were opened Monday through Saturday on a rotating basis, which meant that the painting and sculpture galleries were accessible twice a week, from 10:00 A.M. to 5:00 P.M. in the summer, from 11:00 A.M. to 3:00 P.M. in the winter. On these days, as Gustav Klemm condescendingly noted, Berlin's art was available "for the so-called general

FIGURE 19. Karl Louis Preusser, *In the Dresden Gallery* (1881).

public, that is, for every peasant, barrowman, wagon driver, and so on."[122] The fact that the collections were closed on Sundays, the one day when many members of the "so-called general public" might not have to work, meant that few of them could take advantage of the opportunity. The Glyptothek was open only Monday through Friday morning from eight to twelve to those with tickets, and on Fridays from nine to eleven to everyone; through special arrangement with the director, "travelers" could gain access at other times. Elsewhere, museum hours were even more limited: in 1830, the collections in Karlsruhe were open to the public on Wednesdays from 8:00 to 12:00 A.M. and 2:00 to 4:00 P.M.; the new Kunsthalle was open every weekday morning from nine to noon during the summer, three days a week from 10:00 A.M. to 1:00 P.M. in winter.[123]

In addition to these formal restrictions, the organization and atmosphere of most museums discouraged casual visitors. Items were usually not well identified: in the Berlin sculpture gallery, each statue was labeled with a single word, which might have been enough for experts but said nothing to most general viewers. Catalogues, even when they were available to those who could afford them, presupposed more knowledge than most visitors could be expected to have.[124] Furthermore, there is some evidence that during those hours when the collections were open to the public, the staff was instructed to be especially alert for any infraction of the rules. In the Munich Alte Pinakothek, ordinary visitors were led through the gallery in groups. This was essential, as Dillis wrote in 1838, "to prevent mischief and . . . to protect invaluable objects from being vandalized by visitors who very often belong to the lowest classes of the nation."[125] Even Waagen, despite his announced populist views, was afraid that the wrong sort of visitor might damage a museum's treasures. In 1853, he warned the British against allowing small children and unkempt adults into their new national gallery, not only because such people would annoy other visitors (especially by their body odors) but also because of the harm done to paintings by "the exhalation of any large number of persons." Waagen's anxiety about the harmful effects on art of the lower orders' breath is a revealing expression of the limitations inherent in nineteenth-century culture's universality.[126]

In the course of the century, museums did gradually extend their hours, improve the labeling of their works, and publish more readily accessible guides to their collections. In the 1880s, Richard Schöne managed to open the Berlin museums on Sundays and attempted to have them remain open in the evenings.[127] But museum officials continued to view the general public with suspicion. A curator in Dresden commented in 1884 that on the days when admission was free, the museum was filled with people "who would have been better off somewhere else." Wilhelm Bode opposed evening hours because he did not think pictures could be properly seen in the artificial light eventually installed in museums; the only people likely to come in the evening, he believed, would be young lovers looking for a warm and quiet spot for a rendezvous.[128]

Unfortunately, very little is known about how many people actually visited nineteenth-century museums and even less about what they experienced there.[129] Artists, scholars, and connoisseurs were regular museum visitors; in most places, they could gain entrance outside of normal public hours. During the summer, the galleries were filled with tourists, whose numbers grew as more and more people had the means to travel and as travel itself became cheaper and easier. Guidebooks, their increased presence paralleling the growth of commercial tourism, listed the most important museums, their major works, and visiting hours. In wintertime, some galleries, which were usually cold and often dark, had few visitors. The director of the Kunsthalle in Karlsruhe, for example, believed that being open two hours a week during the winter was sufficient to take care of those who wanted to see the art.[130]

Some visitors, of course, responded to what they saw just as the first museum builders had hoped. One of these was the novelist Fanny Lewald, then an impressionable twenty-one-year-old from Königsberg, who remembered her first time in Schinkel's museum as a turning point in her life:

> Out of the hot spring daylight, away from the noise of the street, we . . . entered the cool, silent rotunda. . . . I had never seen a noble structure, never a work of sculpture, and it was as if I were suddenly in another world, a world of which I had only unclear inklings as from a distant homeland. . . . I enjoyed for the first time that spiritual liberation which I would experience so often in later years when I observed beauty.[131]

Friedrich Pecht recalled his first visit to the Glyptothek in much the same way: "The solemnity of this temple of art, where one was cut off from the profane external world and was exposed to a new, more noble one, naturally affected my sensitive feelings."[132]

But not everyone was so edified. Fanny Lewald's father, for example, tried to shield his daughter's eyes from the nude classical statues and spoiled their hurried tour of the painting gallery with critical comments about the immorality of the subject matter. Theodor Fontane's Effi Briest, who passes through Munich on her wedding trip, visits the Pinakothek, which she finds "wonderful but strenuous." She manages to avoid going "to the other one opposite, which I'm not going to mention because I'm not certain how to spell it." In fact, the Glyptothek does not seem to have been very popular; in photographs from the 1850s, the building has a run-down, neglected look. It may well have been, as J. M. Wagner bitterly remarked, that for most of the public the beer stein held more interest than the antiquities he had worked so hard to acquire. And according to Pecht, Munich's love for art was formed in the local *Kunstverein* rather than Ludwig's great museums.[133]

Thomas Nipperdey once defined art's place in nineteenth-century German culture by referring to the *Kunstreligion* of the educated public.[134] This is a useful metaphor, especially if we remember that religious experience comes in a variety of forms, ranging from mystical devotion to conven-

tional observance, from deeply committed piety to purely formal affiliation. The same variety was to be found in public attitudes toward art: for a few, it was a secular source of salvation; for others, an important but subordinate part of life; for many, the object of occasional edification. And the religion of art, like the theological sort, permitted deathbed conversions: in Rudolf Wilke's cartoon of 1907, the "Dying Münchner" promises his companion that if he survives this illness, he will most certainly visit the Pinakothek (fig. 20).

The nineteenth-century art museum, then, meant different things to different people. For some, it was a semi-sacred site in which to practice an aesthetic faith, perhaps with the fervor of the young Fanny Lewald, more often with a sense of social obligation. For scholars, it was an archive of historical documents with which the past could be reconstructed. And for practicing artists, of course, it was the key to becoming part of art history. Keeping in mind the multiplicity of purposes that the museum served for its several publics, we can now turn to the spaces in which its varied rituals of aesthetic devotion were enacted.[135]

III. Monumental Museums

Because architecture has the strongest ties to the past and the clearest aspirations to build for the future, Rudolf Marggraff wrote in 1838, it is the most monumental of the arts.[136] Architecture's ties to the past were everywhere apparent in nineteenth-century European cities, which themselves seemed museums of architectural styles, filled with buildings that evoked Greek temples, Roman baths, Gothic cathedrals, and Renaissance palaces. But these historical allusions should not obscure architecture's innovative energy and creative impulses. Behind the columns, arches, and spires with which they adorned their buildings, nineteenth-century architects deployed new materials and techniques in order to solve unprecedented structural problems and perform thoroughly modern functions. We find exactly this blend of tradition and innovation in the great museums that were constructed during the century's middle decades. For their design and decoration, their builders adopted styles from throughout architectural history. But however much the exterior of museums might recall the past, their functions were new. They were built not to be shrines for ancient gods or residences for princely families but rather to serve as official custodians of artistic treasures, sites of public enlightenment, and settings for scholarly research.

Architects and those responsible for museum management quickly became aware of the museum's distinctive character. Unlike Prince Ludwig, who had vainly searched for historical models for his Glyptothek, museum builders after 1830 had an increasing number of new structures that they could examine, critically analyze, and, when appropriate, emulate. Periodicals devoted to contemporary architecture discussed museum projects; eventually, architec-

FIGURE 20. "Schorschl, if I survive, I will definitely go to the Pinakothek."
Rudolf Wilke, *The Dying Münchner* (1907).

tural handbooks provided extensive treatments of museum types. Experts
debated technical issues connected with museum construction, especially the
persistently difficult question of how best to light paintings.[137] Between the
1830s and the 1880s, therefore, the art museum, like the nineteenth century's
other characteristic structures, became a clearly established building type,
with well-defined problems and generally recognized precedents.

The Alte Pinakothek

The most significant contribution to the creation of the museum as a building
type was Leo von Klenze's Alte Pinakothek in Munich, which Nikolaus
Pevsner regarded as "the most influential museum building of the nineteenth
century."[138] Although begun only a few years after the Glyptothek and under
construction at the same time, it had a very different character, in part because
it was designed for paintings rather than sculpture but mostly because it
reflected that shift in the intellectual climate—from Romanticism to histori-
cism—discussed earlier in this chapter. The Glyptothek, like Schinkel's

museum in Berlin, still reflected the aesthetic aspirations of the revolutionary age; the Pinakothek sang art's praises in a different key.

Built in an undeveloped area outside of the central city, not far from the Glyptothek, the Pinakothek stood alone in the middle of a large lawn, cut off from the surrounding streets by a low fence and bushes. The site itself had no representative function. Unlike the Berlin museum, the Pinakothek did not fit into an ensemble of buildings; unlike the Glyptothek (or the Fridericianum in Kassel), it was not meant to dominate a square. In fact, the location's chief advantages were practical: by being away from other buildings, the Pinakothek was less vulnerable to fire, its contents less subject to the noxious fumes, dust, and smoke that pervaded the urban scene. Moreover, the site enabled Klenze to orient the long line of the structure from east to west, thus maximizing its exposure to northern light. From the start, therefore, the Pinakothek's planners had the particular functional needs of a painting gallery on their minds.[139]

The building took the form of a flattened *H*: a long, rectangular central structure with short extensions on each end (fig. 21). The exterior's unifying features all ran horizontally: a smoothly rusticated pedestal on which the building rested, a lightly decorated string course separating the first and second stories, and a cornice around the roof. The most important exterior contrasts were not between the main and secondary elevations but rather between the first and second stories. There were no common vertical elements; on all four elevations, the ground floor was simpler and more restrained, the second more elegant and elaborate. From the south, the lower half of the building appeared to be the pedestal on which the second story rested, alerting the observant visitor to the subordination of all the other elements to the second floor, where the collection was displayed.

The south elevation, facing in the direction of the city center, was somewhat more richly decorated than the others: it had engaged columns (rather than pilasters) on the second story, a balustrade topped with twenty-four statues of famous painters, and a portico resting on four unfluted ionic columns. But in comparison with the Glyptothek or Berlin's Altes Museum, whose main facades dominated their design, the distinctiveness of the Pinakothek's south elevation had limited structural and symbolic significance. Furthermore, the south portico, unlike the entrance to the Glyptothek or to Schinkel's museum, did not establish the Pinakothek's *marche*; it led only into the ground floor, which had large, windowless storage areas and, around its perimeter, small rooms housing secondary collections.

The main entrance to the collection itself was a modest doorway on the east end, behind which was a staircase that led to the second floor. These stairs did not unify the interior space, as they would have done in a baroque building; nor did they connect the interior and exterior worlds, as did Schinkel's outer stairway in Berlin. Instead, the stairs brought visitors directly to the collections, isolating them from the rest of the building and focusing their attention on the experience ahead. At the top of the stairs, immediately before entering the gallery proper, visitors passed through an

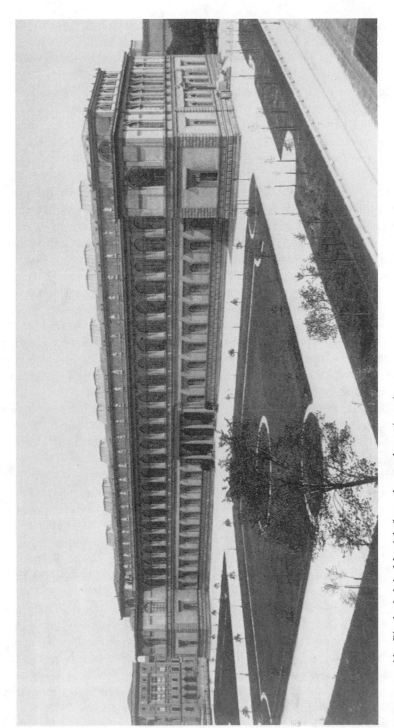

FIGURE 21. Alte Pinakothek in Munich from the southeast (1911).

imposing room that commemorated the Wittelsbachs' patronage of the arts. On the walls, which were elegantly covered with red damask, hung formal pictures of the six members of the dynasty who had built the collection on display, including a life-sized portrait of Ludwig himself in full court regalia. At the top of the walls, a frieze with fourteen medallions depicted historical scenes from the legendary beginnings of Bavaria in the seventh century to Ludwig's laying of the Walhalla's cornerstone in 1830. Here one could experience the museum as dynastic monument that established the Wittelsbachs' position in the state's history by celebrating their patronage of art and culture.

The dynasty's monumental presence in the Pinakothek was much more apparent than in the Glyptothek or Berlin museum. Nevertheless, like them, the Pinakothek's primary purpose was to be a monument to art. Its dynastic patrons' claims rested on the quality of the art they had acquired and on their willingness to share it with the public; it was to the ruling house's "magnanimity," according to the plaque on the cornerstone, that the people of Bavaria owed "this building and its treasures."[140] Like the other princes whose names were inscribed on the facade of nineteenth-century museums and whose pictures often adorned their entrances, the Wittelsbachs appeared on the threshold of their collection as generous intermediaries between the nation and the world of art. Once this role had been duly noted, visitors could pass through the yellow marble doorway between the Donors' Hall and the gallery and enter a realm over which beauty was the true sovereign.

The second story was divided into three kinds of space: a long loggia on the south side, twenty-three cabinets on the north, and a series of large rooms in between (fig. 22). Above the cabinets along the north side, Klenze added another story with a row of small display rooms. The overall interior design was determined by the size and character of the 1,400 pictures that Klenze and Dillis had selected from the Wittelsbachs' collections and then measured to establish the dimensions of the gallery. They arranged the pictures historically but also divided them by size, so that the smaller works would not be overwhelmed by the larger ones. The former were hung in the cabinets with a northern exposure, where they were lighted from the side; the latter were placed in seven interior rooms, lighted with skylights from above.

Unlike the Glyptothek and the Berlin museum, designed so that they revealed their spatial organization only after the visitor entered the building, the Pinakothek's exterior anticipated its interior: the elevations' columns and pilasters correspond to the divisions of the cabinets and loggia; the extension of the roof provided overhead light for the central rooms; the large windows on the south expanded the space of the loggia, and the smaller windows to the north were designed to light the cabinets.

Because he knew which works of art they would contain, Klenze was able to decorate the Pinakothek's exhibition spaces to match their contents, using scenes from the artists' lives, ornamental inscriptions of their names,

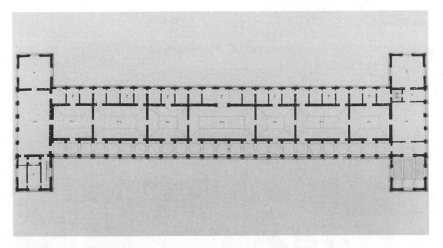

FIGURE 22. Alte Pinakothek in Munich: plan of the main floor.

or some abstract symbolic reference to their work or period. The most signi-
ficant interior decoration was in the loggia along the south side: a series of frescos
designed by Peter Cornelius and executed by Clemens von Zimmermann and
his assistants.[141] Each of the loggia's twenty-five compartments had a ceiling
picture, lunettes, and four portrait medallions (fig. 23). To fill these spaces,
Cornelius produced an elaborate scheme that emphasized the connection be-
tween art and religion—so central to the Nazarenes—and a poetic rendition
of art history which culminated in the central compartment devoted to
Raphael—upon whose Vatican loggia the whole project was based. The belief
that the development of painting had reached its high point with Raphael
was also expressed by Minister Joseph Ludwig von Armansperg at the cere-
mony marking the laying of the museum's cornerstone (which took place,
not coincidentally, on April 7, 1826, the anniversary of Raphael's birth): "All
the treasures gathered in this building point toward him, the spirit who has
created the noblest and most precious objects, who was superior to his pre-
decessors and will remain unsurpassed by his successors."[142] But in addi-
tion to depicting art history's master narrative, Cornelius established the
connection between past and present to which all monumental art aspired:
among the great artists and other heroes inhabiting his frescoes were to be
found a number of contemporaries, including King Ludwig, Klenze, and,
needless to say, Cornelius himself.

The Pinakothek became the model for several of the nineteenth-century's
most important museums. Constructed in some version of the Renaissance
style, these buildings were rectangular in form, with a second floor divided
into small cabinets with northern exposures and large central rooms lighted
from above. Perhaps the best example of the Pinakothek's influence was in
Gottfried Semper's Gemäldegalerie in Dresden, which was built between
1847 and 1855.[143]

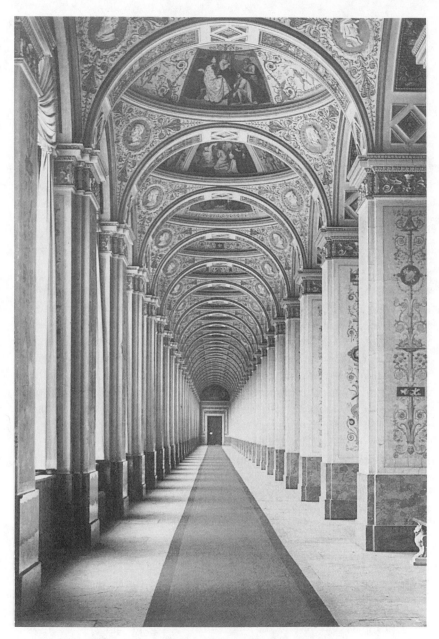

FIGURE 23. Alte Pinakothek in Munich: loggia.

The Gemäldegalerie in Dresden

Saxony's capital, one of central Europe's most dynamic cultural centers in the eighteenth century, had suffered severely during the Napoleonic period, from which the kingdom emerged territorially diminished and politically shaken. In 1830, widespread unrest ended the disastrous reign of King Anton, forced the government to introduce a series of reforms, and set up a regency for Prince Frederick August, who became King Frederick August II in 1836. Among the new ruler's attempts to enhance the dynasty's influence and popularity was a reinvigorated cultural policy, including plans for the construction of a gallery in which his extraordinarily rich collection of paintings could be displayed.[144]

In order to leave no doubt about its dynastic provenance, the gallery had to be part of the complex of religious and cultural buildings that clustered around the royal palace on the banks of the Elbe. Because of the difficulty of finding a proper site within this complex, the planning process took ten years, from the initial report of a special royal commission in February 1837 to the laying of the cornerstone in the summer of 1847. Two aspects of the long debate over the building's location, cost, and design are worth noting. First, it was institutionally more complicated than the planning process for earlier museums because all the elements of the nineteenth-century political establishment—including the monarch and his court, the bureaucracy, and the state parliament—were involved. Second, participants in the debate were well informed about the art museum as a building type; from the start, they recognized the particular problems of museum construction and the relevance of other museum buildings. At one point, for example, the royal master of ceremonies traveled around Europe gathering information about lighting, security, and conservation practices.[145]

Although its final plans were the product of a broad process of consultation and compromise, the Dresden gallery was primarily the work of Gottfried Semper.[146] Born in 1803, the son of a prosperous wool merchant in Altona, Semper had studied briefly at Göttingen, worked in an architect's studio in Paris, and then spent three years in Italy and Greece. Full of promise but with virtually no experience, he was appointed head of the technical school for the building trades and professor of architecture at the Dresden Academy of Art in 1834; he remained there until he was forced into exile following his involvement in the abortive popular revolt of May 1849. After six years abroad, Semper eventually found a position at the new technical school in Zurich, which he left in 1869 to oversee the construction of the cultural forum in Vienna. In the course of his long career, Semper designed many important buildings throughout Europe; his first commission, a small private gallery in Altona, and his last, the massive project in Vienna, were museums.

In addition to being an extraordinarily productive practitioner, Semper also wrote influential theoretical statements about modern architecture,

including a treatise on style in the "technical and tectonic arts" (of which only the first two volumes were published). In both his buildings and his writings, Semper personified the blend of innovation and tradition which characterized nineteenth-century architectural theory and practice. On the one hand, he was deeply interested in all sorts of modern materials and techniques. On the other hand, however, he recognized the importance of what he called *Bekleidung*, the stylistic dressing that was necessary to embellish all objects, including buildings. Like many of his contemporaries, Semper sometimes seemed to suffer under the imposing weight of architecture's past. He was, for instance, critical of "the flat and insipid affectations of the neo-Greek," as well as "the false coquettish romanticism of the neo-Gothic." But until modern culture came up with a "new idea of universal importance," modern architects would not be able to create a style distinctively their own. Meanwhile, he wrote, "[we must] reconcile ourselves to make do as best we can with the old."[147] For him, the best of the old turned out to be some version of the imperial Roman style, especially as it had been interpreted by the great Renaissance architects. This was the style that he used, following Klenze's example, for the Dresden gallery.

Even before 1838, when the royal commission instructed him to submit plans for a new museum, Semper had been working on a design for a cultural forum, which was to be composed of an ensemble of buildings between the Zwinger—a U-shaped set of exhibition buildings from the early eighteenth century—and the bank of the Elbe. His royal theater, constructed while the planning process for the gallery was still under way, was meant to be part of that overall design. Eventually, financial considerations compelled Semper to abandon his original idea of enlarging the forum with a gallery extending from the Zwinger's eastern elevation. Instead, he was compelled to place his building on the Zwinger's open northeast side, where it would serve as the fourth element of an enclosed square. The site required enormous tact. On one side, Semper had to relate his gallery to the delicate harmonies of the Zwinger, while on the other, he had to confront several important public buildings, including the austere neoclassical guardhouse that had been designed by Schinkel and built by Joseph Thürmer in 1831–1832.[148]

Semper accommodated the site by giving the building's north and south elevations subtly different decorative motifs. The north side had a restrained monumentality that fit with the palace, the royal church, Semper's theater (built between 1835 and 1841, destroyed by fire in 1869, then rebuilt between 1870 and 1878), and Schinkel's guardhouse (fig. 24). The south elevation, facing the Zwinger, was more elaborately decorated; in order to ease the visual transition, it had a second balustrade running along the top of the second-story windows beneath the cornice. As in the Pinakothek, the unifying elements in Semper's design ran horizontally: a rusticated ground floor, ornamented string course, and cornice with balustrades. But unlike Klenze's museum, the Dresden gallery was divided by a firmly articulated central pavilion whose three barrel-vaulted openings gave it the appearance of a

triumphal arch. This element also helped to adapt the gallery to its site: functionally, by providing an outside opening into the Zwinger courtyard, and visually, by associating the gallery with the gateway in the Zwinger's southern wing directly opposite it. This association of the gallery with the gateway, which was adorned with a crown that celebrated the high point of Saxon prominence in the eighteenth century, emphasized the new structure's dynastic connections.

The main entrance to the gallery was through a door inside the archway of the central pavilion. It led to a decorated vestibule from which visitors could either enter the ground-floor exhibition areas or ascend a flight of stairs to a splendid room dedicated to the collection's dynastic founders. Their symbolic presence at the beginning of the building's *marche* proclaimed the dynasty's role as patrons of the arts, just as in the Pinakothek. This *Stiftersaal* opened into a central octagonal space from which it was possible to move through a series of rooms organized around art history's master narrative: one wing was devoted to Italian paintings and culminated with Raphael's *Sistine Madonna*; an analogous series was devoted to other European painters and ended with the Madonna then attributed to Holbein.[149] Except for the central pavilion, the interior design resembled the Pinakothek: a largely separate ground floor, which was difficult to light and therefore only partially useful; on the second floor, a set of large interior rooms with overhead lighting and a row of smaller rooms along the north side; and, also on the north, a third-floor mezzanine.

Compared with the Pinakothek's restrained exterior, both main elevations of Semper's building had complicated decorative schemes. On the north, facing the river, were classical themes: the pavilion's cornice was topped with statues of the sculptors Phidias and Lysippus and the statesmen Pericles and Alexander the Great—a combination that once again expressed the museum's monumental aspiration to join past and present, art and politics. Along the facade and around the windows were medallions and figures from classical mythology. The decorations on the south elevation were even more elaborate. Once again, the figures on the pavilion established the central theme: across the top, statues of Giotto, Holbein, Dürer, and Cornelius evoked the Italian origins of painting and its finest German representatives; in two central niches above the arches, Raphael and Michelangelo personified the historical high point of European art. The pavilion also contained an inscription commemorating Frederick August's patronage of the gallery. Around the second-floor windows along the facade were representations of various religious scenes and figures that had provided many painters with their subject matter.

The interior decorations began by restating the building's monumental message. In the vestibule, visitors were immediately confronted with two long frieze reliefs, on one side depicting the history of painting in Italy from the middle ages to the eighteenth century; on the other, in Germany and the Low Countries, ending with contemporary artists and such royal patrons of

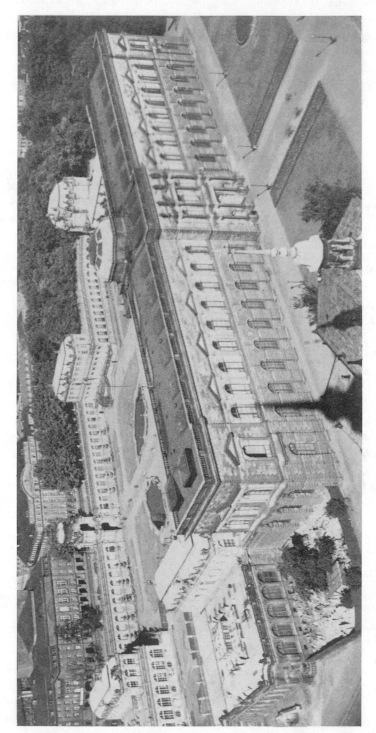

FIGURE 24. Gemäldegalerie in Dresden from the north.

the arts as Frederick William IV of Prussia, Ludwig of Bavaria, and Frederick August of Saxony. Ceiling paintings featured the emergence of Christian art from the ruins of classical civilization, and other religious themes. In addition to conventional artistic subjects (allegories of the seasons, the muses, gods and goddesses), the main exhibition rooms on the first floor—devoted to Correggio, the Venetian masters, Rubens, and others—were decorated with pictures particularly appropriate to the masterpieces they contained.[150]

The Pinakothek and the Dresden gallery were meant to be experienced quite differently from either Klenze's Glyptothek or Schinkel's Berlin museum. In the Glyptothek, as in a baroque gallery, the visitor was led through a series of separate but interconnected spaces that flowed into one another; in Berlin, Schinkel's rotunda established a central space, hidden from the outside and separated from the rest of the interior, which isolated visitors and prepared them for the aesthetic pleasures to follow. The Pinakothek and Gemäldegalerie, by contrast, had neither spatial unity nor a structural center. They provided the visitor with a series of separate experiences, each significant in itself but distinctive in character. The layout of their exhibition spaces made this separation possible by allowing visitors to move from one room—and thus from one school of painting—to another without having to follow the whole sequence of art history. The buildings' fundamental unity, therefore, came less from their architectural design than from the arrangement of their contents and their decorative programs, which established the historical narrative and political values around which their collections were organized.

The Kunsthistorisches Museum in Vienna

In 1869, almost thirty years after he began work on the Dresden gallery, Semper became involved in building two new museums in Vienna. They were part of the great urban development project begun in 1857 when Emperor Franz Joseph decided to replace the fortifications surrounding the old city with a ring of public and private projects. The scale and complexity of this undertaking, together with the fact that it was pursued against a backdrop of severe international and domestic upheaval, made the entire Ringstrasse enterprise politically charged and aesthetically contentious. By the time Semper joined those planning the museums, the selection of their exact site and style had sparked a bitter feud among Viennese architects, bureaucratic agencies, and court factions, each group with its supporters and opponents in the press.[151] The final decision belonged to Franz Joseph, who read Semper's report, met with him twice, and eventually gave him the commission, on which he was assigned to work with Carl Hasenauer, a young Viennese architect. Even by nineteenth-century standards, the construction of the Kunsthistorisches Museum took a long time; it was not formally opened until 1891, three decades after the first plans were proposed. Semper was mainly responsible for the building's exterior, on which he worked until 1877. Then, his rela-

tionship with Hasenauer having become impossible, he left Vienna for Rome, where he died two years later.[152]

Set in a square between the Hofburg and the old court stables, Hasenauer and Semper's museum occupied a centrally important space in the Ringstrasse complex. Originally, Semper had planned to link this site to the Ringstrasse itself with a triumphal arch, by means of which, as Carl Schorske has written, he wanted to assert "the symbolic preeminence of the imperial principle over the *bürgerliche* space beyond."[153] In some ways, therefore, Semper's plan recalls the way Schinkel sited his museum in the Lustgarten, which also honored art by associating it with monarchical power. Yet two significant differences are immediately apparent. First, Semper did not make the same claims about art's special place in culture. His museum not only contained things other than the fine arts (for example, the Hapsburgs' collection of weapons); it also shared its space with a museum of natural history, which occupied a parallel position across the square. Second, the museum site in Vienna lacked the cohesion of Schinkel's Lustgarten; although it was clear enough that the museums were public extensions of the imperial collections, their relationship to the other public buildings on the Ringstrasse remained unresolved, both visually and symbolically.

The art museum building was a larger, grander, more ornate version of the Dresden gallery: rectangular in form, it had two end pavilions and a central pavilion with three arched doorways. Unlike the arches in the Gemäldegalerie, however, these doors were the museum's main entrance, opening into a foyer and a grand central staircase around which the interior space could be organized (fig. 25). And Semper's decorative scheme, like the building as a whole, was significantly more elaborate. Each exterior wall was divided into three zones: the "material" (decorations illustrating the technical arts), on the ground floor, "cultural-historical" (historical scenes) on the main story, and "personal" (statues of artists, poets, scientists, and other men of genius) on the roof. Each elevation was devoted to a particular historical era: the ancient world, the Middle Ages, the Renaissance, and modernity. Not surprisingly, the Renaissance was given the most prominent position, on the main facade facing Maria Theresa Platz.[154]

Monumental Decorations

In most of the German art museums built between the 1830s and the end of the century, an elaborate system of decoration contributed to the process of mediation which Hegel regarded as necessary for an understanding of art in the modern age.[155] Exteriors were embellished with statues, medallions, and, occasionally, friezes. Characteristically, entrance halls, main stairways, and sometimes also the ceilings of exhibition rooms were decorated with paintings and sculpture. In contrast to the decoration in a baroque or rococo building, these images and ornaments were clearly separated from the architecture; they were not supposed to ease the transition from one structural element to

FIGURE 25. Kunsthistorisches Museum in Vienna: main entrance.

another or to extend the building's interior space. Instead, they were affixed to the structure in order to help articulate its central purpose. Like the museum's catalogues (and the scholarship on which they rested), its decorations provided a framework within which art was to be seen and understood. According to an 1853 guidebook, Wilhelm von Kaulbach's murals in Berlin's Neues Museum were meant to be studied, not simply viewed.[156]

In some museums, the decorative frame was substantially broader than the collections themselves. For example, Kaulbach's murals—six large panels featuring scenes from prehistoric times to the Reformation, plus thirty-two smaller representations of different nationalities, historical portraits, and allegorical renditions of the arts and sciences—were an encyclopedic vision

of human culture and history which reached beyond the museum's own diverse contents.[157] Similarly, Theodor Grosse's wall paintings in Leipzig used subjects from Greek mythology and the Hebrew Bible to symbolize the range and diversity of human experience. With these allegories, wrote the museum's director, Max Jordan, Grosse intended "to set against the scattered impressions of a diverse collection the impression of a cohesive world of ideas and images, through which one can be reminded of art's highest purposes and which brings to a gallery of modern, genre paintings work done in a historical style as well as a monument to classical artistic genius."[158]

In most museums, decorations were designed to fulfill the primary function of all monumental architecture: to locate the building and its contents historically. We have already seen how the *marche* of both the Pinakothek and the Dresden Gemäldegalerie began with historical presentations of the dynasty's contribution to art. The Karlsruhe Kunsthalle was decorated with frescoes showing the development of the arts in Baden; in one of them, the ruling Grand Duke Leopold appeared in historical costume at the dedication of the Freiburg cathedral by his twelfth-century forebears—a characteristic expression of monumental art's aspiration to connect past and present.[159] A similar aspiration was evident in the frescoes that Edward Steinle painted for the main staircase of Cologne's Wallraf-Richartz between 1861 and 1864: four large panels showed the flourishing of art in the city during the Roman era, middle ages, early modern period (from 1550 to 1825), and nineteenth century; a series of smaller pictures depicted various aspects of Cologne society and culture.[160]

In contrast to the mythological statements about human destiny to be found in the Glyptothek and in Schinkel's scheme for the Berlin museum, the decoration of nineteenth-century museums usually emphasized the development and nature of art itself. (The most prominent exceptions were Kaulbach's murals in Berlin.) Sometimes, as in the loggia of the Pinakothek or Philipp Veit's frescoes in the Städel, the emphasis was on the connection between art and religion. Sometimes there were allegorical depictions of art's development: in Leipzig, Grosse represented architecture with Egypt, sculpture with ancient Greece, painting with Italy, and finally music—"the purest expression of the most comprehensive aesthetic sense"—with Germany.[161] After midcentury, a number of museum architects, following Semper's practice in the Gemäldegalerie, decorated the exterior of their buildings with the statues of great artists. In some places, these statues indicated the museum's particular strengths: in Kassel, there were statues of Rubens and Rembrandt, whose paintings were well represented in the collection. More often, however, the imagery suggested an ideal history of art. The Hamburg Kunsthalle, for example, which did not have an important collection of old pictures, nonetheless displayed on its exterior an array of statues and medallions featuring both past masters such as Bramante, Leonardo, and Michelangelo, and contemporaries such as Schinkel, Cornelius, and Rauch. Just as art historians had become more and more concerned with biographical studies,

architects used an "iconography of genius" to suggest art's evolution and achievements.[162]

The high point of the grand narrative of art history expressed in the museum's decorations was the Renaissance. We can see this clearly expressed in Carl Gehrts's *Art of the Renaissance*, which he painted for the staircase of the Düsseldorf museum (fig. 26). The picture was by far the most vivid and dramatic of four panels on the history of art (the others represented imperial Rome, the Middle Ages, and the modern era). *Art of the Renaissance* shows two groups of painters and their patrons standing on either side of an enthroned personification of Ecclesia; on the left are Titian, Michelangelo, and Leonardo with Julius II; on the right, Vischer, Lucas Cranach, and an unidentified princely patron stand behind Dürer and Raphael, whose joined hands form a bridge between Italian and German artistic greatness.[163] The composition of the painting clearly evokes Renaissance models, especially the representation of famous figures from different eras in masterpieces such as Raphael's *School of Athens*. At the same time, Gehrts's painting suggests the iconographical flexibility of the Renaissance, which could be used to glorify church and state, classical and Christian values, German Protestantism (Dürer) and Italian Catholicism (Raphael). Above all, Gehrts captures the two fundamental ideas upon which the monumental museum was based: the aesthetic superiority of sixteenth-century art, and the necessary connection between artistic greatness and political patronage.

In the second half of the nineteenth century, the Renaissance replaced the ancient world as the most popular model for public buildings; after 1870, as Theodor Fontane wrote, "the world of the Renaissance dislodged Schinkel's world."[164] Originally developed to legitimate the wealth and cultural aspirations of Italy's new urban elite, then turned to the service of emergent absolute monarchies, the Renaissance style naturally lent itself to a wide variety of uses. It could be the basis for administrative offices and royal palaces; it could be progressive and bourgeois, or conservative and aristocratic. It might express the cultural ambitions of prosperous merchants, as in Hamburg, or the achievements of a dynastic family, as in Dresden. It could be adapted to a public institution, such as the Pinakothek, or a private residence, such as Klenze's Leuchtenberg Palais. Museums, libraries, universities, post offices, banks, and villas could all be built in a Renaissance manner. The style seemed to fit everywhere, to be equally at home next to Pöppelmann's Zwinger or Johann Fischer von Erlach's palace in Vienna. In short, when the nineteenth century aspired to build a monumental architecture that could celebrate and dignify all sorts of political, economic, and cultural attainments, the Renaissance offered the perfect source of inspiration.

The source of the Renaissance's popularity in the nineteenth century was a powerful sense of kinship, what Julius Meyer, the art historian who was director of paintings at the Berlin museum, called the period's "inner connection with the assumptions of our age."[165] The Renaissance, Semper wrote in 1852, stood at the beginning of the modern era because it experi-

FIGURE 26. Carl Gehrts, *Art of the Renaissance* (1887).

enced "that emancipation of forms whose lasting consequences are modern art's only vital principle." Adolf Bayersdorfer went so far as to write that "we now live in the final stages of a great historical epoch, that is, of the Renaissance." Even Jacob Burckhardt, who regarded the Renaissance as a distinct historical epoch whose "brief splendor" was gone forever, called the Italians he studied in his classic *Kultur der Renaissance* "the first born among the sons of modern Europe."[166] Like the nineteenth century, the Renaissance was an age deeply concerned with history; in both, culture was defined by people's engagement with the past. It was then, Burckhardt once remarked, that architecture voluntarily expressed itself in a foreign language for the first time.[167] Coming to terms with the language of the past was, as we have seen, the principal task facing every nineteenth-century architect.

If, as Rudolf Marggraff maintained, architecture was the most monumental of the arts, then the art museum was the most monumental of building types. Museums, of course, were monuments *to* the past, whose significance they proclaimed in the ample grandeur of their design and the evocative splendor of their ornaments. The museum's exhibition space, library, restoration workshop, and publications were all organized to conserve, venerate, and explicate the history of art. But museums were also monuments *for* the future, built both to celebrate their patrons' power, wealth, and generosity and to manifest contemporary culture's aesthetic sensibilities and scholarly achievements. Essentially, the monumental museum proclaimed the connections between the present and the past, between modern culture and its historical heritage, modern rulers and their ancestors.

There were similar attempts to make such connections throughout nineteenth-century culture, in history books, painting, opera, festivals, and scores of other monumental ventures. The museum, however, was such a vivid expression of these broader cultural themes that it quickly became a target of the cultural critics whose work began to reshape the established art world in the century's last decades.[168]

4

MUSEUMS AND MODERNISM, 1880–1914

THE NINETEENTH-CENTURY MUSEUM RESTED UPON THREE assumptions about the nature of art: first, that painting and sculpture, like poetry, architecture, and music, belonged to a particular category of experience defined as "art"; second, that art should be seen and understood historically; and third, that from the contemplation of art's history, people would receive both moral instruction and civic virtue. In the century's last decades, however, these assumptions came under increasing attack from artists, intellectuals, and public figures. Critics found the monumental museum's definition of the fine arts too narrow to contain the variety of possible aesthetic experiences; they questioned the utility of the conventional narrative of art history as a basis for organizing museum collections; and they became increasingly skeptical about whether the museum's presentation of "art" was actually playing the moral and social role it had been assigned.

These criticisms of conventional views of art and art museums must be seen in the light of the changes in institutional scale that were taking place throughout the German art world. In the late nineteenth and early twentieth centuries, the number of practicing artists dramatically increased, as did the number of exhibitions and the quantity of works they displayed, the number and size of museums, galleries, and private collections, and the variety of intermediate institutions that were founded to promote an interest in art.[1] At the same time, the art world expanded by becoming both more international and more regionally dispersed; German artists and art critics looked for support and inspiration not only to London, Paris, and New York but also to Hamburg, Darmstadt, Bremen, and Hagen. And despite the frequently expressed contemporary lament that there was no public for art, more Germans than ever before bought art objects, subscribed to art periodicals, belonged to artistic associations, and visited galleries, exhibitions, and museums.

This chapter begins by examining the impact of art's expanding horizons on the foundational assumptions of the monumental museum. Then we turn to the museum's changing institutional role within the art world. Finally,

we will conclude by tracing the effects of these ideas and institutions on the design of the spaces in which art was displayed.

I. Critiques of a Museum Culture

The most radical critics of the nineteenth-century art world traced its problems to the taproot of modern aesthetics: the concept of artistic autonomy. Kant and Schiller had regarded this autonomy as the source of art's spiritual power, and Schinkel had used it as the principle around which to organize his great museum in the Lustgarten. But just after the turn of the century, the writer and critic Julius Meier-Graefe argued that art's autonomy had led to its marginalization. The great philosophical advocates of aesthetic freedom, Meier-Graefe wrote, forgot that freedom always has its price: "In her impulsive vehemence, art cast away the elements that made her indispensable to man. The vaster the wide ocean of unbounded aims before her, the more distant was the terra firma which had been her home. She lost her native land."[2] To find a new home for art was the central task confronting the German art world during the quarter-century before 1914.

Nietzsche and the Problem of Art and Life

Let us begin our consideration of this quest with Friedrich Nietzsche (1844–1900), whose ideas were as important for the art world of the early twentieth century as Hegel's had been for nineteenth-century historicism. Like Hegel, Nietzsche is most often approached retrospectively, along one of the several mine shafts through which his disciples have extracted the rich and malleable ore from his philosophy. For our purposes, it may be more useful to begin from the other direction: that is, by examining Nietzsche's relationship to the founders of modern aesthetics. From this perspective, we can recognize not only what separated the great iconoclast from his predecessors but also how he remained part of a continuing German discourse about art.[3]

Consider, for example, Nietzsche's relationship to Kant. In a well-known passage in *The Genealogy of Morals*, he criticized Kant for basing his theory of art on the spectator rather than the producer—and thereby called into question the perspective from which modern aesthetics began. Kant's emphasis on the spectator was especially unfortunate, Nietzsche argued, because Kant had no notion of how people actually experience art; instead of recognizing the desires and delights that shape this experience, Kant was content to describe the appreciation of beauty as disinterested—as if, Nietzsche mischievously added, it were possible to look at the statue of a naked woman "without interest."[4] But although Nietzsche gently ridiculed "the country parson's naiveté" that characterized Kant's approach to art, he shared with him—and with the mainstream of classical German aesthetics—two important premises. First, like Kant, Nietzsche believed that the object of aesthetic

analysis should be the psychological origins and effects of art—in the consciousness of both maker and spectator. Second, also like Kant, Nietzsche viewed art not as an end in itself but rather as a way of acquiring knowledge—although, of course, the two philosophers differed dramatically about how and what art helps people to know.

Like Winckelmann and several generations of German classicists, Nietzsche turned to ancient Greece for the source of his aesthetic theory, and, like them, he contrasted the power of Greek culture with its feeble modern counterpart. The Greeks, he wrote in *The Birth of Tragedy*, set standards that no one else could meet; they were like "the charioteers for our own and every culture, but they find the steeds and carts of inferior stuff, insufficient for the driver's glory, so they take delight in driving the team into an abyss—over which they, with the agility of Achilles, leap to safety."[5] Obviously, Nietzsche's Greece was not Winckelmann's. Instead of the land of harmonious beauty that had been so perfectly captured by the great sculptors of the golden age, his Greece was the home of dark, primitive rites of which only a few faint traces remained. This was the Greece inhabited by the followers of Dionysus, whose energy and passions were shaped but not yet smothered by the formative powers of Apollonian reason. Just on the threshold of what most of his contemporaries regarded as classical culture, Nietzsche found his ideal of art in the music and dance of the early chorus, where the distinction between performers and audience, individuals and community, art and life had not yet made its appearance.[6]

Against his own vision of the ancient world, Nietzsche, like Winckelmann, Schiller, Hegel, and many others, set his analysis of what was wrong with contemporary culture. In contrast to the chorus with its life-enhancing art, we moderns resembled the Alexandrine world of theoretical reflection and scholarly classification. "Our modern culture [*Bildung*]," he wrote (in "The Use and Disadvantage of History for Life"), "is not a real culture at all, but rather a kind of knowledge about culture." Expensive veneration of monuments merely disguised modernity's self-hatred; its motto seemed to be, "Let the dead bury the living."[7] There was no better symptom of this modern disdain for life than contemporary art, which collected and imitated the past without being able to create anything of its own. Modern painters, for example, filled with erudition, philosophy, and theory, were "the sons of a learned, tormented, and reflective generation."[8] And no wonder, since they spent their time inside museums, studying old masters, rather than outside, experiencing the beauty of nature and the painful joys of life.

For Nietzsche, the scholarly research and cultural monuments upon which nineteenth-century governments lavished so many resources were lifeless and irrelevant. True culture could not be created in the professor's lonely study; true art was not to be found in a museum's solemn halls. "I want to set against the art of artworks a higher art," Nietzsche declared in a fragment from 1881, "the art of inventing festivals."[9] Festivity, music, dance, and similar expressions of energy and community offered some hint of what

art could and must do, a glimpse of how art and life might fuse. This was, as he wrote in *The Birth of Tragedy*, the true lesson of Greek art: "Art saved their culture and through that the Greeks themselves—their life." The message of Dionysian art was that "despite fear and pity, we are joyously alive, not as individuals but as part of a living being with whose procreative powers we are fused."[10]

During the last, sad decade of his life, when he was totally incapacitated by mental illness, Nietzsche's influence spread across the intellectual landscape, from the expressionists ("Die Brücke," the name taken by a group of avant-garde painters, is thought to come from a passage in Nietzsche's *Zarathustra*) to patriotic advocates of a true "German" art, architectural modernists, and educational reformers.[11] Even more than that of most influential thinkers, Nietzsche's appeal came from the way his ideas could be used to support a variety of aims. But almost all his diverse disciples took from his work two closely connected convictions: first, that the established art of the nineteenth century had failed; second, that this failure had left an unhealthy fissure between art and society. The problem to which Nietzsche's followers devoted themselves, therefore, was how to find a way of bridging the gap between artists and their public, aesthetic experience and society, art and life.

Among the first and most widely read attempts to use Nietzsche's ideas to analyze the problem of art and life was Julius Langbehn's *Rembrandt als Erzieher* (the title, "Rembrandt as educator," evoked the third of Nietzsche's "untimely meditations," *Schopenhauer als Erzieher* from 1874).[12] Langbehn (1851–1909) was just the sort of reader Nietzsche had always feared: crude, opinionated, and badly educated, he turned Nietzsche's complex and often ambiguous ideas into leaden slogans and clichés. Nevertheless, when *Rembrandt als Erzieher* was published anonymously in January 1890, it was an immediate sensation; in the first two months after its appearance and even before it had received much public notice, the book was reprinted three times; over the next two years it went through thirty-nine editions. As remarkable as the quantity of its readers was their quality and diversity. Not surprisingly, Langbehn got a sympathetic response from the right-wing critics of modernity whose views he seemed to echo. But he was admired also by prominent journalists such as Friedrich Pecht, who reviewed *Rembrandt* in *Die Kunst für Alle*; the architect Hermann Muthesius, who continually cited the book in support of his reform efforts; and Karl Ernst Osthaus, one of Germany's leading patrons of modern art, who was inspired by Langbehn at a critical point in his own development.

Also among Langbehn's supporters were leading museum officials such as Richard Schöne, the director of the Berlin museums, and Woldemar von Seidlitz, the scholarly head of the art department in the Saxon Kultusministerium. Even Wilhelm Bode, whom Seidlitz had introduced to Langbehn, found some kind words to say about *Rembrandt* in an early and influential review for the *Preussische Jahrbücher*. Bode called Langbehn's book "a po-

lemic issued from the deepest springs of the German spirit" and went on to say that "in its clear presentation of our corrupted contemporary situation can be found clues for the necessary rebirth of German art and culture [*Bildung*]."[13]

That members of the museum establishment such as Schöne, Seidlitz, and Bode could be so sympathetic to Langbehn was all the more remarkable, considering that he had identified the art museum as a telling symptom of cultural decline. Just as a dictionary's disconnected columns of words cannot convey the essence of a living language, he argued, so the sterile rows of objects in a museum cannot express the meaning of artistic vitality. Museums "should not present the language of art in lifeless columns but rather teach its vital interconnections." In order for them to do so, he went on, art rather than scholarship must dominate their administration and design; only then will museums "serve the muse," who should appear with a lyre rather than a lexicon under her arm. If museums would stop allowing scholarship to shape their purposes, they could help to reestablish the connection between art and its own true source, which is "the nuanced variety but ultimate unity of our national character."[14] Rembrandt, whom Langbehn transformed into a quintessential German artist, could lead contemporary Germans back to this deep wellspring in the rich traditions and endless potential of their national soul.

Museums as Mausoleums

Nietzsche was certainly not the first thinker to point out the tension between cultural creativity and historical consciousness. Nor was Langbehn the first to suggest that museums were the tombs of lifeless art. In 1842, for example, Friedrich Theodor Vischer had called them "beautiful graves" and said they demonstrated the prominence of "collectors rather than creators."[15] But even though such criticisms of the art museum had a long genealogy, they had never been so widespread and intense as they increasingly became toward the end of the century.

"There is a great deal of dissatisfaction with museums," wrote Ludwig Pallat in 1906, "despite their brilliant development, about which there is of course a great deal of pride." Pallat was not an outsider like Langbehn, who attacked a cultural world in which he seemed to have no place. Rather, as former director of the museum in Nassau and, since 1898, an official in the Prussian Kultusministerium, Pallat was firmly rooted in the cultural establishment and thus provides a particularly convincing illustration of that mixture of anxiety and pride which attended the enormous growth of museums in the twentieth century. Like many of his colleagues in cultural administration, Pallat thought something was wrong with the relationship of museums and art to the public: "It is unfortunately true that in most great museums, the size and character of the exhibits exhausts visitors or encourages them to a quick and superficial tour."[16] In 1906, the same year that Pallat made

his disturbing assessment, Eugen Kalkschmidt prepared a pamphlet for the *Dürerbund* in which he deplored both the "the flight from museums [*Museumsflucht*]" by the apathetic or uneducated and the "disgust with museums [*Museumsekel*]" of the aesthetically sensitive. Looking back on these years before the war, Werner Weisbach, a Berlin collector with close ties to the museum establishment, remembered "what could be called a museum crisis."[17]

Although the reputation of museums was growing, Eberhard von Bodenhausen told his friend Alfred Lichtwark in 1901, and processions of tourists were filing past their collections, they would not enrich the culture: "Will such museum art make any changes in our fellow citizens' taste? Can these abstractions shape their cultural faculties? Do they have any connection at all with life?" The *Museums-Idee*, Bodenhausen concluded, was finished. Hermann Muthesius, architect and art reformer, looked upon museums as giant warehouses stuffed full of disconnected objects; to him, the idea that as such they could be a blessing for art was "one of the disappointments of the last century."[18]

Even those who were more sympathetic agreed that museums no longer met their founders' expectations. In a programmatic essay on the future of these institutions, Theodor Volbehr posed this question: "Since Goethe, we have sought to turn museums into the nation's educators, but what have we accomplished?" His answer was not encouraging: "For scholarship, for the recognition of the past, perhaps this and that; but for the present, astonishingly little." Museums had not inspired contemporary artists, who found little there to interest them; aesthetically sensitive visitors were repelled by the way objects were displayed; and, despite various efforts to make them more accessible, ordinary visitors remained oddly detached and unmoved by the masterpieces available to them. The general public, Volbehr reluctantly noted, was "remarkably cool" toward museums.[19]

If, as some had claimed, the museum was a modern temple of art, what happened there merely served to illuminate modernity's spiritual malaise. In their temples, wrote Max Osborn in 1905, the Greeks made contact with the divine, just as Christians found spiritual nourishment in their cathedrals. How different was the experience of the museum visitor, who "crosses the threshold of the great building with a sense of alienation and anxiety, then heedlessly rushes through the rooms." People were not drawn to museums by "love or inner compulsion"; they did not seek spiritual renewal or historical connection. They went, Osborn believed, out of a sense of duty, because they thought it was the right thing to do, something that would be good for them in ways they were unable to articulate.[20]

Some critics traced the museums' problems to their extraordinary institutional growth. In his survey of German museums, published in 1913, Valentin Scherer argued that they had become so large, their collections so heterogeneous, that they no longer conveyed any sense of order and harmony. The ordinary museum visitor was simply overwhelmed by all there was to

see: "Restlessly his eye races from one object to another in the crowded spaces, often captured by superficial things and overlooking what is significant, until he is finally totally exhausted."[21] Friedrich Naumann pointed to this kind of experience as the central paradox of the museum age: although more art was accessible to more people than ever before, it had become harder to see and understand: "The larger museums and exhibitions became, the more oppressive was the burden of art history for the individual visitor." Once thought of as visible histories of art in which people could experience the ebb and flow of beauty's development through time, museums were now exhausting reminders of history's burdensome weight upon the present.[22]

Among museum officials, many did look for ways to make their institutions more open and accessible, more aesthetically pleasing, and more culturally creative. They also helped establish organizations to educate the public about art, to support progressive movements in all the visual arts, and to encourage the advance of beauty in every aspect of life. Above all, they hoped to transform the museum into an instrument of cultural and artistic renewal and thus to struggle against the unhappy fact that, as Georg Swarzenski, the director of the Städel, complained in 1911, "artists and the public have never been so isolated from each other as they are today."[23]

New Definitions of Art

Some reformers believed that the only way to improve museums was to transform their collections completely. As early as 1852, Gottfried Semper had argued that most people found a historical art museum unintelligible because its contents were fragments torn from their original context. To reawaken people's sense of beauty and restore their taste, Semper recommended moving from "learned collections" to museums devoted to arts and crafts. That year he sketched an "ideal" museum with five departments, the first four each containing one basic element of the applied and fine arts—ceramics, textiles, wood, stone—and the fifth a combination of these four.[24] In 1864, Jacob Falke's important essay on "the contemporary question" of museums also called for a redefinition of the collections. Like Semper, Falke began with the assumption that traditional art museums had failed: "If the saying is true that 'by their fruits you shall know them,' then until now the usefulness of museums for popular education [*Volksbildung*] has been exactly zero." Museums, he went on, had to stop being "aesthetic soup kitchens for the culture-hungry public"; instead they should join the dynamic forces of knowledge and industry at work in modern society.[25] In other words, he wanted museums to be popular with the masses, but he also wanted them to have a positive impact not only on people's aesthetic sensibility but on their manufacturing skills.

Semper and Falke believed that art museums should take their inspiration not from the great historical collections of classical sculpture and European painting but rather from museums displaying both arts and crafts, such as

London's South Kensington Museum (now the Victoria and Albert), which Semper had visited soon after it opened in 1851, or Vienna's Museum für Kunst und Industrie, in which Falke was employed as a curator. Museums devoted to what was conventionally called "applied art" (*Kunstgewerbe*)— a range of old and new objects including textiles, glassware, ceramics, and furniture—became increasingly popular in central Europe during the last quarter of the century. Some of them—the Museum für Kunst und Industrie, the Kunstgewerbemuseum in Berlin, and the Museum für Kunst und Gewerbe in Hamburg—were imposing institutions with large collections; others remained relatively modest exhibits organized by local artisans.[26] In contrast to traditional art museums, they were designed to be practical, didactic, and popular. Their founders wanted to use them to improve the aesthetic quality and commercial potential of German products; they were supposed to teach people how to appreciate and emulate successful design; and they set out to appeal to a broad cross section of the population. "Even the common man," wrote Pallat in 1906, "who stands timidly and without understanding before the treasures of a great gallery, should be able to feel at home in this new kind of museum and to benefit from them."[27] In fact, it is not clear how much impact these museums had on "the common man." It is clear, however, that they influenced the way critics and artists thought about art—and therefore about art museums.

By the 1890s, an increasing number of critics and practicing artists had begun to question the conventional definition of the fine arts as it had been formulated in the eighteenth century. For instance, members of the *Werkbund*—an association of artists and craftsmen—were uneasy about the very word *art*, which they used sparingly and often in quotation marks: "art" as it had been traditionally defined—painting, sculpture and architecture— should *not* be separated from nor seen as superior to crafts such as glass-blowing, pottery, weaving, and woodworking. In aesthetic movements such as the *Jugendstil*, the German version of art nouveau, and in organizations like the *Werkbund*, people sought to reunite arts and crafts.[28] At the same time, there was a growing appreciation of the aesthetic and historical signi-ficance of textiles, ceramics, glasswork, and other crafts, which individuals began to collect and preserve just as they did paintings, statues, and antiqui-ties. Following this trend away from "the fine arts," the new law on artistic copyright that went into effect in 1907 did not distinguish between the fine and applied arts but regarded both as objects that were produced to give aes-thetic pleasure.[29] As we will see later in this chapter, in some museums, the works of artists and artisans were exhibited in ways that illustrated their aes-thetic commonalities.

Hermann Muthesius, who was a founding member of the *Werkbund*, viewed the reunification of arts and crafts as a way to overcome the malaise so convincingly described in Langbehn's *Rembrandt*. "Our cultured classes," Muthesius wrote, had ignored the work of craftsmen—"the indispensable foundation of the entire artistic condition"—and instead devoted themselves

to "what was presumed to be higher and purer in art." But this higher and purer art was "a phantom in the air," cut off from the earthbound realities of life. Like William Morris and others in the British arts and crafts tradition, Muthesius argued that skilled artisans, rather than so-called artists and their professorial defenders, could show how to restore art to its proper place in society; this is why he was convinced that artistic reform should begin with domestic architecture—"in the German house."[30]

Reformers not only called into question the traditional notion of the fine arts; they also undermined established ideals of beauty by praising the aesthetic achievements of so-called primitive art. For most of the nineteenth century, people had not viewed the products of tribal societies as art. Interest in such objects, insofar as it existed at all, was anthropological; tribal artifacts were displayed in ethnographical museums, not art galleries. But just as Nietzsche had been drawn to the primal vitality of the ancient chorus, many writers and artists began to turn to the visual art of primitive cultures because it had not been smothered by historical scholarship and theoretical self-consciousness. Muthesius, for example, thought one visit to an ethnographic museum sufficient to demonstrate that "almost all aboriginal tribes must be termed artistic"; their works showed that "the artistic instinct belongs to the elementary powers of mankind and casts a still more peculiar light on a time such as ours, which has left these powers to wither."[31] It was a matter not of imitating the style of tribal art, Hermann Obrist observed in 1903, but rather of creating art as primitive artists did, "unconsciously, genuinely, simply, naturally, without thousands of stimuli and distractions." And it was precisely tribal art's apparent simplicity and authenticity that so appealed to artists as different as Emil Nolde and Vassily Kandinsky.[32] After the turn of the century, some museum curators began to argue that the arts of Africa, the Americas, and the Pacific had the same value, and should be exhibited in the same setting, as canonical works from the West.[33]

New definitions of art and new standards of beauty had a powerful impact on the study of art history, whose origins were inseparable from both the system of fine arts and the classical ideal. By the 1880s, art historians themselves were becoming increasingly interested in the decorative arts, which some of them regarded as more fundamental and perhaps more authentic than the fine arts. "The pulse of an era," Heinrich Wölfflin wrote in 1886, could best be felt "in the minor decorative arts, in lines of decoration, the shape of letters, and the like."[34] In 1901, Alois Riegl, who had worked as the curator of textiles at the Museum für Kunst und Industrie before becoming a professor of art history at the university of Vienna, published his pathbreaking *Die spätrömische Kunstindustrie*, which examined the arts and crafts of the late Roman empire, a period that had not been part of the historical canon.[35] By 1910, Wilhelm Worringer was prepared to jettison not only the established historical canon but also the notion of *art* itself, which he regarded as a dangerous superstition: "Captured by this superstition, we are again and again caught up in the criminal attempt to reduce the multiplicity of phenomena to a single category."[36]

These historians no longer believed in the timeless relevance of the classical ideal. In 1888, Wölfflin noted in his diary, "Winckelmann [is] no longer possible—we do not recognize a single ideal. I simply don't believe in a single development that can be understood from one perspective."[37] Even Carl Justi, Winckelmann's biographer and great admirer, noted sadly the failure of his hero's aesthetic project. Aside from a few outstanding exceptions, Justi wrote, "the imitation of the Greeks did not, as Winckelmann hoped, make the moderns great and inimitable; rather it has brought us an art that is shadowy and only half-alive."[38] The Greeks remained historically important, their art valuable and interesting, but they had lost the normative power they had exercised over art history since the eighteenth century.

The new art historians did not lose interest in history, but they did reassess what history could teach them about art. Riegl, for example, doubted that a basic understanding of art's nature could come from the "ostensible development [*scheinbarer Wandel*]" of art history; instead, like many of his contemporaries, he turned to psychological categories—in his case, the abiding human drive to impose order on matter, which he called *Kunstwollen*.[39] Nor did Riegl believe that the study of history would produce those fundamental values against which art could be judged: "At the beginning of the twentieth century, most of us [art historians] have come to the conclusion that there is no such absolute art-value, and that it is pure fiction to consider ourselves wiser arbiters than were the contemporaries of misunderstood masters in the past."[40] With the weakening of the conviction that value could be found in the traditional view of history, the relativism that had always been coiled around historicism's heart was released. Where could a new source of value be found? The answer, some critics believed, was in a new conception of art and a new kind of art history.

A Modern History of Art

Modernity begins, Arthur Danto has commented, "with the loss of belief in the defining narrative of one's own culture."[41] In different ways and for different purposes, philosophers such as Nietzsche, historians such as Riegl, and reformers such as Muthesius undermined the defining narrative that had traced the history of art in the accomplishments of its great sculptors and painters from ancient Greece to the eighteenth century. But the creation of what Danto called "modernity" required more than a crisis of faith in the normative power of this grand narrative; no less important was the formulation of something to take its place, a narrative that could explain art's contemporary character and establish contemporary values. Modern art, therefore, required a modern art history.

Critics and historians had always had trouble extending the grand narrative of art history into the present; Winckelmann, for instance, never explained how imitation could lead to originality. In this important respect, the history of art differed from other versions of nineteenth-century historicism, which

were firmly anchored in visions of the contemporary world. For instance, in his three-volume *Geschichte der neueren deutschen Kunst* 1835–1841, Athanasius Count Raczynski, a leading collector and connoisseur of contemporary art, was unable to connect the living artists he admired with their predecessors; despite its title, Raczynski's *Geschichte* is a remarkably unhistorical work.[42] And like Raczynski, most historians of art left a gap between their accounts of the past and the present. Anton Springer began his *Kunsthistorische Briefe* (1857) by characterizing of his own "artistically impoverished time" as one in which art had "a depressed, shabby existence that is far from the brilliance of the past and from the universal significance it had achieved in previous ages." Although Springer's book provided a sweeping narrative of art from its origins in prehistoric times, it ended abruptly in the seventeenth century, when, the author rather vaguely suggested, the modern period began.[43] "We are very much at home," wrote Rudolf Marggraff in 1838, "when it comes to evaluating the artistic products of the past, but all our standards desert us when we must talk about the art of the present day."[44]

Beginning in the 1890s, a number of German writers sought to formulate a history of art that could help them understand the "art of the present." Among the first and most popular of these new histories was Richard Muther's *Geschichte der Malerei im 19. Jahrhundert*, which appeared in 1893–1894. Muther, who taught art history at Munich and then Breslau, was a somewhat unsavory character with occasionally unreliable tastes, an excessive interest in the erotic, and the unfortunate habit of borrowing other people's prose. But he had a good eye for artistic innovation and, unlike many German critics, had traveled widely and knew about recent developments throughout Europe. Muther was a confirmed opponent of the classical ideal: "Every great artist since Giotto has been great despite, rather than because of, antiquity." Classicism, together with the whole weight of past art, had alienated the modern artist from his own world and cut him off from true creativity. It was maintaining this unhappy condition of dependence and estrangement that traditional art history had seen as its essential task. Muther wanted his history of nineteenth-century art to emancipate artists from false models, break the power of the academy, and restore artistic vitality and originality. Modern art, he argued, must make its way "from historical and genre pictures to painting, from stylistic imitations to natural observation, from antiquity to life, from abstraction to character, from the typical to the individual, from epigone to independence, from classicism to the classic, from the schools to personality." His history, therefore, would be a guide on a long and difficult journey leading not toward the re-creation of past greatness but toward what Muther regarded as the century's greatest goal: "the recovery of art on its own terms and the creation of new art."[45]

A more substantial and ultimately more influential attempt to produce a history of artistic innovation was Julius Meier-Graefe's *Entwicklungsgeschichte der modernen Kunst*, first published in 1903. An industrialist's son who had enough money to live well without regular employment, Meier-Graefe

wrote novels, collected art, ran a gallery, edited periodicals, and produced a series of important critical and historical works on contemporary art. Intellectually, he belonged to the generation that was most powerfully and directly influenced by Nietzsche (his *Der Fall Böcklin* of 1905 echoed Nietzsche's *Der Fall Wagner*, just as Langbehn's use of Rembrandt had recalled Nietzsche's of Schopenhauer). Furthermore, in the range of his activities—author, critic, collector, dealer, journalist—and in the breadth of his international circle of collaborators, he personified the expanded art world at the turn of century.[46]

Like Muther, Meier-Graefe was critical of traditional histories of art because they contributed nothing to artistic creativity. Historians were "clever people," he acknowledged, but too concerned with biographical detail and cultural context; as a result, they had a lot to say about history, little or nothing about art. The past, Meier-Graefe believed, was important only because of its connection to the present: "Everything valuable being done today has its antecedents."[47] The historian's task was to examine these antecedents in a way that explained and promoted innovation. This meant reversing the relationship between past and present as it was conceived by most art historians: instead of trying to determine how what was being done in the present might compare with the great art of the past, historians should seek precursors for the best contemporary work. Meier-Graefe, therefore, focused his scholarly attention on artists such as Michelangelo, whom he saw as a great outsider, and El Greco, in whose work he found foreshadowings of modernity. More immediately, he traced the historical origins of modern art to the extraordinary achievements of French painting that began with Manet.

What mattered most to Meier-Graefe were not ideas about art's cultural significance or facts about an artist's life but rather those elements that he regarded as distinctively artistic; in painting, these were color, line, and form. By concentrating on the aesthetic dimensions of art, he could ignore traditional notions of the stylistic epoch, dissolve the grand classical narrative, and create a new history whose terminus ad quem was what he regarded as the best art of the contemporary era: impressionism.

This was the history that Meier-Graefe hoped would emerge from the important exhibition devoted to German painting from 1775 to 1875, held at the National Gallery in Berlin in 1906.[48] Meier-Graefe, together with the director of the gallery, Hugo von Tschudi, and other leaders of the art world, wanted this exhibition to initiate a new history of German art, one that would be based on aesthetic, "painterly" qualities and would point toward the best art of the present: that is, toward the German representatives of impressionism. In practice, the Century Exhibition (*Jahrhundertausstellung*) turned out to be more inclusive than Meier-Graefe had wished. Still, its antiacademic bias was unmistakable; in the words of one reviewer, the exhibition demonstrated that "the history of nineteenth-century European art is essentially the history of the secessionists, the history of the progressive struggle of individuals against the masses, of independents against the academies."[49] In short, if seen properly, the exhibition of 1906 was a visible history of the avant-garde.

Like many of his contemporaries, Meier-Graefe had deep misgivings about museums. "In itself," he wrote in 1913, "a museum is always a monstrosity, or at least so it seems to the layman." The condition of museums in Germany seemed to him especially deplorable: "In no other country does the kind of brutal hostility to art that occurs in our museums go unpunished." Nevertheless, he recognized that despite its many problems, the museum was an essential part of the modern art world, the inevitable replacement of traditional dynastic and religious patrons of the arts, the place where scholars, artists, and the public could experience the full range of the past's artistic treasures. But if they were to play their proper role, Meier-Graefe argued, museums must be taken away from the bureaucrats and put in the hands of artistically sensitive leaders such as his friend and collaborator Tschudi, whose early death provided the occasion for these remarks. Meier-Graefe was not at all sure, however, that the progressive forces personified by Tschudi would prevail; at that moment, the bureaucrats, led by the most powerful figure in the museum world, Wilhelm von Bode, clearly had the initiative.[50]

II. Museums in an Expanding Art World

Despite the criticism and self-doubt that surrounded museum culture, museums themselves flourished in the years before 1914. Gustav Pauli, the director of the Bremen Kunsthalle, remembered this period as a "a new epoch in the construction of our museums," which grew "like mushrooms" all over Germany. As in the past, their growth was fueled by competition between local authorities, which became, in the words of one contemporary, "almost like a sport." In the eighteenth century, princes had competed with one another; in the nineteenth, no state worthy of the name could be without a museum; in the early twentieth, as Theodor Volbehr remarked in 1909, "museums are established in every city, indeed in every village." That same year, Fritz Wichert, the director of the newly opened Mannheim Kunsthalle, declared that "every city has the moral obligation to bring people the values of high culture."[51] Even though no state or local government devoted more than a small portion of its income to fulfilling this obligation, in the prosperous prewar years, this was enough to support an impressive program of construction and expansion. In 1906, the Prussian budget for museums was 2.6 million marks, plus another 350,000 for special purchases. According to one estimate, 210 museums were built in Germany between 1900 and 1920—almost as many as in all the preceding century.[52]

Some of the new museums were exclusively devoted to the fine arts; some, following the model of the South Kensington Museum, combined arts and crafts; others emphasized art and artifacts that illustrated national or local history. In addition to these established types, museums were built to exhibit increasingly diverse collections from the realms of science and tech-

nology, natural history, and anthropology.[53] These had to be organized differently from the classic art museum yet retained much of the atmosphere and many of the modes of display to be found in the great nineteenth-century galleries.[54] Aesthetic reformers had hoped that by broadening the definition of art, they might reconnect art and life; instead, they seem to have expanded the number of things that might legitimately find their way into a museum.

Museums as Intermediaries

"Art," wrote Georg Malkowsky in 1912, "is, to be sure, not power, but it signifies power and becomes a political factor without surrendering thereby its own creative splendor."[55] What Malkowsky said about art in general was certainly true for art museums in particular: although they were not institutional centers of power, the determination of their organization and contents was an expression of power and thus necessarily a part of the political process.

Until the end of the German monarchies in 1918, the royal courts continued to exert some influence over art museums. If the ruler himself had an interest in art, supervision of the museums became one of his functions; more often it was delegated to another member of the dynasty. The relationship between court and museum could be relatively untroubled: in Berlin, Richard Schöne got on well with Crown Prince Frederick; in Dresden, Karl Woermann usually cooperated with Prince Johann Georg, who represented his brother on the acquisitions committee. In Darmstadt, Grand Duke Ernst Ludwig generously supported the arts and supervised the construction of an important new museum. Crown Prince Rupprecht of Bavaria, the most aesthetically sensitive Wittelsbach since Ludwig I, helped to promote modern art in Munich.[56] Emperor William II, as difficult as he could be in matters having to do with contemporary art, vigorously backed the Berlin museums' aggressive acquisitions policy, not only with his own funds but also by encouraging generosity in others.

Yet William II and other monarchs could also be intrusive and disruptive. Even so reticent a man as Prince Regent Luitpold of Bavaria sometimes intervened on behalf of his cronies in the Munich artistic establishment. And, to cite one final example, there was the case of Grand Duke Wilhelm Ernst of Weimar, around whom Count Harry Kessler hoped to build a modern version of that state's golden age. Unfortunately, Wilhelm Ernst turned out to be narrow-minded and mean-spirited; after three years of reluctant support, he forced Kessler to resign his post as director of the Weimar arts and crafts museum in 1906.[57] That a man as sophisticated as Kessler could put so much trust in a patron as unpromising as Wilhelm Ernst shows that the dream of the court as a center of cultural renewal, which had captivated Goethe in the late eighteenth century, remained part of the German cultural scene.

Despite the persistence of courtly patronage, the relative importance of princes for German culture everywhere declined. As the art world expanded,

the influence of any single person, even someone with royal authority, necessarily diminished. And as museums of all sorts became larger and more complicated, it was increasingly difficult for any nonprofessional, no matter how well placed or powerful, to exert sustained control over them. Rulers, therefore, could occasionally interfere with but never persistently determine museum management. As was the case with many other institutions, the policies and practices of museums were shaped by the two most powerful forces at work in Wilhelmian Germany: the state and the market.

In the major German states, museums were usually under the jurisdiction of the Kultusministerium. Sometimes, as was the case with Saxony's Woldemar von Seidlitz, the official responsible for art policy might be a knowledgeable and effective collaborator with museum officials; elsewhere, as in Bavaria in the late nineteenth century, the ministry paid relatively little attention to the museums' day-to-day operations.[58] In every state, however, any significant new project, especially if it cost a substantial amount of money, would eventually engage a complex array of governmental agencies. In 1910, for example, Ludwig Justi's plans for remodeling the National Gallery had to have the approval of William II, the Kultusminister, the finance minister, the minister of public works, the war minister (because of some battle scenes Justi wanted to move), the general director of museums (even though Justi was not directly responsible to him), the general director of royal libraries, the commander of the arsenal—and of course, the Landtag, which had to approve the expense.[59]

Museum administrators and their ministerial superiors were still subjected to careful scrutiny and occasionally sharp attacks on the floor of the state parliaments. This was most likely to happen when the museum's acquisitions policy offended some influential sector of public opinion, but parliamentarians also complained about inefficient or ineffectual management.[60] Nor were municipal museums immune to political interference. In Krefeld, the city council became actively involved in museum policies when Catholics realized that the liberal city government planned to build a new museum on the site of their annual Corpus Christi procession. In Halle, the museum director was directly responsible to a ten-person committee that was chaired by the mayor and included local businessmen as well as the professor of art history at the university; at the same time, Halle's city council could use its control over his salary and budget to influence museum policy. The Hamburg Kunsthalle was governed by a commission whose members were selected by the senate, the city council, and the local Kunstverein.[61]

One should not overestimate the significance of these political pressures on art museums. Most museum officials got on reasonably well with the civil servants who supervised them; moreover, parliamentary interference was always sporadic and rarely decisive. Like the heads of most other administrative bodies, museum directors learned to live with—and, often enough, to make use of—these political forces. In practice, no German museum director had as much trouble with his political superiors as the heads of

Frankfurt's Städel Institute had with the small, self-perpetuating group of trustees to whom they were responsible. In 1893, for example, the trustees summarily dismissed Henry Thode, a distinguished art historian; ten years later, Ludwig Justi was forced to resign after a brief term when the trustees refused to support his plans for merging the institute with a municipal gallery. The situation improved somewhat under Justi's more politically adept successor, Georg Swarzenski, but the administration of the Städel did not run smoothly until the 1920s.[62] It is not surprising that most museum directors got along much better with civil servants, with whom they had a good deal in common, than with patricians such as the Städel trustees, who took a proprietary interest in the institution's day-to-day operations.

At least as powerfully as the courts, bureaucracies, and parliaments, the market defined the museum's place in the late nineteenth-century art world. The market's power is easy to overlook or underestimate; whereas the involvement of political institutions in museum affairs could spark public controversies and parliamentary debates, the market's influence was pervasive but silent. Nevertheless, it affected—and was, in turn, affected by—virtually every aspect of museum policy.

The art market, of course, had been in existence for a very long time, but its relative importance increased in the last decades of the nineteenth century as traditional sources of patronage and distribution declined. Fewer artists were being employed by a single patron; the role of academies in artistic training diminished; and the prominence of *Kunstvereine*, the most characteristic form of bourgeois artistic association, decreased. Most artists now sold—or hoped to sell—their works either directly from their studios or indirectly through a commercial gallery, annual exhibition, or auction.

As the art market's relative significance grew, the market itself became larger and more complex. The expansion of the art world was, more than anything else, a product of the expanding size and diversity of the market, with more and more people buying and selling an ever greater variety of things that could be defined as art. At the same time, the competition for historical masterpieces intensified, in part because of the growing demand from museums and wealthy private collectors (including the legendarily rich Americans), in part because of an absolute decline in the supply of major works which, once acquired by a museum or shipped across the Atlantic, were unlikely ever to reappear on the market. The buyers' market of the late eighteenth and early nineteenth centuries, in which patrons such as King Ludwig had been able to acquire large collections of classical sculpture and Renaissance paintings, was gone forever. For this reason if no other, the museums and the individuals who began to collect art at the end of the century had to look outside the established canon to find objects they could afford.

In so dynamic and complicated a market, most buyers, especially those who lacked the kind of experience and resources available to traditional patrons of the arts, needed experts to help them decide what was truly valuable: what sorts of carpets or pottery were worth collecting, what tribal carv-

ings had aesthetic interest, which living artists were doing significant work. As a result, a variety of institutional sources of knowledge and opinion developed to serve as intermediaries between art and its publics. Perhaps most significant were the commercial galleries that spread throughout central Europe toward the end of the century. Cassirer in Berlin (with a branch in Cologne after 1913), Richter and Arnold in Dresden, and comparable establishments in Frankfurt, Hamburg, Munich, and other German cities catered to their customers' personal interests and refined tastes. More flexible and open to innovation than the *Kunstvereine*, more specialized and discriminating than the overcrowded annual exhibitions, these galleries were ideally situated to alert their customers to interesting new artists or to help them locate and evaluate increasingly rare older works.[63]

In principle, commercial galleries and museums belonged to quite different parts of the art world: the former sought to make a profit by turning art into a commodity, the latter to edify the public by preserving art in a sacred space. But in practice, the two were closely connected. Museum officials not only purchased more and more of their artworks from galleries rather than from the salons or exhibitions, they also cooperated with gallery owners in many other ways.[64] For example, when the Galerie Commeter held a show of contemporary art in Hamburg in 1900, Alfred Lichtwark, the director of the Kunsthalle, wrote its exhibition catalogue—the existence of which suggests the gallery's aspiration to be more than just a commercial outlet. When the Mannheim Kunsthalle opened in 1909, Fritz Wichert, its director, organized an exhibition of works borrowed from various dealers; in addition to the usual information, each label included the picture's price.[65] In most cities, gallery owners and museum officials moved in the same social world, attended the same auctions and exhibitions, and read—and sometimes wrote for—the same journals. Each reinforced the other's intermediary position in the art world.

By the turn of the century, wealthy private collectors were hardly less important for museums than for galleries. Like art dealers, museum officials provided these connoisseurs with information and contacts; moreover, powerful directors such as Wilhelm von Bode could bring collectors into high society and even get them honors and awards. In return, the collectors gave the museums money and eventually donated some of their best pieces—an essential source of acquisitions in an increasingly tight market.[66] Around the turn of the century, a number of museums institutionalized these relationships in museum associations (*Museumsvereine*), which provided their members with private lectures, guided tours, and public recognition of their generosity. In addition to paying a hefty annual fee, association members were supposed to help the museum take advantage of unusual opportunities to buy artworks that were not covered by the regular acquisition budget.[67]

These organizations were not just ways to raise funds; they were also supposed to create that educated, discriminating public for art which many museum officials feared had been lost. "It is the misfortune of our era," Hugo

von Tschudi once remarked, "that the small, sensitive public, with a sustained and intimate feeling for art, has disappeared and has been replaced by the broad masses who will scarcely ever develop an artistic culture and certainly never be able to recognize artistic genius."[68] In 1894, Tschudi joined Meier-Graefe, Max Liebermann, and several prominent museum officials on the editorial board of the journal *Pan*, an expensive, sumptuously produced, and vaguely modernist effort to improve the level of taste and sophistication among Germany's new commercial and political elites.

Some museum officials, however, wanted to broaden their appeal to include the masses as well as the elites. "Among the characteristic phenomena of the late nineteenth century," Gustav Pauli recalled, "was the insight that the . . . essential connection between art and the nation had been lost."[69] In 1903, a group of museum administrators met in Mannheim to discuss their institutions' role as "sites for popular education" (*Volksbildungsstätten*). No one believed anymore, one participant told his colleagues, "that museums are only supposed to serve scholarship or provide entertainment for tourists"; rather, they existed to provide the population with the aesthetic education that was essential for their happiness and well-being.[70] Museum leaders were well represented among the various art reform organizations that developed around the turn of the century: in 1913, the trustees of the *Werkbund* included ten museum directors. Many museums offered vacation courses for high school teachers, special lectures and tours for working people, and inexpensive guides to their collections. In the Mannheim Kunsthalle, Fritz Wichert established a library and print room that was opened to everyone; in addition, he sponsored three public lectures a week and an art association with 12,000 members.[71]

In the efforts of energetic museum officials to secure the material support of new elites and to expand their popular base among working men and women, one could see signs of the changing social dimensions of the German art world. From the middle of the eighteenth to the end of the nineteenth century, art's ideal public had been theoretically universal—even when it was practically restricted. The most manifest institutional expression of this public was the *Kunstverein*, which claimed to speak for and to all members of the art-loving community. We have seen a visual representation of this public in Karl Louis Preusser's portrayal of the Dresden gallery (reproduced in fig. 19). Both the plutocratic museum associations and populist organizations such as Wichert's Association for Art, however, signaled the recognition among museum officials that no such universal public existed. Instead, museums now had to serve members of many publics—courtiers and connoisseurs, scholars and dedicated amateurs, wealthy patrons and culturally ambitious workers—who came to them from different backgrounds and with different expectations.

For all its publics, the museum was an intermediary, a guide to the world of art in all its varied manifestations. In their role as intermediaries, museums had some powerful advantages. Without losing their traditional ties to the

royal courts, they were part of the state's cultural mission, had a close rela-
tionship with academic scholarship, and could call upon the financial support
of an increasingly prosperous business elite. Each source of power had its
price, since any one of these allies might try to interfere with the museum's
autonomy. But they also provided the prestige and resources that enabled
museums to add to their collections, remodel their interiors, and embark on
ambitious building projects.

At the same time that museums expanded their connections to the art
world, they became increasingly conscious of their own institutional identity
and autonomy. Like so many other institutions in Wilhelmian Germany—
the army, the civil service, economic enterprises, universities—the muse-
ums' sense of their own interests sharpened at the same time that their ties
to the rest of society multiplied. To understand this process, we now turn to
the careers of the men who ran museums and were primarily responsible for
their growth and development. Before we examine museum officials as a
professional group, let us look at the three most famous and successful mu-
seum directors in the Wilhelmian period.

Bode, Tschudi, and Lichtwark

Better than any other individual, Wilhelm Bode personified both the emer-
gence of museums' institutional self-interest and their complex connections
to the world around them. Born in 1845 into a family of scholars and jurists
who had been prominent in Braunschweig for several generations, Bode had
acquired a law degree and begun a career in the civil service before he de-
cided to devote himself to the study of art. In 1872, he was one of the first
men with a doctorate in art history to go to work in a museum; beginning as
an assistant in the sculpture collection in Berlin, he gradually worked his way
up until, in 1905, he became the general director of Berlin's museums. By
then, he was one of the most famous museum officials in Europe, widely
known for his extraordinary knowledge, energy, and dedication. Contem-
porary descriptions portray him as a force of nature, constantly surrounded
by visitors, dealers, and potential benefactors, pausing briefly to write letters,
answer calls, and host social gatherings, then traveling to exhibitions, culti-
vating people with influence—and all the while producing an impressive list
of books and articles on a wide range of artistic subjects. To be with Bode,
one admirer recalled, was to be at the very center of the art world: "Here all
the threads of art policy, scholarship, and commerce came together."[72]

As a scholar, Bode acknowledged the importance of art's historical con-
text and was deeply influenced by the work of Jacob Burckhardt (whose
Cicerone he revised), but his great strength was his ability to describe, identify,
and evaluate particular objects. Against anyone who dared to question his
expertise, Bode responded with bitter intensity. In 1881, for example, Anton
von Werner, the leading academic painter and future aesthetic alter ego of
William II, tried to reopen the question of the artist's role in acquisition

policies by questioning Bode's assessment of a Rubens that he had purchased for the museum. The result was a feud between these two paladins of the Berlin art scene which lasted until Werner's death.[73] But although Bode vigorously defended the need for professional as opposed to merely artistic expertise, he was by no means an uncritical admirer of academic art history, which he regarded as literary and theoretical rather than visual and concrete; this was one reason that he sympathized with Julius Langbehn's antagonism toward scholarship in *Rembrandt als Erzieher*.[74]

Bode's talents perfectly matched the museum's role as the arbiter of artistic quality and authenticity, just as his personality matched the increasingly competitive art market. Into this world of big money and high risk, Bode brought unlimited confidence in his own judgment and enormous physical energy. As he himself never tired of pointing out, his heroic efforts were often frustrated by the apparent timidity of his superiors, as well as by irksome bureaucratic details such as budget allocations and orderly procedures. His early career was filled with intolerable frustrations; even when he became more powerful and independent, he never stopped bumping into the limits of the possible. Throughout his long professional life, he remained the kind of person, familiar to academic administrators everywhere, whose unvarying response to any situation is to ask for more resources.

Although Bode was a difficult subordinate and, his detractors said, an unreliable colleague, he could be a skillful diplomat and ingratiating courtier. He began his ascent of the museum hierarchy by winning the confidence of Count Usedom during the former diplomat's less than stellar tenure as general director. But Bode also developed his own line of communication to the Kultusministerium, benefited from his father's political connections (the elder Bode, a National Liberal, was a Reichstag deputy from 1871 to 1874 and from 1877 to 1881), and established good relations with the crown prince, when the latter was serving as royal protector of the museums. After Frederick's early death, Bode managed to gain the support of William II, to whom he would sometimes appeal when other avenues of influence were blocked. Owing in part to his efforts, in part to the government's commitment to devote some of its growing wealth to art and culture, resources for museum acquisitions dramatically increased: between 1900 and 1905, Prussia spent 2.5 million marks for paintings alone, in addition to undertaking massive building projects.[75]

Bode realized that no matter how successfully he tapped state funds or acquired royal assistance, those sources would never bring him enough money to compete for the best of the dwindling supply of great art. In addition to the museum official's sources of support at court and in the government, therefore, he skillfully cultivated a small group of prominent Berlin businessmen who were eager to use their new wealth to patronize the arts. In 1882, for example, when James Simon, the heir to a textile fortune, sought Bode's advice about a painting he wanted to buy, Bode responded immediately, and thus began a long and mutually beneficial relationship that helped Simon to

acquire a splendid private collection—much of which ended up in the Berlin museum.[76] To men such as Simon, Bode offered his expertise and encouragement and, if they were interested in such things, the chance of official recognition from the court for their contributions to the nation's artistic patrimony. In 1896, these arrangements were institutionalized in the Kaiser-Friedrich Museum Association, which eventually numbered 100 patrons each of whom pledged to contribute at least 500 marks annually to the acquisitions fund.[77]

During the half-century in which he was actively involved with the Berlin museums, Bode managed to acquire, often under very difficult circumstances, one of the world's great art collections. His own interests and his collection's special strengths emphasized Renaissance painting and sculpture, but his expertise ranged well beyond Europe and the fine arts. He became an expert on carpets, help build the museum's collection of ancient coins, and was knowledgeable about the arts and crafts of Asia, the Middle East, and North America.[78]

Through his friendship with the great German impressionist painter Max Liebermann, and his ties to the Cassirer gallery, Bode had contact with and developed some sympathy for modernism; he certainly did not share the nationalist animosities often expressed by William II and other contemporary critics. Nonetheless, Bode was not an admirer of most modern art. In the last analysis, his tastes reflected the conventional art historical narrative. Contemporary art, he wrote in 1900, was "foggy and effervescent, incessant, striving and grasping, imprecise and uncertain, anarchic and formless, using a hostility to style as the foundation for an allegedly new style."[79] To emphasize contemporary art would be a dangerous policy for any museum, he believed, because its aesthetic value and historical significance had not yet stood the test of time. Unlike his onetime friend and former colleague Hugo von Tschudi, he remained convinced that the essential function of the museum was to conserve the treasures of the past, not to predict the course of the future.

When Bode first met Tschudi in 1883, he was immediately impressed by the younger man's knowledge and taste.[80] Born in 1851, Tschudi, like Bode, belonged to a distinguished family of scholars and jurists; his father, a well-known naturalist and explorer, had served as the Swiss representative in Vienna; his mother was the daughter of Ludwig Schnorr von Carolsfeld (the director of the Belvedere gallery) and the niece of Julius Schnorr von Carolsfeld (the well-known painter). Tschudi—again, like Bode—had abandoned the law in order to devote himself to art, which he studied on his own for almost a decade. Except for some time as a volunteer in Vienna's Museum für Kunst und Industrie, he had had no previous experience when Bode recommended him to be the assistant director of the Berlin painting collection in 1884. At first, the two men worked harmoniously on various projects, but eventually their relationship deteriorated. Nevertheless, Tschudi played an active role in the Berlin museums, coedited new catalogues of painting and postclassical

sculpture, wrote monographs on art history, and participated in a multivolume lexicon of artists' biographies. In 1894, he was given the title of professor— in part, as General Director Schöne argued to the ministry, to compensate him for his rather slim chances for promotion within the museum itself. Just two years later, however, and much to everyone's surprise, he was appointed Max Jordan's successor as director of the National Gallery.[81]

Schöne used the occasion of Jordan's departure to persuade the minister to accept a new statute according to which the National Gallery's director, like the directors of the other collections, would be directly responsible to the general director of museums. But this did not alter the existing structure for the approval of acquisitions. That remained in the hands of a committee dominated by Berlin artists, who saw themselves as the representatives of the national art to which the gallery was supposed to be devoted.[82] Their hostility to modernism, and especially to its foreign manifestations, was strongly supported by William II, whose own tastes inclined toward the conventional treatment of edifying subjects.[83]

When Tschudi became director of Germany's most important modern museum, his published work had dealt almost exclusively with Renaissance Italian and seventeenth-century Dutch art. In fact, his lack of connections with modernism may have been one of the reasons he seemed such an attractive candidate, both to William II and to the cultural bureaucrats who were eager not to provoke the emperor. But Tschudi had recently come to admire the French impressionist paintings he had seen in some Berlin private collections, and that admiration was strengthened during a trip to Paris with Liebermann in 1896. Soon after his appointment, therefore, the new director began to display an inclination toward modern art. First he published an essay that expressed some mild criticism of Adolf von Menzel, who was generally regarded as Germany's greatest realist. Then he set about reorganizing the gallery, removing some of the collection's battle scenes and patriotic portraits to make room for works by French and German modern masters. In order to acquire these paintings, Tschudi bypassed the acquisitions committee with the help of a small group of wealthy Berliners whom he mobilized as patrons of the gallery.[84]

As soon as he revealed his sympathies for modernism, Tschudi was embroiled in controversy. The acquisitions committee resisted his efforts to buy modernist pictures, particularly those by foreign artists, which they felt had no place in a gallery officially dedicated "to German Art." When the remodeled gallery opened in December 1897, it drew mixed reviews—enthusiastic support from some, loud condemnation from others, including a few members of the Prussian Landtag, who used the debate on the museum's budget allocation to attack the director's policies.[85] In 1899, Tschudi clashed directly with William II. Tschudi himself made the first move toward confrontation with an extraordinary address on "art and the public," delivered in the emperor's presence and on the occasion of his birthday. Although he did not mention William by name (except for some mild, formulaic praise at the

end), the speech was a sustained and thinly disguised attack on the emperor's aesthetic views.[86] When William visited the gallery a few months later and expressed his disapproval of the new arrangement, Tschudi defended himself in what observers regarded as a dramatic clash of personalities. Soon thereafter, the emperor formally demanded that the gallery be returned to its former condition; Tschudi had no alternative but to obey. From then on, he was under attack, both from the enemies of modernism in the public and, behind the scenes, from his rivals at court and in the bureaucracy, including Bode.

Although Tschudi's opponents were able to make his time as director of the National Gallery what one scholar has called a "permanent crisis," he remained in office for nine years, acquired some important modern works, redesigned the gallery, and mounted several important shows, including the major exhibition in 1906 of a century of German painting. Finally, as the result of a complex conflict over acquisitions, he was forced to take a long leave of absence. Even then, however, he was not dismissed; rather, he resigned in 1909 to take up a new post as director of Munich's art museums.[87]

In Munich as in Berlin, Tschudi was consistently opposed by many local artists, who found allies in the press and parliament and at court. Furthermore, the Bavarian museum system, though not as well funded as its Prussian counterpart, had a structure of committees and overlapping jurisdictions which rendered decision-making at least as difficult as it was in Berlin. Nevertheless, Tschudi had the support of the crown prince, a few key individuals in the bureaucracy, and a number of wealthy private patrons who saw in him the best chance to reestablish Munich as the foremost center of German art.[88] Despite his deteriorating health (he suffered from lupus, which left him in chronic pain and often unable to walk), he made a number of significant acquisitions and began a substantial reorganization of both the Alte and the Neue Pinakothek.[89] Although his work was shadowed by new conflicts and controversies at the time of his death in 1911, he had accomplished a great deal during his brief tenure in Munich.

Tschudi, like Bode, was essentially a connoisseur, able to interpret the meaning and assess the authenticity of particular works of art. But Tschudi believed that in dealing with contemporary art, connoisseurship's primary task was not analysis or attribution but evaluation. This demanded a different kind of historical understanding: in order to determine the value of modern works, the connoisseur had to be able to read history retrospectively—not from the ideal past to the present but from the best contemporary art to its historical predecessors. We do not study the great masters of the past in order to evaluate our contemporaries, Tschudi argued; rather we study our contemporaries in order to see what is truly worthwhile in the past. "As paradoxical as it may sound," he wrote in the last year of his life, "the path from the art of the past to that of the present is difficult to travel. The natural way is to go from the present to the past."[90]

Like his friend and sometime collaborator Meier-Graefe, Tschudi viewed the emergence of modern art as a struggle against historical con-

ventions, academic interests, and public insensitivity—a long, and painful struggle in which the modern museum director had to fight on the side of progress, beauty, true art. Unlike his predecessors in the nineteenth century, his primary task was not to collect and conserve treasures isolated from the present but to "transmit the aesthetic values" essential for his time. His acquisitions should not fill existing gaps in his collection but rather "contribute to the organic development toward modernity."[91]

Even someone less sensitive to criticism than Wilhelm von Bode would have recognized that Tschudi's portrait of nineteenth- and twentieth-century museum directors was a direct reference to the differences between Tschudi and himself. In a reply that appeared several months after Tschudi's death, Bode defended his own conception of the director's role. "The young art historian does not need to be trained in the art of his own day," he maintained, "but rather should gain an understanding of art in general and seek to make himself at home in the art of bygone epochs"; only then would he acquire "a secure standard" for his opinions. After this restatement of the conventional view of the past as a source of value, Bode focused on what was in fact the central weakness in Tschudi's position: if we were to go from the present to the past as Tschudi suggests, he asked, how would we know which of the various currents of the present to choose?[92] Of course, Tschudi thought he knew where the center of contemporary artistic creativity was to be found—in some version of French and German impressionism. But without this normative commitment, a narrative of art history written retrospectively, as Tschudi wished, would be no less problematic than the classical narrative proposed by Winckelmann.

In 1896, when Tschudi was appointed head of the National Gallery, among the first people to whom he turned for advice was Alfred Lichtwark, who had been director of the Hamburger Kunsthalle for a decade.[93] Two aspects of Lichtwark's background separated him from Bode and Tschudi, as well as from most other museum leaders of this generation. First, he came from a family with neither wealth nor social position; born in 1852, Lichtwark began his long, difficult climb into the *Bildungsbürgertum* with a job teaching school in Hamburg. Second, his entrance into the museum world was through the applied rather than the fine arts. While working as a teacher, he had gotten to know Justus Brinckmann, who eventually hired him at the Museum für Kunst und Gewerbe. Brinckmann then helped Lichtwark find financial backing to study art history with Springer in Leipzig, where he received his Ph.D. in 1884 with a dissertation on ornamental engraving in the early German Renaissance. Before finishing his degree, Lichtwark took a job at the recently opened Berlin Kunstgewerbemuseum. It did not take him long to establish himself as an important figure on the new capital's active art scene.

In 1886, when the city fathers of Hamburg decided they needed a full-time director for their Kunsthalle, they offered Lichtwark the position. He

accepted at once, against the advice of friends who did not understand how he could abandon the excitement of Berlin for Hamburg's cool, commercial climate. Perhaps Lichtwark was shrewd enough to realize that he needed a secure base from which to move into the larger world. More important, Hamburg gave him the chance to establish a museum with deep local roots, one not primarily designed for scholars or tourists but committed to reflecting the interests and serving the needs of a particular community. For these purposes, Hamburg seemed ideal—a city large and rich enough to support an important collection but small and cohesive enough to be directly engaged in the museum's various activities.

Although Hamburg did not always live up to Lichtwark's hopes, he remained at the Kunsthalle until his death in 1914. His publications, and especially the semipublic letters he wrote to the museum's trustees, record a life of constant activity. Like Bode and Tschudi, he traveled often to meet with dealers, attend auctions, and examine other collections; like them, he lived in an essentially international art world. In the second half of his career, Lichtwark was also intensely involved in various reform projects throughout Germany, mainly those concerned with the spread of artistic knowledge and the improvement of the applied arts. But despite his frequent trips and manifold institutional commitments, Lichtwark's activity continued to have a local center. Chief among his achievements was his building of a great collection of Hamburg artists, ranging from medieval masters to Philipp Otto Runge, an early nineteenth-century Romantic painter whom Lichtwark rescued from obscurity. He also cultivated contacts with the city's working artists, whose pictures and statues he bought and to whom he gave annual commissions. Unlike many municipal museums, therefore, the Kunsthalle was not just a smaller version of the great national collections; it had its own regionally based personality.[94]

Although a passionate and discriminating collector, Lichtwark did not, like Bode, seek to amass a treasure trove of great art from the past. Nor did he, like Tschudi, only want to advance the most creative artistic forces on the contemporary scene. Above all, Lichtwark remained a teacher, seeing the museum's fundamental purpose as pedagogy rather than scholarship or conservation. "We don't want a museum that sits there and waits," Lichtwark told the Hamburg senate and city council in his inaugural lecture of 1886, "but rather an institution that is actively engaged in the artistic education of our community."[95] Educating the community meant engaging the interests and loyalties of the city's elite upon whom the museum depended. But its educational mission, he believed, should reach well beyond the wealthy and powerful to include those who belonged to the Kunsthalle's affiliated organizations, attended its lecture series and regular tours, and used its library. And beyond this still rather limited public, it should extend into the schools and the adult educational movement. Introducing ordinary men and women to art was not merely ethically and morally essential; it was also of direct practical value in improving the quality of German craftsmanship.

For Lichtwark, the history of art and its institutionalization in the museum were always means to an end. He himself had never fully absorbed the conventional norms of art history. He did not spend an extended period of time in Italy until 1888, and although he certainly admired the achievements of classical antiquity and the Renaissance, he regarded them as closed historical periods rather than sources of lasting value. Similarly, Lichtwark used historical analysis as a teaching device but did not believe that it was the only, or perhaps even the best, way to approach art.[96] Nor, he sometimes admitted, were museums the best place to learn about beauty. He never quite lost the negative view that many officials of *Kunstgewerbe* museums had of the great art museums, which they believed did not really appeal to most ordinary people.[97] Despite his great reputation and unquestioned commitment to his profession, there was an undercurrent of self-doubt in Lichtwark, who, much more than either Bode or Tschudi, shared his contemporaries' uneasiness about the culture of museums.

Professionalization and Its Limits

"The leadership of today's museum," Lichtwark declared in his 1886 inaugural lecture, "is no longer a place for experimental dilettantism." Lichtwark knew from his own experience that a museum director had to be able to evaluate new works of art, conserve old ones, organize special exhibitions, hang a picture to best advantage, defend a budget, conduct a tour of his collection, and persuade a donor to part with one of his cherished possessions. He had to be willing to travel to auctions in Munich, know his way around the galleries of Paris, and have a sharp eye for a neglected masterpiece in someone's attic. This was not a job for a man like Johann Christian Meyer, the onetime art dealer and auctioneer whom Lichtwark had replaced as head of the Kunsthalle. Museum management had become, Lichtwark insisted, "a discipline of its own, which required as much intensive training as any other branch of the administration."[98]

The generation of museum officials to which Lichtwark, Bode, and Tschudi belonged—that is, men born in the 1840s and 1850s—had often followed a circuitous path into museum work.[99] By the 1890s, however, a new generation had begun to appear in museums; men born in the 1870s and later who usually began their careers with graduate work in art history and then followed a fairly well-defined route up through the museum's administrative ranks, frequently moving from one place to another as better positions became available. This group included many who became museum directors after the turn of the century and who frequently remained in office through the 1920s. Among them were Ludwig Justi, the director of the Städel in 1904 and Tschudi's successor at the National Gallery in 1909; Gustav Pauli, the director of the Bremen Kunsthalle from 1899 to 1914 and then Lichtwark's successor in Hamburg; Ernst Gosebruch, the director of the Folkwang Museum after its move from Hagen to Essen in 1922; Karl

Koetschau, who ran museums in Berlin, Weimar, and Düsseldorf; Hans Posse, the director of the Gemäldegalerie in Dresden after 1910; Max Sauerlandt, who directed museums in Halle and then Hamburg.

Almost everyone who became a museum director after 1900 had an advanced degree in art history. There were, to be sure, occasional exceptions, and some prominent artists continued to argue that artistic talent rather than academic training was the proper background for museum work. But the initiative had clearly passed to the scholars. In 1908, for example, when William II tried to have Anton von Werner appointed as Tschudi's successor at the National Gallery, he met with widespread resistance. Koetschau, then director of the Weimar museum and editor of *Museumskunde*, insisted that historians were the natural leaders of museums, even of those devoted to modern art.[100] Two years earlier, Crown Prince Rupprecht, who would eventually help bring Tschudi to Munich, had offered an equally compelling reason that historians rather than artists should run museums: historians, he told the Bavarian Reichsrat, usually have a better sense of the international art market than creative artists, who tend to be associated with one particular kind of art.[101] Here we see an explicit statement of that close connection between scholarship and the market which was so important for the museum's development.

Academic training was a necessary but not a sufficient preparation for a successful career in museum administration. Koetschau, who received his Ph.D. at Leipzig in 1893, recalled that he was ill prepared for his first job as head of the art and antiquities department of a small provincial museum: "The art historical training that I brought with me from the university was useful only in the scholarly aspects of my job, and even here was not sufficient."[102] Like most professionals, museum officials had to combine academic study with practical, on-the-job training. Many began by serving as unpaid volunteers or subaltern officials in one of the great German museums, often with Bode in Berlin (where Heinrich Weizsäcker, Justi, Swarzenski, and many others spent some time), or with Karl Woermann in Dresden, or perhaps in one of the smaller provincial collections. In 1912, Bode introduced a two-year training program for those considering a museum career; by rotating through the museum's various departments, these interns learned the practical skills essential for the management of art collections.[103] Max Friedländer, who had replaced Tschudi as Bode's assistant, expressed a view widely held by museum officials when he wrote that art historians could be divided into two groups: scholars, who occupied academic positions and liked to proceed from the general historical setting to the individual work of art, and connoisseurs, who worked in museums and preferred to move from particular objects to general interpretations.[104]

The long period of formal study and unpaid internship required for a museum position meant that prospective employees remained dependent on their families until they were well into their twenties or early thirties. Even junior officials, fortunate to have a salary, were often paid so little that they

needed family support to live properly. Bode, for instance, earned 2,400 marks a year in the 1870s, which he found barely sufficient for a bachelor; Walter Kaesbach, an assistant in the National Gallery just before the First World War, got 150 marks a month, which he supplemented with a 400-mark allowance from his family.[105] It is not surprising, therefore, that so few museum officials came from poor families (Lichtwark was the outstanding example); in fact, many seem to have been rich. Karl Woermann, director of the Dresden gallery from 1882 to 1910, belonged to a wealthy Hamburg family; Max Friedländer's father was a well-to-do Berlin banker; and Gustav Pauli, who would eventually succeed Lichtwark in Hamburg, came from the Bremen patriciate.[106]

Appointments and promotions remained relatively informal and personal, made without clearly defined procedures or regular examinations.[107] An influential friend at court could still be of use: Friedrich Lippmann, an amateur scholar and wealthy collector, became director of the Berlin print collection in 1876 because of his wife's friendship with the crown princess. Tschudi was hired largely on Bode's recommendation. Lichtwark would not have been appointed director of the Kunsthalle without the support of Justus Brinckmann and his other Hamburg friends. Family contacts certainly helped Gustav Pauli become director of the Bremen Kunsthalle, and his assistant, Gustav Hartlaub, also had local ties. Ludwig Justi, Tschudi's successor in Berlin, was the son of an important orientalist and nephew of the art historian Carl Justi, whose work William II knew and admired. Rudolf Oldenbourg, who assisted Tschudi in Munich while still in his early twenties, was a member of the famous publishing family as well as Bode's nephew.[108] Most of these men turned out to be talented and effective officials, but it would be hard to say that any of them had compelling experience or credentials for the positions to which they were appointed.

By later standards, the staffs of German museums were exceedingly small. Lichtwark, for example, did not have a full-time assistant at the Kunsthalle until 1911; when Pauli took over three years later, he hired a new secretary and an academically trained curator for the print collection. Karl Woermann ran the Dresden gallery with the help of a few volunteers. In Darmstadt, Friedrich Back was hired as director of paintings and prints, but when the head of the antiquities department died, Back simply assumed those duties as well; eventually he acquired two assistants to help administer the entire collection.[109] Even in Berlin, which had a larger and more elaborate administrative structure than any other German museum system, the table of organization was remarkably lean: in 1914, the general director's office had a staff of eight officials (plus three on overseas assignment); each of the various departments had a director, one or two curators, and one or two assistants. For all of Berlin's art museums (including the Kunstgewerbemuseum, though not the National Gallery), there were about sixty budgeted positions.[110]

There was, as one would expect, considerable diversity among museum officials. Their ranks ranged from nationally prominent figures such as

Wilhelm von Bode—the only one to be ennobled for his achievements—to the directors of small provincial museums. Moreover, they had different areas of expertise—painting, classical antiquities, coins, crafts—and, needless to say, different tastes. Nevertheless, by the turn of the century, they had begun to think of themselves as a profession, with similar interests and responsibilities. In 1904, Karl Koetschau established *Museumskunde*, a periodical devoted to the practical and theoretical problems of museum administration. At annual meetings of the Deutscher Museumsbund, an association of museum officials, experts came together to share new information and discuss common problems.[111]

Museums and Modernism

The most dramatic and potentially contentious problem confronting museum directors before 1914 was the acquisition of contemporary art. On questions about historical works or building projects, any objections from their superiors in the ministry or municipal government were most likely to be financial, but contemporary work often brought into play another set of political, cultural, and moral issues. When Gustav Pauli wrote in 1930 that "there is probably no more serious question than how they should relate to contemporary art," he knew what he was talking about.[112] Twenty years earlier, when he purchased van Gogh's *Poppy Fields* for the Bremen Kunsthalle, he had found himself at the center of a nationwide storm of protests and polemics which included, among other publications, Carl Vinnen's famous *Ein Protest deutscher Künstler*. The conflict was aggravated by the vigorous public and legal activities of Theodor Alt, a self-appointed defender of patriotic German art against what he called the web of influence being spun by "the spiders of Berlin West."[113] Two years later, Max Sauerlandt got into trouble with the city fathers of Halle when he bought two paintings by Emil Nolde for the local museum. Georg Treue in Dresden, Swarzenski in Frankfurt, and of course Tschudi in Berlin and Munich were also embroiled in controversies stemming from their unconventional acquisitions policies.[114]

The intensity of these controversies reveals the significance of art museums as arbiters of value in an expanding art world. Many different groups cared about what museums bought and exhibited. And of course no group was more directly concerned than the artistic community, whose members were increasingly uneasy about the new art world, in which a few artists could grow rich and famous while the majority had trouble finding buyers for their work.[115] Faced with these profound challenges to their livelihoods, many artists, like the shopkeepers who agitated against department stores and the farmers who condemned grain imports, formed organizations to defend themselves. And, again like other threatened interest groups, artists represented themselves as the personification of genuine German values, under assault by dishonest market manipulators (often thought to be Jews, as Alt's reference to "Berlin West" was meant to suggest) and unfair competitors

(usually thought to be foreigners). For these artists, therefore, regaining their rightful place in German museums was not just a matter of their own narrow self-interest; it was in the interest of German culture as a whole.[116]

The defenders of German art were a heterogeneous coalition: William II disliked the modernists' style and themes; Catholic leaders objected to their allegedly obscene subject matter; and a variety of politicians and publicists were always ready to condemn anything foreign, unconventional, or elitist. In public speeches, parliamentary debates, and the pages of mainstream periodicals such as the *Preussische Jahrbücher* and *Grenzboten*, critics of modernity attacked decadent artists, greedy dealers, and their advocates throughout the art world.

Yet despite the bitter hostility of many artists, the persistent complaints of some parliamentarians and publicists, and the public displeasure of the emperor, the advocates of modernism were not driven from German museums. Treue, Swarzenski, Pauli, and Sauerlandt all kept their jobs. Tschudi, after managing to remain in Berlin until 1909, was replaced not by some champion of patriotic art (such as Anton von Werner) but by Ludwig Justi, who pursued—albeit with considerably more tact and discretion—policies that were quite like Tschudi's own.[117] All these men survived because they found powerful allies, sometimes (like Sauerlandt) in the city government, sometimes in the ministries, more often among wealthy private patrons who had been won over to the modernist cause.

Considering the controversies that modernism generated in various parts of the German art world and the public criticism to which allegedly modernist museum directors were often subjected, it is remarkable how much excellent modern art found its way into German collections. Tschudi was able to acquire an impressive number of major works for the National Gallery and the Neue Pinakothek. Even more impressive were the modern works to be found in the Hansa cities and in the industrial west: Osthaus in Hagen, Wichert in Mannheim, Gosebruch in Essen, and others gathered significant new work by both foreign and German modernists.[118]

Of course, not all museum officials were sympathetic to modernism. Bode, in addition to criticizing Tschudi, later attacked both Sauerlandt and Swarzenski for their unreliable views. And many officials, including Tschudi himself, did not care for the work of most Postimpressionists. Nevertheless, by 1914 modernism had clearly penetrated German art museums, and the receptivity to new developments had begun to shape the spaces in which art was displayed and the way it was intended to be seen.

III. Toward the Modern Museum

Monumental museums nicely illustrate the two convictions that, according to Donald Olsen, characterized nineteenth-century architecture: first, "that architecture was a language, capable of expressing complex and important

ideas," and second, "that such ideas ought to be directed to the service of public good and private morality."[119] These convictions were at work in Schinkel's grand colonnade in Berlin and in Semper's elaborate decorative scheme in Vienna, both of which expressed art's historical meaning and social value. In the twentieth century, however, many architects gave up the attempt to make their buildings express complex ideas and moral messages; the decorative programs that had once defined monumental structures disappeared; the historical vocabulary with which they established their connections to the past was abandoned. Eventually, as Alan Colquhoun has written, "the power of architectural style to convey definite meanings disappeared entirely."[120]

The art museums that we will consider in this section followed two different paths away from the messages of monumentality. Architects such as Alfred Messel and Henry van de Velde turned toward more abstract, functional buildings in which we can see the uncertain beginnings of classical modernism. Much more frequently, turn of the century builders deployed a variety of historicist styles but used them without specific meanings. Unlike Schinkel's and Klenze's Greek columns or Semper's Renaissance forms, these historical elements were, in Colquhoun's words, no longer "ideologically active." They were intended to evoke a diffuse sense of grandeur and importance, not to communicate ideas about art and society.

We can see this second approach in the way architects used baroque styles for a number of major public buildings, including several important art museums.[121] For an age given to elaborate ornamentation and massive scale, the baroque had obvious attractions, but its popularity also suggests that even before the rise of modernism, architects had begun to abandon their attempt to communicate particular messages. Making baroque models appropriate for new museums required stripping them of their traditional association with princely absolutism and courtly extravagance—associations that had led earlier generations to regard the style as politically suspect and aesthetically decadent. Although the fact is often difficult to recognize in the extravagant eclecticism of turn-of-the-century baroque buildings, their construction takes us one step closer to modernity. Let us examine this tendency in one of the first great museums to be built in the twentieth century, the Kaiser-Friedrich Museum in Berlin.

The Kaiser-Friedrich Museum in Berlin

The museum named in honor of the late emperor was formally opened on October 18, 1904, the seventy-third anniversary of his birth.[122] The museum's architect, Ernst Eberhard Ihne (1848–1917), had spent the first decade of his career building country houses, including Schloss Friedrichshof, the rural estate in the Taunus to which the emperor's widow had retired after her husband's death. Known for his mastery of neo-Renaissance and neo-baroque forms, he had been strongly recommended for the museum project

by William II, who could be confident that Ihne was uncontaminated by modernist fads.[123]

The Kaiser-Friedrich was part of the museum complex that would fill the northern end of the island between the Spree and Kupfergraben Rivers—the site that King Frederick William IV had hoped to use for a forum in which an ensemble of artistic and cultural buildings could be joined to the Lustgarten (and therefore to the dynastic, ecclesiastical, and public buildings with which Schinkel had connected his museum). But the king's plans were not realized; instead, the area became what would be called, appropriately enough, the *Museumsinsel*—a self-contained island of museums set apart from the larger urban environment (see fig. 9).[124] Schinkel's building now marked a boundary between the museums and Berlin's central public space rather than establishing, as he had intended, a spatial and symbolic linkage of art, religion and political authority. The five imposing structures (Schinkel's museum, the Neues Museum, the National Gallery, the Kaiser-Friedrich Museum, and the Pergamon Museum) that eventually covered the island certainly expressed the German Empire's deep commitment to preserving great art, but their placement made no statement about art's relationship to the wider world.

The Kaiser-Friedrich was sited on a triangular plot of land at the end of the island, separated from the other buildings by the municipal railway tracks that had been laid in 1882. It was, to say the least, a difficult place in which to construct a major building. Ihne decided simply to overwhelm the site by filling it entirely with a triangular structure, two wings rising directly from the water, the third running along the rail line. On the river elevations, the ground floor served as a pedestal for two upper stories, which were divided into bays by pilasters; at their ends were risalits with engaged columns and pediments; the roof had a heavy entablature topped by a balustrade. The main entrance, in the building's apex at the confluence of the rivers, was through a rounded facade penetrated by archways and decorated with engaged columns; behind its balustrade rose a splendid dome topped with a crown. Except for six statues representing the arts along the balustrade of the entrance, the exterior had no programmatic features. Designed to recall a baroque residence, the museum was stylistically related to the royal palace and the arsenal, but although Ihne managed to convey a certain sense of grandeur and importance, his design said nothing about the building's particular purpose.

As was usually the case in major nineteenth-century art museums, the *marche* began with a celebration of the dynasty whose generosity had made possible all that was to follow. In fact, the dynastic element was here repeatedly expressed, first by an equestrian statue of Frederick III opposite the entrance, then by the inscription over the entrance ("Kaiser Wilhelm II. dem Andenken Kaiser Friedrichs III."), and, most elaborately, in the entrance hall itself—a richly adorned, domed space that contained not only a cast of Andreas Schlüter's statue of the Great Elector (on its original base) but also portrait medallions of four Hohenzollern rulers and other dynastic emblems. Finally, in a smaller domed space at the opposite end of the middle axis, there

FIGURE 27. Kaiser-Friedrich Museum in Berlin: floor plans.

were statues of Frederick the Great and his greatest generals in the niches of a rococo stairway.[125] Museums had clearly come a long way from the days when a simple inscription on the facade was enough to establish the importance of dynastic patronage.

On the central axis, which connects the main entrance with the rococo stairway, Ihne placed the so-called Basilica, a rectangular room that was supposed to resemble an Italian Renaissance church (fig. 27). Along its sides, in chapel-like alcoves, were displayed religious pictures, statues, altar tables, and funerary monuments; the Basilica's central space contained some furniture from the fifteenth century, a fountain, and a lectern; the walls were decorated with coats of arms and, at one end, a fine oriental carpet. Situated at the core of the museum, the Basilica was two stories high, with a barrel-vaulted ceiling and windows above the arched alcoves; it was the only room along the ground floor's central axis in which the museum's function was revealed, for neither the main entrance nor the smaller stairway had any manifest connection to art. The Basilica's form and contents reaffirmed the paradigmatic quality of the Renaissance for art history; its quasi-ecclesiastical character recalled art's sacred purposes. But although the space evoked both history and religion, it was neither accurate enough for scholarship nor sublime enough for contemplation. The only experience the Basilica had to offer was aesthetic; it was meant to delight the eye with a harmonious blend of objects whose combination recalled, but did not seek to reconstruct, art's greatest age.

If, instead of proceeding into the corridor leading to the Basilica, visitors climbed the entrance hall's curved stairway to the second floor, they gained

access to the painting collection: in one wing, Italian, French, and Spanish works; in the other, German, Dutch, and Flemish. To the proper display of art in these spaces Bode devoted his formidable energy and expertise. He kept a roughly chronological organization of the pictures but was willing to sacrifice "historical order" in the interests of a more powerful "effect" (*Wirkung*). In the first place, he gave the collection's masterpieces special prominence, even if it meant taking them out of their chronological place. Second, he limited the number of pictures on display, thereby sacrificing historical coverage to achieve a more beautiful exhibition. Finally, in some rooms, Bode brought together paintings, sculpture, and furniture in what he called an "artistic arrangement" of space that was pleasing to the eye even if not always historically consistent.[126] A particularly striking example was the room devoted to James Simon's collection of Renaissance objects, which was meant to evoke the rich variety and particular tastes of an individual connoisseur.[127]

By concentrating on the collection's most important works and by creating ensembles of different kinds of objects, Bode sought to respond to the charge that museums were overcrowded warehouses of art. His primary purpose was to heighten the viewer's aesthetic experience by conveying an over-powering impression of art's richness and harmony. To be sure, his design drew elements from the museum's past: the representational splendor of the princely gallery, the sacred spaces of the Romantics' aesthetic church, and the scholar's visible narrative of art's history. But another important source of his design was the collector's unique, aesthetically shaped display of his treasures.[128] The Simon room was not only a tribute to patronage's growing importance for the museum but also a key to the kind of emotions that Bode wanted to inspire and celebrate.

The contemporary response to the Kaiser-Friedrich Museum was mixed.[129] In Paris, *Figaro* called it "amazingly ugly." The German press tended to be respectful and positive, but progressive art critics such as Albert Dresdner, who associated the building with William II's anti-modernist campaign, naturally regretted its excessive historicism. And after examining the museum in 1911, when he was gathering ideas for extending the Hamburg Kunsthalle, Alfred Lichtwark had nothing at all good to say about it. "It is," he told his board of directors, "in all essential ways a complete failure." But the most astute assessment may have come from a young architect who toured the museum soon after it opened. Despite his effort to pay attention to the building, he found himself continually distracted by the objects on display. The Kaiser-Friedrich, he concluded, was "a truly outstanding museum, in which one forgets the museum itself and pays attention to the contents."[130] In fact, the building itself *was* forgettable. Unlike Schinkel's museum, it did not seek to impose a particular mood on the visitor; unlike Semper's Dresden gallery, it did not make a programmatic statement about the history of art. Instead of being a unified work of art, the Kaiser-Friedrich Museum was a loosely knit set of self-contained aesthetic experi-

ences from which visitors could select as they wished. The building, there-
fore, had rather more in common with modern museums than its baroque
design and decorations might have led one to suspect.

The Grossherzogliches Museum in Darmstadt

A more self-consciously modern project was the Grossherzogliches Museum
in Darmstadt, constructed between 1897 and 1902 and formally opened in
November 1906. Darmstadt was one of the last German capitals to build a
museum. Hesse-Darmstadt's ruling house had interesting and diverse col-
lections of art and artifacts, which had become "public" property as early as
1820. But they remained poorly displayed and maintained in the palace,
where they were, as Wilhelm Lübke complained in 1884, "as good as dead
and buried."[131] In 1885, the government established a committee to prepare
plans for a new building; six years later, five prominent architectural firms
were invited to enter a competition to decide the museum's design. Most of
their submissions involved the kind of heavily ornamented neo-baroque
structures that seemed appropriate for museums at the end of the historicist
era. None of them took into account either the proposed museum's site or
the particular features of the grand ducal collection.[132]

The development of the project was decisively altered in the spring of
1892 when, following his father's sudden death, twenty-three-year-old Ernst
Ludwig became grand duke of Hesse-Darmstadt. Determined to make his
state a center of artistic innovation, Ernst Ludwig eventually attracted an
important colony of artists and craftsmen whose houses and exhibition hall
were built on the Mathildenhöhe, just above the old city center.[133] And one
of the new ruler's first acts as patron of the arts was to reject all the 1891
submissions to the museum competition and to commission Alfred Messel
to draw up a new set of plans.

Born in 1853, the son of a Darmstadt banker, Messel had made his
career in Berlin. He was neither a state official nor a court architect; like
Ihne, Messel was in private practice, and his clients included governments,
princes, individuals, and commercial institutions.[134] He designed many of
the era's characteristic buildings—banks, city halls, post offices, apartment
houses, and suburban villas. His most famous project was the Wertheim
department store in Berlin, whose open, light-filled spaces were quickly
celebrated as an expression of the modern age and a break with the ex-
hausted styles of the past. Throughout his career, Messel had both an
interest in art and a professional concern for the architectural problems of
displaying objects. In 1881, he submitted a design for an exhibition hall to
the Schinkel prize competition; he contributed the section on exhibition
halls to the first (1903) edition of Wagner's authoritative architectural hand-
book; and in addition to the Darmstadt museum, he did the preliminary
plans for Berlin's Pergamon Museum, which was completed after his death
by Ludwig Hoffmann.[135]

Although viewed as an innovator by his admirers, Messel's real talent was for compromise and conciliation; his aim was to deploy traditional forms in new, flexible ways. In his best buildings, such as the Wertheim store, the individual elements had an obvious historical source, but they were streamlined and shaped to serve the building's purpose. As Barbara Lane has written, progressive architects such as Messel used "the vocabularies of the older styles, chiefly gothic and baroque, in new, more orderly and more vigorous combinations," thereby deriving from them "a new set of principles that were at once novel and visually related to the past."[136] This blend of innovation and convention was perfectly expressed in the Darmstadt museum (fig. 28).

The museum, standing on the Paradeplatz next to a neoclassical theater and behind the grand ducal palace, was part of a complex urban site with elements from the sixteenth, seventeenth, and eighteenth centuries. Following the instructions of the grand duke, Messel attempted to fit his building into this architecturally rich environment. Both the proportions and the style of the facade were meant to establish visual connections with the palace.[137] The front (south) elevation was a single story, set on a ground floor pedestal, with five bays on each side and slightly extended risalits on either end. A pavilion-like entrance emphasized the center of the facade with a high, hipped roof and a pediment containing the ducal coat of arms. Although the origins of the facade were clearly baroque, its stylistic elements were articulated with great restraint. The only flamboyant feature, on the southeast corner next to the theater, was a three-story tower without a functional or structural link to the main body of the building. By evoking a tower that was planned but never constructed in the palace complex, this tower was apparently supposed to affirm the dynasty's importance for the museum.[138]

When he asked Messel to draw up plans, Ernst Ludwig had instructed him to study the collections carefully: "The spatial relationships of the building must come from the collections themselves. Then the plan of how the rooms follow one another can be drawn, and only then comes the exterior's architecture."[139] The key to the building's interior design, therefore, is its relationship to the various sorts of objects it was meant to contain: paintings, sculpture, antiquities, weapons and other historical objects, and a natural-history collection as well. To meet the different requirements of these exhibits, Messel designed a "clustered building" (*gruppirtes Gebäude*), with spaces appropriate for various sorts of displays.[140] The paintings, for example, were in the second story of the north wing, where they could be illuminated with a combination of sky-lights and northern exposure. On the first floor were a number of historical rooms, including a medieval chapel and a Renaissance hall, in which the architecture matched the objects on display.[141]

The museum's diverse spaces were structurally unified by a hallway along the central axis, from which visitors could enter the different rooms on the ground floor or climb a stairway to the upper floors of the north wing. The hallway was beautifully proportioned and splendidly decorated; it repeated in more elaborate form the motifs from the facade. But it was not

FIGURE 28. Alfred Messel, "Grossherzogliches Museum in Darmstadt: view from the Southeast."

intended to create a particular mood or teach a historical lesson; it had no purpose other than to provide access to the individual collections. Messel's building, therefore, was not unified in the way monumental museums had aspired to be; neither its design nor its decoration was meant to convey a single message. It was—and was intended to be—no more than the sum of its parts.

The Folkwang Museum in Hagen

At the same time that the Darmstadt museum was being built and Ernst Ludwig was assembling his colony of artists on the Mathildenhöhe, Karl Ernst Osthaus was attempting to create a center of aesthetic innovation in the Westphalian city of Hagen. At the heart of his efforts was the Folkwang Museum, which opened in the summer of 1902.[142]

Osthaus was born in Hagen in 1874; his family's banking and industrial enterprises had flourished in the fast-growing economy of the German west. After a miserable interlude as an apprentice businessman, Osthaus devoted himself to art history and aesthetics. At the university, he established ties to

right-wing political groups with which—despite his increasingly radical artistic tastes—he would continue to identify. In terms that clearly echo Langbehn's assessment of the German condition, Osthaus conceived his life's mission as using culture to counter the degeneration of the age: "Today culture is not a question of class," he declared in 1904. "It is a national question [*Volksfrage*], the greatest question of the age."[143] An admirer of Nietzsche as well as Langbehn, an associate of Meier-Graefe, Kessler, and Lichtwark, Osthaus was touched by many of the most important new ideas at work in the late nineteenth- and early twentieth-century German art world.

Inheriting a fortune from his maternal grandparents in 1896 gave Osthaus the chance to put his ideas into practice. He began by hiring Carl Gérard, a Berlin architect, to build a museum in which the citizens of Hagen could see his growing natural-history collection. Gérard dutifully produced a three-story neo-Renaissance building complete with a tower, ornamental dome, large entrance hall, and grand staircase—in short, a building very much like the villas he had previously designed for Osthaus's father and other successful businessmen. In 1900, when the exterior construction was finished, Osthaus experienced a kind of aesthetic conversion, supposedly after reading an article by Meier-Graefe about the Belgian artist and designer Henry van de Velde. Although one may wonder whether his conversion was quite as Pauline as he later claimed, no doubt he did recognize himself (and, even more forcefully, his father) in Meier-Graefe's contemptuous reference to the historicist pretensions of "our millionaires." In any case, Osthaus dismissed Gérard and engaged van de Velde to design the museum's interior.[144] The result was the Folkwang, which, despite its Nordic name (Folkwang was the dwelling of Freya, the goddess of beauty, in Valhalla), became one of the most important centers of international modernism in central Europe.[145]

Van de Velde had begun his artistic career as a painter but was soon caught up in the Europe-wide arts and crafts movement inspired by William Morris. Unlike Ihne or Messel (or, on a much lower level of competence, Gérard), van de Velde's reputation was not based on large-scale building projects; when Osthaus hired him, he had spent most of the preceding decade designing domestic, everyday objects, including his wife's clothes and their own modest house.

Inside Gérard's historicist shell, van de Velde created a total environment in which where every object and decorative motif, from the door handles to the display cabinets, were connected in a harmonious whole. Unifying the design was van de Velde's attempt to develop a visual language purged of historical residues, a language of sinuous lines, organic forms, and bright, sharp colors. Intended to be efficient, functional, and aesthetically pleasing, the design had no underlying programmatic purpose; van de Velde did not set out to create what Gertrud Osthaus, Karl Ernst's wife, dismissively called an environment that "overwhelms the works of art and uses inauthentic, Romantic means to express some sort of historical mood." Instead, the museum was "neutral" without being drab and featureless, a setting in which—again to quote Gertrud Osthaus—"a well-arranged distribution and sequence of

spaces, together with a rhythmic blend of their proportions and colors, creates an almost imperceptible but vital atmosphere, in which each object can freely release its power."[146] The Folkwang was thus a unified work of art, but its message was neither monumental nor spiritual nor historical; it was built not to honor a dynasty or convey a message about the past but rather to display the distinctive beauty of individual objects.

The Folkwang was best known for its remarkable collection of modern sculpture, paintings, and graphics, which eventually included works by impressionists such as Renoir and Liebermann, and representatives of the prewar avant-garde—Gauguin, Kandinsky, Matisse, Munch, Nolde, and others—several of whom were shown there for the first time in Germany.[147] The museum also contained a wide variety of other arts and crafts: carpets and weapons from the Middle East, bronzes from China, straw weavings and woodcuts from Japan, tiles from Spain, and furniture and ceramics by contemporary European artisans. In its range and diversity, the Folkwang resembled early-modern cabinets or curiosities, but with one important difference: Osthaus valued his possessions not because they were rare or odd or scientifically interesting but because they were beautiful. They all were, in one way or another, art—selected on the basis of what he called "their artistic, inspirational worth." Because the collection's first law was "quality" he said, "the art of all periods and areas of the world is displayed in an exemplary selection."[148] The most important principle of the museum's organization was neither historical nor technical but aesthetic: things were displayed together because their color, form, or mood seemed harmonious.[149]

In "Museums in the Service of Art," a lecture he delivered in 1904, Osthaus contrasted conventional art museums with those that sought to connect with the living art of the present. In words reminiscent of Lichtwark's pedagogical aspirations, Osthaus called upon museum officials to become part of their community, to educate ordinary citizens, and to encourage creative artists; he thought the educational mission especially necessary in modern industrial cities, where the workers' shabby tenements and the owners' pretentious villas were equally without true culture.[150] To this mission Osthaus dedicated the Folkwang. Beginning in the winter of 1902–1903, he gave a series of lectures on topics ranging from modern painting to Japanese printmaking. The following year, he had Peter Behrens design an auditorium where he could use pieces from the museum's own collection as the basis for his talks. Like Lichtwark and many other art reformers, Osthaus joined the *Werkbund* and supported various projects devoted to aesthetic education. Eventually, however, he apparently became disappointed with the results of his efforts. In the years just before the war, his interest in the Folkwang waned, and he turned instead to urban planning as a means of spreading his artistic values.[151] The museum did not survive Osthaus's early death in 1921 and the economic upheavals of the postwar era; the bulk of its collection was sold to the city of Essen, where it formed the basis for what is now called the Folkwang Museum.

Despite its rather brief existence, Osthaus's Folkwang in Hagen is important to the museum story because it so vividly reflected many of the ideas at work in the prewar art world. Nowhere else can we see more clearly efforts to expand the concept of art, introduce purely aesthetic principles of organization, and thus replace both the classical art-historical narrative and the traditional definition of the fine arts upon which it had been based. But the building's direct influence on German art museums is difficult to establish. One reason may have been the inherent limitation of van de Velde's design, which, like most art nouveau, worked best on a small scale. Even when van de Velde himself turned to more monumental structures, such as the Abe memorial in Jena and his later museum projects, the results were usually heavy and dull. But a more important explanation for the Folkwang's minor influence was the fact that few museum directors had Osthaus's autonomy. Most had to work within an existing building; even those who could participate in the construction of a new museum had usually inherited a collection; and almost all the officials were responsible to higher authorities who set limits on how much they could spend and what they could buy and display. For the most part, therefore, innovation came not through the construction of totally new museums but through the reorganization and redecoration of existing spaces.

Renovations

Around the turn of the century, museums were renovated for several practical reasons. There were, for example, continued efforts to resolve the issue of lighting, which remained the most vexing problem for the proper display of paintings: the layout of some older buildings was changed in order to conform to new ideas about the use of natural light; a few were altered to take advantage of recent advances in artificial lighting.[152] Museums also had to renovate their spaces in order to fulfill some of the new functions that reformers such as Lichtwark were pressing upon them. Some built or expanded libraries in order to enhance their scholarly activities; others put in reading rooms and lecture halls to improve their educational mission; still others added a room reserved for their most important private patrons.[153] And of course almost every museum needed additional space for its growing staff: offices for the director and his assistants, work spaces for restoration and conservation.[154] In the early twentieth century, museums were still a long way from those of today, in which exhibition space may take up less than half the building, but they had also come a long way from the buildings designed by Schinkel and Klenze, which were given over almost entirely to display.

The most insistent pressures for museum renovation came from the steady expansion of their holdings. Many early museums, as we have seen, were built with a particular collection in mind: Klenze, for example, had calculated the dimensions of the Pinakothek by measuring King Ludwig's pictures. Consequently, most were full when they first opened their doors:

Semper's Dresden gallery, which initially exhibited 2,200 paintings, even
had a surplus of 700—some of which were later sold. Once opened, how-
ever, museums regularly added to their holdings through both gifts and
purchases. (Most directors, after all, wanted to leave their mark by acquir-
ing significant new works; such additions were, and still are, an important
way of measuring the success of a director's tenure). As a result, the
museum staff continually faced the often painful task of finding a place for
new objects by removing old ones, which usually meant placing them in
storage, sending them to less important museums, or displaying them in
other public buildings. Between 1887 and 1904, the leaders of the Dresden
gallery managed to put 244 of its extra pictures in eighteen different loca-
tions around Saxony.[155]

As can be seen in Preusser's painting of the Dresden gallery (reproduced
in fig. 19), the traditional museum attempted to display as much of its
collection as possible. Especially in their large, top-lighted central spaces,
museums covered their walls with several rows of pictures; they were hung
by school and period but also necessarily had to be grouped according to size.
Precisely this kind of arrangement opened museums to the criticism that they
had become mere storehouses of art, boring, intimidating, or simply over-
whelming to ordinary visitors. By the turn of the century, many museum
administrators were looking for ways to make their collections more acces-
sible to the public and more aesthetically pleasing to connoisseurs.

The method used in both the Kaiser-Friedrich and Darmstadt Museums
was to create an appropriate architectural setting for a particular set of objects:
a medieval chapel for an altarpiece; a Renaissance interior for fifteenth-
century paintings and sculpture. This had long been common practice in
both historical and craft museums, in which a room's architectural style,
interior decoration, furnishings, and artifacts combined to reproduce the look
of a particular period. It had also been used with dramatic effect to display
the Hohenzollern Egyptian collection in Berlin's Neues Museum. And it
obviously met the objection that museums too often uprooted art objects from
their historical context.

But the use of such period rooms to display art created some serious
problems. For one thing, these rooms enhanced but also fragmented the
visitor's experience; their presence acknowledged that the museum no longer
offered a unified visual history of art but rather presented a series of pleasing
but separate experiences. Moreover, period rooms were extremely expen-
sive and almost always required painful choices between historical accuracy
and aesthetic effect. Few museums had enough authentic objects from the
same era to fill a room. And even if they did, serious scholars realized that
the result was hardly what the interior of a chapel or a palazzo actually looked
like. Finally, period rooms necessarily committed the museum to a particu-
lar arrangement of its exhibitions. Once one or more of them had been built,
it was very hard to change them, which meant that they inhibited the museum's
future growth and reorganization.[156]

Rather than trying to embed objects in their historical context, most museum designers moved in the opposite direction: that is, they began to isolate important works of art and thus make them more individually accessible to the viewer.[157] Gradually, museums abandoned the convention of filling their available wall space with pictures in favor of displaying a relatively small number of works, usually in a single row at eye level. Sufficient space was left around each picture so that it could be viewed separately, although every effort was made to establish visually pleasing relationships among the individual works. In the decade before 1914, most major German museums began to display their pictures in this new fashion; their walls became less densely filled, their rooms brighter and more spacious, their spaces less crowded with heavy furniture (fig. 29).[158]

In their new visual style of display, art museums were following the lead of commercial galleries, which had developed new ways of exhibiting their wares. In Berlin, for example, the Cassirers hired van de Velde to remodel their Berlin showrooms, whose bright, stylish spaces became appropriate settings for the works they contained.[159] "Everything is new, fresh, modern," wrote a visitor to a Munich gallery in the 1890s. "Everything glitters and sparkles . . . in light, clear tones."[160] It was precisely the desire to be new, fresh, and modern that led officials to strip the red damask from museum walls, get rid of heavy curtains and ornate decorations, and remove a substantial number of their less important works. Again, one is struck by the reciprocal character of the relationship between galleries and museums: just as galleries had adopted the traditional museum's dignified atmosphere and scholarly attitudes, so museums followed the galleries' efforts to create an attractive, uncluttered environment in which visitors could focus their attention on a few works of high quality.

It is not surprising that one of the first and most impressive remodeling projects took place in Berlin, where Tschudi, the friend and collaborator of several prominent gallery owners, faced the Herculean task of transforming the National Gallery into an attractive setting for contemporary art. That it needed renovation was painfully obvious to its new director. Based on Frederick William IV's sketch of a building to house the Academy of Art, the National Gallery resembled a Greek temple perched on a high pediment. Architecturally, it was an awkward building with an inflexible floor plan, limited exhibition space, and poor lighting—in sum, a prime example of the divorce of function from form that bedeviled late historicism. To make matters worse, it was bursting at the seams with a large, uneven collection of pictures, many of them mediocre works that had been selected because of their patriotic subject matter. Of the 376 pictures exhibited when the gallery opened in 1876, only 88 survived Tschudi's review of the collection after the turn of the century.[161]

Soon after he assumed the directorship in 1896, Tschudi not only began to weed the collection and add some interesting new works; he also changed

FIGURE 29. National Gallery in Berlin: redecorated interior (1908).

the mode of display. The old color scheme, which some said looked like an unappetizing mixture of coffee and chocolate, was replaced with brighter, more vibrant tones of pink, light green, and yellow. Although some of these innovations had to be abandoned after his dramatic confrontation with the emperor in 1899, Tschudi pressed on with a less direct approach.[162] In 1905, he took advantage of the exhibition marking Adolf von Menzel's eightieth birthday to introduce more changes in the decorative scheme. The following year he employed Peter Behrens to design the Century Exhibition. Behrens replaced the gallery's ornate, heavily ornamented interiors with an open, brightly colored environment; he put a relatively small number of works on smooth walls, painted in light colors of gray, yellow, or white and decorated with elegantly simple, rhythmic designs.[163]

Tschudi continued to work on improving museum displays after his move to Munich in 1909. In a remarkably brief period, he rearranged the Alte Pinakothek's collection: he put some of its works into storage, sent others to provincial museums, and rehung the best of what remained on repainted walls. Now, he told a Munich newspaper, "every single work is able to lead its own life." At the same time, he began to plan a major expansion of the museum building and a reorganization of the Neue Pinakothek, projects that were left unfinished at the time of his death.[164]

Both in Berlin and Munich, Tschudi's efforts met stubborn opposition. Some of it came from people who could not imagine a museum without red damask walls, heavy drapes, and row upon row of pictures. As might be expected, local artists vigorously objected to having their work shipped off somewhere so that the rest of the collection might be more effectively displayed. Moreover, even among those who accepted the need to reduce the number of pictures shown, there was no consensus about what constituted the best background. Bode made some caustic remarks about the colors Tschudi used in Munich; even Lichtwark, who was substantially more sympathetic to modern fashions, was skeptical about Tschudi's decorative scheme for the Pinakothek.[165]

But despite opposition from the artistic establishment and disagreement about how reform should be implemented, the new style of exhibition took hold almost everywhere. In one version or another, it was adopted by Woermann and Seidlitz in Dresden, Justi in Frankfurt, and many other museum professionals. Even in Berlin and Munich, where opposition to innovation had been especially vigorous, Tschudi's successors—Justi in Berlin, Heinz Braune in Munich—were eventually able to put most of his principles into practice.[166] No longer did museum directors attempt to have as much of their collection as possible on display. Some even suggested that there should be two kinds of museum space, a *Schausammlung*, a display collection for the general public, organized according to aesthetic principles, and a *Depotsammlung*, a depository collection for scholars interested in strict chronology and historical coverage.[167]

The Decline of Monumentality

Meier-Graefe was prepared to do more than just abandon strict chronology and historical coverage; in his ideal museum, art would be grouped not by "nationality, century, or other arbitrary concepts" but only according to the character of the individual works.[168] Meier-Graefe's formulation directly attacked the very foundations of traditional art history: if place and time were no more than "arbitrary concepts," then the historical development of art as it had been understood since Winckelmann would lose its meaning. Only in a few places such as Osthaus's Folkwang was such a radical rejection of historical order put into practice; most museums continued to use some kind of chronological arrangement to display their collections. Nevertheless, by 1900 it had become clear that history was not the only, and sometimes not the most important, principle of organization; an increasing number of museum professionals were prepared to sacrifice history to aesthetics. Woldemar von Seidlitz wrote in 1904 that the "basis" for the success of museum reform was "not historical or cultural considerations . . . but rather artistic ones."[169]

Another indication of history's waning influence as the intellectual framework for art was the virtual disappearance of the programmatic decorations that had characterized museum architecture before the 1880s. Except for the discreet statuary above the entrance to the Kaiser-Friedrich, there were no programmatic elements in the three buildings discussed in this chapter: no artists' portraits, no friezes, murals, or allegorical ornaments. In the section on museums in his architectural handbook, Heinrich Wagner acknowledged that a decorative background might be appropriate in exhibitions of folklore or natural history but was rarely effective in painting galleries. Above all, he insisted, "in the exhibition spaces, the architecture should not be intrusive."[170] Most new construction proceeded from this assumption. For example, when the authorities in Wiesbaden invited plans for a new museum in 1906, they explicitly stated, "We do not put any special value on splendid decorations."[171] A similar attitude toward ornamentation was evident in the investigation of museum architecture which Lichtwark conducted in preparation for an extension to the Hamburg Kunsthalle: "We are again and again led into making mistakes by the deeply embedded assumption that monumental buildings must have a different character from domestic ones." In its final form, the new extension did not avoid a restrained sort of monumentality, but its staircase remained unadorned by programmatic murals, and its entrance hall celebrated the generosity of its donors, not the grand narrative of art's history.[172]

There was a retreat from monumentality throughout the art world after the turn of the century. Modernism's style and subject matter, as well as its institutional foundations and social location, were not compatible with the monumental projects that had been the hallmark of artistic achievement and

economic success for such men as Cornelius and Kaulbach.[173] The decline of monumentality had a special significance for the museum's physical appearance and institutional identity. "The future destiny of museum buildings," Lichtwark wrote, "depends on changes in the soul for which the museum is a shell." In 1928, Georg Swarzenski made the same point more directly when he declared, "We should speak more of the artistic contents of museums rather than of *the* museum. . . . There is no 'museum as such.'"[174] Of course the "museum as such" remained, but it no longer aspired to express unchanging aesthetic values and unbroken historical continuity. Those monumental aspirations did not survive the cultural crisis that was apparent as the new century began.

The shift away from monumentality would eventually transform museums everywhere in Europe and America. Eventually, their programmatic character would give way to apparently neutral contexts for the display of art, thus moving museums toward what Brian O'Doherty has called the "white cube" mode of exhibition space.[175] Objects were isolated, each one to be seen and understood on its own, without the distracting mediation of programmatic decoration. The separation of contents and context, objects and architecture, which had begun in the princely galleries at the end of the old regime, was now complete.

But although the architecture of museums grew silent, their facades stripped of decoration and their interiors made properly unobtrusive, the museum's role as a source of value and meaning did not decline. In fact, the open-ended quality of the museum's setting tended to make its institutional decisions about what objects to display and how to display them all the more important. As Mary Douglas once astutely noted, "The high triumph of institutional thinking is to make the institutions completely invisible."[176] In the nineteenth century, museums had expressed a cultural consensus within the art world about art's history, meaning, and value. In the twentieth, as this consensus waned, it was left to museums themselves to create histories, meanings, and values to take its place. The decline of monumentality changed but did not diminish the museum's intermediary role in an increasingly complex and divided art world.

CONCLUSION

From their origins in the eighteenth century, German art museums reflected and reinforced the art world's leading ideas and institutions. At the end of the old regime, this meant ideas about art's autonomy and moral purpose and institutions shaped by court and public. In the revolutionary era, when the first great museum building projects were conceived in Munich and Berlin, museums and the art world were charged with a widespread belief in art's role in the creation of a new civic community. During the middle decades of the nineteenth century, museums were part of the art world's monumental aspirations to connect past, present, and future. And finally, at that century's end, museums became the site of a broader cultural struggle between the advocates and enemies of artistic modernism. It is impossible, of course, to know how this struggle might have ended because the Wilhelmian art world, like so much else in Germany, failed to survive the catastrophes of war and revolution. Our story therefore comes to an abrupt and indecisive conclusion in 1914, when a new chapter in the history of the German art world begins.

Although the art world was fundamentally altered by the First World War and its aftermath, one should not overlook the lines of continuity that stretch across the chasm of 1914–1918. The men who made up the core of the museum establishment in the 1920s, for example, had all begun their careers during the *Kaiserreich*. Ludwig Justi, Tschudi's successor at the National Gallery in Berlin, remained in office under the Weimar Republic. Max Sauerlandt, another member of the group that Vernon Lidtke has called "museum modernists," returned from military service to his post as director in Halle and then moved to the Museum für Kunst und Gewerbe in Hamburg. Similarly, Ernst Gosebruch (Essen), Walter Kaesbach (Erfurt), Emil Waldmann (Bremen), Georg Swarzenski (Frankfurt), and Gustav Pauli (Hamburg) held important posts both before and after the war.[1] These men were not, in Peter Gay's memorable phrase, "outsiders" who became "insiders"; rather, their prominence during the republic represented the replacement of one group of insiders by another.[2]

Most of the museum modernists were forced from office when the Nazis took power in 1933, and the modern art that they had so carefully acquired

was removed from museum collections. Some of it ended up in the notorious exhibition of "degenerate art" that opened in Munich in 1937 and then toured Germany for the next three years.[3] Some was destroyed or sold at bargain prices to collectors throughout the world. The Nazis also made some desultory efforts to promote art in keeping with the new national spirit and began to plan massive new building projects—including a vast museum complex in Hitler's hometown of Linz—that would express their own conceptions of art, history, and power. Few of these plans were realized. The only important exhibition building actually constructed in the 1930s was the Haus der Deutschen Kunst, which was built according to plans by Hitler's favorite Munich architect, Paul Ludwig Troost, and opened at the same time as the "degenerate art" exhibition in 1937 (fig. 30). Troost's translation of Schinkel's motifs from the Altes Museum into the crude idiom of fascist architecture clearly displays the limitations of Nazi aesthetics.

For all their talk about transforming museums into "national shrines of German art," the Nazis had little positive effect on museums in particular or the art world in general.[4] They were better at destroying what they did not like than at putting something of value in its place. Like their other cultural endeavors, Nazi artistic policy consisted of empty promises and real threats.

In 1939, German art museums were swiftly caught up in the destructive fury unleashed by Hitler's drive for European hegemony. Initially, they were among the beneficiaries of the gigantic looting campaign that attended Germany's military victories from 1939 to 1942. Thousands of valuable objects from both public and private collections throughout Europe were shipped back to the Reich, where they were assigned to existing museums, put in storage for the proposed artistic center in Linz, or made a part of Hermann Göring's personal collection.[5] Then, after briefly enjoying the fruits of victory, museums joined the long list of institutions that suffered the pains of defeat. Most of the buildings discussed in this book were badly battered; some were totally destroyed. And although museums often managed to preserve their collections, their own monumental decorations were damaged beyond repair.

The history of the German art world after 1945 was a characteristic postwar combination of reconstruction and innovation. Gradually, the most important museums were rebuilt. Some, such as the Gemäldegalerie in Dresden, were attempts to reproduce the original; others, such as Hans Döllgast's reconstruction of the Alte Pinakothek in Munich, retained visual evidence of war damage in the fabric of the building.[6] Beginning in the 1960s, new museums were built in the Federal Republic, among them some of the postwar era's finest buildings: Mies van der Rohe's new National Gallery in West Berlin (1965–1968), Philip Johnson's Kunsthalle in Bielefeld (1966), Alexander von Branca's Neue Pinakothek in Munich (1974–1981), James Stirling and Michael Wilford's Neue Staatsgalerie in Stuttgart (1977–1982), and Richard Meier's Museum für Kunsthandwerk in Frankfurt (1979–

FIGURE 30. Haus der Deutschen Kunst in Munich from the east.

1985).[7] As the architects' names immediately reveal, German architecture in the postwar period became again what it had been in the age of du Ry and Tiepolo—an international enterprise.

Let us conclude by looking at Stirling and Wilford's Neue Staatsgalerie, which can serve as a kind of coda to the history of museum architecture since the end of the old regime. The building stands in Stuttgart's former cultural center, which once included the original Staatsgalerie, the museum of natural history archives, library, and theater. Most of these buildings were destroyed during the war, and the spatial integrity of the area itself was broken by the busy Konrad-Adenauer-Strasse, a divided road that runs directly in front of the new gallery. In contrast to Schinkel's Altes Museum or Klenze's Glyptothek, Stirling's gallery could not command the space around it but had to find a place within a crowded, hectic urban environment. Stirling began by separating his site from the roadway with a line of forty plane trees, which will eventually shield the museum from some of the street noise. Within the site, Stirling proceeded with tact and discretion: he attempted, as one critic put it, to create an architecture that "would engage and reflect the urban fabric" around it.[8] The gallery, therefore, conforms to the contours of the site; it fits gracefully into its surroundings and provides a public passageway to the street above and behind it.

From the moment visitors enter the glass-covered portico from the Konrad-Adenauer-Strasse, they know that they are in a modern building. The gallery's bright colors, the undulating curve of its glass facade, the red doorways into the building, the green hard-rubber floor, and the exaggerated fragmentation of the structure itself all emphasize Stirling's identification with modernist styles. At the very center of the foyer, reverently set under its own little rotunda, stands the museum's gift shop, whose prominence recalls contemporary art's close connections to commerce. But although self-consciously modern, Stirling was no less mindful of history: "I hope," he said, "that the building will evoke associations with museums and I want the observer to feel that 'this looks like a museum.'" With the monumental beauty of its stone exterior as well as a series of architectural allusions its details, Stirling sought to set his gallery firmly within the museum's history. The building's success, therefore, depends on a series of carefully constructed balances between structure and site, aesthetics and functionalism, the monumental and the playful.

The most striking example of Stirling's blend of modernity and tradition is the rotunda, which in the Stuttgart gallery—as in Schinkel's Berlin museum—forms the central element. Indeed, a comparison of Stirling's plan with Schinkel's (cf. fig. 31 and fig. 11) makes the kinship between the two museums unmistakable. And yet the two rotundas are dramatically different: Schinkel's was closed, separated from the rest of the building and carefully concealed from the outside world; Stirling's is open—open to the sky, to the outside (it is part of the passageway up to the next street), to the other parts of the gallery, even to the natural world, which is represented by the ivy cling-

FIGURE 31. Neue Staatsgalerie in Stuttgart: plan of the gallery level.

ing to its walls. The differences between their rotundas point to the most important difference between Schinkel's and Stirling's visions of a museum. Schinkel's rested firmly on his faith in the social value of art and the time-less relevance of the classical ideal; he left no doubt about how he wanted his museum to be experienced and what this experience should do for visitors. There is, by contrast, a self-conscious openness about Stirling's building, which offers visitors a number of alternatives: they can sit down together in the restful quiet of the rotunda, walk around the exhibition rooms and look at the art, or just pass through on their way to someplace else. Whichever alternative they choose, the building will suit their needs. In this way, Stirling has returned to the variety of social experiences offered by art in the old regime, the experiences that Beger pictured in his drawing of an ideal cabinet (fig. 2) and Chodowiecki satirized in his drawings of natural and affected *Connoisseurship* (fig. 1).

The museum, Stirling once wrote, is a place "in which the styles of different eras are brought together as in a giant collage—so why shouldn't the building itself also be such a collage of architectural quotations?"[9] Stirling's insight, which his Stuttgart gallery beautifully expresses, is an ap-propriate place for us to conclude because it captures one of this story's most important messages: among the significant artifacts that museums contain are the intellectual, institutional, and architectural traces of their own his-tory, residues of their own past.

NOTES

Abbreviations

AR	Architectural Review
AfK	Archiv für Kulturgeschichte
AB	The Art Bulletin
AH	Art History
AJ	The Art Journal
CEH	Central European History
DR	Deutsche Rundschau
DK	Deutsches Kunstblatt
FAZ	Frankfurter Allgemeine Zeitung
Gb	Grenzboten
HZ	Historische Zeitschrift
INR	Im neuen Reich
JbBM	Jahrbuch der Berliner Museen
JbPKS	Jahrbuch der preussischen Kunstsammlungen
JbPKB	Jahrbuch Preussischer Kulturbesitz
JAAC	Journal of Aesthetics and Art Criticism
JHC	Journal of the History of Collections
JMH	Journal of Modern History
KfA	Kunst für Alle
KK	Kunst und Künstler
KSA	F. Nietzsche, Kritische Studienansgabe 15 vols. (1967–1988)
MJbBK	Münchner Jahrbuch der bildenden Kunst
Mk	Museumskunde
NDB	Neue Deutsche Biographie
NR	Neue Rundschau
NYRB	New York Review of Books
OAJ	Oxford Art Journal
PJbb	Preussische Jahrbücher
RM	Review of Metaphysics
SJb	Städel-Jahrbuch
VKM	Velhagen und Klasings Monatshefte
WRJb	Wallraf-Richartz Jahrbuch
Wm	Westermanns Hefte
ZBK	Zeitschrift für die bildende Kunst
ZGO	Zeitschrift für die Geschichte des Oberrheins
ZKG	Zeitschrift für Kunstgeschichte
ZRG	Zeitschrift für Religions- und Geistesgeschichte

Introduction

1. There is a very large literature on the significance of museums for modern culture. See, for example, Bennett, *Birth* (1995); Duncan and Wallach, "Survey" (1980); Duncan, *Rituals* (1995); Bourdieu, *Distinction* (1984); Crimp, *Museum's* (1993); Bal, *Exposures* (1996). I have found Fisher, *Making* (1991), and Lübbe, *Fortschritt* (1982), of particular value. Guides to further reading include Sherman and Rogoff, eds., *Museum Culture* (1994), and Vergo, ed., *Museology* (1989).

2. Among the general histories, Malraux's flawed classic, *Voices* (1978), remains the most influential. See also Bazin, *Age* (1967); Wittlin, *Museum* (1949); Hudson, *History* (1975) and *Museums* (1987); Grasskamp, *Museumsgründer* (1972); and Haskell, ed., *Saloni* (1981). McClellan, *Inventing* (1994), is a fine case study of the Louvre.

3. Danto, "Art World" (1964).

4. Becker, *Art Worlds* (1982), p. x. Also of use on the institutional context for art is Zolberg, *Constructing* (1990). On the sociology of art and of museums in particular, see César Graña's essays, collected in *Fact* (1971) and *Meaning* (1989).

Chapter 1

1. Quoted in Kristeller, "System" (1980), p. 203 n. 200.

2. Kristeller, "System" (1980).

3. Abrams, "Art as Such" (1989).

4. Abrams, "Art as Such" (1989), p. 137.

5. During the Enlightenment, Cassirer wrote in *Philosophy* (1951), p. 298, "psychology and aesthetics . . . enter into so intimate an alliance that for a time they appear to be completely amalgamated."

6. Busch, "Chodowieckis" (1989), and *Bild* (1993), pp. 309–26; Link, "Practice" (1992); Kemp, "Kunst" (1989); Geismeier, *Chodowiecki* (1993).

7. Art, wrote the author of an article published in *Miscellaneen artistischen Inhalts* in 1780, is accessible only to those who are sincere, open, and unaffected; only they can learn its lessons and savor its delights. "The noble ambition as well as the pleasure from the fine arts can only develop in free souls": [Anon.], "Kunstgefühl" (1780), pp. 4, 8.

8. Baumgarten, *Ästhetik* (1983) is a useful collection. On Baumgarten, see Lotze, *Geschichte* (1868), pp. 4 ff.; Dilthey, "Epochen" (1892), pp. 254 ff.; Cassirer, *Philosophy* (1951), chap. 7; Norton, *Soul* (1995), pp. 83 ff. The best brief introduction to eighteenth-century aesthetics is Ritter, "Aesthetik" (1971).

9. Baumgarten, *Ästhetik* (1983), pp. 2, 11.

10. Quoted in Ritter, "Aesthetik" (1971), p. 558. Unless otherwise identified, all the translations in this book are mine.

11. Quoted in Woodmansee, *Author* (1996), pp. 15–16.

12. Norton, *Soul* (1995).

13. MacIntyre, *History* (1966), esp. pp. 167 ff.

14. On Sulzer, see Dobai, *Künste* (1978); Norton, *Soul* (1995), pp. 192; and van der Zande, "Orpheus" (1995). There is a useful translation of some of his most important work in Sulzer, *Aesthetics* (1995).

15. Sulzer, *Theorie* (1972–1994), 3:72.

16. Quoted in Link, "Practice" (1992), p. 6. In "Orpheus" (1995), van der Zande emphasizes Sulzer's ideas about the social importance of art.

17. On Kant's aesthetic writings in the 1760s, see the useful summary in Norton, *Soul* (1995), pp. 93–99. There is an enormous literature on Kant's third critique;

for an introduction to the philosophical issues, see Guyer, "Kant's" (1994), and *Kant* (1979). I am especially indebted to the analysis in John Zammito, *Genesis* (1992).

18. Kant, *Critique* (1952), para. 5, p. 50 (Meredith translation). Further references appear in parentheses in the text.

19. We can also ignore the puzzling shift in focus between the first and second parts of the *Critique*, which is examined at length in Zammito, *Genesis* (1992).

20. Goethe, "Winckelmann" (1805), in *Werke* (1981), 12:110.

21. The classic work on Winckelmann remains C. Justi's three-volume biography, *Winckelmann* (1956). Pfotenhauer, et al., eds., *Frühklassizismus* (1995) has a useful selection of his writings with excellent editorial material. The most recent work in English is Potts, *Flesh* (1994). Also of value are E. M. Butler's characteristically brilliant and eccentric treatment in *Tyranny* (1958), p. 11; Hatfield, *Winckelmann* (1943); W. Waetzoldt, *Kunsthistoriker* (1965), 1:51 ff.; Dilly, *Kunstgeschichte* (1979), pp. 90 ff.; the essays in Gaehtgens, ed., *Winckelmann* (1986); the brief account of his influence in Seeba, "Winckelmann" (1982); and Marchand, *Olympus* (1996), chap. 1.

22. Winckelmann, *Werke* (1969), p. 2.

23. Koselleck, *Zukunft* (1979).

24. Winckelmann, *Werke* (1969), p. 180.

25. Quoted in C. Justi, *Winckelmann* (1956), 3:160. See also Potts, *Flesh* (1994), pp. 54 ff. and chap. 6.

26. On the enduring appeal of this ideal in German thought, see Chytry, *State* (1989).

27. Quoted in C. Justi, *Winckelmann* (1956), 2:48.

28. Goethe, "Winckelmann" (1805), in *Werke* (1981), 12:116.

29. Hegel, *Ästhetik* (1970), 1:92. Dilly, *Kunstgeschichte* (1979), pp. 97–98, has references to Foucault on the eighteenth century's discovery of the "eye"; Baxandall, *Patterns* (1985), pp. 8–9, discusses the changing role of visual analysis in art history.

30. C. Justi, *Winckelmann* (1956), 3:199.

31. C. Justi, *Winckelmann* (1956), 1:316 ff.

32. Haskell and Penny, *Taste* (1988), pp. 102–3; C. Justi, *Winckelmann* (1956), 2: 93 ff.; Gesche, "Bemerkungen" (1982), pp. 439–60 (p. 445 for the quotation, from Winckelmann's additions to his *Geschichte*).

33. Podro, *Historians* (1982), p. 2. See also Meinecke, "Klassizismus" (1959).

34. Winckelmann, *Werke* (1969), p. 180.

35. Winckelmann, *Geschichte* (1964), p. 536.

36. Goethe, *Werke* (1981), 5:7 ff. A reference to Iphigenia appears in Johann Tischbein's well-known painting "Goethe in the Campagna" (now in the Städel in Frankfurt), where the frieze behind the poet shows her meeting with her brother and thus the beginning of her homecoming. Another example of this theme's popularity is Anselm Feuerbach's painting in which—as he put it—Iphigenie is shown on the seashore "searching for the land of the Greeks with her soul": quoted in H. Börsch-Supan, *Malerei* (1988), p. 478.

37. Quoted in Boyle, *Goethe* (1991), p. 437.

38. Habermas, *Strukturwandel der Öffentlichkeit*, was first published in 1961. This is obviously not the place to engage the complex debate surrounding Habermas's work. For an introduction to the critical literature see the essays in Calhoun, ed., *Habermas* (1992); on the history of the German public, seen in comparative perspective, see the excellent review article: LaVopa, "Public" (1992).

39. Quoted in Habermas, *Transformation* (1989), p. 26.

40. Another illustration of the trend toward subjectivity was in church music, which increasingly attempted to encourage individual devotion rather than to inspire the congregation to proclaim God's glory. Or consider the difference in design between a formal baroque garden and the informal English garden so popular in the eighteenth century: the former was a setting for social action; the latter, for private contemplation. See Dahlhaus, *Music* (1989), p. 179; Beenken, *Jahrhundert* (1944), p. 17 f.; Landsberger, *Kunst* (1931), pp. 40–41.

41. Habermas, *Transformation* (1989), p. 43. The classic statement of this position is Balet and Gerhard, *Verbürgerlichung* (1936).

42. Griffiths and Carey, *Printmaking* (1994), p. 16. See also Busch, "Chodowieckis" (1989), and the comments by Wolfgang Martens in Barner, ed., *Tradition* (1989).

43. Quoted in C. Justi, *Winckelmann* (1956), 2:352. On Albani, see Haskell and Penny, *Taste* (1988), pp. 65 ff.

44. Boyle, *Goethe* (1991), p. 251.

45. Braun and Gugerli, *Macht* (1993), p. 189. The most complete treatment is Hirsch, *Dessau-Wörlitz* (1988). On Dessau's architecture, see Watkin and Mellinghoff, *Architecture* (1987), pp. 29–34.

46. Pevsner, *History* (1976), pp. 74–76, on Berlin. For the changing role of the courts as patrons of the arts, see T. Kaufmann, *Court* (1995), and Daniel, *Hoftheater* (1995).

47. On the court as a mode of communication, see Daniel, *Hoftheater* (1995), pp. 27–28.

48. Mannlich's memoirs of court life can be found in his *Rokoko* (1966). On his career, see Roland, "Mannlich" (1964). Haskell, *Patrons* (1980), summarizes the role of patronage in the seventeenth and eighteenth centuries.

49. Chodowiecki, *Briefe* (1921), contains his correspondence with Graff; on the Berlin offer, see p. 60.

50. W. Geismeier, *Chodowiecki* (1993); Pevsner, *Academies* (1973); Koch, *Kunstaustellung* (1967).

51. Warnke, *Hofkünstler* (1985).

52. Seelig, "Munich *Kunstkammer*," especially the schematic reconstruction printed as plate 32. The classic work on early modern collecting is Schlosser, *Kunst- und Wunderkammern* (1908); the most up-to-date is T. Kaufmann, *Mastery* (1993). See also T. Kaufmann, *Court* (1995), chap. 7; Pomian, *Ursprung* (1988), and *Collectors* (1990). Samples of recent scholarship are collected in Impey and MacGregor, *Origins* (1985), and Grote, *Macrocosmos* (1994). For the Italian background, see Findlen, *Possessing* (1994). Balsiger, "Kunst- und Wunderkammern" (1970), provides catalogues of the most important collections.

53. Scheicher, "Collection" (1985).

54. Bredekamp, *Antikensehnsucht* (1993), p. 23.

55. Scherer, *Museen* (1913), p. 55.

56. See Connelly, "Gallery" (1972), and McClellan, *Inventing* (1994), on the French case; Mordaunt, *Museum* (1972), on the British (quotation, p. 53). See also the essays in Bjurström, *Genesis* (1993).

57. Dobai, *Künste* (1978), p. 132.

58. Hans Müller, *Akademie* (1896), p. 188. Schröter, *Maler* (1954), is the best general account. In Munich's Hofgarten gallery, artists and other visitors could ask to have the pictures they wanted to copy moved into a room set aside for the purpose. Hauntiger, *Reise* (1964), p. 70, reports a visit in 1784.

59. See Eberlein, *Literaturgeschichte* (1919); Lehmann, *Anfänge* (1932); Klemm, *Geschichte* (1838).

60. Quoted in Glaser, ed., *Krone* (1980), p. 345. On access and hours, see Pevsner, *History* (1976), p. 117.

61. Nicolai, *Beschreibung* ([1769], 1988), p. 348.

62. Bock, "Kunstsammlungen" (1993), p. 116.

63. Solimena's picture is described by Distelberger, in Impey and MacGregor, eds., *Origins* (1985), p. 46; the elector's portrait is reproduced in Scherer, *Museen* (1913), p. 65.

64. Schiller, *Werke* (1987–1989), 5:880.

65. Mannlich, *Rokoko* (1966). For another example, see Antoni, *Staatsgalerie* (1988), on Stuttgart.

66. There is a good brief account of Hagedorn in Justi, *Winckelmann* (1956), 1:408–17. See also Cremer, *Hagedorns* (1989).

67. This account is based on Wüthrich, *Mechel* (1956).

68. See Griffiths and Carey, *Printmaking* (1994), pp. 33 ff., and W. Becker, *Paris* (1971), p. 21.

69. There is an unflattering portrait of Mechel in Klöden, *Jugenderinnerungen* (1911), pp. 289–93. See also Meijers, *Kunst* (1991), pp. 163–73.

70. See Stübel, "Galeriewerke" (1925), for an introduction to this material.

71. Quoted in Stübel, "Galeriewerke" (1925), p. 306.

72. Quoted in Cremer, *Hagedorns* (1989), pp. 147–48.

73. In addition to the works cited in note 21, see Berliner, "Geschichte" (1928).

74. Quoted in W. Geismeier, *Chodowiecki* (1993), p. 8. The best introduction to printmaking in the eighteenth century is Griffiths and Carey, *Printmaking* (1994).

75. Heinse's work is reprinted with useful critical apparatus in Pfotenhauer, *Frühklassizismus* (1995).

76. Fisher, *Making* (1991), pp. 26–27, has pointed out the characteristically modern character of this coexistence of public and individualized cultural experiences.

77. Goethe, *Dichtung und Wahrheit*, in *Werke* (1981), 9:320. My translation is a revised version of John Oxenford's, in Goethe, *Autobiography* (1974), 1:346–47. See Woermann, "Goethe" (1912), for a description of the gallery as he saw it.

78. Kostof, *History* (1985), p. 3.

79. Ehalt, *Ausdrucksformen* (1980); Kruedener, *Rolle* (1973); Alewyn, *Welttheater* (1985).

80. Findlen, *Possessing* (1994), p. 98.

81. See, for example, T. Kaufmann, *Mastery* (1993), pp. 178–79.

82. Summarized in Pevsner, *History* (1976), p. 114. See Posse, "Briefe" (1931).

83. Pevsner, *History* (1976), pp. 118 ff., and Fabianski, "Iconography" (1890). On Boullée, see E. Kaufmann, *Architecture* (1955), Chap. 12.

84. The best account of early museum architecture is Seling's dissertation, "Entstehung" (1952), which is summarized in his article "Genesis" (1967). Seling's work provides the basis for the first half of the chapter on museums in Pevsner, *History* (1976). See also Liebenwein, "Sammlungsarchitektur" (1982). Of particular value for the origins and development of German museums is Plagemann, *Kunstmuseum* (1967).

85. Scherer, *Museen* (1913), pp. 38–41; Christian Theuerkauff, in Impey and MacGregor, eds., *Origins* (1985), pp. 110–14; Rave, *Schriften* (1994), pp. 177–201. For a description of the Hohenzollern *Kunstkammern* after they were moved to the new Berlin Palace, see Nicolai, *Beschreibung* ([1769], 1988), pp. 327 ff.

86. On the role of the baroque *Treppenhaus*, see Alewyn, *Welttheater* (1985), pp. 52–53.

87. Frosien-Leinz, "Antiquarium" (1980). See also Haskell, *History* (1993), pp. 38–39, and T. Kaufmann, *Court* (1995), p. 176.

88. Stübel, "Galeriewerke" (1925), p. 247; Seling, "Entstehung" (1952), pp. 12 ff. On galleries in the rest of Europe, see Brown, *Kings* (1994), pp. 28 ff., and Findlen, *Possessing* (1994), pp. 116–17.

89. Fink, *Geschichte* (1954), especially pp. 37–40, and Gerkens, *Lustschloss* (1974), especially pp. 111–25.

90. Woermann, "Anfang und Ende" (1881).

91. T. Kaufmann, *Court* (1995), pp. 325–33.

92. Heres, *Kunstsammlungen* (1991), esp. the fine picture of this gallery by Bernardo Bellotto, reproduced on p. 20.

93. There is some information on government buildings in Pevsner, *History* (1976).

94. Hirsch, *Dessau-Wörlitz* (1988), p. 214. Winterling, *Hof* (1986), has other examples. The classic contemporary work on these royal retreats is Jacques François Blondel, *De la distribution des maison de plaisance et de la décoration des édifices en général* (Paris, 1737).

95. Baumgart, "Hof" (1981), p. 31.

96. Kurth, *Sanssouci* (1964).

97. See K. Clark, *Looking at Pictures* (1960), pp. 75–87.

98. Quoted in Eckardt, "Bildergalerien" (1981), p. 141, which has a good brief account of the gallery. See also Eckhardt, *Bildergalerie* (1975); H. Börsch-Supan, *Kunst* (1980), pp. 119 ff.; and Rave, *Schriften* (1994).

99. Reproduced in Kurth, ed., *Kunst* (1920), p. 29.

100. In addition to Eckardt, see Nicolai, *Beschreibung* ([1769], 1988), pp. 517–25.

101. For an up-to-date and well-balanced account of Frederick, see Ingrao, *State* (1987), which downplays the significance of the mercenaries.

102. Boehlke, *Simon Louis du Ry* (1980).

103. Keim, *Städtebau* (1990), pp. 71 ff.; *Aufklärung* (1979); Giedion, *Klassizimus* (1922), pp. 119 ff.

104. A good brief account of the building is in Watkin and Mellinghof, *Architecture* (1987), pp. 46–47. For a stylistic analysis, see Beenken, *Bauideen* (1952), p. 41; Giedion, *Klassizismus* (1922), p. 70.

105. Stix, *Aufstellung* (1922); Distelberger in Impey and MacGregor, eds., *Origins* (1985), p. 46.

106. Stix, *Aufstellung* (1922), pp. 17 ff. See also Aurenhammer and Aurenhammer, *Belvedere* (1971).

107. See, for example, the poem by Michael Denis and the allegorical painting by Vinzenz Fischer discussed in Meijers, *Kunst* (1991), pp. 18–19. There is a contemporary description in Nicolai, *Beschreibung* ([1781], 1994), 16:492–501.

108. Mechel, *Verzeichnis* (1783), p. v.

109. Mechel, *Verzeichnis* (1783), pp. xi–xii. See Wüthrich, *Mechel* (1956), p. 162.

110. Meijers, *Kunst* (1991), cautions against viewing Mechel's work retrospectively rather than as part of eighteenth-century ideas about the arrangement of art and natural-history collections. She skillfully analyzes the connections between his work at the Belvedere and contemporary ideas about time and nature. Nevertheless, although the "modernity" of his conceptions should not be overestimated, Mechel seems to me to deserve his place as an innovator.

111. Nicolai, *Beschreibung* ([1781], 1994), 16:496; Schröter, "Maler" (1954), p. 18. Mannlich attempted to enlist Goethe's support in an interesting series of letters: see Goethe, "Briefwechsel" (1908).

112. J. K. Wezel, quoted in Lehmann, *Anfänge* (1932), pp. 119–20.

113. Jordanova quoted in Vergo, ed., *Museology* (1989), p. 23.

114. Thus Schapiro, *Theory* (1994), p. 7, describes the frame as belonging "to the space of the observer. . . . It is a finding and focusing device placed between the observer and the image."

Chapter 2

1. See, for example, Goethe's remarks in the introduction to the *Propyläen* in 1798: Goethe, *Werke* (1981), 12:55.

2. Zammito, *Genesis* (1992), p. 1.

3. Quoted in Hamburger, *Reason* (1957), p. 16.

4. Schiller, *Werke* (1987–1989), 1:174–75.

5. The most important of Schiller's writings about art are available in his *Werke* (1987–1989), vol. 5. There is a good brief analysis of the evolution of his ideas in Podro, *Manifold* (1972), chap. 3–4. See also Chytry, *State* (1989), pp. 70 ff.

6. My account owes a great deal to the notes and introduction to Wilkinson and Willoughby's splendid edition of Schiller, *Education* (1967). I cite their translation in the text by letter, paragraph, and page: e.g. 2.5, p. 9 is the fifth paragraph of the second letter, to be found on p. 9. On Schiller's intellectual debt to and departures from Kant, see Henrich, "Beauty" (1992).

7. Quoted in editors' introduction to Schiller, *Education* (1967), p. xvii.

8. For a discussion of this uncertainty, see Woodmansee, "Art" (1993).

9. Schlegel quoted in Jauss, *Studien* (1989), p. 82. For the meaning and context of the remark, see Izenberg, *Individuality* (1992), chap. 3.

10. See Chytry, *State* (1989), pt. 2. For a full account of the "Systemprogramm," with particular emphasis on its relationship to Schiller, see Gethmann-Siefert, *Funktion* (1984).

11. Hegel, *Werke* (1971), 1:235–36.

12. See Frank, *Gott* (1982), for a stimulating examination of this theme.

13. On Romanticism, see Sheehan, *German History* (1989), chap. 6, and the literature cited there. Apel, *Kunstlehre* (1992), has a good selection of texts.

14. Holt, *Triumph* (1979), p. 150.

15. See Mitchell, *Art* (1994), pp. 116 ff.; Einem, *Malerei* (1978), pp. 90 ff.; Hofmann, "Friedrichs" (1989); and Koerner, *Friedrich* (1990).

16. The official publication date was 1797. I use the English edition prepared by Schubert: Wackenroder, *Confessions and Fantasies* (1971), cited in the text by page number.

17. Hofmann, *Paradies* (1974), p. 69. See also Ziolkowski's thoughtful treatment in *Romanticism* (1990).

18. F. Schlegel, *Ansichten* (1959), with a good introduction by Hans Eichner; the quotation is from p. 79. I use the translation in Ziolkowski, *Romanticism* (1990), p. 369. See also Herding, "Galerieerlebnis" (1991).

19. Ziolkowski, *Romanticism* (1990), pp. 355 ff.; and W. Waetzoldt, *Kunsthistoriker* (1965), 1:233 ff.

20. Schlegel and Schlegel, "Gemälde" (1846), p. 12.

21. On the political uses of art during the revolution, see Leith, *Idea* (1965), and Cleve, *Geschmack* (1996), which compares France and Württemberg. For more on the German art world, see Grossmann, *Künstler* (1994).

22. Quotations in McClellan, *Inventing* (1994), pp. 98, 91. This is the most recent history of the Louvre from its conception under the old regime to its revolu-

tionary creation. See also Harten, *Museen* (1989), and the essays in Fliedl, ed., *Erfindung* (1996).

23. In addition to McClellan, *Inventing* (1994), see Wescher, *Kunstraub* (1976), and Gould, *Trophy* (1965). The quotation is from Haskell and Penny, *Taste* (1988), p. 108.

24. It is no surprise that the portrayal of the Roman legions transporting their spoils, which was carved on the Arch of Titus at the end of the first century C.E., closely resembles contemporary pictures of Napoleon's Italian treasures arriving in Paris: Koch, *Kunstaustellung* (1967), illus. 7.

25. Saisselin, *Enlightenment* (1992), pp. 132–42.

26. On Lenoir and his museum, see McClellan, *Inventing* (1994), chap. 5; Haskell, *History* (1993), chap. 9; and the contemporary description in Humboldt, *Werke* (1960–1964), 1:519–52.

27. McClellan, *Inventing* (1994), p. 195.

28. Schiller, "Die Antiken zu Paris" (written about Napoleon's first Italian campaign but not published until 1803) in *Werke* (1987–1989), 1:213.

29. Varnhagen von Ense, *Werke* (1987–), 2:93, 94, 102. Goethe's line is from the "Venetianische Epigramme" (no. 9), in *Werke* (1981),1:176.

30. Quoted in Stierle, "Hauptstädte" (1983), p. 94.

31. Boisserée, *Briefwechsel* ([1862], 1970), 1:22.

32. Quoted in Messerer, ed., *Briefwechsel* (1966), p. xvii. See also W. Becker, *Paris* (1971), pp. 71 ff.

33. On Berlin in this period, see Paret, *Clausewitz* (1976), chaps. 3–4.

34. Gilly, *Essays* (1994), is a good introduction to his life and work. See also the exhibition catalogue: Berlin Museum, *Friedrich Gilly* (1987). In addition to Vidler's fine *Ledoux* (1990), see E. Kaufmann's classic *Architecture* (1955).

35. See Goethe, *Italienische Reise*, in *Werke* (1981), 11:441–42, and 684–85 n. Hirt also appears in Goethe's novella of 1799, "Der Sammler und die Seinigen." *Werke* (1981), 12:73–96. Goethe liked Hirt, appreciated his expertise, but disagreed with his aesthetic theories.

36. Stock, "Vorgeschichte" (1928).

37. Ebert, "Daten" (1980), p. 9.

38. Seidel, "Vorgeschichte" (1928), and the description (with Hirt's drawings) reprinted in Kühn-Busse, "Entwurf" (1938). See also Hammer, "Museumspolitik" (1980), and Vogtherr, "Kunstgenuss" (1995).

39. On Frederick William's character, see Stamm-Kuhlmann, *König* (1992).

40. Kühn-Busse, "Entwurf" (1938), p. 119; Schadow, *Kunstwerke* (1987), 2:522; Stock, "Vorgeschichte" (1928), pp. 134 ff.; Ebert, "Daten" (1980), p. 10; Moyano, "Quality" (1990).

41. Karl Freiherr vom Stein zum Altenstein (1770–1840) drafted this memorandum in Riga for the future Chancellor Karl August von Hardenberg. Altenstein himself played an active role in the reform period and after 1817 led the newly formed Kultusministerium. Selections from his memorandum are reprinted in Müsebeck, *Kultusministerium* (1918), pp. 241–63 (quotation p. 242).

42. Müsebeck, *Kultusministerium* (1918), pp. 64 ff; Gebhardt, *Humboldt* (1896–1899), vol. 1, bk. 2. In 1817, the educational, public health, and religious functions of this department became a separate ministry.

43. Kaehler, *Humboldt* (1963), p. 13. Kaehler provides a stimulating if not always convincing analysis of Humboldt's character. Sweet's two-volume *Humboldt* (1978–1980) is a reliable introduction to his career. A selection of Humboldt's own works is available in a convenient five-volume edition; cited here as *Werke* (1960–1964).

44. Humboldt, "Über Religion," in *Werke* (1960–1964), 1:12, 17. On Humboldt's aesthetics, see Müller-Vollmer, *Poesie* (1967), and Otto, *Bildung* (1987).

45. This essay eventually appeared as chapter 8 of Humboldt, *Limits* (1969); the quotation is from p. 75 of the English translation. See Izenberg, *Individuality* (1992), pp. 27 ff. Humboldt's ideas are closely related to Schiller's concept of an aesthetic education; in fact, the two men were in close contact while Schiller was writing his essay, which Humboldt believed captured essential, unforgettable truths about "the concept of beauty, the role of the aesthetic in creativity and action, therefore about the basis of all art, as well as about art itself": "Über Schiller und den Gang seiner Geistesentwicklung" in *Werke* (1960–1964), 2:367.

46. For Humboldt's concept of *Bildung*, see Menze, *Bildungsreform* (1975).

47. Humboldt, *Limits* (1969), p. 75; Lübbe, "Humboldt" (1981), p. 93.

48. Gebhardt, *Humboldt* (1896–1899), 1:184–86; Ebert, "Daten" (1980), p. 11.

49. For an introduction to these developments, see Sheehan, *German History* (1989), chap. 5.

50. Weis in Spindler, ed., *Handbuch* (1974–1975), p. 39; Huber, *Dokumente* (1957–1966), 1:145.

51. See Glaser, ed., *Krone* (1980), especially the essay by Hardtwig.

52. Roland, "Mannlich" (1964), and "Mannlich und die Kunstsammlungen" (1980), p. 363. See also Böttger, *Pinakothek* (1972), pp. 68 ff.

53. Schelling, "Verhältnis," ([1857], 1959), pp. 426–27, 429. See also Sziborsky, "Schelling" (1986).

54. Quoted in Zacharias, *Kunstakademie*, (1985), p. 327.

55. The best biography is Gollwitzer, *Ludwig* (1986); there is also a brief but insightful analysis by Weis in Spindler, ed., *Handbuch* (1974–75), pp. 89 ff.

56. Gollwitzer, *Ludwig* (1986), p. 745.

57. Catel's picture is now in the Neue Pinakothek.

58. Another example: at the banquet held to celebrate the completion of Cornelius's murals in the Glyptothek, the guest of honor was the artist, not his patron; see Förster, *Cornelius* (1874), 1:459. On Ludwig as patron, see Messerer, in Spindler, ed. *Handbuch* (1974–1975), especially pp. 1178–79; and Bauer, "Kunstanschauung" (1980), who suggests the comparison with his baroque counterparts. (The Neue Pinakothek is discussed in chapter 3).

59. Quoted in Förster, *Cornelius* (1874), 2:12.

60. See, for example, his decision to change the way the doors were decorated: Franz, *München* (1936), p. 71.

61. Messerer, *Briefwechsel* (1966), p. 463.

62. Wünsche, "Skulpturenerwerbuntgen" (1980), has a complete account of Ludwig's acquisitions. On Ludwig's relationship with Wagner, see Pölnitz, *Ludwig I.* (1929).

63. Plagemann, *Kunstmuseum* (1967), pp. 43 ff., is the basic source for the planning and construction of the museum. For more details, see Schwahn, *Glyptothek* (1983) and the essays in Vierneisel and Leinz, eds., *Glyptothek* (1980); on the rivalry between Fischer and Klenze, see Buttlar, "Fischer" (1984). Klenze's own description of the building is in Klenze and Schorn, *Beschreibung* [1830] 1842. The best analyses of the architecture can be found in Beenken, *Bauideen* (1952), and Giedion, *Klassizismus* (1922).

64. Schwahn, *Glyptothek* (1983), p. 45.

65. Hitchcock, *Architecture* (1962), chap. 2; Pevsner, *History* (1976), p. 122; Steinhauser, "Boullées" (1983); Szambien, *Durand* (1984).

66. Hederer, *Klenze* (1964), is useful but often inaccurate. The best single treatment is Buttlar, "Baukunst" (1987). Buttlar's definitive biography, *Klenze* (1999), appeared too late to be used in this chapter.

67. For some insights into the atmosphere in which Klenze had to work, see Messerer, *Briefwechsel* (1966), pp. 444–45.

68. Böttger, *Pinakothek* (1972), p. 105.

69. Braunfels, *Design* (1988), pp. 204 ff.; Beenken, *Bauideen* (1952), 11–15.

70. See Schwahn, *Glyptothek* (1983), pp. 99 ff., and the detailed analysis (with illustrations) in Vierneisel and Leinz, eds., *Glyptothek* (1980).

71. See Förster, *Cornelius* (1874), for biographical material. Kuhn, *Cornelius* (1921), places him in his intellectual context; Büttner, *Cornelius* (1980), is a good recent account of his fresco projects. On the Nazarines, see Börsch-Suppan, *Malerei* (1988), p. 151.

72. Quoted in Görres, *Briefe* (1874), 2:433–39.

73. Einem, "Cornelius" (1954), pp. 118 ff.; Einem and Büttner in Vierneisel and Leinz, eds., *Glyptothek* (1980), pp. 214–33, 576–99; Droste, *Fresko* (1980) provides a general introduction to fresco painting in the nineteenth century; Schulze, *Bildprogramme* (1984) is indispensable for museum decorations.

74. Seznec, *Survival* (1961), pp. 319–23.

75. Quoted in Schwahn, *Glyptothek* (1983), p. 72.

76. Quoted in Hederer, *Klenze* (1964), p. 186.

77. Plagemann, *Kunstmuseum* (1967), p. 384.

78. Trachtenberg and Hyman, *Architecture* (1986), p. 445.

79. Quoted in Bauer in "Kunstanschauung," (1980), p. 351; I am indebted to Bauer for the interpretation in this paragraph. As Beenken pointed out in *Jahrhundert* (1944), pp. 67 ff., the changing character of palace architecture reflected a transformation in the nature of kingship; Schinkel's plans for a palace for the new king of Greece, for instance, "was not an expression of the prince's power, but rather of his 'highly cultivated life,' his participation in art and learning, and in the life of the nation."

80. Wescher, *Kunstraub* (1976), p. 143. See also Schadow, *Kunstwerke* (1987), 1:107–8, 2:559, 562.

81. Plagemann, *Kunstmuseum* (1967), pp. 66–67. The fate of this project is recounted below.

82. Stamm-Kuhlmann, *König* (1992), pp. 491 ff., and Grossmann, *Künstler* (1994), pp. 80 ff.

83. Lowenthal-Hensel, "Erwerbung" (1971). Attempts by Schinkel and others to persuade the government to buy the Boisserée collection of early German art failed: see Schulz, "Museum" (1990).

84. Plagemann, *Kunstmuseum* (1967), pp. 66 ff., describes the planning process. Stock, "Urkunden" (1930) and "Urkunden" (1937) published some of the most important documents. On the building itself, see Rave, *Schinkel* ([1941] 1981) and "Schinkels" (1960); Spiero, *Schinkels* (1933) and "Schinkels" (1934); H. Kaufmann, "Zweckbau" (1963); Crimp, "End" (1987); Ziolkowski, *Romanticism* (1990); Goalen, "Schinkel" (1991); Mai, "Kanon" (1994); and Moyano, "Schinkel" (1989), Chap. 2.

85. In the vast literature by and on Schinkel, the place to begin is the ongoing multivolume collection, *Lebenswerk* (1939–). The most recent work in English is Bergdoll, *Schinkel* (1994). The articles in Snodin, ed. *Schinkel* (1991), are valuable, as are the volumes from the two major exhibits marking his bicentennary: *Karl Friedrich Schinkel, 1781–1841* (1981) and *Karl Friedrich Schinkel. Architektur, Malerei, Kunstgewerbe* (1981). Rave, *Schinkel* (1953), and Grisebach, *Schinkel* (1983), are good brief treatments. Still the most complete collection of his own fragmentary writings is Schinkel, *Nachlass* (1862–1864); Goerd Peschken has skillfully edited Schinkel, *Lehrbuch* (1979).

86. Schinkel later acquired Gilly's design for his monument to Frederick the Great, which eventually hung in the conference room of the *Bauakademie*, his home and office in Berlin. On the relationship between Gilly and Schinkel, see Bergdoll, *Schinkel* (1994), p. 12.

87. Schinkel, *Nachlass* (1862–1864), 3:346. There is an early expression of this faith in his 1800 sketch of a museum where classical forms provide a timeless setting for the contemplation of art's sacred beauty. See Rosenblum's analysis of this image in *Transformations* (1967), p. 137.

88. On Schinkel's administrative duties and their significance for Prussian architecture, see Moyano, "Schinkel" (1989).

89. See Sweet, *Humboldt* (1978–1980), 2:380; Lübbe, "Humboldt" (1981); Stamm-Kuhlmann, *König* (1992), pp. 491 ff.; Bussmann, *Preussen* (1990), pp. 84, 87–88.

90. Rave, *Schinkel* ([1941] 1981), pp. 33 ff.; Stamm-Kuhlmann, *König* (1992), pp. 458 ff., 494 ff; Müsebeck, *Kultusministerium* (1918), pp. 296–97.

91. Stamm-Kuhlmann, *König* (1992), p. 493. See Rave, *Schinkel* (1948).

92. Goethe, "Einleitung in die Propyläen," in *Werke* (1981), 12:38. On the architectural function of entrances, see Reinle, *Zeichensprache* (1976), p. 245.

93. Schinkel, *Nachlass* (1862–1864), 3:245.

94. "Art itself is religion [and] the religious is eternally accessible to art. The religious building alone . . . can be the point of departure for the entire definition of an architecture": Schinkel, *Lehrbuch* (1979), p. 33.

95. I am especially indebted to Beenken's analysis in *Bauideen* (1952), pp. 55–56. See also Illert, *Treppenhaus* (1988), and Bergdoll, *Schinkel* (1994), p. 82.

96. See Gropius, *Schinkels* (1874), for some striking reproductions and a discussion of Schinkel's selection of colors. Here again one is struck by the contrast between the sensibilities of Schinkel's generation and those of the rococo: whereas the latter used soft colors to blur or mask divisions—between painting and architecture, walls and ceilings, exterior and interior—the former used strong, solid colors to establish distinctions and divisions.

97. *Karl Friedrich Schinkel 1781–1841* (1981), p. 138; on his classical models, see Haskell and Penny, *Taste* (1988), pp. 136–37.

98. These are described and reproduced in *Karl Friedrich Schinkel, 1781–1841* (1981), pp. 147 ff. Bettina von Arnim, "Schinkels" (1836), admired Schinkel's sketches, but most contemporary critics disliked the finished product; see, for example, Kugler, *Schriften* (1854), 3:633–34, and Vischer, *Gänge* (1914–1922), 5:178. See also Wilhelmi, *Fresken* (1882), and Schulze, *Bildprogramm* (1984), pp. 45 ff.

99. Schinkel, *Reise* (1986), and *Journey* (1993), an English translation with valuable editorial material.

100. Sweet, *Humboldt* (1978–1980), 2:450 ff.; Gebhardt, *Humboldt* (1896–1899), 2:425 ff. Humboldt's report was published in the Academy Edition of his *Schriften* (1903–1920), 12:539–66. The administrative structure of the Berlin museums is discussed in chapter 3.

101. Hirt's inscription was bitterly criticized as ungrammatical and inappropriate by Berlin's classical scholars. See Hirt, "Inschrift" (1829); for the controversy and its wider significance, see Wyss, "Klassizismus" (1983).

102. Moyano, "Quality" (1990), has a good account of this debate and its significance; see also Vogtherr, "Norm" (1992).

103. The best account of this process is Vogtherr, "Norm" (1992), which includes the text of Humboldt's memorandum of May 1829.

104. Schinkel, *Nachlass* (1862–1864), 3:257. For an appreciative contemporary response, see C. D. Rauch's letters from Berlin, in K. Eggers, ed., *Briefwechsel* (1890–1891), 1:110, 113, 136, 154.

Chapter 3

1. Klemm, *Geschichte* (1838), intro. Klemm was royal librarian and curator at the Zwinger in Dresden.

2. Burckhardt, *Studium* (1982), p. 83. See also Sheehan, *German History* (1989), pp. 542 ff.

3. Quoted in Osten, "Museum" (n.d.), p. 161. For a representative statement on historical preservation, see Ferdinand von Quast's memorandum of 1837, in Kohte, "Quast" (1977), pp. 132 ff.

4. Schinkel, *Nachlass* (1862–1864), 3:350, 345–46.

5. The original was destroyed in 1945; fortunately, there is a copy by Wilhelm Ahlborn and the engraving by Wilhelm Witthöft, which is reproduced as fig. 14. The fullest account of the picture is Vogt, *Schinkel* (1985). See also Jaffé, "Schinkels" (1982); Buddensieg, "Antithese" (1991); and Mitchell, *Art* (1994), p. 157.

6. Schinkel, *Lehrbuch* (1979), p. 27. Schiller spoke in similar terms of "die stillredenden, trauernden Zeugen/Längst schon entschwundener edler Geschlechter." Quoted by Schinkel's colleague in the museum project: Waagen, *Schriften* (1875), pp. 54–55.

7. H. G. Hotho assembled the texts from Hegel's drafts and students' notes; they were first published in 1835, 1837, and 1838. My citations are to *Werke* (1970), vols. 13–15. Hotho described his relationship to Hegel in *Vorstudien* (1835), pp. 383–99. For an introduction to Hegel's aesthetics, see the essays collected in Gethmann-Siefert and Pöggeler, *Welt* (1986). My account is especially indebted to Szondi, *Poetik* (1974). On Hegel and Schinkel, see Wyss, "Museum" (1991); Dilly, "Hegel" (1986); and Buddensieg, "Antithese" (1991). Hegel mentioned Schinkel's museum only once in his lectures—in February 1829 he commented positively about the arrangement of paintings: *Werke* (1970), 14:102.

8. Hegel, *Werke* (1970), 13:21.

9. See the essays in Pöggeler, ed., *Hegel* (1981); and Pöggeler, *Kulturpolitik* (1987).

10. Hegel, *Werke* (1970), 13:30, 14:26. See also Sheehan, "Vergangenheit" (1993).

11. Hegel, *Werke* (1970), 13:25, 142, 143. On the "end of art," see Harries, "Hegel" (1974); Belting, *Ende* (1995); and Gethmann-Siefert and Pöggeler, eds., *Welt* (1986).

12. Hegel, *Werke* (1970), 13:341 and 25–26.

13. Danto, "Art World" (1964).

14. Quoted in Kultermann, *Geschichte* (1981), p. 171. Another example: Lübke, "Kunst" (1866), p. 12.

15. Belting, *Ende* (1995), p. 23.

16. Bickendorf, *Beginn* (1985), argues for the paradigmatic significance of Waagen's work.

17. On the development of art history, see W. Waetzoldt, *Kunsthistoriker* (1965); Dilly, *Kunstgeschichte* (1979); and Kultermann, *Geschichte* (rev. ed. 1990). For comparable developments in the study and understanding of music, see Dahlhaus, *Music* (1989).

18. The best guide to this is Dilly, *Kunstgeschichte* (1979).

19. See, for example, Rumohr, *Reisen* (1832), pp. 6–8.

20. Eitelberger von Edelberg, *Resultate* (1874).

21. Woermann, "Neuerwerbungen" (1912), p. 291. There is a list of Ludwig's pictures with their original and current attribution in *Ihm, welcher* (1986), pp. 236–58.

22. Charles Smith is quoted in Vergo, ed., *Museology* (1989), p. 18. Burckhardt, "Echtheit" ([1882], 1984), pp. 290–91, made the connection between the growing concern for authenticity and the changing structure of the art market.

23. The most influential member of this international elite was Giovanni Morelli, who was especially critical of the attribution techniques in German museums. See Gibson-Wood, *Studies* (1988), sec. 5.

24. Vierneisel and Leinz, eds., *Glyptothek* (1980), pp. 67–69.

25. See Althöfer, ed., *19. Jahrhundert* (1987); and C. Wagner, *Arbeitsweisen* (1988).

26. Pecht, "Briefe" (1864), p. 377.

27. Humboldt, "Denkschrift von 1830," in *Schriften* (1903–1920), 12:555.

28. Kugler, *Beschreibung* (1838), p. vii.

29. Quoted in W. Waetzoldt, *Kunsthistoriker* (1965), 2:83. On the concept itself, see Pochat, "Epochenbegriff" (1985), and Dilthey's important essay "Epochen" (1892), especially pp. 219–23.

30. Burckhardt, *Age* ([1852], 1983) pp. 242–43. Compare his remark in 1851 that "Art is not the measure of History, its development or decline does not provide absolute evidence for or against a period or a nationality, but it is always one of the highest living elements of gifted peoples": quoted in Haskell, *History* (1993), p. 332. On Burckhardt's views of art, see Hardtwig, *Geschichtsschreibung* (1974).

31. The allegedly German character of the Gothic had been identified by Goethe in his essay of 1770 on German architecture and was often repeated in the nineteenth century.

32. Quoted (from the edition of 1837) in R. Kaufmann, *Renaissancebegriff* (1932), p. 83 n.382.

33. The same process was at work in the history of music; see Dahlhaus, *Music* (1989), pp. 325–26.

34. Keller, *Der grüne Heinrich* ([1855] 1978), bk. 3, chap. 6.

35. See Cahn, *Masterpieces* (1979).

36. Curtius, *Kunstmuseen* (1870); see Herman Grimm's response in "Curtius" (1870).

37. Schröter, *Maler* (1954), pp. 109 ff.

38. Werner Hofmann, *Paradies* (1974), p. 24, writes, "The development of historicism in the eighteenth century marks a totally transformed artistic consciousness. . . . the entire nineteenth century had its origins in historicism." See also Nipperdey, *Bürgertum* (1988), pp. 37 ff.

39. On this complicated process, see especially W. Busch, *Bild* (1993). In 1825, Cornelius told King Ludwig that the Munich Academy should not hire people to teach different kinds of painting: "The genres of painting are no more than moss on the great branch of art": quoted in Förster, *Cornelius* (1874), 1:368.

40. Bringmann, *Pecht* (1982), p. 124; Feuerbach quoted in Schröter, *Maler* (1954), p. 114.

41. There is an astute summary of these advantages in Busch, *Arabeske* (1985), p. 255. On the material benefits of museums, and the lucrative arrangements that local artists had with the Neue Pinakothek, see Lenman, *Kunst* (1994), p. 116. See also Grewe, "Schadow" (1998), especially pp. 373 ff.

42. Schadow quoted in Grewe, "Rafael" (1998), p. 123; Haskell, "Artist" (1987), p. 33.

43. See Hinz, "Triumph" (1979).

44. Overbeck's description of the painting is reprinted in Apel, *Kunstlehre* (1992), pp. 466–77, 902–11; quotation p. 477.

45. Vischer, *Kritische Gänge* (1914–1922), 5:7–8. See also Oelmüller, *Vischer* (1959).

46. On Kaulbach's painting, see H. Börsch-Supan, *Malerei* (1988), pp. 411–12, and Hans Müller, *Kaulbach* (1893), 1:384 ff.

47. Quoted in Schulze, *Bildprogramm* (1984), p. 83.

48. The most complete account of the Neue Pinakothek is Mittlmeier, *Pinakothek* (1977). See also the brief summary by Goldberg in Nerdinger, ed., *Romantik* (1987), pp. 386–90.

49. W. Busch, *Arabeske* (1985), p. 123, argues that Kaulbach's caricatures were "an expression of the ultimate crisis of classical allegory and thus of historical painting."

50. Schnorr von Carolsfeld, *Wege* (1909), p. 198; Schwind quoted in Förster, *Cornelius* (1874), 2:318. W. B. Scholz defended Kaulbach in "Gang" (1856–1857). On the frescoes, see Mittlmeier, *Pinakothek* (1977), and Schulze, *Bildprogramm* (1984), pp. 88 ff. An example of the conventional treatment of artistic achievement is Eugen Napoleon Neureuther's painting "The Flowering of Art in Munich," also done in 1856, now in the Schackgalerie in Munich.

51. Quoted in Schulze, *Bildprogramme* (1984), p. 83.

52. For an excellent discussion of monarchial institutions, with particular reference to Bavaria, see Gollwitzer, *Ludwig I.* (1986), chap. 1. Daniel, *Hoftheater* (1995), pp. 118–21, has a useful survey of monarchical income in the mid-nineteenth century.

53. Eventually, the city had to settle for an indemnity of 150,000 taler. See Woermann, "Anfang" (1881), p. 158, and Kalnein, "Akademiemuseum" (1971), p. 329.

54. Quoted in Messerer, "Dillis" (1961), p. 34.

55. Huber, *Dokumente* (1957–1966), 1:145, n. 9. See also Brunner, *Hofgesellschaft* (1987), pp. 81 ff.; Hardtwig, "Privatvergnügen" (1993), pp. 87 ff.; Ghattas, "Patronage" (1986), pp. 95–96.

56. Huber, *Dokumente* (1957–1966), 1:226; Woermann, *Lebenserinnerungen* (1924), 2:6 ff. For a similar arrangement in Vienna, see Haupt, *Museum* (1991), pp. 227 ff.

57. Bott, *Gemäldegalerie* (1968), pp. 11–12.

58. Huber, *Dokumente* (1957–1966), 1:66–67; this arrangement was confirmed by the constitution of 1848a (p. 389).

59. Jaeschke, "Politik" (1983), p. 31. On the collection, see Lowenthal-Hensel, "Erwerbung" (1971).

60. Ohlsen, *Bode* (1995), pp. 55–56.

61. Fleischhauer, *Hetsch* (1929), p. 30.

62. *NDB* (1953–), 8:27–28; Thieme and Becker, *Lexikon* (1907–1950), 8:369–71.

63. H. Börsch-Supan, *Malerei* (1988), pp. 234–38; Schnorr von Carolsfeld, *Wege* (1909), pp. 20 ff.

64. H. Börsch-Supan, *Malerei* (1988), pp. 414–25; Karlsruhe, *Kunst* (1990), p. 227.

65. Gölz, *Landtag* (1926), p. 139. See also the hostile account in Nerdinger, *Romantik* (1987), and the more balanced treatment in Hardtwig, "Privatvergnügen" (1993).

66. Ghattas, "Patronage" (1986), chap. 2.

67. Beringer, "Moritz von Schwinds" (1915).

68. A. Stern, *Hettner* (1885), pp. 164–65; Woermann, *Lebenserinnerungen* (1924), 2:8 ff.

69. Jaeschke, "Politik" (1983); Lübbe, "Idealismus" (1983). *Kultus*, of course, refers to that ministry's religious responsibilities. In a memorandum of September 1830, Altenstein argued for the incorporation of museum administration: see Stock, "Urkunden" (1937), p. 18. For more information on the Altes Museum, see the two commemorative volumes, published in 1880 and 1980, listed in the bibliography under Berlin. There is a guide to the source materials in Künzel, "Quellen" (1992).

70. Stock, "Gesuche" (1932). For further evidence of the king's influence, see Michaelis, "Überfluss" (1992), on the decision of what to do with surplus art.

71. Humboldt, "Museum" (1904), p. 567. See also Lübbe, "Humboldt" (1981).

72. See Humboldt, "Museum" (1904), and the documents in Stock, "Urkunden" (1937).

73. See Daniel, *Hoftheater* (1995).

74. Quoted from the decree establishing the museum, in Woltmann's introduction to Waagen, *Schriften*, (1875), p. 11.

75. Wegner, "Einrichtung" (1989), p. 274; Altenstein in Stock, "Urkunden" (1937), p. 20.

76. Humboldt, "Museum" (1904), pp. 567, 570. See also Vogtherr, "Norm" (1992).

77. On Waagen, see the articles from the symposium given in Berlin in 1994, reprinted in *JbBM* (1995); I. Geismeier, "Waagen" (1980); and the biographical sketch by Alfred Woltmann in Waagen, *Schriften* (1875), pp. 3–52. Waagen advised a number of individuals on their collections and appeared before a committee of the British House of Commons to talk about the proposed National Gallery in London. Although well known, he was not universally admired; see the critical comments compiled in Haskell, *Rediscoveries* (1977), p. 93 n. 113.

78. Wegner, "Einrichtung" (1989), pp. 277–78.

79. See the sympathetic biography by Krosigk, *Brühl* (1910).

80. Rave, "Geschichte" (1994). For a good summary of the museum's organization, see S. Waetzoldt, "Bode" (1996).

81. For an introduction to Kugler's career, see Treue, "Franz Theodor Kugler" (1953).

82. Berlin, *Geschichte* (1880), pp. 51–52; Rave, "Olfers" (1961); Zuchold, "Olfers" (1989); Olfers, *Briefe* (n.d.), prints his correspondence with Alexander von Humboldt.

83. Berlin, *Geschichte* (1880), p. 52.

84. I. Geismeier, "Waagen" (1980), pp. 414–17. Zuchold, "Olfers" (1989), pp. 383 ff., prints a letter of December 1867 from Waagen to Prince Karl asking him to intervene with the king.

85. Prussia, "Statut" (1868), pp. 588–98.

86. Poschinger, *Kaiser Friedrich* (1898), 3:146, and 310–13.

87. One can follow the progress of Usedom's appointment in the correspondence printed in Heyderhoff and Wentzcke, *Liberalismus* (1967), 2:35–37, 44–45, 60. There is a good description of his management style in Erman, *Werden* (1929), pp. 120 ff.

88. On these controversies, the best source is Pallat, *Schöne* (1959), pp. 109 ff. W. Waetzoldt, "Museen" (1930), has a good brief account. See T. Mommsen, "Museen," in *Reden* (1905), pp. 228–35, for the Landtag speech of March 1876 in which Mommsen harshly attacked the museum's administration.

89. Prussia, "Statut" (1878), pp. 654–60; Pallat, *Schöne* (1959), pp. 138 ff.

90. Pallat's biography (1959) is the best work on Schöne. Erman's account in *Werden* (1929) praises Schöne and is implicitly critical of Bode. For Bode's characteristically partisan views, see his *Leben* (1930), 1:182. The critic Adolf Rosenberg, "Publikationen" (1883), p. 196, called Schöne's appointment "a total break with the past."

91. Quoted from an 1883 article by Rosenberg in Löhneysen, "Einfluss" (1960), p. 19.

92. Marchand, *Olympus* (1996), pp. 65 ff.

93. Grimm, "Reihe" (1872), pp. 752–53.

94. Kekulé, "Behandlung," (1872), pp. 698, 700.

95. See the critique of Waagen's catalogue of Berlin's paintings in [Anon.], "Bildergallerie" (1868), and the general remarks in Dove, "Wiedertaufe" (1872), and Rosenberg, "Katalog" (1888). For other examples, see Schmidt, "Bemerkungen" (1876), which attacked the recently published catalogue of the Darmstadt gallery.

96. For a summary of Pecht's activities, see Bringmann, *Pecht*.

97. The most recent guide to the controversy is Batschmann and Griener, *Holbein* (1998). Woltmann's remark is from his introduction to Waagen, *Schriften* (1875), p. 12.

98. Woermann, *Lebenserinnerungen* (1924), 2:21–22; Wünsche, "Skulpturenerwerbungen" (1980), p. 85.

99. Quoted in Döhmer, "Style" (1976), p. 75.

100. Quoted in Schlink, *Burckhardt* (1982), p. 6. Burckhardt wrote the entry on *Kunstverein* for the widely used *Brockhaus-Conversations-Lexicon* (1864–1868).

101. Over one hundred of these associations were founded in the German states during the nineteenth century. See the brief summary in "Einbürgerung" (1993); Grasskamp, the essays in Gerlach, ed., *Nutzen* (1994); Dilly, *Kunstgeschichte* (1979), pp. 199 ff.; Hein, "Künstlertum" (1996); and Grossmann, *Künstler* (1994), pp. 91 ff. Monographs on individual *Vereine* include Sternberg, *Geschichte* (1977), on Karlsruhe; Langenstein, *Kunstverein* (1983), on Munich. Contemporary material can be found in periodicals such as the *Kunstblatt*.

102. On Bremen, see Pauli, *Erinnerungen* (1936), pp. 150–52. On Hamburg, Hentzen, *Kunsthalle* (1969); Luckhardt, *Geschichte* (1994); and Plagemann, "Anfänge" (1966).

103. One can trace the growing supply of art in the rapidly rising number of works displayed at the Berlin exhibitions: see H. Börsch-Supan, ed., *Kataloge* (1971). See also Grossmann, "Künstler" (1994), pp. 105 ff., and *Künstler* (1994), pp. 161 ff.; Radziewsky, *Kunstkritik* (1983), pp. 168 ff.

104. Kalnein, "Akademiemuseum" (1971), pp. 334–35; Sauerlandt, "Forschungsaufgaben" (1930), p. 195.

105. Bussmann, *Preussen* (1990), especially pp. 308 ff.; Barclay, *Frederick William IV* (1995), p. 110, n. 39; H. Börsch-Supan, *Malerei* (1988), p. 266.

106. Grossmann, "Künstler" (1994), p. 107; Kugler, *Schriften* (1854), 3:503 ff.

107. Grossmann, *Künstler* (1994), pp. 215 ff.; With, *Landeskunstkommission* (1986), pp. 18 ff.; Mai, "Kunstakademie" (1981), p. 447; [F. Eggers], "Reformen" (1850).

108. Kugler, *Grundbestimmungen* (1859), pp. 10, 29–30.

109. Quoted in D. Hein, "Künstlertum" (1996), p. 114.

110. Deiters, *Geschichte* (1904). See also the material in Eberlein, "Vorgeschichte" (1930), and "Idee" (1930); Rave, *Geschichte* (1968).

111. Roters, "Nationalgalerie" (1993), p. 75. For a contemporary example of the hopes for art created by the new era, see Müller von Königswinter, *Verhältnis* (1861). A *Gb* contributor gave a more critical account of the project: [Anon.], "Berliner Kunstbericht" (1867).

112. On the building, see Rave, *Geschichte* (1968), pp. 27 ff.

113. There is a good summary of the building's iconography in Gaehtgens, *Museumsinsel* (1992), pp. 72–76. See also Forster-Hahn, "Politics" (1995).

114. Scheffler, *Nationalgalerie* (1912), p. 6.

115. With, *Landeskunstkommission* (1986), is the best source for the gallery's organizational structure.

116. Kugler quoted in Beenken, *Jahrhundert* (1944), p. 140; Waagen, in Hochreiter, *Musentempel* (1994), p. 182. The best introduction to the concept is Vierhaus, "Bildung" (1972).

117. Jordan, "Wandmalereien" (1872), p. 841.

118. Quoted from a memo to the cultural minister in May 1875, in Dilly, *Kunstgeschichte* (1979), p. 152; compare the similar formulation in Grimm, "Porträtsbüsten" (1883), pp. 414–15.

119. Bourdieu, *Distinction* (1984), p. 241.

120. Bourdieu, "Outline" (1968), p. 611, and Bourdieu and Darbel, *Love* (1990), p. 113. Duncan, *Rituals* (1995), p. 55, makes a similar point: "Public art museums . . . provided elites with clear class boundaries, while simultaneously giving them an identity that was seemingly above class interests." See also Kaschuba, "Bürgerlichkeit" (1988).

121. Quoted in, respectively, Stock, "Urkunden" (1937), pp. 26–27; Schwahn, *Glyptothek* (1983), p. 244; Cleve, *Geschmack* (1996), p. 320. Waagen, "Über die Stellung, welche der Baukunst, der Bildhauerei und der Malerei unter den Mitteln menschlicher Bildung zukommt," quoted in I. Geismeier, "Waagen " (1980), p. 405.

122. Quoted in Mundt, *Kunstgewerbemuseen* (1974), p. 194.

123. Schwahn, *Glyptothek* (1983), p. 245; Vierneisel and Leinz, eds., *Glyptothek* (1980), p. 84. See Zirk, *Geschichte* (1954), p. 11, and the survey in F. Eggers, "Zugänglichkeit" (1851).

124. Erman, *Werden* (1929), p. 197.

125. Messerer, *Briefwechsel* (1966), pp. 729–30. See also Pecht, *Zeit* (1894), pp. 100–103.

126. Waagen, "Thoughts" (1853), p. 123.

127. By 1907, the Berlin museums were open from 12:00 to 6 P.M. on Sunday, 10:00 A.M. to 4 P.M. on Tuesday through Saturday. Some museums charged an entrance fee on two or three days, presumably so that their more prosperous patrons could enjoy the collections without a crowd.

128. Pallat, *Schöne* (1959), pp. 193 ff.; Graesse, "Grundsätzen" (1884); Bode, *Leben* (1930), 1:174.

129. This remains true: "How can one possibly judge," Kenneth Hudson wonders, in *Museums* (1977), p. 1, "what is going through a visitor's mind as he stands gazing at a Giotto or a giraffe?"

130. On cultural tourism, see Wolbring, "Arkadien" (1996); Rössling, "Studien" (1986), p. 96, on Karlsruhe. H. A. Müller, *Museen* (1857), is an example of a guidebook designed to aid travelers.

131. Lewald, *Lebensgeschichte* (1980), p. 136. Another example is A. Werner, *Jugenderinnerungen* (1994), p. 12. See also Herding, "Galerieerlebnis" (1991).

132. Pecht, *Zeit* (1894), 1:104–5.

133. Theodor Fontane, *Effi Briest* ([1895] 1976), chap. 5; Wagner quoted in Scherer, *Museen* (1913), p. 146; Pecht, *Zeit* (1894), 1:107.

134. Nipperdey, *Geschichte* (1983), p. 539.

135. Duncan, *Rituals* (1995), talks about the museum's "ritual task," see, for example, her discussion of the Louvre (p. 27).

136. Cited in Döhmer, "Style" (1976), p. 87.

137. Important museum projects were regularly described in the *Bauzeitung*. See also H. Wagner, "Museen" (1906), for an authoritative statement of the museum as a building type; and Magnus, "Entwurf" (1867), on technical matters.

138. Pevsner, *History* (1976), p. 128. See also Rüdiger an der Heiden's essay in *Ihm, welcher* (1986). Sherman, *Monuments*, (1989), pp. 176–77, discusses the Pinakothek's influence on provincial French museums.

139. The most complete account is Böttger, *Pinakothek* (1972). See also Plagemann, *Kunstmuseum* (1967), pp. 82–89; Hederer, *Klenze* (1964), pp. 289–99; Heiden in Nerdinger, ed., *Romantik* (1987), pp. 362–67; the essays in *Ihm, welcher* (1986); and the useful information in Messerer, *Briefwechsel* (1966).

140. Böttger, *Pinakothek* (1972), p. 20.

141. Messerer, *Briefwechsel* (1966), pp. 655–57; Förster, *Cornelius* (1874), 1:421 ff.; Kühn, *Cornelius* (1921), pp. 165 ff. The fullest description is in Schulze, *Bildprogramme* (1984), especially pp. 203–24. Bielmeier, *Kunstgeschichte* (1983), has a good account of the frescoes' reception. All the decorations were destroyed in the Second World War.

142. Quoted in Schulze, *Bildprogramme* (1984), p. 55. Raphael was also the central figure among the artists on the balustrade.

143. Three other examples: the Gemäldegalerie in Kassel 1877; the new building for the Städel Institute in Frankfurt, 1878; and the museum in Braunschweig, 1887. See Tippmann, *Entwicklung* (1931), pp. 71–92, and Martin, "Ikonographie" (1983), for a survey of museum construction. On the Städel, see Ziemke, *Kunstinstitut* (1980); on the Braunschweig museum, Riegel, "Museumsgebäude" (1889).

144. Sheehan, *German History* (1989), pp. 400–401, 604–5, 614.

145. There is a brief account of the planning process in Plagemann, *Kunstmuseum* (1967), pp. 131–33.

146. The best account of Semper's career is Mallgrave, *Semper* (1996). Semper, *Elements* (1989), is a valuable translation of his most important writings with a useful biographical introduction. See also Herrmann, *Semper* (1984), and the catalogue of an exhibition marking the hundredth anniversary of his death: *Gottfried Semper* (1980).

147. The quotations are from an 1869 lecture, "On Architectural Styles," reprinted in Semper, *Elements* (1989), pp. 267, 284.

148. Mütterlein, "Semper" (1913), and Plagemann, *Kunstmuseum* (1967), pp. 131–44. See also Mallgrave, *Semper* (1996), pp. 107 ff., and Marx and Magirius, *Gemäldegalerie* (1992).

149. Portraits of Raphael and Holbein were on the cover of Julius Hübner's catalogue of the gallery, first published in 1856.

150. The best guide to the gallery's decorative program is in Marx and Magirius, *Gemäldegalerie* (1992). See Förster, "Museum" (1857–1858), for a contemporary account.

151. The most complete account of the Ringstrasse project is the multivolume classic edited by Wagner-Rieger, *Ringstrasse* (1969–): the museum is covered by Klaus Eggert in vol. 8 (1978); the controversy surrounding the museum, by Elisabeth Springer in vol. 2 (1979), pp. 310–36, 471–89, and also in Schorske, "Museum" (1993). On the building itself, see Lhotsky, "Museum" (1974); Haupt, *Museum* (1991); and Kriller and Kugler, *Museum* (1991).

152. Mallgrave, *Semper* (1996), chap. 5.

153. Schorske, "Museum" (1993), p. 232.

154. Mallgrave, *Semper* (1996), pp. 329–31; Semper, *Hofmuseen* (1892).

155. The best guides to these decorations are Schulze, *Bildprogramme* (1984), and Martin, "Ikonographie" (1983).

156. Scherer, *Museen* (1913), p. 171.

157. There is a fine analysis of these murals in Busch, "Kaulbach" (1986). See also Schulze, *Bildprogramme* (1984), pp. 97–107, 250–65, and the extensive contemporary treatment in Schasler, *Wandgemälde* (1854).

158. Jordan, "Wandmalereien" (1872), pp. 852–53.

159. See Beringer, "Moritz von Schwinds" (1915), and Karlsruhe, *Kunst* (1990), pp. 162–63.

160. Andrée, "Fresken" (1963).

161. Jordan, "Wandmalereien" (1872), pp. 854–55.

162. Duncan, *Rituals* (1995), p. 29. On the Kunsthalle's decorations, see Plagemann, "Anfänge" (1966).

163. Grossmann and Krutisch, eds., *Renaissance* (1992–1995), 1:372–73. See also Martin, "Ikonographie" (1983), pp. 269 ff.

164. Quoted in E. Börsch-Supan, "Renaissance-Begriff" (1976), p. 160. See Milde, *Neorenaissance* (1981).

165. Quoted in Milde, *Neorenaissance* (1981), p. 181. There is a similar statement in Bayersdorf, *Leben*, (1908), p. 118.

166. Semper quoted in Milde, *Neorenaissance* (1981), p. 241; Bayersdorf, *Leben* (1908), p. 118.; Burckhardt, *Civilization* (1958), pp. 425, 143.

167. Behrendt, *Building* (1937), p. 21.

168. "Perhaps more than any other institution," Stephan Waetzoldt has remarked, "the museum was shaped by the spirit of the nineteenth century." This is why, he continued, "its 'crisis' is best understood as the adjustment of traditional structures and values to the changing demands and conditions of modern society": quoted in Mundt, *Kunstgewerbemuseen* (1974), p. 9.

Chapter 4

1. One crude but illustrative measure is that between 1895 and 1907, the number of German "artists" increased by over 50 percent, from 8,890 to 14,000: Lenman, "Painters" (1989), p. 120. On the significance of scale for the art world, see Zolberg, *Constructing* (1990), and Crane, *Transformation* (1987).

2. Meier-Graefe, *Art* (1908), 1:3.

3. Reuber, *Lebensformen* (1988), chap. 1, discusses Nietzsche's departure from traditional theories of art.

4. *KSA*, 5:346–47. On this passage, see Seeba, "Kinder" (1976).

5. *KSA*, 1:98.

6. *KSA*, 1:61.

7. *KSA*, 1:273, 264.

8. From a fragment of 1886–87, *KSA*, 12:286. See also remarks in "Birth of Tragedy" and "Advantage and Disadvantage," *KSA*, 1:119–20, 327.

9. *KSA*, 9:506, quoted in Reuber, *Lebensformen* (1988), p. 80.

10. *KSA*, 1:56, 109.

11. Lloyd, *Expressionism* (1991), p. 18; Scharabi, *Architekturgeschichte* (1993), pp. 297 ff.; Paul, *Tschudi* (1993), p. 53.

12. The classic account remains Stern, *Politics* (1963). See also Hein, *Transformation* (1991), pp. 62 ff.

13. Bode, *"Rembrandt,"* (1890), p. 301. On the response to Langbehn's ideas, see Stern, *Politics* (1963), pp. 153 ff. Some examples: S. Anderson's introduction to

Muthesius, *Style* ([1902], 1995), p. 6; Lloyd, *Expressionism* (1991), pp. 8–12 on Osthaus; Woermann, *Lebenserinnerungen* (1924), 2:55.

14. Langbehn, *Rembrandt* ([1890], 1922), pp. 85–86, 68.

15. Vischer, "Der Zustand der jetzigen Malerei" (1842), "Kunstbestrebungen der Gegenwart" (1843) and "Die Münchner Kunst" (1846), all in *Kritische Gänge* (1914–1922), 5:38, 80–81, and 176. Another example: Neumann, "Bildung" (1896).

16. Pallat, "Kunst" (1906), p. 360. See the biographical sketch in Pallat, *Schöne* (1959).

17. Kalkschmidt, *Museum* (1906), p. 4; Weisbach, *Geist* (1956), p. 56.

18. Bodenhausen, *Leben* (1955), pp. 122–23; Muthesius, *Style* ([1902], 1995), p. 60.

19. Volbehr, *Zukunft* (1909), pp. 59, 58. As an example, see Scheffler's reminiscences about museum-going in his youth in *Jahre* (1946), pp. 225–26.

20. Osborn, "Museen" (1905), p. 1249.

21. Scherer, *Museen* (1913), p. 245.

22. Naumann, "Das Wissen von der Kunst," in *Werke* (1964), 6:7. Other examples: H. Wagner, "Museen" (1906), pp. 233–35; Justi, *Winckelmann* (1956), 1:320–21.

23. Quoted in Lloyd, *Expressionism* (1991), p. 17.

24. Semper, "Science, Industry, and Art," in *Elements* (1989), pp. 160–61, and "Plan eines Idealen Museums" ([1852], 1966).

25. Falke, "Museumsfrage" (1864), pp. 205, 164. See also Falke, *Lebenserinnerungen* (1897).

26. See Mundt, *Kunstgewerbemuseen* (1974), pp. 238–52, for a useful list of such institutions and a guide to the literature about them.

27. Pallat, "Kunst" (1906), p. 358.

28. On this movement, see Schwartz, *Werkbund* (1996).

29. Germany, "Gesetz" (1907). For another illustration of the expanding definition of art, compare the articles on *Kunst* in *Brockhaus-Conversations-Lexikon* (1864–1868), 9:116–18, and *Meyers Grosses Konversations-Lexikon* (1908–1909), 7:804 ff.

30. Muthesius, *Style* ([1902], 1995), pp. 61, 85.

31. Muthesius, *Style* ([1902], 1995), p. 50.

32. Obrist quoted in Lloyd, *Expressionism* (1991), p. 5. See the selections from Nolde's unpublished work on primitive art in Chipp, ed., *Theories* (1968), pp. 146 ff., and the material cited in Wyss, *Wille* (1996), pp. 14 ff.

33. Scheffler, *Jahre* (1946), p. 253.

34. Quoted from Wölfflin's dissertation on the psychology of architecture, in Joerissen, *Kunsterziehung* (1979), pp. 201–2.

35. On Riegl, see Iverson, *Riegl* (1993), and Podro, *Historians* (1982), pp. 71–97. Riegl, *Problems of Style* (1993), a recent translation, is a good place to begin reading his work.

36. Quoted in J. Weber, *Entmündigung* (1987), p. 188. Worringer was deeply influenced by Riegl. His dissertation, *Abstraktion* (1908), caused a sensation when it first appeared; see his introduction to the English translation: Worringer, *Abstraction* (1953).

37. Wölfflin, *Tagebücher* (1982), pp. 59–60

38. C. Justi, *Winckelmann* (1956), 3:288.

39. Riegl, "Eine neue Kunstgeschichte," quoted in Iverson, *Riegl* (1993), p. 5. Compare the concepts of "abstraction" and "empathy" in Worringer, *Abstraction* (1953), p. 4. For the larger intellectual context of this trend, see Schnädelbach, "Abkehr" (1983). On the origins of psychological aesthetics, see Drüe, "Ästhetik" (1983).

40. Quoted in Iverson, *Riegl* (1993), p. 7.

41. Danto, *Brillo Box* (1992), p. 124.

42. On Raczynski, see H. Börsch-Supan, "Geschichte" (1975).

43. A. Springer, *Briefe* (1857), pp. 1–2; see also his views in "Wege und Ziele" (1867).

44. Marggraff, "Zustand" (1838), p. 8. Another example: Müller von Königs-winter, *Verhältnis* (1861), p. 18.

45. Muther, *Geschichte* (1893–1894), 1:102, 184, 154. See Jensen, *Marketing* (1994), pp. 212 ff.

46. On Meier-Graefe, see Hans Belting's introduction to the newest edition of the *Entwicklungsgeschichte* (1987); Jensen, *Marketing* (1994), chap. 8; Moffett, *Meier-Graefe* (1973); and Paret, *Secession* (1980). For a hostile contemporary reaction from the critical establishment, see Kalkschmidt, "Umschau" (1907).

47. Quoted in Berman, "Meier-Graefe" (1996), p. 91.

48. See Tschudi's introduction to *Ausstellung 1906* (1906), vol. 1, and his essay, "Jahrhundertausstellung" (1906). Alfred Lichtwark, another organizer, regarded it as a great "Revisionsausstellung": Lichtwark, *Briefe* (1924), 1:409. For more on the exhibition, see Paul, *Tschudi* (1993), pp. 238 ff.; Jensen, *Marketing* (1994), p. 261; and Krahmer, "Tschudi" (1996).

49. Gensel, "Malerei" (1906), p. 110. For another positive response, see Knapp, "Jahrhundertausstellung" (1906).

50. Meier-Graefe, "Museum" (1913), pp. 32–33. For a similar argument, see Scheffler, *Nationalgalerie* (1912), pp. 291–92.

51. Pauli, *Erinnerungen* (1936), p. 276; Scheffler, *Jahre* (1946), p. 249; Volbehr, *Zukunft* (1909), p. 5; Wichert quoted in Fath, "Wickert" (1996), p. 314.

52. Drey, *Grundlagen* (1910), pp. 316–17; Treinen, "Ansätze" (1973), p. 351 n. 8. See also Feldenkirchen, "Kunstfinanzierung" (1982).

53. For a useful summary, see Bahns, "Kunst- und kulturgeschichtliche Museen" (1977).

54. For an introduction to the relationships among different types of museums, see Hochreiter, *Musentempel* (1994).

55. Malkowsky, *Kunst* (1912), p. 66.

56. Pallat, *Schöne* (1959), pp. 211 ff.; Woermann, *Lebenserinnerungen* (1924), 2:84–85.

57. On Munich, see Möckl, "Hof" (1985), pp. 220 ff.; on Weimar, Grupp, *Kessler* (1995), pp. 86 ff., and Easton, "Rise" (1996).

58. Ghattas, "Patronage" (1986), p. 96.

59. L. Justi, *Ausbau* (1913), p. vii.

60. See, for example, the discussions in the Bavarian Landtag, July 11, 1906, and July 19, 1908: Siefert, "Tschudis" (1996), pp. 402–3.

61. Mommsen, "Stadt" (1991), p. 83, on Krefeld; Sauerlandt, *Kampf* (1957), p. 40, on Halle; Schiefler, *Kulturgeschichte* (1985), pp. 90 ff., on Hamburg.

62. Hansert, *Bürgerkultur* (1992), especially pp. 161 ff.

63. Jensen, *Marketing* (1994), especially pp. 67 ff.; Junge, ed., *Avantgarde* (1992); Ghattas, "Patronage" (1986), p. 156, on Munich; Lenman, "Brown Sauce" (1996), pp. 53 ff. Brühl, *Cassirers* (1991), has some useful information on the most important Berlin gallery.

64. Lenman, "Kunstmarkt" (1993), p. 140.

65. Jensen, *Marketing* (1994), p. 69; Fath, "Wichert" (1996), p. 315. Wichert added the price not to help sell the works but to show his supporters how expensive it would be to build a first-class collection.

66. See the essays in Mai and Paret, eds., *Sammler* (1993), and in Braun and Braun, eds., *Mäzenatentum* (1993). For a contemporary response to changes in the character of collecting, see Rosenberg, "Kunstsammler" (1898).

67. The best study of a *Museumsverein* is Hansert, *Geschichte* (1994), on Frankfurt, with some comparative data from other cities.

68. Quoted, with approval, in [A.P.], "Kunst" (1899), p. 597. See the similar remark in Dilthey, "Epochen" (1892), p. 200.

69. Pauli, *Erinnerungen* (1936), p. 285.

70. Centralstelle, *Vorberichte* (1903); quotation from Robert von Erdberg, p. 43. See Alfred Lichtwark, remarks on these issues, in "Museen" (1905) and Swarzenski, "Kunstsammlungen" (1922), pp. 201 ff.

71. Pallat, *Schöne* (1959), pp. 279 ff. Centralstelle, *Vorberichte* (1903), pp. 44–91, has a survey of tours, lectures, etc. On Mannheim, see Fath, "Wickert" (1996), p. 316. On the *Werkbund*, see Campbell, *Werkbund* (1978), and Schwartz, *Werkbund* (1996).

72. Uhde-Bernays, *Lichte* (1947), pp. 459–60. Other contemporary portraits: Friedländer, *Erinnerungen* (1967); Schmidt-Ott, *Erlebtes* (1952); Pauli, *Erinnerungen* (1936); Scheffler, *Auswahl* (1969); and—particularly useful—Pallat, *Schöne* (1959). The basic source for Bode's career is his two-volume autobiography, *Leben* (1930), now available in a new edition (1997), edited with notes and an introduction by Thomas Gaehtgens and Barbara Paul. Ohlsen's *Bode* (1995) uses archival sources to correct many of the details in Bode's own account but does not have much to say about the historical context of his career. Among briefer accounts, see especially the works by Gaehtgens: *Museumsinsel* (1992), "Bode" (1993), and "Bismarck" (1995). The catalogue of an exhibition marking the 150th anniversary of his birth suggests the range of his interests and accomplishments: *Wilhelm von Bode* (1995). See also the articles from the anniversary symposium, published in *JbBM*, 38, supp. (1996). W. Waetzoldt, "Trilogie" (1932), is a finely drawn triple portrait of Bode, Tschudi, and Lichtwark.

73. Bode, "Erwerbung" (1881); Ohlsen, *Bode* (1995), pp. 114 ff. For a later statement of his opposition to artists as museum officials, see Bode, "Zukunft" (1909).

74. Bode, "Rembrandt" (1890), p. 311; Grimm, "Universitätsstudium" (1891).

75. Hammer, "Museumspolitik" (1980).

76. Giradet, "Simon" (1982); Gaehtgens, *Museumsinsel* (1992); Hardtwig, "Porträts" (1993); Paul, "Bode" (1993). Weisbach, whose father was one of Bode's collectors, gives a rather jaundiced view of their relationship in his memoirs, *Erinnerungen* (1937), pp. 100–107.

77. See *Wilhelm von Bode* (1995), pp. 91–98, on the Museumsverein.

78. See *Wilhelm von Bode* (1995) on his breadth of interests.

79. From an essay written on the new century, reprinted in Bode, *Kunst* (1901), pp. 167–68. Not totally pessimistic about modern art, Bode was somewhat hopeful about developments in England and the United States, as well as about the art-and-crafts movement in Darmstadt.

80. On Tschudi, see especially Paul, *Tschudi* (1993), and the essays in Hohenzollern and Schuster, eds., *Manet* (1996). Also of value is the analysis in Paret, *Secession* (1980), and "The Tschudi Affair" (1981). Tschudi's most important essays were collected after his death: *Schriften* (1912). For contemporary portaits, see Scheffler, *Jahre* (1946), pp. 236 ff; Gräff, "Tschudi" (1913); Meier-Graefe, "Museum" (1913); and West, "Tschudi" (1913).

81. The precise details of Tschudi's appointment remain obscure. He was not among the first group of candidates to be considered but seems to have been chosen

after the other alternatives did not work out. Bode, though he had complained to Schöne about Tschudi on several occasions, did not oppose his appointment, no doubt in part because he was happy to get rid of him. See the material in Pallat, *Schöne* (1959), pp. 249 ff. For a contemporary reaction, see Lichtwark, *Briefe* (1924), 1:231–32.

82. Kessler, *Künstler* (1988), p. 73, surely had the National Gallery in mind when he wrote that the basic acquisitions policy of modern collections seemed to be "to buy a picture from every artist who paints a picture every few years and is a professor." See Rave, *Geschichte* (1968), and With, *Landeskunstkommission* (1986), pp. 87 ff.

83. For a characteristic statement of William's artistic views, see his speech at the 1901 dedication of the Siegesalle, in Wilhelm II, *Reden* (n.d.). Paret, *Secession* (1980), pp. 24–28, has a balanced analysis of the emperor's aesthetics.

84. In addition to the full account in Paul, *Tschudi* (1993), pp. 96 ff., see With, *Landeskunstkommission* (1986), pp. 87 ff.

85. For a positive response, see Bie, "Nationalgalerie" (1899).

86. Tschudi, *Kunst* (1899). On the conflict between William and Tschudi, see Paret, *Secession* (1980), pp. 160 ff.

87. The best account is Paret, "Tschudi Affair" (1981), which convincingly portrays it as "an example of the emperor's assertion of power at a time when he had already let much of it slip out of his grasp" (p. 589). The fact that the controversy over Tschudi's future coincided with the crisis in imperial authority created by his tactless interview in the *Daily Telegraph* surely limited William's ability to impose his will.

88. On the Munich art world, see Makela, *Secession* (1990), and Ludwig, *Kunst* (1986).

89. See Paul, *Tschudi* (1993), chap. 5; Uhde-Bernays, *Lichte* (1947), pp. 456 ff. On the administrative structure, see Bavaria, *Ministerialblatt* (1907), pp. 243–48. A contemporary reaction: Kalkschmidt, "Kunstkrieg" (1910).

90. Tschudi, "Vorwart" (1911).

91. Tschudi, "Vorwart" (1911).

92. Bode, "Beruf" (1912), pp. 811–12. Lichtwark was among those who immediately recognized Bode as Tschudi's target: *Briefe* (1924), 2:349.

93. The bibliography in Kayser, *Lichtwark* (1977), lists 624 items that cover an extraordinary range of subjects. See also Präffcke, *Kunstbegriff* (1986), and Junge, "Lichtwark" (1993). Schiefler, *Kulturgeschichte* (1985), is a good account of Lichtwark's relationship to his Hamburg patrons. Gustav Pauli's introduction to his edition of Lichtwark's *Briefe* (1924) gives a sympathetic but shrewd portrayal of his friend's accomplishments. Lichtwark, *Erziehung* (1991), is a useful collection of his essays.

94. Lichtwark, "Eine heimatliche Kunst" (1896); Hentzen, *Kunsthalle* (1969); Luckhardt, *Kunst* (1994).

95. Lichtwark, "Aufgaben der Kunsthalle," in *Organisation* (1887), p. 12.

96. Below, "Probleme" (1975), emphasizes the unhistorical character of Lichtwark's aesthetics.

97. In his letter of 1881, for instance, he calls museums "barbarisms": quoted in Präffcke, *Kunstbegriff* (1986), p. 23. Other examples: Lichtwark on the museums in Munich in 1893, in *Briefe* (1924), 1:134, and his remarks in "Museen" (1905), p. 96.

98. Lichtwark, *Organisation* (1887), p. 1. On Meyer, see Hamburg Kunsthalle, *Jahresbericht* (1886–87), 1:55.

99. See the remarks on this group in Schmarsow, *Kunstgeschichte* (1891), p. 14.

100. Koetschau, "Künstler" (1908), pp. 37–38. See also Bode, "Zukunft" (1909), and Swarzenski, "Kunstsammlungen" (1922). Daniel, *Hoftheater* (1995),

pp. 371 ff, traces a comparable trend toward professionalization among theater directors.

101. Quoted in Siefert, "Tschudis" (1996), p. 403.

102. Koetschau, *Vorbildung* (1918), p. 4.

103. Bode, "Beruf" (1912).

104. Friedländer, *Kunst* ([1946], 1992). Friedländer (1867–1958) received his Ph.D. at Leipzig in 1891, was a volunteer in the print department in Berlin, and worked briefly at the Wallraf-Richartz Museum in Cologne before returning to Berlin in 1896. He was director of the print collection from 1908, until he was forced into exile by the Nazis.

105. Ohlsen, *Bode* (1995), p. 95; Fehlemann, "Kaesbach" (1992), p. 188.

106. Woermann, *Lebenserinnerungen* (1924); Friedländer, *Kunst* ([1946], 1992); Pauli, *Erinnerungen* (1936).

107. Bourdieu, "Museumskonservatoren" (1972), views this informality as a persistent characteristic of museum managers. Mariner, "Museum" (1969), has some interesting things to say about the professionalization of the staff in an American art museum.

108. Friedländer, *Kunst* (([1946], 1992), pp. 67–68, on Lippmann; Hille, "Hartlaub" (1992); L. Justi, *Dienst* (1936; K. Winkler, "Justi" (1992).

109. Hentzen, *Kunsthalle* (1969), p. 17; Pauli, *Erinnerungen* (1936), pp. 202 ff.; Bode, "Zukunft" (1909), p. 190; Back, "Erinnerungen" (1933), p. 193. See West, "Denkschriften" (1913), on museum administration.

110. Berlin, "Direktorialbeamte" (1914), pp. 353–54.

111. The *Deutscher Museumsbund* was founded in 1917.

112. Pauli, "Museen" (1930), p. 97.

113. Pauli's own account is in *Erinnerungen* (1936). See also Salzmann, "Pauli" (1992); Dirksen, "Pauli" (1938); and Alt, *Herabwertung* (1911), pp. 469 ff. For the context of the debate, see Paret, *Secession* (1980), pp. 182 ff.

114. Hüneke, "Sauerlandt" (1992); Sauerlandt, *Kampf* (1957), pp. 41 ff.; Knoll, "Kunst" (1996), on Treue. See Gallwitz, ed., *ReVision* (1991), and Hansert, *Geschichte* (1994), p. 83, on modernism in the Städel.

115. According to Lenman, "Painters" (1989), pp. 130–31, 84 percent of the works shown at Munich's Glaspalast exhibitions from 1890 to 1894 and from 1900 to 1908 remained unsold. See also Drey, *Grundlagen* (1910).

116. Two representative examples are Carl Vinnen, *Protest* (1911), and Alt, *Herabwertung* (1911).

117. Paret, "Tschudi Affair" (1981), and "Affäre" (1996).

118. Using American examples, Zolberg, *Constructing* (1990), pp. 62 ff., points out that provincial museums have often been more willing to take risks and support new trends. For the German situation, see Gemmeke, "Gosebruch" (1992), and Scheffler, *Jahre* (1946), p. 250.

119. Olsen, *City* (1986), p. 281. See also Hammerschmidt, *Anspruch* (1985), p. 633.

120. Colquhoun, *Modernity* (1991), p. 17.

121. Milde, *Neorenaissance* (1981), pp. 301 ff.; Hammerschmidt, *Anspruch* (1985), pp. 79 ff.

122. The Kaiser-Friedrich Museum was carefully described by several contemporaries: see Seeck, "Museum" (1905), and Clemen, "Kaiser-Friedrich" (1905). There is a good brief treatment, with excellent illustrations, in Petras, *Bauten* (1987), pp. 102 ff. I am especially indebted to the account in Gaehtgens, *Museumsinsel* (1992).

See also Paul, "Bodes" (1994). On the planning process, see Bode, *Leben* (1930), and Ohlsen, *Bode*, pp. 116 ff.

123. *NDB* (1953–), 10:128–29.

124. The term was first used in the 1870s in a memorandum on the future of the Berlin museums: Bernau, "Kunstkammer" (1995). On the development of Berlin's museums, see Petras, *Bauten* (1987), and the essays in Zentralinstitut, *Berlins* (1994).

125. Gaehtgens, *Museumsinsel* (1992), emphasizes the museum's dynastic connections.

126. See Bode, "Kunstsammlungen" (1905), pp. 36–39; Gaehtgens, *Museumsinsel* (1992), has a useful analysis of the museum's method of hanging its works. See also Joachimides, "Schule" (1995), and Baker, "Bode" (1996).

127. There is a good picture of this room in Petras, *Bauten* (1987), p. 121.

128. Of course, museums also influenced the way individual connoisseurs exhibited their art, which was often displayed in museumlike spaces that had no other purpose. See Gaehtgens, "Bode" (1993), p. 164.

129. Gaehtgens, *Museumsinsel* (1992), pp. 35–36, surveys the contemporary response. See especially Gensel, "Künste" (1904–1905); and Seeck, "Museum" (1905).

130. Lichtwark, *Briefe* (1924), 2:361. The unidentified architect is quoted in Seeck, "Museum" (1905), p. 17.

131. Quoted in Beeh, "Museumsbau" (1983), p. 69.

132. See Beeh, "Museumsbau" (1983), and "Parade zum Friedensplatz" (1985–1987); and Bott, "Wettbewerb" (1977).

133. Knodt, *Ernst Ludwig* (1978).

134. For an introduction to changes in the architectural profession, see Clark, "Struggle" (1990).

135. The best account of Messel's work remains Behrendt's sympathetic monograph, *Messel* (1911); see also Behrendt, *Building* (1937), especially p. 79, and the special issue of *Berliner Architekturwelt* devoted to Messel in 1911. Two highly positive contemporary views are Escherich, "Messel" (1909), and Bie, "Messel" (1909). On his work on the Berlin museum, see Petras, *Bauten* (1987), pp. 138 ff., and Gaehtgens, *Museumsinsel* (1992), pp. 96 ff. On Darmstadt, see Bott, "Museum" (n.d.), and Back, "Erinnerungen" (1933). For a sympathetic contemporary assessment, see Trenkwald, "Landesmuseum" (1907).

136. Lane, *Architecture* (1968), pp. 12–13.

137. Messel had to modify his original plans for the exterior not only to control costs but also in response to objections from members of the Landtag; Beeh, "Museumsbau" (1983) has a good account. The facade was altered again in the building's reconstruction after the Second World War.

138. Joseph Olbrich's *Hochzeitsturm*, built in honor of Ernst Ludwig and his bride on the Mathildenhöhe in 1907, might be seen as a competitive response to Messel's tower.

139. From Ernst Ludwig's memoirs, quoted in Knodt, *Ernst Ludwig* (1978), p. 266.

140. The first example of this sort of structure was evidently the Zurich museum. See Bahns, "Museen" (1977), pp. 184–85.

141. The best account of the interior is Back, "Einrichtung" (1909).

142. For a contemporary's comparison of the two projects, see van de Velde, *Geschichte* (1986), pp. 217 ff.

143. Quoted in Lahme-Schlenger, "Osthaus" (1992), p. 228. The best introduction to his life and work is the collection of essays edited by Hesse-Frielinghaus

et al., *Osthaus* (1971). See also Grasskamp, *Museumsgründer* (1972), pp. 101–4. For the intellectual context of Osthaus's ideas, see Schwartz, *Werkbund* (1996).

144. On their relationship, see Osthaus et al., *Van de Velde* ([1920], 1984) and van de Velde, *Geschichte* (1986), especially pp. 174 ff. on their first meeting.

145. See the essays in Hesse-Frielinghaus et al., *Osthaus* (1971); Sembach, *Van de Velde* (1989), pp. 72–126.

146. Quoted in Hesse-Frielinghaus et al., *Osthaus* (1971), p. 129. See also van de Velde's account of his intentions in *Geschichte* (1986), p. 205.

147. Hesse-Frielinghaus et al., *Osthaus* (1971), pp. 519–26, reproduces the museum's tenth-anniversary catalogue. See also Osthaus Museum, *Impuls* (1984).

148. Quoted in Lloyd, *Expressionism* (1991), pp. 8–9.

149. See Freyer, "Folkwang" (1912).

150. Cited in Lahme-Schlenger, "Osthaus" (1992), p. 229.

151. Letter of October 1910, in Lichtwark, *Briefe* (1924), 2:324 ff.

152. See Scherer, *Museen* (1913), pp. 180–81. For an early discussion of the lighting problem, see Berlin, *Vier Gutachten* (1868), on the renovation of the Altes Museum.

153. Lichtwark, "Museumsbauten" (1905), is a critique of existing museums and a discussion of what was needed to bring them up to date. See also H. Wagner, "Museen" (1906), on new buildings and possibilities.

154. Werkbecker, "Museen" (1911–1912), especially pp. 27 ff.

155. Woermann, "Raumfrage" (1912, from a memorandum of 1907). See also Woermann, *Lebenserinnerungen* (1924), 2:78 ff.

156. Hammerschmidt, *Anspruch* (1985), pp. 510 ff., and Bahns, "Museen" (1977). The debate over these issues between Bode and Julius Lessing, the director of Berlin's Kunstgewerbemuseum, is reported in Rückert and Segelken, "Kampf" (1995).

157. "Every truly good work of art must be isolated," wrote Adolf Furtwängler, "Kunstsammlungen" ([1899], 1988), p. 92. "One must be able to experience it in a way that it alone can speak, otherwise it can't be understood. And this is naturally totally impossible in our palatial warehouses."

158. Some examples: L. Justi, "Neuordnung" (1905), on the Städel; Pazaurek, "Gemäldegalerie" (1907), on Stuttgart; Haupt, *Museum* (1991), p. 51, on Vienna.

159. Jensen, *Marketing* (1994), pp. 183, 200. For a description of Berlin galleries, see Häsker, "Kunstaustellungen" (1899–1900).

160. Makela, *Secession* (1990), p. 70.

161. With, *Landeskunstkommission* (1986), p. 154 n. 25. Many contemporary critics were unremittingly hostile to the National Gallery from the start: see, for example, the harsh comments in [Anon.], "Gebäude" (1876), and Karl Scheffler's critique in *Nationalgalerie* (1912), pp. 12 ff. For more recent analyses, see E. Börsch-Supan, *Baukunst* (1977), pp. 55 ff., and Forster-Hahn, "Politics" (1995).

162. Paul, *Tschudi* (1993), pp. 96 ff., 218 ff.

163. Behrens, like van de Velde, began as a painter before turning to architecture and the applied arts. He worked briefly in Darmstadt and then in Berlin, where he did his best-known buildings for Germany's General Electric Corporation [AEG] and other industrial firms: For a good guide to the literature on Behrens, see Pfeifer ed., *Behrens* (1990); Windsor, *Behrens* (1981), is a useful brief introduction. There is a description of the Century Exhibition in Wesenberg, "Impressionismus" (1996), p. 369.

164. Goldberg, "Tschudi" (1996), p. 414.

165. Lichtwark, *Briefe* (1924), 2:331–32; see also p. 111 on the "Tschudi principle" as used in Cassel. For another contemporary critique, see Gräff, "Tschudi" (1912).

166. See L. Justi, *Ausbau* (1913), and *Umbau* (1914); Rohe, "Umhängung" (1913–1914); Freska, "Pinakothek" (1914).

167. Weisbach, "Kunstgenuss" (1908), and *Geist* (1956), p. 56.

168. Quoted in Krahmer, "Tschudi" (1996), p. 374.

169. Seidlitz, *Kunstmuseen* (1907), p. 6.

170. H. Wagner, "Museen" (1906), p. 246. See also Plagemann, *Kunstmuseum* (1967), pp. 197–98, and Schulze, *Bildprogramme* (1984), pp. 145 ff.

171. Quoted in Hammerschmidt, *Anspruch* (1985), p. 523.

172. Lichtwark, "Museumsbauten" (1905); Luckhardt, *Geschichte* (1994), pp. 32 ff.

173. Schulze, *Bildprogramme* (1984), pp. 138–39, notes that the competition to paint the murals for the Düsseldorf Kunsthalle in 1881 attracted little interest among artists. About the same time, Valentin Ruths produced the murals on the Treppenhaus in the Hamburg Kunsthalle, which have no programmatic connection to the collection or its purposes.

174. Lichtwark quoted in Tippmann, *Entwicklung* (1931), p. 153; Swarzenski, *Museumsfragen* (1928), p. 9.

175. O'Doherty, *Cube* (1986). See also Kemp, "Kunst" (1989). Harbison, *Spaces* (1988), p. 141, suggests an interesting connection between this kind of space the prevalence of slides in teaching art history.

176. Douglas, *Institutions* (1986), p. 98, quoted in Sherman, *Monuments* (1989), p. 192.

Conclusion

1. Lidtke, "Museen" (1993).

2. Gay, *Culture* (1968).

3. On this exhibition, see Barron, ed., *Degenerate Art* (1991).

4. Holst, "Kunstmuseum" (1934), p. 7. For a skeptical assessment of Nazi artistic policies, see Nerdinger, "Pseudomäzenatentum" (1993).

5. See Nicholas, *Rape* (1994).

6. See Barthelmess, *Museum* (1988), pp. 24 ff., and the essay by Erich Altenhöfer in *Ihm, welcher* (1986). This feature of Döllgast's structure was removed in the most recent renovation of the Alte Pinakothek.

7. See Klotz and Krase, *Museumsbauten* (1985), for a guide to these buildings. For a historically informed treatment of the contemporary problems of Berlin's museums, see the essays in Zentralinstitut *Berlins* (1994).

8. Rodiek, *Stirling* (1984), p. 13. There is an appreciative analysis of Stirling's building in Newhouse, *Museum* (1998), pp. 179 ff.

9. Quoted in Barthelmess, *Museum* (1988), p. 115.

BIBLIOGRAPHY

Abrams, M. H. "Art as Such: The Sociology of Modern Aesthetics." In *Doing Things with Texts*, pp. 135–58. New York: Norton, 1989.

Alewyn, Richard. *Das grosse Welttheater. Die Epoche der höfischen Feste*. Munich: Beck, 1985.

Alt, Theodor. *Die Herabwertung der deutschen Kunst durch die Parteigänger des Impressionismus*. Mannheim: F. Nemnich, 1911.

Althöfer, Heinz, ed. *Das 19. Jahrhundert und die Restaurierung*. Munich: Callwey, 1987.

Andrée, Rolf. "Die Fresken Steinles im ersten Wallraf-Richartz-Museum." *Museen in Köln* 2, no. 2 (1963): 155–60.

[Anon.] "Über das Kunstgefühl. Ursachen seines Mangels und seiner Verstimmung." *Miscellaneen artistischen Inhalts*. 3 (1780): 3–18.

[Anon.] "Die Bedeutung der Kunstgeschichte für unsere Zeit." *Gb* 14, no. 1 (1855): 287–95.

[Anon.] "Geschichte der bildenden Künste." *Gb* 15, no. 4 (1856): 201–10.

[Anon.] "Berliner Kunstbericht. Die Nationalgalerie und ihr Haus." *Gb* 26, no. 3 (1867): 94–106.

[Anon.] "Die Berliner Bildergalerie und ihr Katalog." *Gb* 27, no. 2 (1868): 281–91.

[Anon.] "Das Gebäude der Nationalgalerie." *INR* 6, no. 1 (1876): 781–96.

[Anon.] "Die Kunst für das Volk." *Gb* 57, no. 1 (1898): 262–70.

Antoni, Irene. *Die Staatsgalerie Stuttgart im 19. Jahrhundert. Ein "Museum der bildenden Künste."* Munich: Tuduv, 1988.

[A.P.] "Die Kunst für Alle oder für wenige?" *Gb* 58, no. 2 (1899): 593–97.

Apel, Friedmar, ed. *Romantische Kunstlehre. Poesie und Poetik des Blicks in der deutschen Romantik*. Frankfurt: Deutscher Klassiker Verlag, 1992.

Arnim, Bettina von. "Schinkels Gemälde für die Vorhalle des Museums zu Berlin." *Museum*. 4, no. 15 (1836): 113–19.

Aufklärung und Klassizismus in Hessen-Kassel unter Landgraf Friedrich II. 1760–1785. Kassel: Verein für Publikationen, 1979.

Aurenhammer, Hans, and Gertrude Aurenhammer. *Das Belvedere in Wien. Bauwerk, Menschen, Geschichte*. Vienna: Schroll, 1971.

Ausstellung deutscher Kunst aus der Zeit von 1775–1875 in der Königlichen Nationalgalerie: Berlin 1906. 2 vols. Munich: F. Bruckmann, 1906.

Back, Friedrich. "Die Einrichtung der Kunst- und historischen Sammlungen des Grossherzoglichen Landesmuseums in Darmstadt." *Mk* 5 (1909): 63–82.

———. "Erinnerungen. Aus der Bauzeit des Landesmuseums in Darmstadt." *Volk und Scholle* 11, nos. 7–8 (1933): 192–204.

Bahns, Jörn. "Kunst- und kulturgeschichtliche Museen als Bauaufgabe des späten 19. Jahrhunderts. Das Germanische Nationalmuseum und andere Neubauten seit etwa 1870." In Deneke und Kahsnitz, eds., *Museum* (1977), pp. 176–92.

Baker, Malcolm. "Bode and Museum Display: The Arrangement of the Kaiser-Friedrich-Museum and the South Kensington Response." *JbBM* 38, supp. (1996): 143–53.

Bal, Mieke. *Double Exposures: The Subject of Cultural Analysis*. New York: Routledge, 1996.

Balet, Leo, and E. Gerhard. *Die Verbürgerlichung der deutschen Kunst. Literatur und Musik im 18. Jahrhundert*. Berlin: Ullstein Verlag, [1936] 1972.

Balsiger, Barbara. "The Kunst- und Wunderkammern: A Catalogue Raisonné of Collecting in Germany, France, and England, 1565–1750." Ph.D. diss., University of Pittsburgh, 1970.

Barclay, David E. *Frederick William IV and the Prussian Monarchy*. Oxford: Oxford University Press, 1995.

Barner, Wilfried, ed. *Tradition, Norm, Innovation. Soziales und literarisches Traditionsverhalten in der Frühzeit der deutschen Aufklärung*. Munich: Oldenbourg, 1989.

Barron, Stephanie, ed. *"Degenerate Art": The Fate of the Avant-Garde in Nazi Germany*. Los Angeles: Los Angeles County Museum of Art, 1991.

Barthelmess, Stephan. *Das postmoderne Museum als Erscheinungsform von Architektur. Die Bauaufgabe des Museums im Spannungsfeld von Moderne und Postmoderne*. Munich: Tuduv, 1988.

Bartmann, Dominik. *Anton von Werner. Zur Kunst und Kunstpolitik im Deutschen Kaiserreich*. Berlin: Deutscher Verlag für Kunstwissenschaft, 1985.

Batschmann, Oskar, and Pascal Griener. *Hans Holbein d. J. Die Darmstädter Madonna. Original gegen Fälschung*. Frankfurt: Fischer Verlag, 1998.

Bauer, Hermann. "Kunstanschauung und Kunstpflege in Bayern von Karl Theodor bis Ludwig I." In Glaser, ed., *Krone* (1980): pp. 345–55.

Baumgart, Peter. "Der deutsche Hof der Barockzeit als politische Institution." In Buck, et al., eds., *Hofkultur* (1981), 1:24–43.

Baumgarten, Alexander Gottlieb. *Theoretische Ästhetik. Die grundlegenden Abschnitte aus der "aesthetica" (1750/58)*. Ed. Hans Rudolf Schweizer. Hamburg: F. Meiner, 1983.

Bavaria. *Ministerialblatt für Kirchen- und Schulangelegenheiten*. 43, no. 14 (April 30, 1907): 243–48.

Baxandall, Michael. *Patterns of Intention: On the Historical Explanation of Pictures*. New Haven: Yale University Press, 1985.

Bayersdorfer, Adolf. *Leben und Schriften aus seinem Nachlass*. Munich: F. Bruckmann, 1908.

Bazin, G. *The Museum Age*. New York: Universe, 1967.

Beck, Herbert, and Peter C. Bol, eds. *Forschungen zur Villa Albani. Antike Kunst und die Epoche der Aufklärung*. Berlin: Mann, 1982.

Beck, Herbert, et al., eds. *Ideal und Wirklichkeit der bildenden Kunst im späten 18. Jahrhundert*. Berlin: Mann, 1984.

Becker, Howard S. *Art Worlds*. Berkeley: University of California Press, 1982.

Becker, Wolfgang. *Paris und die deutsche Malerei, 1750–1840*. Munich: Pestel, 1971.

Beeh, Wolfgang. "Der Museumsbau Messels für Darmstadt: Die Fassadenänderung zwischen Entwurf und Ausführung." *Kunst in Hessen und am Mittelrhein* 21 (1983): 67–74.

———. "Vom Parade zum Friedensplatz vor Messels Museum in Darmstadt. Entwürfe, Pläne, Ausführungen." *Bernhard Hoffmann zum 65. Geburtstag*. Reprinted from *Kunst in Hessen und am Mittelrhein* 25, 27 (1985–1987): 65–81.

————. *Das Darmstädter Landesmuseum von Alfred Messel. Skizzen, Entwürfe, Fotografien 1891–1906*. Darmstadt: Hessisches Landesmuseum, 1986.

Beenken, Hermann. *Das 19. Jahrhundert in der deutschen Kunst*. Munich: F. Bruckmann, 1944.

————. *Schöpferische Bauideen der deutschen Romantik*. Mainz: Matthias Grunewald, 1952.

Behrendt, Walter Curt. *Alfred Messel*. Berlin: B. Cassirer, 1911.

————. *Modern Building: Its Nature, Problems, and Forms*. New York: Harcourt, Brace, 1937.

Below, Irene. "Probleme der 'Werkbetrachtung.' Lichtwerk und die Folgen." In Irene Below, ed., *Kunstwissenschaft und Kunstvermittlung*, pp. 83–136. Giessen: Anabas, 1975.

Belting, Hans. *Das Ende der Kunstgeschichte. Eine Revision nach zehn Jahren*. Munich: Beck, 1995.

Bennett, Tony. *The Birth of the Museum*. London: Routledge, 1995.

Bergdoll, Barry. *Karl Friedrich Schinkel: An Architecture for Prussia*. New York: Rizzoli, 1994.

Beringer, Josef August. "Moritz von Schwinds Karlsruher Zeit. Ein Beitrag zur badischen Kunstgeschichte des 19. Jahrhunderts." *ZGO* 30, no. 2 (1915): 137–200.

Berlin. *Vier Gutachten über die bei dem Umbau des Daches des älteren Museums in Berlin in Frage gekommenen baulichen Veränderungen der Gemäldegalerie*. Berlin: Reichsdruckerei, 1868.

————. *Zur Geschichte der königlichen Museen in Berlin. Festschrift zur Feier ihres fünfzigjährigen Bestehens am 3. August 1880*. Berlin: Reichsdruckerei, 1880.

————. *Statut für die königlichen Museen zu Berlin, nebst Abänderungs- und Ergänzungsbestimmungen*. Berlin: Reichsdruckerei, 1908.

————. "Direktorialbeamte . . . am 1. September 1911." *Amtliche Berichte aus den königlichen Kunstsammlungen* 35, no. 12 (September 1911): 294.

————. "Direktorialbeamte . . . am 1. September 1914." *Amtliche Berichte aus den königlichen Kunstsammlungen* 35, no. 12 (September 1914): 352–53.

————. "150 Jahre staatliche Museen zu Berlin." *Staatliche Museen zu Berlin. Forschungen und Berichte* 20–21 (1980).

Berliner, Rudolf. "Zur älteren Geschichte der allgemeinen Museumslehre in Deutschland." *MJbBK*, n.s., 5 (1928): 327–52.

Berlin Museum. *Friedrich Gilly, 1772–1800, und die Privatgesellschaft junger Architekten*. Berlin: W. Arenhövel, 1987.

Berman, Patricia. "The Invention of History: Julius Meier-Graefe, German Modernism, and the Genealogy of Genius." In Forster-Hahn, ed., *Imagining* (1996): pp. 91–105.

Bernau, Nikolaus. "Von der Kunstkammer zum Musenarchipel. Die Berliner Museumslandschaft, 1830–1994." In Joachimides et al., eds., *Museumsinszenierung* (1995): pp. 15–35.

Bickendorf, Gabriele. *Der Beginn der Kunstgeschichtsschreibung unter dem Paradigma "Geschichte." G. F. Waagens Frühschrift über Hubert und Johann van Eyck*. Worms: Wernersche Verlagsgesellschaft, 1985.

Bie, Oskar. "Die Nationalgalerie." *Wm* 86 (1899): 427–44.

————. "Alfred Messel." *NR* 20, no. 2 (1909): 750–54.

Bielmeier, Stefanie. *Gemalte Kunstgeschichte. Zu den Entwürfen des Peter von Cornelius für die Loggien der Alten Pinakothek*. Munich: UNI-Druck, 1983.

Bismarck, Beatrice von. "Georg Swarzenski und die Rezeption des französischen

Impressionismus in Frankfurt: Eine Stadt 'Im Kampf um die Kunst?'" In Galtwitz, ed., *ReVision* (1991): pp. 31–40.

Bjurström, Per, ed. *The Genesis of the Art Museum in the 18th Century.* Stockholm: Nationalmuseum, 1993.

Bock, Henning. "Fürstliche und öffentliche Kunstsammlungen im 18. und frühen 19. Jahrhundert in Deutschland." In Bjurström, ed., *Genesis* (1993): pp. 112–30.

Bode, Wilhelm von. "Die neueste Erwerbung der Berliner Gemäldegalerie, 'Neptun und Amphitrite' von P. P. Rubens." *PJbb* 47, no. 4 (1881): 420–33.

———. "Rembrandt als Erzieher von einem Deutschen." *PJbb* 65, no. 3 (1890): 301–14.

———. *Kunst und Kunstgewerbe am Ende des 19. Jahrhunderts.* Berlin: Cassirer, 1901.

———. "Das Kaiser Friedrich-Museum in Berlin. Zur Eröffnung am 18. Oktober 1904." *Mk* 1 (1905): 1–16.

———. "Kunstsammlungen und Museumsbauten hüben und drüben." *KK* 3, no. 1 (1905): 33–38.

———. "Die Zukunft der Dresdener Gemäldegalerie." *Mk* 5 (1909): 189–93.

———. "Beruf und Ausbildung des Museumsbeamten." *Die Woche* 14, no. 20 (1912): 810–12.

———. *Mein Leben.* 2 vols. Berlin: Reckendorft, 1930.

———. *Mein Leben.* Ed. T. W.Gaehtgens and Barbara Paul. 2 vols. Berlin: Nicolai, 1997.

Bodenhausen, Eberhard von. *Ein Leben für Kunst und Wirtschaft.* Düsseldorf: E. Diederichs, 1955.

Boehlke, Hans-Kurt. *Simon Louis du Ry. Ein Wegbereiter klassizistischer Architektur in Deutschland.* Kassel: J. Stauda, 1980.

Boisserée, Sulpiz. *Briefwechsel/ Tagebücher.* 2 vols. Göttingen: Vandenhoeck & Ruprecht, [1862], 1970.

Börsch-Supan, Eva. "Der Renaissance-Begriff der Berliner Schule im Vergleich zu Semper," In A. M. Vogt, ed., *Gottfried Semper und die Mitte des 19. Jahrhundert,* pp. 153–74. Basel: Birkhaeuser, 1976.

———. *Berliner Baukunst nach Schinkel: 1840–1870.* Munich: Pestel, 1977.

Börsch-Supan, Helmut, ed. *Die Kataloge der Berliner Akademie-Ausstellungen, 1786–1850.* 2 vols. Berlin: B. Hessling, 1971.

———. "Die 'Geschichte der neueren deutschen Kunst' von Athanasius Graf Raczynski." In Schadendorf, ed., *Beiträge* (1975), pp. 15–26.

———. *Die Kunst in Brandenburg-Preussen. Ihre Geschichte von der Renaissance bis zum Biedermeier dargestellt am Kunstbesitz der Berliner Schlösser.* Berlin: Mann, 1980.

———. *Die deutsche Malerei von Anton Graff bis Hans von Marées, 1760–1870.* Munich: Beck, 1988.

Bott, Gerhard. *Die Gemäldegalerie des Hessischen Landesmuseums in Darmstadt.* Hanau: Peters, 1968.

———. "Der Wettbewerb für einen Museumsneubau in Darmstadt 1891." In Deneke and Kahsnitz, eds., *Museum* (1977): pp. 193–204.

———. "Das grossherzogliche Museum in Darmstadt, erbaut 1897–1902 von Alfred Messel." In Hans Grohn and W. Stubbe, eds., *Beiträge Kunst und Museum.* Hamburg: Christians, n.d.

Böttger, Peter. *Die alte Pinakothek in München. Architektur, Ausstattung und museales Programm.* Munich: Pestel, 1972.

Bourdieu, Pierre. "Outline of a Sociological Theory of Art Perception." *International Social Science Journal* 20 (1968): 589–612.

————. "Die Museumskonservatoren," In Thomas Luckmann and W. Sprondel, eds., *Berufssoziologie*, pp. 148–54. Cologne: Kiepenheuer & Witsch, 1972.

————. *Distinction: A Social Critique of the Judgement of Taste*. Cambridge: Harvard University Press, 1984.

Bourdieu, Pierre, and Alain Darbel. *The Love of Art: European Art Museums and Their Public*. Stanford: Stanford University Press, 1990.

Boyle, Nicholas. *Goethe: The Poet and the Age*. Vol. 1: *The Poetry of Desire (1749–1790)*. Oxford: Oxford University Press, 1991.

Braun, Günter, and Waldtraut Braun, eds. *Mäzenatentum in Berlin. Bürgersinn und kulturelle Kompetenz unter sich verändernden Bedingungen*. Berlin: De Gruyter, 1993.

Braun, Rudolf, and David Gugerli. *Macht des Tanzes / Tanz der Mächtigen. Hoffeste und Herrschaftszeremoniell, 1550–1914*. Munich: Beck, 1993.

Braunfels, Wolfgang. *Urban Design in Western Europe: Regime and Architecture, 900–1900*. Chicago: University of Chicago Press, 1988.

Bredekamp, Horst. *Antikensehnsucht und Maschinenglauben. Die Geschichte der Kunstkammer und die Zukunft der Kunstgeschichte*. Berlin: Wagenbach Verlag, 1993.

Bringmann, Michael. *Friedrich Pecht (1814–1903). Maßstäbe der deutschen Kunstkritik zwischen 1850 und 1900*. Berlin: Gebr. Mann, 1982.

Brockhaus-Conversations-Lexikon. 11th ed. 15 vols. Leipzig: F. A. Brockhaus, 1864–1868.

Brown, Jonathan. *Kings and Connoisseurs: Collecting Art in Seventeenth-Century Europe*. Princeton: Princeton University Press, 1994.

Brühl, Georg. *Die Cassirers. Streiter für den Impressionismus*. Leipzig: Edition Leipzig, 1991.

Brunner, Max. *Die Hofgesellschaft. Die führende Gesellschaftsschicht Bayerns während der Regierungszeit König Maximilian II*. Munich: UNI-Druck, 1987.

Buck, August, et al., eds. *Europäische Hofkultur im 16. und 17. Jahrhundert*. 3 vols. Hamburg: Hauswedell, 1981.

Buddensieg, Tilmann. "Die hellenische Antithese. Das Museum als Tempel—Schinkel und Hegel am Berliner Lustgarten." *FAZ*, August 24, 1991.

Burckhardt, Jacob. *The Civilization of the Renaissance in Italy*. 2 vols. New York: Harper, 1958.

————. *Über das Studium der Geschichte. Der Text der Weltgeschichtlichen Betrachtungen*. Munich: Beck, 1982.

————. *The Age of Constantine the Great*. Berkeley: University of California Press, [1852], 1983.

————. "Über die Echtheit alter Bilder" [1882]. In *Die Kunst der Betrachtung. Aufsätze und Vorträge zur bildenden Kunst*, ed. H. Ritter, pp. 281–91. Cologne: Dumont, 1984.

Busch, Günter. "Die Museifizierung der Kunst und die Folgen für die Kunstgeschichte." In Ganz, ed., *Kunst* (1991), pp. 219–29.

Busch, Werner. *Die notwendige Arabeske. Wirklichkeitsaneignung und Stilisierung in der deutschen Kunst des 19. Jahrhunderts*. Berlin: Mann, 1985.

————. "Wilhelm von Kaulbach—Peintre philosophe und Modern Painter. Zu Kaulbachs Weltgeschichtszyklus im Berliner Neuen Museum." In Gethmann-Siebert and Pöggler, eds., *Welt* (1986), pp. 117–138.

————. "Chodowieckis Darstellung der Gefühle und der Wandel des Bildbegriffs nach der Mitte des 18. Jahrhunderts." In Barner, ed., *Tradition* (1989), pp. 315–43.

————. *Das sentimentalische Bild. Die Krise der Kunst im 18. Jahrhundert und die Geburt der Moderne*. Munich: Beck, 1993.

Bussmann, Walter. *Zwischen Preussen und Deutschland. Friedrich Wilhelm IV. Eine Biographie*. Berlin: Siedler, 1990.

Butler, E. M. *The Tyranny of Greece over Germany*. Boston: Beacon, 1958.

Buttlar, Adrian von. "Fischer und Klenze. Münchner Klassizismus am Scheideweg." In Beck et al., eds., *Ideal* (1984), pp. 141–62.

———. "Es gibt nur eine Baukunst? Leo von Klenze zwischen Widerstand und Anpassung." In Nerdinger, ed., *Romantik* (1987), pp. 105–15.

———. *Leo von Klenze. Leben. Werk. Vision*. Munich: Beck, 1999.

Büttner, Frank. *Peter Cornelius. Fresken und Freskenprojekte*. Wiesbaden: Steiner, 1980.

Cahn, Walter. *Masterpieces: Chapters on the History of an Idea*. Princeton: Princeton University Press, 1979.

Calhoun, Craig, ed. *Habermas and the Public Sphere*. Cambridge, Mass.: MIT Press, 1992.

Campbell, Joan. *The German Werkbund: The Politics of Reform in the Applied Arts*. Princeton: Princeton University Press, 1978.

Cassirer, Ernst. *The Philosophy of the Enlightenment*. Princeton: Princeton University Press, 1951.

Centralstelle für Arbeiter- und Wohlfahrtseinrichtungen. *Vorberichte für die XII. Konferenz am 21. und 22. September 1903 in Mannheim*. Berlin: Carl Heymanns, 1903.

Chipp, Herschel B., ed. *Theories of Modern Art: A Source Book by Artists and Critics*. Berkeley: University of California Press, 1968.

Chodowiecki, Daniel. *Briefe Daniel Chodowieckis an Anton Graff*. Berlin: De Gruyter, 1921.

Chytry, Josef. *The Aesthetic State: A Quest in Modern German Thought*. Berkeley: University of California Press, 1989.

Clark, Kenneth. *Looking at Pictures*. London: Holt, Rinehart, & Winston, 1960.

Clark, Vincent. "A Struggle for Existence: The Professionalization of German Architects." In *German Professions, 1800–1950*, ed. G. Cocks and K. Jarausch, pp. 143–60. New York: Oxford University Press, 1990.

Clemen, Paul. "Das Kaiser-Friedrich Museum zu Berlin." *ZBK*, n.s., 16 (1905): 25–84.

Cleve, Ingeborg. *Geschmack, Kunst, und Konsum. Kulturpolitik als Wirtschaftspolitik in Frankreich und Württemberg, 1805–1845*. Göttingen: Vandenhoeck & Ruprecht, 1996.

Cohen, Ted, and Paul Guyer, eds. *Essays in Kant's Aesthetics*. Chicago: University of Chicago Press, 1982.

Colquhoun, Alan. *Modernity and the Classical Tradition: Architectural Essays, 1980–1987*. Cambridge, Mass.: MIT Press, 1991.

Connelly, James L. "The Grand Gallery of the Louvre and the Museum Project: Architectural Problems." *Journal of the Society of Architectural Historians* 31 (1972): 120–32.

Crane, Diana. *The Transformation of the Avant-Garde: The New York Art World, 1940–85*. Chicago: University of Chicago Press, 1987.

Cremer, Claudia. *Hagedorns Geschmack. Studien zur Kunstkennerschaft in Deutschland im 18. Jahrhundert*. Bonn: C. S. Cremer, 1989.

Crimp, Douglas. "The End of Art and the Origin of the Museum." *AJ* 46, no. 4 (1987): 261–66.

———. *On the Museum's Ruins*. Cambridge, Mass.: MIT Press, 1993.

Curtius, Ernst. *Kunstmuseen. Ihre Geschichte und ihre Bestimmung*. Berlin: Wissenschaftlicher Verein, 1870.

Dahlhaus, Carl. *Nineteenth-Century Music*. Berkeley: University of California Press, 1989.

Daniel, Ute. *Hoftheater. Zur Geschichte des Theaters und der Höfe im 18. und 19. Jahrhundert*. Stuttgart: Klett-Cotta, 1995.

Danto, Arthur. "The Art World." *Journal of Philosophy* 61 (1964): 571–84.

———. *Beyond the Brillo Box: The Visual Arts in Post-Historical Perspective*. New York: Farrar, Straus, & Giroux, 1992.

———. *After the End of Art: Contemporary Art and the Tale of History*. Princeton: Princeton University Press, 1997.

Davidson, Mortimer. *Kunst in Deutschland, 1933–45. Eine wissenschaftliche Enzyklopädie der Kunst im Dritten Reich*, vol. 3, pt. 1, *Architektur*. Tübingen: Grabert, 1995.

Deiters, Heinrich. *Geschichte der allgemeinen Deutschen Kunstgenossenschaft*. Düsseldorf: Bagel, 1904.

Deneke, Bernward, and Rainer Kahsnitz, eds. *Das Kunst- und kulturgeschichtliche Museum im 19. Jahrhundert*. Munich: Prestel, 1977.

Dilly, Heinrich. *Kunstgeschichte als Institution. Studien zur Geschichte einer Disziplin*. Frankfurt: Suhrkamp, 1979.

———. "Hegel und Schinkel." In Gethmann-Siefert and Pöggeler, eds., *Welt* (1986), pp. 103–16.

Dilthey, Wilhelm. "Die drei Epochen der modernen Aesthetik und ihre heutige Aufgabe." *DR* 72 (July–Septempber 1892): 200–36.

Dirksen, Victor. "Gustav Pauli." *Mk*, n.s., 10 (1938): 135–39.

Dittmann, Lorenz. *Kategorien und Methoden der deutschen Kunstgeschichte, 1900–1930*. Stuttgart: F. Steiner, 1985.

Dobai, Johannes. *Die bildenden Künste in Johann Georg Sulzers Ästhetik*. Winterthur: Stadtbibliothek, 1978.

Döhmer, Klaus. "In welchem Style sollen wir bauen?" In *Architekturtheorie zwischen Klassizismus und Jugendstil*. Munich: Prestel, 1976.

Douglas, Mary. *How Institutions Think*. Syracuse: Syracuse: University Press, 1986.

Dove, Alfred. "Die Wiedertaufe im Berliner Museum." *INR* 2, no. 2 (1872): 773–76.

Drey, Paul. *Die wirtschaftliche Grundlagen der Malkunst. Versuch einer Kunstökonomie*. Stuttgart: Cotta, 1910.

Drier, Franz. "The Kunstkammer of the Hessen Landgraves in Kassel." In Impey and MacGregor, eds., *Origins* (1985), pp. 102–9.

Droste, Magdalena. *Das Fresko als Idee. Zur Geschichte öffentlicher Kunst im 19. Jahrhundert*. Münster: Lit, 1980.

Drüe, Hermann. "Die psychologische Ästhetik im deutschen Kaiserreich." In Mai et al., eds., *Ideengeschichte* (1983), pp. 71–98.

Duncan, Carol. *Civilizing Rituals: Inside Public Art Museums*. London: Routledge, 1995.

Duncan, Carol, and Alan Wallach. "The Universal Survey Museum." *AH* 3, no. 4 (December 1980): 448–69.

Easton, Laird. "The Rise and Fall of the 'Third Weimar': Harry Graf Kessler and the Aesthetic State in Wilhelmian Germany, 1902–1906." *CEH* 29, no. 4 (1996): 495–532.

Eberlein, Kurt. *Die deutsche Literargeschichte der Kunst im 18. Jahrhundert*. Ph.D. diss., Berlin University, 1919.

———. "Idee und Entstehung der Deutschen National-Museen." *WRJb* n.s., 1 (1930): 269–81.

————. "Vorgeschichte und Entstehung der Nationalgalerie." *JbPKS* 51 (1930): 250–61.

Ebert, Hans. "Daten zur Vorgeschichte und Geschichte des Alten Museums." In Berlin, "Jahre" (1980), pp. 9–25.

Eckardt, Goetz. *Die Bildergalerie in Sanssouci. Zur Geschichte des Bauwerks und seiner Sammlungen bis zur Mitte des 19. Jahrhunderts.* Potsdam: Generaldirektion der Staatlichen Schlösser und Gärten, 1975.

————. "Die beiden königlichen Bildergalerien und die Berliner Akademie der Künste bis zum Jahre 1830," In *Studien zur deutschen Kunst und Architektur um 1800,* ed., P. Betthausen, pp. 138–64, Dresden: Verlag der Kunst, 1981.

Eggers, Friedrich. "Die Reformen unserer Zeit in der Kunstverwaltung." *DK* 1, nos. 29, 33 (1850): 225–26, 257–58.

————. "Denkschrift über eine gesammelte Organisation der Kunst. Angelenheiten im Auftrage des Preussischen Kultusministeriums zusammengestellt." *DK* 2, nos. 20–51 (July 19—Dec. 20, 1851).

————. "Die Zugänglichkeit der Museen," *DK* 2, no. 4 (1851): 25.

Eggers, Karl, ed. *Briefwechsel zwischen Rauch und Rietschel.* 2 vols. Berlin: F. Fontane, 1890–1891.

Ehalt, Hubert. *Ausdrucksformen absolutistischer Herrschaft. Der Wiener Hof im 17. und 18. Jahrhundert.* Munich: Oldenbourg, 1980.

Einem, Herbert von. "Peter Cornelius." *WRJb* 16 (1954): 104–60.

————. *Deutsche Malerei des Klassizismus und der Romantik 1760–1840.* Munich: Beck, 1978.

Eitelberger von Edelberg, Rudolf. *Die Resultate des ersten internationalen kunstwissenschaftlichen Congresses in Wien.* Vienna: Hof- und Staatsdruckerei, 1874.

————. "Die deutsche Renaissance und die Kunstbewegungen der Gegenwart." In *Gesammelte kunsthistorische Schriften,* 2:370–404. Vienna: 1872–1884.

Erman, Adolf. *Mein Werden und mein Wirken. Erinnerungen eines alten Berliner Gelehrten.* Leipzig: Quelle & Meyer, 1929.

Escherich, Mela. "Alfred Messel." *DR* 139 (April–June 1909): 297–300.

Fabianski, Marcin. "Iconography of the Architecture of Ideal Musea in the Fifteenth to Eighteenth Centuries." *JHC* 2, no. 2 (1990): 95–134.

Falke, Jakob. "Die moderne Museumsfrage in Bezug auf Geschichte, Kunst und Kunstindustrie." *Österreichische Wochenschrift für Wissenschaft, Kunst und öffentliches Leben* 3 (1864): 161–68, 200–207, 257–63, 298–307.

————. *Lebenserinnerungen.* Leipzig: G. H. Meyer, 1897.

Fath, Manfred. "Fritz Wickert in Mannheim." In Hohenzollern and Schuster, eds., *Manet* (1996), pp. 313–17.

Fehlemann, Sabine. "Dr. Walter Kaesbach." In Junge, ed., *Avantgarde* (1992), pp. 187–97.

Feldenkirchen, Wilfried. "Staatliche Kunstfinanzierung im 19. Jahrhundert." In *Kunstpolitik und Kunstforderung im Kaiserreich,* ed. Ekhehard Mai et al., pp. 35–54. Berlin: Mann, 1982.

Findlen, Paula. *Possessing Nature: Museums, Collecting, and Scientific Culture in Early Modern Italy.* Berkeley: University of California Press, 1994.

Fink, August. *Geschichte des Herzog-Anton-Ulrich-Museums in Braunschweig.* Brunswick: N.p., 1954.

Fisher, Philip. *Making and Effacing Art: Modern American Art in a Culture of Museums.* New York: Oxford University Press, 1991.

Fleischhauer, Werner. *Philipp Friedrich Hetsch. Ein Beitrag zur Kunstgeschichte Württembergs.* Stuttgart: H. Matthaes, 1929.

Fliedl, Gottfried. "Die Zivilisierten vor den Vitrinen." In *Gegenstände der Fremdheit*, ed. Hans-Hermann Groppe, 22–41. Hamburg: Jonas, 1989.

———, ed. *Die Erfindung des Museums. Anfänge der bürgerlichen Museumsidee in der Französischen Revolution.* Vienna: Verlag Turia+Kant, 1996.

Fontane, Theodor. *Effi Briest.* London: Penguin, [1895] 1976.

Förster, Ernst. "Das neue Museum in Dresden." *Wm* 3 (1857–1858): 62–73, 185–93, 299–309, 425–32.

———. *Peter von Cornelius. Ein Gedenkbuch aus seinem Leben und Werken.* 2 vols. Berlin: Georg Reimer, 1874.

Forster-Hahn, Françoise. "The Politics of Display or the Display of Politics?" *AB* 77, no. 2 (June 1995): 174–79.

———, ed. *Imagining Modern German Culture, 1889–1910.* Hanover, N.H.: University Press of New England, 1996.

Frank, Manfred. *Der kommende Gott. Vorlesungen über die neue Mythologie.* Frankfurt: Suhrkamp, 1982.

Franke, Ernst. *Publikum und Malerei in Deutschland vom Biedermeier bis zum Impressionismus.* Emsdetten: Lechte, 1934.

Franz, Eugen. *München als deutsche Kulturstadt im 19. Jahrhundert.* Berlin: De Gruyter, 1936.

Freska, Friedrich. "Die neue Pinakothek—wie sie war und wie sie ist." *VKM* 27, no. 2 (January–April 1914): 294–301.

Freyer, Kurt. "Das Folkwang Museum zu Hagen i. W." *Mk* 8 (1912): 133–45.

Friedländer, Max J. *Erinnerungen und Aufzeichnungen.* Mainz: Kupferberg, 1967.

———. *Von Kunst und Kennerschaft.* Leipzig: Reclam, [1946] 1992.

Friedrichs-Friedlaender, Carola. *Architektur als Mittel politischer Selbstdarstellung im 19. Jahrhundert. Die Baupolitik der bayerischen Wittelsbacher.* Munich: R. Wolfe, 1980.

Frosien-Leinz, Heike. "Das Antiquarium der Residenz: Erstes Antikenmuseum Münchens." In Vierneisel and Gottlieb, eds., *Glyptothek* (1980), pp. 310–21.

Furtwängler, Adolf. "Über Kunstsammlungen alter und neuer Zeit." [1899]: In Lang, ed., *Beiträge* (1988), pp. 71–96.

Gaehtgens, Thomas. *Die Berliner Museumsinsel im Deutschen Kaiserreich: Zur Kulturpolitik der Museen in der wilhelminischen Epoche.* Munich: Deutscher Kunstverlag, 1992.

———. "Die grossen Anreger und Vermittler. Ihr prägender Einfluss auf Kunstsinn, Kunstkritik und Kunstforderung." In Braun and Braun, eds., *Mäzenatentum* (1993), pp. 99–126.

———. "Wilhelm von Bode und seine Sammler," In Mai and Paret, eds., *Sammler* (1993), pp. 153–72.

———. "Ein Bismarck der Künste. Kenner, Sammler, Forscher, Wilhelm von Bode." *FAZ*, December 9, 1995.

———, ed. *Johann Joachim Winckelmann, 1717–1768.* Hamburg: F. Meiner, 1986.

Gallwitz, Klaus, ed. *ReVision. Die Moderne im Städel, 1906–1937.* Frankfurt: Gert Hatje, 1991.

Ganz, Peter, ed. *Kunst und Kunsttheorie.* Wiesbaden: Harrassowitz, 1991.

Gay, Peter. *Weimar Culture: The Outsider as Insider.* New York: Harper & Row, 1968.

Gebhardt, Bruno. *Wilhelm von Humboldt als Staatsmann.* 2 vols. Stuttgart: Cotta, 1896–1899.

Geismeier, Irene. "Besucheranalyse in der Frühzeit der Museen." *Kunstwissenschaftliche Beiträge. Beilage zur Bildende Kunst.* 5 (1981): 4–5.

————. "Gustav Friedrich Waagen—45 Jahre Museumsarbeit." In Berlin. "Jahre" (1980), pp. 397–419.

Geismeier, Willi. *Daniel Chodowiecki*. Leipzig: Seemann, 1993.

Gemmeke, Claudia. "Ernst Gosebruch." In Junge, ed., *Avantgarde* (1992), pp. 111–17.

Gensel, Walther. "Die bildenden Künste. Rück- und Ausblicke auf das Kunstleben der Gegenwart." *Wm* 97 (1904–1905): 588–607.

————. "Ein Jahrhundert deutscher Malerei." *DR* 127 (April–June 1906): 108–25, 267–85.

Gerkens, Gerhard. *Das fürstliche Lustschloss Salzdahlum und sein Erbauer Herzog Anton Ulrich von Braunschweig Wolfenbüttel*. Braunschweig: Geschichtsverein, 1974.

Gerlach, Peter, ed. *Vom realen Nutzen idealer Bilder. Kunstmarkt und Kunstvereine*. Aachen: Alano, 1994.

Germany. "Gesetz, betreffend das Urheberrecht an Werken der bildenden Künste und der Photographie vom 9. Januar 1907." *Reichs-Gesetzblatt* 3 (1907): 7–18.

Gesche, Inga. "Bemerkungen zum Problem der Antikenergänzungen und seiner Bedeutung bei Johann Joachim Winckelmann." In Beck and Bol, eds., *Forschungen* (1982), pp. 439–60.

Gethmann-Siefert, Annemarie. *Die Funktion der Kunst in der Geschichte. Untersuchungen zu Hegels Ästhetik*. Bonn: Bouvier, 1984.

————. "Die Rolle der Kunst im Staat. Kontroverses zwischen Hegel und den Hegelianern." In Gethmann-Siefert and Pöggeler, eds., *Welt* (1986), pp. 65–102.

Gethmann-Siefert, Annemarie, and Otto Pöggeler, eds. *Welt und Wirkung von Hegels Ästhetik*. Bonn: Bouvier, 1986.

Ghattas, Monika. "Patronage and Painters in Munich, 1870–1910." Ph.D. diss., University of New Mexico, 1986.

Gibson-Wood, Carol. *Studies in the Theory of Connoisseurship from Vasari to Morelli*. New York: Garland, 1988.

Giedion, Siegfried. *Spätbarocker und romantischer Klassizismus*. Munich: Brückmann, 1922.

Gilly, Friedrich. *Essays on Architecture*. Santa Monica, Calif.: Getty Center for the History of Art and the Humanities, 1994.

Girardet, Cella-Margaretha. "James Simon." *JbPKB* 19 (1982): 77–98.

Glaser, Herbert, ed. *Krone und Verfassung. König Max I. Joseph und der neue Staat. Beiträge zur bayerischen Geschichte und Kunst, 1799–1825*. Munich: Hirmer, 1980.

Goalen, Martin. "Schinkel and Durand: The Case of the Altes Museum." In Snodin, ed., *Schinkel* (1991), pp. 27–35.

Goethe, Johann Wolfgang von. "Goethes Briefwechsel mit Christian von Mannlich und ein Brief der Frau von Stein." *Hyperion* 1 (1908): 131–53.

————. *Autobiography*. Trans. John Oxenford. 2 vols. Chicago: University of Chicago Press, 1974.

————. *Werke*. 14 vols. Munich: Beck, 1981.

Goldberg, Gisela. "Hugo von Tschudi und die Modernisierung der Pinakotheken." In Hohenzollern and Schuster, eds., *Manet* (1996), pp. 413–18.

Gollwitzer, Heinz. *Ludwig I. von Bayern*. Munich: Süddeutscher Verlag, 1986.

Gölz, Wilhelmine. *Der bayerische Landtag 1831. Ein Wendepunkt in der Regierung Ludwigs I*. Munich: Studenthaus, 1926.

Görres, Joseph. *Gesammelte Briefe*. Vol. 2. Munich: Literarisch-Artistische Anstalt, 1874.

Gottfried Semper: 1803–1879. Baumeister zwischen Revolution und Historismus. Munich: Callwey, 1980.

Gould, Cecil. *Trophy of the Conquest: The Musée Napoleon and the Creation of the Louvre.* London: Faber, 1965.

Graesse, J. G. Th. "Nach welchen Grundsätzen soll der Zutritt zu den Museen gestattet werden?" *Zeitschrift für Museologie und Antiquitätenkunde* 7, no. 22 (1884): 173–76.

Gräff, Walter. "Hugo von Tschudi." *Mk* 8 (1912): 45–49.

Graña, César. *Fact and Symbol: Essays on the Sociology of Art and Literature.* New York: Oxford University Press, 1971.

———. *Meaning and Authenticity: Further Essays on the Sociology of Art.* New Brunswick, N.J.: Transaction, 1989.

Grasskamp, Walter. "Die Einbürgerung der Kunst. Korporative Kunstförderung im 19. Jahrhundert." In Mai and Paret, eds., *Sammler* (1993), pp. 104–13.

———. *Museumsgründer und Museumsstürmer. Zur Sozialgeschichte des Kunstmuseums.* Munich: Beck, 1972.

Grewe, Cordula. "Wilhelm Schadow (1788–1862). Monographie und Catalogue Raisonné." Ph.D. diss., University of Freiburg, 1998.

———. "Wir rufen zwar fortwährend Rafael! Aber was ist von Rafael in uns?" *Anzeiger des Germanischen Nationalmuseums* (1998): 123–32.

Griffiths, Antony, and Frances Carey. *German Printmaking in the Age of Goethe.* London: British Museum Press, 1994.

Grimm, Herman. "E. Curtius über Kunstmuseen." *PJbb*, 25, no. 6 (1870): 616–23.

———. "Eine Reihe von Gesichtspunkten, unsere öffentlichen Anstalten für Pflege der Kunst betreffend." *PJbb* 29, no. 6 (1872): 747–55.

———. "Italienische Porträtbüsten des Quattrocento." *PJbb* 2, no. 4 (1883): 400–416.

———. "Das Universitätsstudium der neueren Kunstgeschichte." *DR* 66 (1891): 391–413.

Grisebach, August. *Karl Friedrich Schinkel. Architekt, Städtebauer, Maler.* Vienna: Ullstein, 1983.

Gropius, Martin. *Schinkels Dekorationen innerer Räume.* Berlin: Ernst, 1874.

Grossmann, Georg, and Petra Krutisch, eds. *Renaissance der Renaissance.* 3 vols. Munich: Deutscher Kunstverlag, 1992–1995.

Grossmann, Joachim. *Künstler, Hof und Bürgertum: Leben und Arbeit von Malern in Preussen, 1786–1850.* Berlin: Akademie, 1994.

———. "Künstler und Kunstvereine im Preussen des Vormärz (1815–1848)." In Gerlach, ed., *Nutzen* (1994), pp. 100–111.

Grote, Andreas, ed. *Macrocosmos in Microcosmo: Die Welt in der Stube. Zur Geschichte des Sammeln, 1450 bis 1800.* Opladen: Leske & Budrich, 1994.

Grupp, Peter. *Harry Graf Kessler. 1868–1937. Eine Biographie.* Munich: Beck, 1995.

Guyer, Paul. *Kant and the Claims of Taste.* Cambridge: Harvard University Press, 1979.

———. "Kant's Conception of Fine Art." *JAAC* 52, no. 3 (1994): 275–85.

Habermas, Jürgen. *The Structural Transformation of the Public Sphere: An Inquiry into a Category of Bourgeois Society.* Cambridge, Mass.: MIT Press, 1989.

Hamburg Kunsthalle. *Jahresberichte der Kunsthalle zu Hamburg.* Hamburg: Kunsthalle, 1886–87.

Hamburger, Michael. *Reason and Energy: Studies in German Literature.* New York: Grove, 1957.

Hammer, Karl. "Preussische Museumspolitik im 19. Jahrhundert." In *Bildungspolitik in Preussen zur Zeit des Kaiserreichs*, ed. Peter Baumgart, pp. 256–77. Stuttgart: Klett-Cotta, 1980.

Hammerschmidt, Valentin. *Anspruch und Ausdruck in der Architektur des späten Historismus in Deutschland, 1860–1914.* Frankfurt: P. Lang, 1985.

Hansert, Andreas. *Bürgerkultur und Kulturpolitik in Frankfurt am Main. Eine historisch-soziologische Rekonstruktion.* Frankfurt: Karmer, 1992.

———. *Geschichte des städelschen Museums-Vereins Frankfurt am Main.* Frankfurt: Umschau, 1994.

Harbison, Robert. *Eccentric Spaces.* Boston: Godine, 1988.

Hardtwig, Wolfgang. "Drei Berliner Porträts: Wilhelm von Bode, Eduard Arnhold, Harry Graf Kessler. Museumsmann, Mäzen, und Kunstvermittler." In Braun and Braun eds., *Mäzenatentum* (1993), pp. 39–71.

———. *Geschichtsschreibung zwischen Alteuropa und moderne Welt. Jacob Burckhardt in seiner Zeit.* Göttingen: Vandenhoeck & Ruprecht, 1974.

———. "Privatvergnügen oder Staatsaufgabe? Monarchisches Sammeln und Museum 1800–1914." In Mai and Paret, eds., *Sammler* (1993), pp. 81–103.

Hardtwig, Wolfgang, and Harm-Hinrich Brandt, eds. *Deutschlands Weg in die Moderne. Politik, Gesellschaft und Kultur im 19. Jahrhundert.* Munich: Beck, 1993.

Harries, Karsten. "Hegel on the Future of Art." *RM* 27, no. 4 (1974): 677–96.

Harten, Elke. *Museen und Museumsprojekte der Französischen Revolution. Ein Beitrag zur Entstehungsgeschichte einer Institution.* Münster: Lit, 1989.

Haskell, Francis, *Rediscoveries in Art: Some Aspects of Taste, Fashion, and Collecting in England and France.* Ithaca, N.Y.: Cornell University Press, 1977.

———. *Patrons and Painters: Art and Society in Baroque Italy.* New Haven: Yale University Press, 1980.

———. "The Artist and the Museum." *NYRB*, December 3, 1987.

———. *History and Its Images: Art and the Interpretation of the Past.* New Haven: Yale University Press, 1993.

———, ed. *Saloni, Gallerie, Musei e loro Influenza sullo sviluppo dell'Arte dei Secoli XIX e XX.* Bologna: CLUEB, 1981.

Haskell, Francis, and Nicholas Penny. *Taste and the Antique: The Lure of Classical Sculpture, 1500–1900.* New Haven: Yale University Press, 1988.

Häsker, Hermann. "Kunstausstellungen und Kunstsalons in Berlin." *Wm* 87 (1899–1900): 708–17.

Hatfield, Henry. *Winckelmann and His German Critics, 1755–1781: A Prelude to the Classical Age.* New York: King's Crown, 1943.

Hauntinger, Johann Nepomuk. *Reise durch Schwaben und Bayern im Jahre 1784.* Weissenhorn: Konrad, 1964.

Haupt, Herbert. *Das kunsthistorische Museum: Die Geschichte des Hauses am Ring. Hundert Jahre im Spiegel historischer Ereignisse.* Vienna: Brandstätter, 1991.

Hederer, Oswald. *Leo von Klenze. Persönlichkeit und Werk.* Munich: Callwey, 1964.

Hegel, G. W. F. *Vorlesungen über die Aesthetik.* In *Werke*, vols. 13–15. Frankfurt: Suhrkamp, 1970.

———. *Werke in zwanzig Bänden*, vol. 1. *Frühe Schriften.* Frankfurt: Suhrkamp, 1971.

Hein, Dieter. "Bürgerliches Künstlertum. Zum Verhältnis von Künstlern und Bürgern auf dem Weg in die Moderne." In Hein and Schulz, eds., *Bürgerkultur* (1996), pp. 102–20.

Hein, Dieter, and Andreas Schulz, eds. *Bürgerkultur im 19. Jahrhundert. Bildung, Kunst und Lebenswelt.* Munich: Beck, 1996.

Hein, Peter Ulrich. *Transformation der Kunst. Ziele und Wirkungen der deutschen Kultur- und Kunsterziehungsbewegung.* Cologne: Böhlau, 1991.

Heinse, J. J. *Briefe aus der Düsseldorfer Gemäldegalerie (1776–71).* Ed. A. Winkler. 2d ed. Leipzig: E. Schmid, 1914.

Henrich, Dieter. "Beauty and Freedom: Schiller's Struggle with Kant's Aesthetics." In Cohen and Guyer, eds., *Essays* (1982), pp. 221–36.

Hentzen, Alfred, et al., eds. *Hamburger Kunsthalle. Meisterwerke der Gemäldegalerie.* Cologne: DuMont Schauberg, 1969.

Herding, Klaus. "'. . . Woran meine ganze Seele Wonne gesogen . . .' Das Galerieerlebnis—eine verlorene Dimension der Kunstgeschichte?" In P. Ganz, ed., *Kunst* (1991), pp. 257–85.

Heres, Gerald. *Dresdener Kunstsammlungen im 18. Jahrhundert.* Leipzig: Seemann, 1991.

Herrmann, Wolfgang. *Gottfried Semper: In Search of Architecture.* Cambridge, Mass.: MIT Press, 1984.

———, ed. *In What Style Should We Build? The German Debate on Architectural Style.* Santa Monica, Calif.: Getty Center for the History of Art and the Humanities, 1992.

Hesse-Frielinghaus, Herta, et al. *Karl Ernst Osthaus. Leben und Werk.* Recklinghausen: Bongers, 1971.

Heyderhoff, J., and Paul Wentzcke, eds. *Deutscher Liberalismus im Zeitalter Bismarcks,* vol. 2, *Im neuen Reich, 1871–1890.* Osnabrück: Biblio, 1967.

Hille, Karoline. "Mit heissem Herzen und kühlem Verstand. Gustav Friedrich Hartlaub und die Mannheimer Kunsthalle." In Junge, ed., *Avantgarde* (1992), pp. 129–38.

Hinz, Berthold. "Der Triumph der Religion in den Künsten. Overbecks 'Werk und Wort' im Widerspruch seiner Zeit." *SJb.* 7 (1979): 149–70.

Hirsch, Erhard. *Dessau-Wörlitz. Zierde und Inbegriff des 18. Jahrhunderts.* 2d ed. Munich: Beck, 1988.

Hirt, Alois. "Über die Inschrift auf dem königlichen Museum in Berlin." *Berliner Kunstblatt* 2 (February 1829): 44–47.

Hitchcock, Henry Russell. *Architecture: Nineteenth and Twentieth Centuries.* 2d ed. Baltimore, Md.: Penguin, 1962.

Hochreiter, Walter. *Musentempel zum Lernort. Zur Sozialgeschichte deutscher Museen, 1800–1914.* Darmstadt: Wissenschaftliche Buchgesellschaft, 1994.

Hofmann, Werner. *Das irdische Paradies. Motive und Ideen des 19. Jahrhunderts.* Munich: Prestel, 1974.

———. "Caspar David Friedrichs *Tetschener Altar* und die Tradition der protestantischen Frömmigkeit." In *Anhaltspunkte*, pp. 134–67. Munich: Fischer, 1989.

Hohenzollern, Johann Georg Prinz von, and Peter-Klaus Schuster, eds. *Manet bis van Gogh. Hugo von Tschudi und der Kampf um die Moderne.* Berlin: Prestel, 1996.

Holst, Niels von. "Das Kunstmuseum im nachliberalistischen Zeitalter." *Mk,* n.s. 6 VI (1934): 1–9.

Holt, Elizabeth Gilmore, ed. *The Triumph of Art for the Public.* Garden City, N.Y.: Anchor, 1979.

Horne, Donald. *The Great Museum: The Re-Presentation of History.* London: Pluto, 1984.

Hotho, Heinrich Gustav. *Vorstudien für Leben und Kunst.* Stuttgart: Cotta, 1835.

Huber, Ernst Rudolf. *Dokumente zur deutschen Verfassungsgeschichte.* 3 vols. Stuttgart: Kohlhammer, 1957–1966.

Hudson, Kenneth. *A Social History of Museums: What the Visitors Thought.* Atlantic Highlands, N.J.: Humanities, 1975.

———. *Museums for the 1980s.* London: Macmillan, 1977.

———. *Museums of Influence: The Pioneers of the Last 200 Years.* Cambridge: Cambridge University Press, 1987.

Humboldt, Wilhelm von. "Über das Museum in Berlin (1830–1834)." In *Gesammelte Schriften*, 12:539–94. 17 vols. Berlin: Behr, 1903–1920.

———. *Werke*. 5 vols. Ed. A. Flitner and K. Giel. Stuttgart: Cotta, 1960–1964.

———. *The Limits of State Action*. Trans. J. W. Burrow. Cambridge: Cambridge University Press, 1969.

Hüneke, Andreas. "Von der Verantwortung des Museumsdirektors—Max Sauerlandt," In Junge, ed., *Avantgarde* (1992), pp. 261–68.

"Ihm, welcher der Andacht Tempel baut . . ." Ludwig I und die Alte Pinakothek. Festschrift zum Jubiläumsjahr. Munich: Bayerische Staatsgemäldesammlungen, 1986.

Illert, Wolfgang. *Das Treppenhaus im deutschen Klassizismus*. Worms: Wernersche Verlagsgesellschaft, 1988.

Impey, Oliver, and Arthur MacGregor, eds. *The Origins of Museums: The Cabinet of Curiosities in Sixteenth and Seventeenth Century Europe*. Oxford: Oxford University Press, 1985.

Ingrao, Charles. *The Hessian Mercenary State: Ideas, Institutions, and Reform under Frederick II, 1760–1785*. Cambridge: Cambridge University Press, 1987.

Iverson, Margaret. *Alois Riegl: Art History and Theory*. Cambridge, Mass.: MIT Press, 1993.

Izenberg, Gerald. *Impossible Individuality: Romanticism, Revolution, and the Origins of Modern Selfhood, 1787–1802*. Princeton: Princeton University Press, 1992.

Jaeschke, W. "Politik, Kultur und Philosophie in Preussen." *Hegel Studien* 22, supp. (1983): 29–48.

Jaffé, H. C. "Schinkels Gemälde *Blick in Griechenlands Blüte*—ein Bildungsbild." *Wissenschaftliches Zeitschrift der Ernst-Moritz-Arndt Universität* 31, nos. 2–3(1982): 124–27.

Jauss, Hans Robert. *Studien zum Epochenwandel der ästhetischen Moderne*. Frankfurt: Suhrkamp, 1989.

Jensen, Robert. *Marketing Modernism in Fin-de-Siècle Europe*. Princeton: Princeton University Press, 1994.

Joachimides, Alexis. "Die Schule des Geschmacks. Das Kaiser-Friedrich-Museum als Reformprojekt." In Joachimides et al., eds., *Museumsinszenierungen* (1995), pp. 142–56.

———. *Museumsinszenierungen. Zur Geschichte der Institution des Kunstmuseums. Die Berliner Museumslandschaft: 1830–1900*. Dresden: Verlag der Kunst, 1995.

Joerissen, Peter. *Kunsterziehung und Kunstwissenschaft im wilhelminischen Deutschland, 1871–1918*. Cologne: Böhlau, 1979.

Jordan, Max. "Die Wandmalereien der Leipziger Museumshalle." *INR* 2, no. 1 (1872): 841–58.

Junge, Henrike. "Alfred Lichtwark und die 'Gymnastik der Sammeltätigkeit.'" In Mai and Paret, eds., *Sammler* (1993), pp. 202–14.

———, ed. *Avantgarde und Publikum. Zur Rezeption avantgardistischer Kunst in Deutschland, 1905–1933*. Cologne: Böhlau, 1992.

Justi, Carl. *Winckelmann und seine Zeitgenossen*. 5th ed. 3 vols. Cologne: Phaidon, 1956.

Justi, Ludwig. "Die Neuordnung der Gemälde-Galerie im Städelschen Kunstinstitut zu Frankfurt/Main." *Mk* 1 (1905): 205–15.

———. *Der Ausbau der Nationalgalerie. Zwei Denkschriften*. Berlin: Bard, 1913.

———. *Der Umbau in der Nationalgalerie*. Berlin: Bard, 1914.

———. *Im Dienste der Kunst*. Breslau: Korn, 1936.

Kaehler, Siegfried A. *Wilhelm von Humboldt und der Staat*. 2d ed. Göttingen: Vandenhoeck & Ruprecht, 1963.

Kalkschmidt, Eugen. *Das Museum der Zukunft*. Munich, 1906.

————. "Kunstgeschichtliche Umschau." *Gb* 66, no. 1 (1907): 637–42.

————. "Kunstkrieg in Bayern." *Gb* 69, no. 2 (1910): 340–42.

Kalnein, Wend von. "Akademiemuseum und Museumstradition in Düsseldorf." *WRJb* 33 (1971): 329–38.

Kant, Immanuel. *The Critique of Judgement*. Trans. James Meredith. Oxford: Oxford University Press, 1952.

Karl Friedrich Schinkel. Architektur, Malerei, Kunstgewerbe. Berlin: Nicolai, 1981.

Karl Friedrich Schinkel, 1781–1841. Berlin: Staatliche Museen, 1981.

Karl Friedrich Schinkel. Werke und Wirkungen. Berlin: Nicolai, 1981.

Karlsruhe. *Kunst in der Residenz. Karlsruhe zwischen Rokoko und Moderne*. Karlsruhe: Staatliche Kunsthalle, 1990.

Kaschuba, Wolfgang. "Deutsche Bürgerlichkeit nach 1800. Kultur als symbolische Praxis." In *Bürgertum im 19. Jahrhundert*, 3 vols. Ed. J. Kocka, 3:9–44. Munich: DTV, 1988.

Kaufmann, Emil. *Architecture in the Age of Reason: Baroque and Post-Baroque in England, Italy, France*. New York: Dover, 1955.

Kaufmann, Hans. "Zweckbau und Monument. Zu Friedrich Schinkels Museum am Berliner Lustgarten." In *Eine Freundesgabe der Wissenschaft für Ernst Hellmut Vits*, ed. G. Hess, pp. 135–66. Frankfurt: Knapp, 1963.

Kaufmann, Rudolf. *Der Renaissancebegriff in der deutschen Kunstgeschichtsschreibung*. Winterthur: Schönenberger, 1932.

Kaufmann, Thomas da Costa. *The Mastery of Nature: Aspects of Art, Science, and Humanism in the Renaissance*. Princeton: Princeton University Press, 1993.

————. *Court, Cloister, and City: The Art and Culture of Central Europe, 1450–1800*. Chicago: University of Chicago Press, 1995.

Kayser, Werner. *Alfred Lichtwark*. Hamburg: Christians, 1977.

Keim, Christiane. *Städtebau in der Krise des Absolutismus. Die Stadtplanungs-Programme der hessischen Residenzstädte Kassel, Darmstadt und Wiesbaden zwischen 1760 und 1840*. Marburg: Jonas, 1990.

Kekulé, Reinhard. "Die Behandlung der Abgüsse im Berliner Museum." *INR* 2, no. 2 (1872): 697–700.

Keller, Gottfried. *Der grüne Heinrich*. Frankfurt: Insel Verlag, [1855] 1978.

Kemp, Wolfgang. *Der Anteil des Betrachters. Rezeptionsästhetische Studien zur Malerei des 19. Jahrhunderts*. Munich: Maander, 1983.

————. "Die Kunst des Schweigens," In Thomas Koebner, ed., *Laokoon und kein Ende: der Wettstreit der Künste*, pp. 96–119. Munich, 1989.

————, ed. *Der Betrachter ist im Bild. Kunstwissenschaft und Rezeptionsästhetik*. Cologne: DuMont, 1985.

Kessler, Harry Graf. *Künstler und Nationen. Aufsätze und Reden 1899–1933*. Frankfurt: Fischer, 1988.

Klemm, Gustav. *Zur Geschichte der Sammlungen für Wissenschaft und Kunst in Deutschland*. 2d ed. Herbst: G. A. Kummer, 1838.

Klenze, Leo von, and Ludwig Schorn. *Beschreibung der Glyptothek*. Munich: J. G. Cotta, [1830] 1842.

Klöden, Karl Friedrich von. *Jugenderinnerungen*. Leipzig: Insel, 1911.

Klotz. Heinrich, and Waltraud Krase. *Neue Museumsbauten in der Bundesrepublik Deutschland*. Stuttgart: Klett-Cotta, 1985.

Knapp, Fritz. "Die deutsche Jahrhundertausstellung in der Nationalgalerie." *Gb* 65, no. 2 (1906): 468–81.

Knodt, Manfred. *Ernst Ludwig, Grossherzog von Hessen und bei Rhein: Sein Leben und seine Zeit*. Darmstadt: Schlapp, 1978.

Knoll, Kordelia. "'Alles, was in der Kunst lebendig war, ging zu allen Zeiten eine Wege.' Georg Treu und die moderne Plastik in Dresden." In Hohenzollern and Schuster, eds., *Manet* (1996), pp. 282–87.

Koch, Georg Friedrich. *Die Kunstausstellung. Ihre Geschichte von den Anfängen bis zum Ausgang des 18. Jahrhunderts.* Berlin: De Gruyter, 1967.

Koerner, Joseph Leo. *Caspar David Friedrich and the Subject of Landscape.* New Haven: Yale University Press, 1990.

Koetschau, Karl. "Künstler, Kunsthistoriker und Museen (Zur Stuttgarter Galeriefrage)." *Mk* 4 (1908): 34–38.

———. *Die Vorbildung der Museumsbeamten.* Hamburg, 1918.

Kohte, Julius. "Ferdinand von Quast (1807–1877). Konservator der Kunstdenkmäler des preussischen Staates." *Deutsche Kunst und Denkmalpflege* 41 (1977): 114–36.

Koselleck, Reinhart. *Vergangene Zukunft. Zur Semantik geschichtlicher Zeiten.* Frankfurt: Suhrkamp, 1979.

Kostof, Spiro. *A History of Architecture: Settings and Rituals.* New York: Oxford University Press, 1985.

Krahmer, Catherine. "Tschudi und Meier-Graefe." In Hohenzollern and Schuster, eds., *Manet* (1996), pp. 371–76.

Kriller, Beatrix, and Georg Kugler. *Das Kunsthistorische Museum. Die Architektur und Ausstattung. Idee und Wirklichkeit des Gesamtkunstwerkes.* Vienna: Christian Brandstätter, 1991.

Kristeller, Paul. "The Modern System of the Arts." In *Renaissance Thought and the Arts*, 2:163–227. New York: Harper, 1980.

Krosigk, Hans von, ed. *Karl Graf von Brühl und seine Eltern. Lebensbilder auf Grund der Handschriften des Archivs zu Seifersdorf.* Berlin: A. S. Miller, 1910.

Kruedener, Jürgen von. *Die Rolle des Hofes im Absolutismus.* Stuttgart: G. Fischer, 1973.

Kruft, Hanno Walter. *Geschichte der Architekturtheorie. Von der Antike bis zur Gegenwart.* Munich: Beck, 1985.

Kugler, Franz. "Über den Beruf und die Bildung des Künstlers." *Museum* 4, no. 1 (1836): 1–7.

———. *Beschreibung der Kunstschätze von Berlin und Potsdam*, vol. 1, *Die Gemälde-Gallerie des königlichen Museums zu Berlin.* Berlin: C. Heymann, 1838.

———. "Die Kunst als Gegenstand der Staatsverwaltung" [1847]. In *Schriften*, 3:578–603.

———. *Kleine Schriften und Studien zur Kunstgeschichte.* 3 vols. Stuttgart: Ebner & Seubert, 1854.

———. *Grundbestimmungen für die Verwaltung der Kunstangelegenheiten im Preussischen Staate. Entwurf.* Berlin: Schroeder, 1859.

———. *Handbuch der Geschichte der Malerei seit Constantin dem Grossen.* 3d ed. Leipzig: Duncker & Humblot, 1867.

Kühn, Alfred. *Peter Cornelius und die geistigen Strömungen seiner Zeit.* Berlin: D. Reimer, 1921.

Kühn-Busse, Lotte. "Der erste Entwurf für ein Berliner Museumsbau 1798." *JbPKS* 59 (1938): 116–19.

Kultermann, Udo. *Geschichte der Kunstgeschichte. Der Weg einer Wissenschaft.* Rev. ed. Frankfurt: Ullstein, 1990.

Künzel, Friedrich. "Quellen zur Museums- und Kunstgeschichte. Die Geschichte und die Bestände des Zentralarchivs auf der Museumsinsel." *JbBM*, n.s. 34 (1992): 195–208.

Kurth, Willy. *Sanssouci. Ein Beitrag zur Kunst des deutschen Rokoko.* Tübingen: Henschel, 1964.

————, ed. *Adolf Menzels graphische Kunst.* Dresden: Verlag Ernst Arnold, 1920.

Lahme-Schlenger, Monika. "Karl Ernst Osthaus und die Folkwang-Idee." In Junge, ed., *Avantgarde* (1992), pp. 225–33.

Landsberger, Franz. *Die Kunst der Goethezeit. Kunst und Kunstanschauung von 1730–1830.* Leipzig: Insel, 1931.

Lane, Barbara Miller. *Architecture and Politics in Germany, 1918–1945.* Cambridge: Harvard University Press, 1968.

Lang, Rolf, ed. *Beiträge aus der deutschen Museologie- und Museums-Geschichtsschreibung. Institut für Museumswesen, Schriftenreihe* 26 (1988).

Langbehn, Julius. *Rembrandt als Erzieher von einem Deutschen.* Leipzig: Hirschfeld, [1890] 1922.

Langenstein, York. *Der Münchner Kunstverein im 19. Jahrhundert. Ein Beitrag zur Entwicklung des Kunstmarkts und des Ausstellungswesens.* Munich: UNI-Druck, 1983.

La Vopa, Anthony. "Conceiving a Public: Ideas and Society in Eighteenth-Century Europe." *JMH* 64 (1992): 79–116.

Lehmann, Ernst. *Die Anfänge der Kunstzeitschrift in Deutschland.* Leipzig: K. W. Hiersemann, 1932.

Leith, James. *The Idea of Art as Propaganda in France. 1750–1799: A Study in the History of Ideas.* Toronto: University of Toronto Press, 1965.

Lenman, Robin. "Painters, Patronage and the Art Market in Germany." *Past and Present* 123 (May 1989): 109–40.

————. "Der deutsche Kunstmarkt, 1840–1923: Integration, Veränderung, Wachstum." In Mai and Paret, eds., *Sammler* (1993), pp. 135–52.

————. *Die Kunst, die Macht und das Geld. Zur Kulturgeschichte des kaiserlichen Deutschlands, 1871–1918.* Frankfurt: Campus, 1994.

————. "From 'Brown Sauce' to 'Plein Air': Taste and the Art Market in Germany, 1889–1910." In Forster-Hahn, ed., *Imagining*, pp. 52–69. (1996).

Lewald, Fanny. *Meine Lebensgeschichte (1861–62).* Frankfurt: Helmer, 1980.

Lhotsky, Alphons. "Das kunsthistorische Museum als Bauwerk." *Aufsätze und Vorträge*, vol. 4, pp. 85–89. Munich: Uldenbourg, 1974.

Lichtenberg, Georg Christoph, and Daniel Chodowiecki. *Handlungen des Lebens.* Stuttgart: Deutsche Verlagsanstalt, 1971.

Lichtwark, Alfred. *Zur Organisation der Hamburger Kunsthalle.* Hamburg: Meissner, 1887.

————. "Eine heimatliche Kunst." *NR* 7, no. 1 (1896): 172–79.

————. *Briefe an die Commission für die Verwaltung der Kunsthalle.* 20 vols. Hamburg: Kunsthalle, 1896–1920.

————. *Drei Programme.* 2d ed. Berlin: B. Cassirer, 1902.

————. "Museumsbauten." In *Deutsche* (1905), pp. 109–27.

————. "Museen als Bildungsstätten." In *Deutsche* (1905), pp. 91–107.

————. *Der Deutsche der Zukunft.* Berlin: B. Cassirer, 1905.

————. *Briefe an die Kommission für die Verwaltung der Kunsthalle.* Ed. Gustav Pauli. 2 vols. Hamburg: Westermann, 1924.

————. *Erziehung des Auges. Ausgewählte Schriften.* Frankfurt: Fischer, 1991.

Lidtke, Vernon. "Museen und die zeitgenössische Kunst in der Weimarer Republik." In Mai and Paret, eds., *Sammler* (1993), pp. 215–38.

Liebenwein, Wolfgang. "Sammlungsarchitektur und Sammlungstheorie." In Beck and Bol, eds., *Forschungen* (1982), pp. 463–505.

Link, Anne-Marie. "The Social Practice of Taste in Late Eighteenth-Century Germany: A Case Study." *OAJ* 15, no. 2 (1992): 3–14.

Lloyd, Jill. *German Expressionism: Primitivism and Modernity*. New Haven: Yale University Press, 1991.

Löhneysen, Wolfgang Freiherr von. "Der Einfluss der Reichsgründung auf Kunst und Kunstgeschmack." *ZRG* 12, no. 1 (1960): 17–44.

Lotze, Hermann. *Geschichte der Aesthetik in Deutschland*. Munich: Cotta, 1868.

Lowenthal-Hensel, Cécile. "Die Erwerbung der Sammlung Solly durch den preussischen Staat. Protokoll einer geheimen Transaktion." *Neue Forschungen zur Brandenburgisch- Preussischen Geschichte*, 1 (1971): 109–59.

Lübbe, Hermann. "Wilhelm von Humboldt und die Berliner Museumsgründung, 1830." *JbPKB* 17 (1981): 87–110.

———. *Der Fortschritt und das Museum. Über den Grund unseres Vergnügens an historischen Gegenständen*. London: University of London, 1982.

———. "Deutscher Idealismus als Philosophie Preussischer Kulturpolitik." In Pöggeler and Gethmann-Siefert, eds., *Kunsterfahrung* (1983), pp. 3–28.

———. "Kunstwissenschaft und Kunstinteresse. Über kulturpolitische Folgen des sozialen Wandels." *ZKG* 46 (1983): 233–44.

Lübke, Wilhelm. "Die heutige Kunst und die Kunstwissenschaft." *ZBK* 1 (1866): 3–13.

Luckhardt, Ulrich. *Zur Geschichte der Hamburger Kunsthalle*. Hamburg: Kunsthalle, 1994.

Ludwig, Horst. *Kunst, Geld und Politik um 1900 in München. Formen und Ziele der Kunstfinanzierung und Kunstpolitik während der Prinzregentenära (1886–1912)*. Berlin: Mann, 1986.

McClellan, Andrew L. "The Politics and Aesthetics of Display: Museums in Paris. 1750–1800." *AH* 7, no. 4 (1984): 438–64.

———. *Inventing the Louvre: Art, Politics, and the Origins of the Modern Museum in Eighteenth Century Paris*. Cambridge: Cambridge University Press, 1994.

MacIntyre, Alasdair. *A Short History of Ethics*. New York: Macmillan, 1966.

Magnus, E. "Entwurf zu dem Bau eines Kunst-Museums." *Zeitschrift für Bauwesen* 17 (1867): 218–24.

Mai, Ekkehard. "Die Berliner Kunstakademie im 19. Jahrhundert. Kunstpolitik und Kunstpraxis" In Mai and Waetzoldt, eds., *Kunstverwaltung* (1981), pp. 431–80.

———. *Expositionen: Geschichte und Kritik des Ausstellungswesens*. Munich: Deutscher Kunstverlag, 1986.

———. "Die Berliner Kunstakademie zwischen Hof und Staatsaufgabe. 1696–1830—Institutionsgeschichte im Abriss." In *Academies of Art*, ed. A. Boschloo et al., pp. 320–31. The Hague: SDU, 1989.

———. "Angriff der Gegenwart auf die verlorene Zeit. Die Kunst der Lebenden verdrängt die Kunst der Toten. Zum Dilemma des klassischen Museums." *FAZ*, November 29, 1993.

———. "Kanon und Decorum. Zur Repräsentanz und Präsentation der Berliner Museumsbauten von Schinkel bis Kreis." In Zentralinstitut, *Berlins* (1994): 27–44.

Mai, Ekkehard, and Peter Paret, eds. *Sammler, Stifter und Museen. Kunstförderung in Deutschland im 19. und 20. Jahrhundert*. Cologne: Böhlau, 1993.

Mai, Ekkehard, and Stephan Waetzoldt, eds. *Kunstverwaltung, Bau- und Denkmal-Politik im Kaiserreich*. Berlin: Mann, 1980.

Mai, Ekkehard, et al., eds. *Ideengeschichte und Kunstwissenschaft. Philosophie und bildende Kunst im Kaiserreich*. Berlin: Mann, 1983.

Makela, Maria. *The Munich Secession: Art and Artists in Turn-of-the-Century Munich.* Princeton: Princeton University Press, 1990.

Malkowsky, Georg. *Die Kunst im Dienste der Staats-Idee. Hohenzollerische Kunstpolitik vom Grossen Kurfürsten bis auf Wilhelm II.* Berlin: Patria, 1912.

Mallgrave, Harry Francis. *Gottfried Semper: Architect of the Nineteenth Century.* New Haven: Yale University Press, 1996.

Malraux, André. *The Voices of Silence.* Princeton: Princeton University Press, 1978.

Mannlich, Johann Christian von. *Rokoko und Revolution. Lebenerinnerungen.* Stuttgart: Koehler, 1966.

Marchand, Suzanne. *Down from Olympus: Archaeology and Philhellenism in Germany, 1750–1970.* Princeton: Princeton University Press, 1996.

Marggraff, Rudolf. "Über den gegenwärtigen Zustand der Kunstpolitik." *MJbBK* 1 (1838): 1–23.

Mariner, Dorothy. "The Museum: A Social Context of Art." Ph.D. diss. University of California at Berkeley, 1969.

Martin, Otto. *Zur Ikonographie der deutschen Museumsarchitektur zu Beginn des zweiten Kaiserreichs. Bauformen und Bildprogramme der Kunst- und Kulturgeschichtlichen Museen in den siebziger und achtziger Jahren des 19. Jahrhunderts.* Ph.D. diss., University of Mainz, 1983.

Marx, Harald, and Heinrich Magirius. *Gemäldegalerie Dresden.* Leipzig: E. A. Seemann, 1992.

Mechel, Christian von. *Verzeichnis der Gemälde der kaiserlichen königlichen Bildergalerie in Wien.* 2d ed. Vienna: Bildergalerie, [1781] 1783.

Meier-Graefe, Julius. *Modern Art, Being a Contribution to a New System of Aesthetics.* 2 vols. New York: Arno, 1908.

———. "Das Museum. Dem Andenken Tschudis." *NR* 24, no. 1 (1913): 29–49.

———. *Entwicklungsgeschichte der modernen Kunst.* 2 vols. 2d rev. ed. Munich: Piper, [1903] 1914.

———. *Entwicklungsgeschichte der modernen Kunst.* New ed., with introduction by Hans Belting. Munich: Piper, 1987.

Meijers, Debora J. *Kunst als natuur. De Habsburgse schilderijengalerij in Wenen omstreeks 1780.* Amsterdam: sua, 1991.

Meinecke, Friedrich. "Klassizismus, Romantizismus und historisches Denken im 18. Jahrhundert." In *Werke.* 4:264–78. Munich: Oldenbourg, 1959.

Menze, Clemens. *Die Bildungsreform Wilhelm von Humboldts.* Hanover: Schroedel, 1975.

Messel, Alfred. *Berliner Architekturwelt.* Sonderheft 5 (1911).

Messerer, Richard. "Georg von Dillis." *Oberbayerisches Archiv* 84 (1961): 7–186.

———, ed. *Briefwechsel zwischen Ludwig I. von Bayern und Georg von Dillis, 1807–1841.* Munich: Beck, 1966.

Meyers Grosses Konversations-Lexikon. 6th ed. Leipzig, 1908–1909.

Michaelis, Rainer. "Der 'Überfluss des Museums.' Abgaben aus Bestanden der Berliner Gemäldegalerie, 1837 bis 1860." *JbBM*, n.s., 34 (1992): 65–81.

Milde, Kurt. *Neorenaissance in der deutschen Architektur des 19. Jahrhunderts. Grundlagen, Wesen und Gültigkeit.* Dresden: Verlag der Kunst, 1981.

Mitchell, Timothy. *Art and Science in German Landscape Painting, 1770–1840.* Oxford: Oxford University Press, 1994.

Mittlmeier, Werner. *Die neue Pinakothek in München, 1843–1854. Planung, Baugeschichte und Fresken.* Munich: Prestel, 1977.

Möckl, Karl. "Hof und Hofgesellschaft in Bayern in der Prinzregentenzeit." In Werner, ed., *Hof* (1985), pp. 183–235.

Moffett, Kenworth. *Meier-Graefe as Art Critic*. Munich: Prestel, 1973.

Mommsen, Theodor. "Über die königlichen Museen" [1876, 1879]. In *Reden und Aufsätze*, pp. 228–41. Berlin: Weidmann, 1905.

Mommsen, Wolfgang J. "Stadt und Kultur im deutschen Kaiserreich." In *Die Welt der Stadt*. ed., T. Schabert, pp. 69–116. Munich: Piper, 1991.

Mordaunt Crook, J. *The British Museum: A Case Study in Architectural Politics*. Harmondsworth, Middlesex: Penguin, 1972.

Moyano, Steven. "Karl Friedrich Schinkel and the Architectural Administration in Prussia, 1810–1840." Ph.D. diss., Northwestern University, 1989.

————. "Quality vs. History: Schinkel's Altes Museum and Prussian Arts Policy." *AB* 72, no. 4 (1990): 585–608.

Müller, Hans. *Wilhelm Kaulbach*. Berlin: Fontane, 1893.

————. *Die königliche Akademie der Künste zu Berlin, 1696 bis 1896*. Berlin: Bong, 1896.

Müller, Hermann Alexander. *Die Museen und Kunstwerke Deutschlands. Ein Handbuch für Reisende und Heimgekehrte*. Leipzig: Weber, 1857.

Müller-Vollmer, Kurt. *Poesie und Einbildungskraft. Zur Dichtungstheorie Wilhelm von Humboldts*. Stuttgart: Metzler, 1967.

Müller von Königswinter, Wolfgang. *Das Verhältnis des Staates zu den bildenden Künsten*. Berlin: Seehagen, 1861.

Mundt, Barbara. *Die deutschen Kunstgewerbemuseen im 19. Jahrhundert*. Munich: Prestel, 1974.

Müsebeck, Ernst. *Das preussische Kultusministerium vor hundert Jahren*. Stuttgart: Cotta, 1918.

Muther, Richard. *Geschichte der Malerei im 19. Jahrhundert*. 3 vols. Munich: G. Hirth, 1893–1894.

Muthesius, Hermann. *Style, Architecture, and Building Art: Transformations of Architecture in the Nineteenth Century and Its Present Condition*. Chicago: University of Chicago Press, [1902] 1995.

Mütterlein, Max. "Gottfried Semper und dessen Monumentalbauten am Dresdener Theaterplatz." *Neues Archiv für sächsische Geschichte und Altertumkunde* 34 (1913): 299–399.

Naumann, Friedrich. *Werke*, Vol. 6, *Ästhetische Schriften*. Cologne: Westdeutscher Verlag, 1964.

Nerdinger, Winfried, ed. *Romantik und Restauration. Architektur in Bayern zur Zeit Ludwigs I. 1825–1848*. Munich: Hugendubel, 1987.

————. "Das Pseudomäzenatentum Adolf Hitlers." In Mai and Paret, eds., *Sammler* (1993), pp. 255–64.

Neue deutsche Biographie. 17 vols. to date. Berlin: Duncker & Humblot, 1953–.

Neumann, Carl. "Die geschichtliche Bildung und die Kunst." *PJbb*, 83 (1896): 217–35.

Newhouse, Victoria. *Towards a New Museum*. New York: Monacelli, 1998.

Nicholas, Lynn. *The Rape of Europa: The Fate of Europe's Treasures in the Third Reich and the Second World War*. New York: Knopf, 1994.

Nicolai, Friedrich. *Beschreibung der königlichen Residenzstädte Berlin und Potsdam*. In *Gesammelte Werke*, vol. 2. Hildesheim: Olms, [1769] 1988.

————. *Beschreibung einer Reise durch Deutschland und die Schweiz im Jahr 1781*. In *Gesammelte Werke*, vols. 15–16. Hildesheim: Olms, [1781] 1994.

Nietzsche, Friedrich. *Kritische Studienausgabe*. Ed. Giorgio Colli and Mazzino Montinari. 15 vols. Munich: DTV/de Gruyter, 1967–1988.

Nipperdey, Thomas. *Deutsche Geschichte, 1800–1866. Bürgerwelt und starker Staat*. Munich: Beck, 1983.

————. *Wie das Bürgertum die Moderne fand.* Berlin: Siedler, 1988.

Norton, Robert. *The Beautiful Soul: Aesthetic Morality in the Eighteenth Century.* Ithaca, N.Y.: Cornell University Press, 1995.

O'Doherty, Brian. *Inside the White Cube: The Ideology of the Gallery Space.* Santa Monica, Calif.: Lapis, 1986.

Oelmüller, Willi. *Friedrich Theodor Vischer und das Problem der nachhegelschen Ästhetik.* Stuttgart: Kohlhammer, 1959.

Ohlsen, Manfred. *Wilhelm von Bode. Zwischen Kaisermacht und Kunsttempel. Biographie.* Berlin: Mann, 1995.

Olfers, E. W. M., ed. *Briefe Alexander von Humboldts an Ignaz von Olfers.* Nuremberg: Sebald, n.d.

Olsen, Donald J. *The City as a Work of Art: London, Paris, Vienna.* New Haven: Yale University Press, 1986.

Osborn, Max. "Museen." *NR* 16, no. 2 (1905): 1248–57.

————. "Die bildenden Künste." *Wm* 116, no. 2 (1914): 805–20.

Osten, Gert von der. "Museum und Öffentlichkeit," In *Museum und Kunst. Beiträge für Alfred Hentzen,* ed. H. W. Grohn W. Stubbe, pp. 137–62. Hamburg: H. Christians, n.d.

Osthaus, Karl Ernst. *Van de Velde.* Berlin: Frölich & Kaufmann, [1920] 1984.

Osthaus Museum. *Der Westdeutsche Impuls, 1900–1914. Kunst und Umweltgestaltung im Industriegebiet. Die Folkwang Idee des Karl Ernst Osthaus.* Hagen: Osthaus Museum, 1984.

Otto, Wolf Dieter. *Ästhetische Bildung. Studien zur Kunsttheorie Wilhelm von Humboldts.* Frankfurt: Peter Lang, 1987.

Pallat, Ludwig. "Kunst- und Kunstgewerbe-Museen." In W. Lexis et al., eds., *Die allgemeinen Grundlagen der Kultur der Gegenwart,* pp. 347–71. Berlin and Leipzig: B. G. Teubner, 1906.

————. *Richard Schöne, Generaldirektor der Königlichen Museen zu Berlin. Ein Beitrag zur Geschichte des preussischen Kunstverwaltung 1872–1905.* Ed. P. O. Rave. Berlin: De Gruyter, 1959.

Paret, Peter. *Clausewitz and the State.* New York: Oxford University Press, 1976.

————. *The Berlin Secession: Modernism and Its Enemies in Imperial Germany.* Cambridge: Harvard University Press, 1980.

————. "The Tschudi Affair." *JMH* 53, no. 4 (1981): 589–618.

————. "Die Tschudi-Affäre." In Hohenzollern and Schuster, eds., *Manet* (1996), pp. 396–401.

Paul, Barbara. *Hugo von Tschudi und die moderne französische Kunst im Deutschen Kaiserreich.* Mainz: Von Zabern, 1993.

————. "'Das Kollektionieren ist die edelste aller Leidenschaften.' Wilhelm von Bode und das Verhältnis zwischen Museum, Kunsthandel und Privatsammlertum." *Kritische Berichte,* March 1993, pp. 41–64.

————. "Wilhelm von Bodes Konzeption des Kaiser-Friedrich-Museums. Vorbild für heute?" In Zentralinstitut, *Berlins* (1994), pp. 205–20.

Pauli, Gustav. "Die Museen und die Kunst unserer Zeit." *Mk,* n.s., 2 (1930): 97–101.

————. *Erinnerungen aus sieben Jahrzehnten.* Tübingen: Wunderlich, 1936.

Pazaurek, Gustav. "Die Stuttgarter Königliche Gemäldegalerie." *Mk* 3 (1907): 62–67.

Pecht, Friederich. "Venetianische Briefe." *Recensionen* 3, nos. 45, 48 (1864): 353–55, 377–79.

————. *Deutsche Künstler des 19. Jahrhunderts. Studien und Erinnerungen.* 2 vols. Nördlingen: Beck, 1877–1879.

————. *Aus meiner Zeit. Lebenserinnerungen.* 2 vols. Munich: Kunst & Wissenschaft, 1894.

————. "Über die staatliche Kunstpflege in Bayern." *KfA* 1, no. 8 (1896): 109–11.

Peschen, Goerd. "Der Beamtenbürger und sein Museum. Schinkels Altes Museum in Berlin und Sempers Kunsthistorisches Museum in Wien als architektonischen Ausdruck bürgerlicher Kunstideologie." *Kunst und Unterricht. Sonderheft: Museum und Schule* (1976): 78–83.

Petras, Renate. *Die Bauten der Berliner Museums-Insel.* Berlin: Stapp Verlag, 1987.

Pevsner, Nikolaus. *Academies of Art: Past and Present.* New York: Da Capo, 1973.

————. *A History of Building Types.* Princeton: Princeton University Press, 1976.

Pfeifer, Hans-Georg, ed. *Peter Behrens.* Düsseldorf: Beton, 1990.

Pfotenhauer, Helmut, et al., eds. *Frühklassizismus. Position und Opposition: Winckelmann, Mengs, Heinse.* Frankfurt: Deutscher Klassiker Verlag, 1995.

Plagemann, Volker. "Die Anfänge der Hamburger Kunstsammlungen und die erste Kunsthalle." *Jahrbuch der Hamburger Kunstsammlungen* 11 (1966): 61–88.

————. *Das deutsche Kunstmuseum, 1790–1870. Lage, Baukörper, Raumorganisation, Bildprogramm.* Munich: Prestel, 1967.

Pochat, Götz. "Der Epochenbegriff und die Kunstgeschichte." In Dittmann, ed., *Kategorien* (1985), pp. 129–67.

Podro, Michael. *The Manifold in Perception: Theories of Art from Kant to Hildebrand.* Oxford: Oxford University Press, 1972.

————. *The Critical Historians of Art.* New Haven: Yale University Press, 1982.

Pöggeler, Otto. "Preussische Kulturpolitik im Spiegel von Hegels Ästhetik." *JbPKB* 18 (1981): 355–76.

————. "Der Philosoph und der Maler. Hegel und Christian Xeller." In Pöggeler and Gethmann-Siefert, eds., *Kunsterfahrung* (1983), pp. 351–79.

————. "System und Geschichte der Künste bei Hegel." In Gethmann-Siefert and Pöggeler, eds., *Welt* (1986), pp. 1–26.

————. *Preussische Kulturpolitik im Spiegel von Hegels Ästhetik.* Opladen: Westdeutscher Verlag, 1987.

————, ed. *Hegel in Berlin. Preussische Kulturpolitik und idealistische Ästhetik.* Berlin: Staatsbibliothek, 1981.

Pöggeler, Otto, and Annemarie Gethmann-Siefert, eds. *Kunsterfahrung und Kulturpolitik im Berlin Hegels.* Bonn: Bouvier, 1983.

Pölnitz, Winfried Freiherr von. *Ludwig I. v. Bayern und Johann Martin von Wagner. Schriftenreihe zur bayerischen Landesgeschichte* (1929).

Pomian, Krzysztof. *Der Ursprung des Museums: Vom Sammeln.* Berlin: Klaus Wagenbach, 1988.

————. *Collectors and Curiosities: Paris and Venice, 1500–1800.* Cambridge: Polity, 1990.

Poschinger, M. von. *Kaiser Friedrich.* 3 vols. Berlin: Schröder, 1898.

Posse, Hans. "Die Briefe des Grafen Francesco Algarotti an den sächsischen Hof." *JbPKS* 52 Beiheft (1931).

Potts, Alex. *Flesh and Ideal: Winckelmann and the Origins of Art History.* New Haven: Yale University Press, 1994.

Präffcke, Hans. *Der Kunstbegriff Alfred Lichtwarks.* Hildesheim: G. Olms, 1986.

Prussia. "Statut für die königlichen Museen zu Berlin vom 25.5.1868." *Centralblatt für die gesamte Unterrichts-Verwaltung in Preussen* 218 (1868): 588.

————. "Statut für die königlichen Museen zu Berlin vom 13.11.1878." *Centralblatt für die gesamte Unterrichts-Verwaltung in Preussen* 220 (1878): 654.

Pundt, Hermann. *Schinkel's Berlin: A Study in Environmental Planning*. Cambridge: Harvard University Press, 1972.

Raczynski, Athanasius Graf. *Geschichte der neueren deutschen Kunst*. 3 vols. Berlin: Selbstverlag, 1836–1841.

Radziewsky, Elke von. *Kunstkritik im Vormärz, dargestellt am Beispiel der Düsseldorfer Malerschule*. Bochum: Brockmeyer, 1983.

Rave, Paul Ortwin. *Das Schinkel Museum und die Kunst-Sammlungen Beuths*. Berlin: Ernst Rathenau, 1931.

———. *K. F. Schinkel. Berlin II. Stadtbaupläne, Brücken, Strassen, Tore, Plätze*. Berlin: Deutscher Kunstverlag, 1948.

———. *Karl Friedrich Schinkel*. Munich: Deutscher Kunstverlag, 1953.

———. "Schinkels Museum in Berlin oder die klassische Idee des Museums." *Mk* 29 (1960): 1–20.

———. "Ignaz von Olfers." *Westfälische Lebensbilder* 9 (1961): 108–24.

———. *Die Geschichte der Nationalgalerie Berlin*. Berlin: Staatliche Museen zu Berlin, 1968.

———. *K. F. Schinkel. Berlin I. Teil, Bauten für die Kunst, Kirchen und Denkmalpflege*. 2d ed. Berlin: Deutscher Kunstverlag, [1941] 1981.

———. *Schriften über Künstler und die Kunst*. Stuttgart: Gerd Hatje, 1994.

———. "Zur Geschichte der preussischen Kunstsammlungen. Schinkel und die artistische Kommission." In *Schriften über Künstler und die Kunst*, pp. 222–33. Stuttgart: Hatje, 1994.

Reinle, Adolf. *Zeichensprache der Architektur. Symbol, Darstellung und Brauch in der Baukunst des Mittelalters und der Neuzeit*. Zurich: Artemis, 1976.

Reuber, Rudolf. *Ästhetische Lebensformen bei Nietzsche*. Munich: Fink, 1988.

Riegel, Herman. "Das neue Museumsgebäude zu Braunschweig in Bezug auf seinen Benutzungszweck gewürdigt." *Jahrbuch der königlichen Preussischen. Kunstsammlungen* 10 (1889): 109–20.

Riegl, Alois. *Problems of Style: Foundations of a History of Ornament*. Princeton: Princeton University Press, 1993.

Ritter, Joachim. "Ästhetik." *Historisches Wörterbuch der Philosophie* 1 (1971): 555–80.

Rodiek, Thorsten. *James Stirling. Die Neue Staatsgalerie Stuttgart*. Stuttgart: Hatje, 1984.

Rohe, M. K. "Zur Neuordnung der Münchner Neuen Pinakothek." *KfA* 29 (1913–1914): 313–24.

———. "Zur Umhängung in der Münchner Neuen Pinakothek." *KfA* 29 (1913–1914): 313–24.

Roland, Berthold. "Johann Christian von Mannlich (1741–1822)." *Pfälzer Lebensbilder*, 1 (1964): 142–66.

———. "Johann Christian von Mannlich und die Kunstsammlungen des Hauses Wittelsbach." In Glaser, ed., *Krone* (1980), pp. 356–65.

Rosenberg, Adolf. "Die Publikationen der Berliner Museen." *Gb* 42, no. 4 (1883): 196–203.

———. "Der neue Katalog der Dresdner Gemäldegalerie." *Gb* 47, no. 1 (1888): 93–98.

———. "Kunstsammler in Berlin." *Gb* 57, no. 3 (1898): 177–84.

Rosenblum, Robert. *Transformations in Late Eighteenth-Century Art*. Princeton: Princeton University Press, 1967.

Rössling, Wilfried. "Studien zur Baugeschichte des 'Akademie-Gebäudes' und der Grossherzoglichen Kunsthalle in Karlsruhe." *Jahrbuch der staatlichen Kunstsammlungen in Baden Württemberg* 23 (1986): 77–119.

Roters, Eberhard. "Die Nationalgalerie und ihre Stifter. Mäzenatentum und staatliche Förderung in Dialog und Widerspruch." In Braun and Braun, eds., *Mäzenatentum* (1993), pp. 73–98.

Rückert, Claudia, and Barbara Segelken. "Im Kampf gegen den 'Ungeschmack.' Das Kunstgewerbemuseum im Zeitalter der Industrialisierung." In Joachimides, ed., *Museumsinszenierungen* (1995), pp. 108–21.

Rumohr, Carl-Friedrich von. *Drey Reisen nach Italien. Erinnerungen.* Leipzig: Brockhaus, 1832.

Saisselin, Rémy. *The Enlightenment against the Baroque: Economics and Aesthetics in the Eighteenth Century.* Berkeley: University of California Press, 1992.

Salzmann, Siegfried. "Gustav Pauli und das moderne Kunstmuseum." In Junge, ed., *Avantgarde* (1992), pp. 235–42.

Sauerlandt, Max. "Die Forschungsaufgaben der kunsthistorischen Museen," In Lang, ed. *Beiträge* (1930), pp. 185–213.

———. *Im Kampf um die moderne Kunst. Briefe 1902–1933.* Munich: Langen, 1957.

Schadendorf, Wulf, ed. *Beiträge zur Rezeption der Kunst des 19. und 20. Jahrhunderts.* Munich: Prestel, 1975.

Schadow, Johann Gottfried. *Kunstwerke und Kunstansichten. Ein Quellenwerk zur Berliner Kunst- und Kulturgeschichte zwischen 1780 und 1845.* Ed. Götz Eckardt. 3 vols. Berlin: Deutscher Verlag für Kunstwissenschaft, 1987.

Schapiro, Meyer. *Theory and Philosophy of Art: Style, Artist, and Society—Selected Papers.* New York: George Braziller, 1994.

Scharabi, M. *Architekturgeschichte des 19. Jahrhunderts.* Tübingen: Wasmuth, 1993.

Schasler, Max. *Die Wandgemälde von Kaulbach im Treppenhause des Neuen Museums zu Berlin.* Berlin: Allgemeine Deutsche Verlagsanstalt, 1854.

Scheffler, Karl. *Der Deutsche und seine Kunst. Eine notgedrungene Streitschrift.* Munich: Piper, 1907.

———. *Die Nationalgalerie in Berlin. Ein kritischer Führer.* Berlin: Cassirer, 1912.

———. *Die fetten und die mageren Jahre. Ein Arbeits- und Lebensbericht.* Leipzig: List, 1946.

———. *Eine Auswahl seiner Essays aus Kunst und Leben, 1905–1950.* Ed. Carl Georg Heise and Johann Langner. Hamburg: Hauswedell, 1969.

Scheicher, Elisabeth. "The Collection of Archduke Ferdinand II at Schloss Ambross." In Impey and MacGregor, eds., *Origins* (1985), pp. 29–38.

Schelling, F. W. J. von. "Über das Verhältnis der bildenden Künstler zur Natur" [1807]. In *Werke*, 3 (2):388–430. Munich: Beck, 1959.

Scherer, Valentin. *Deutsche Museen. Entstehung und kulturgeschichtliche Bedeutung unserer öffentlichen Kunstsammlungen.* Jena: Diederichs, 1913.

Scheuner, Ulrich. "Die Kunst als Staatsaufgabe im 19. Jahrhundert." In Mai and Waetzoldt, eds., *Kunstverwaltung* (1980), pp. 13–46.

Schiefler, Gustav. *Eine hamburgische Kulturgeschichte, 1890–1920. Beobachtungen eines Zeitgenossen.* Hamburg: Verein für Hamburgische Geschichte, 1985.

Schiller, Friedrich. *On the Aesthetic Education of Man: In a Series of Letters.* Ed. Elizabeth M. Wilkinson and L. A. Willoughby. Oxford: Oxford University Press, 1967.

———. *Sämtliche Werke.* 5 vols. Munich: Hauser, 1987–1989.

Schinkel, Karl Friedrich. *Aus Schinkels Nachlass. Reisetagebücher, Briefe und Aphorismen.* Ed. Alfred von Wolzogen. 4 vols. Berlin: Hofbuchdruckerei, 1862–1864.

———. *Lebenswerk.* 22 vols. to date. Berlin: Deutscher Kunstverlag, 1939–.

———. *Das architektonische Lehrbuch.* Ed. Goerd Peschken. Munich: Deutscher Kunstverlag, 1979.

————. *Reisen nach Italien*. Ed. Gottfried Riemann. Berlin, 1979.

————. *Reise nach England, Schottland und Paris im Jahre 1826*. Ed. Gottfried Riemann. Berlin: Henschel, 1986.

————. *"The English Journey": Journal of a Visit to France and Britain in 1826*. Ed. David Bindman and Gottfried Riemann. New Haven: Yale University Press, 1993.

Schlegel, August Wilhelm. *Kritische Ausgabe der Vorlesungen*. Vol. 1, *Vorlesungen über Aesthetik (1798–1808)*, pt. 1. *Die Kunstlehre*. Ed. E. Behler. Paderborn: Schöningh, 1989.

Schlegel, August Wilhelm, and Caroline Schlegel. "Die Gemälde." In A. W. Schlegel, *Sämmtliche Werke*, 9: 3–101. Leipzig: Weidmann, [1799] 1846.

Schlegel, Friedrich. *Ansichten und Ideen von der christlichen Kunst*. Ed. Hans Eichner. In *Kritische Ausgabe*, vol. 4. Munich: Schöningh, 1959.

Schlink, Wilhelm. *Jacob Burckhardt und die Kunsterwartung im Vormärz*. Wiesbaden: Steiner, 1982.

Schlosser, Julius von. *Die Kunst- und Wunderkammern der Spätrenaissance. Ein Beitrag zur Geschichte des Sammelwesens*. Leipzig: Klinkhardt & Biermann, 1908.

Schmarsow, August. *Die Kunstgeschichte an unsern Hochschulen*. Berlin: Reimer, 1891.

Schmidt, Wilhelm. "Kritische Bemerkungen über die grossherzogliche Gemäldegalerie zu Darmstadt." *Repertorium für Kunstwissenschaft* 1 (1876): 249–58.

Schmidt-Ott, Friedrich. *Erlebtes und Erstrebtes, 1860–1950*. Wiesbaden: Steiner, 1952.

Schnädelbach, Herbert. "Die Abkehr von der Geschichte. Stichworte zum 'Zeitgeist' im Kaiserreich." In Mai et al., eds., *Ideengeschichte* (1983), pp. 31–43.

Schnorr von Carolsfeld, Julius. *Künstlerische Wege und Ziele. Schriftstücke aus der Feder des Malers*. Ed. F. Schnorr von Carolsfeld. Leipzig: Wigand, 1909.

Scholz, W. B. "Ein Gang durch die Neue Pinakothek in München." *Wm* 1 (1856–1857): 446–51.

Schorske, Carl. "Museum im ungekämpften Raum. Schwert, Szepter und Ring." In Hardtwig and Brandt, eds., *Deutschlands* (1993), pp. 223–42.

Schröter, Hans. *Maler und Galerie. Das Verhältnis der Maler zu den öffentlichen Galerien Deutschlands im 19. Jahrhundert*. Ph.D. diss. Berlin University, 1954.

Schulz, Eva. "Das Museum als wissenschaftliche Institution. Neue Ideen und tradierte Vorstellungen am Beispiel der Sammlung Boisserée." *WRJb* 51 (1990): 285–317.

Schulze, Sabine. *Bildprogramme in deutschen Kunstmuseen des 19. Jahrhunderts*. Frankfurt: Lang, 1984.

Schwahn, Britta. *Die Glyptothek in München: Baugeschichte und Ikonologie*. Munich: UNI-Druck, 1983.

Schwartz, Frederic. *The Werkbund: Design Theory and Mass Culture before the First World War*. New Haven: Yale University Press, 1996.

Seeba, Hinrich. "Die Kinder des Pygmalion. Die Bildlichkeit des Kunstbegriffs bei Heine. Beobachtungen zur Tendenzwende der Ästhetik." *Deutsche Vierteljahrsschrift* 50 (1976): 158–202.

————. "Johann Joachim Winckelmann. Zur Wirkungsgeschichte eines 'unhistorischen' Historikers zwischen Ästhetik und Geschichte." *Deutsche Vierteljahrsschrift* 56 Sonderheft (1982): 168–201.

Seeck, Otto. "Das Kaiser-Friedrich-Museum." *DR* 122 (1905): 16–44.

Seelig, Lorenz. "The Munich *Kunstkammer*." In Impey and MacGregor, eds., *Origins* (1985), pp. 76–89.

Seidel, Paul. "Zur Vorgeschichte der Berliner Museen. Der erste Plan von 1797." *JbPKS* 49, supp. (1928): 55–64.

Seidlitz, Woldemar von. *Kunstmuseen. Vorschlag zur Begründung eines Fürstenmuseums in Dresden*. Leipzig: Seemann, 1907.

————. "Bode und Tschudi." *PJbb* 147, no. 2 (1912): 315–18.

Seling, Helmut. "Die Entstehung des Kunstmuseums als Aufgabe der Architektur." Ph.D. diss. University of Freiburg, 1952.

————. "The Genesis of the Museum." *AR* 141 (1967): 103–14.

Sembach, Klaus-Jürgen. *Henry van de Velde*. Stuttgart: Hatje, 1989.

Semper, Gottfried. *Kleine Schriften*. Ed. Hans and Manfred Semper. Berlin: Spemann, 1884.

————. *Die k.k. Hofmuseen in Wien und Gottfried Semper. Drei Denkschriften*. Innsbruck: Edlinger, 1892.

————. "Plan eines idealen Museums" [1852]. In *Wissenschaft, Industrie und Kunst*, ed. Hans Wingler, pp. 72–79. Mainz: Kupferberg, 1966.

————. *The Four Elements of Architecture and Other Writings*. Cambridge: Cambridge University Press, 1989.

Seznec, Jean. *The Survival of the Pagan Gods: The Mythological Tradition and Its Place in Renaissance Humanism and Art*. New York: Harper, 1961.

Sheehan, James J. *German History, 1770–1866*. Oxford: Oxford University Press, 1989.

————. "Vergangenheit und Gegenwart in der Geschichte der Kunst," In Hardtwig and Brandt, eds., *Deutschlands* (1993), pp. 201–14.

Sherman, Daniel J. *Worthy Monuments: Art Museums and the Politics of Culture in Nineteenth-Century France*. Cambridge: Harvard University Press, 1989.

Sherman, Daniel, and Irit Rogoff, eds. *Museum Culture: Histories, Discourses, Spectacles*. Minneapolis: University of Minnesota Press, 1994.

Siefert, Helge. "Tschudis Berufung nach München." In Hohenzollern and Schuster, eds., *Manet* (1996), pp. 402–7.

Snodin, Michael, ed. *Karl Friedrich Schinkel: A Universal Man*. New Haven: Yale University Press, 1991.

Spickernagel, Ellen, and Brigitte Walbe, eds. *Das Museum. Lernort contra Musentempel*. Giessen: Anabas, 1976.

Spielmann, Heinz. "Konzeption und Rezeption eines Jugendstil-Sammlung, 1873–1973." In Schadendorf, ed., *Beiträge* (1975), pp. 119–28.

Spiero, Sabine. *Schinkels Altes Museum in Berlin. Seine Baugeschichte von den Anfängen bis zur Eröffnung*. Ph.D. diss. University of Marburg, 1933.

————. "Schinkels Altes Museum in Berlin. Seine Baugeschichte von den Anfängen bis zur Eröffnung." *JbPKS* 55, supp. (1934): 41–86.

Spindler, Max, ed. *Handbuch der bayerischen Geschichte*, vol. 4 (2 parts), *Das Neue Bayern, 1870–1970*. Munich: Beck, 1974–1975.

Springer, Anton. *Kunsthistorische Briefe. Die bildenden Künste in ihrer weltgeschichtlichen Entwicklung*. Prague: Ehrlich, 1857.

————. "Die Wege und Ziele der gegenwärtigen Kunst." In *Bilder aus der neueren Kunstgeschichte*. 2d ed. 2 vols. Bonn: Marcus, 1867.

Springer, Elisabeth. *Geschichte und Kulturleben der Wiener Ringstrasse*. In Wagner-Rieger, ed. *Ringstrasse* vol. 2. Wiesbaden: Steiner, 1979.

Stamm-Kuhlmann, Thomas. *König in Preussens grosser Zeit. Friedrich Wilhelm III. Der Melancholiker auf dem Thron*. Berlin: Siedler, 1992.

Steinhauser, Monika. "Étienne-Louis Boullées *Architecture. Essai sur l'art*: Zur theoretischen Begründung einer autonomen Architektur." *Idea. Jahrbuch der Hamburger Kunsthalle*, 2 (1983): 7–47.

Steinwachs, Burkhart. *Epochenbewusstsein und Kunsterfahrung. Studien zur geschichtsphilosophischen Ästhetik an der Wende vom 18. zum 19 Jh in Frankreich und Deutschland*. Munich: Fink, 1986.

Stern, Adolf. *Hermann Hettner. Ein Lebensbild*. Leipzig: Brockhaus, 1885.

Stern, Fritz. *The Politics of Cultural Despair: A Study in the Rise of the Germanic Ideology*. Berkeley: University of California Press, 1963.

Sternberg, Carsten Bernhard. *Die Geschichte des Karlsruher Kunstvereins*. Ph.D. diss. University of Karlsruhe, 1977.

Stierle, Karlheinz. "Zwei Hauptstädte des Wissens: Paris und Berlin." In Pöggeler and Gethmann-Siefert, eds., *Kunsterfahrung* (1983), pp. 83–111.

Stix, Alfred. *Die Aufstellung der ehedem Kaiserlichen Gemäldegalerie in Wien im 18. Jahrhundert*. Vienna: Museion Mitteilungen, 1922.

Stock, Friedrich. "Zur Vorgeschichte der Berliner Museen. Urkunden von 1786–1807." *JbPKS* 49, supp. (1928): 65–174.

———. "Urkunden zur Vorgeschichte des Berliner Museums." *JbPKS* 51 (1930): 205–22.

———. "Zwei Gesuche Waagens." *JbPKS* 53 (1932): 113–28.

———. "Urkunden zur Einrichtung des Berliner Museums." *JbPKS* 58, supp. (1937): 11–31.

Stübel, Moritz. "Deutsche Galeriewerke und Kataloge des 18. Jahrhunderts." *Monatshefte für Bücherfreunde und Graphiksammler* (1925): 247–54, 301–11.

Studniezka, Franz. "Georg Treu." *Berichte über die Verhandlungen der Sächsischen Akademie der Wissenschaften in Leipzig* 73, no. 2 (1921): 51–62.

Sulzer, Johann Georg. *Allgemeine Theorie der schönen Künste*. 2d ed. 2 vols. Leipzig: Weidmann, 1792–1794.

———. *Aesthetics and the Art of Musical Composition in the German Enlightenment*. Ed. Nancy Baker and Thomas Christensen. Cambridge: Cambridge University Press, 1995.

Swarzenski, Georg. "Kunstsammlungen." In Josef Brix et al., eds., *Handwörterbuch der Kommunalwissenschaften*, 3:201–8. Jena: Fischer, 1922.

———. *Museumsfragen*. Frankfurt: Bibliophile Gesellschaft, 1928.

Sweet, Paul. *Wilhelm von Humboldt: A Biography*. 2 vols. Columbus: Ohio State University Press, 1978–1980.

Szambien, Werner. *Jean-Nicolas-Louis Durand, 1760–1834: De l'imitation à la norme*. Paris: Picard, 1984.

Sziborsky, Lucia. "Schelling und die Münchener Akademie der bildenden Künste. Zur Rolle der Kunst im Staat." In Gethmann-Siefert and Pöggeler, eds., *Welt* (1986), pp. 39–64.

Szondi, Peter. *Poetik und Geschichtsphilosophie*. Frankfurt: Suhrkamp, 1974.

Thieme, Ulrich, and Felix Becker, eds., *Allgemeines Lexikon der bildenden Künstler*. 37 vols. Leipzig: Seemann, 1907–1950.

Tippmann, Max. *Zur Entwicklung des Types der deutschen Gemäldegalerien im 19. Jahrhundert*. Ph.D. diss. University of Leipzig, 1931.

Trachtenberg, Marvin, and Isabelle Hyman. *Architecture: From Prehistory to Postmodernism*. New York: Abrams, 1986.

Treinen, Heiner. "Ansätze zu einer Soziologie des Museumswesens," In *Soziologie, Sprache, Bezug zur Praxis. Verhältnis zu anderen Wissenschaften*, ed., G. Albrecht et al., pp. 336–53. Opladen: Westdeutsche, 1973.

Trenkwald, H. von. "Das Landesmuseum in Darmstadt." *KK* 3 (1907): 163–71.

Treue, Wilhelm. "Franz Theodor Kugler—Kulturhistoriker und Kulturpolitiker." *HZ*, 170, no. 3 (1953): 483–526.

Tschudi, Hugo von. *Kunst und Publikum. Rede zur Feier des Allerhöchsten Geburtstages der Majestät des Kaisers und Königs*. Berlin: Mittler, 1899.

————. "Die Jahrhundertausstellung." *NR* 17, no. 1 (1906): 577–603.

————. "Vorwart." In *Katalog der aus der Sammlung des kgl. Rates Maczell von Nemes-Budapest ausgestellten Gemälde.* Munich: Bruckmann, 1911.

————. *Gesammelte Schriften zur neueren Kunst.* Munich: Bruckmann, 1912.

Uhde-Bernays, Hermann. *Im Lichte der Freiheit: Erinnerungen aus den Jahren 1880–1914.* Munich: Insel, 1947.

Van der Zande, Johan. "Orpheus in Berlin: A Reappraisal of Johann Georg Sulzer's Theory of the Polite Arts." *CEH* 28, no. 2 (1995): 175–209.

Van de Velde, Henry. *Geschichte meines Lebens.* Munich: Piper, 1986.

Varnhagen von Ense, Karl August. *Werke.* Ed. K. Feilchenfeldt. 5 vols. Frankfurt: Deutscher Klassiker Verlag, 1987.

Vergo, Peter, ed. *The New Museology.* London: Reaktion, 1989.

Vidler, Anthony. *Claude-Nicolas Ledoux: Architecture and Social Reform at the End of the Old Regime.* Cambridge, Mass.: MIT Press, 1990.

Vierhaus, Rudolf. "Bildung." *Geschichtliche Grundbegriffe* 1 (1972): 508–51.

Vierneisel, Klaus, and Gottlieb Leinz, eds. *Glyptothek München, 1830–1980.* Munich: Glyptothek, 1980.

Vincenz. "Ein Gang durch das neue Museum zu Berlin." *DK* 1, nos. 35–37 (1850): 273–74, 281–83, 291.

Vinnen, Carl. *Ein Protest deutscher Künstler.* Jena: Diederichs, 1911.

Vischer, Friedrich Theodor. *Kritische Gänge.* 6 vols. Leipzig: Verlag der weissen Bücher, 1914–1922.

Vogt, Adolf Max. *Karl Friedrich Schinkel. Blick in Griechenlands Blüte. Ein Hoffnungsbild für Spree Athen.* Frankfurt: Fischer, 1985.

Vogtherr, Christoph Martin. "Zwischen Norm und Kunstgeschichte. Wilhelm von Humboldts Denkschrift von 1829 zur Hängung in der Berliner Gemäldegalerie." *JbBM,* n.s. 34 (1992): 53–64.

————. "Kunstgenuss versus Kunstwissenschaft. Berliner Museumskonzeptionen bis 1830." In Joachimides et al., eds., *Museumsinszenierungen* (1995), pp. 38–50.

Volbehr, Theodor. *Die Zukunft der deutschen Museen.* Stuttgart: Stricker & Schröder, 1909.

Waagen, Gustav F. "Thoughts on the New Building to Be Erected for the National Gallery of England, and on the Arrangement, Preservation, and Enlargement of the Collection." *AJ* 5 (1853): 101–3, 121–25.

————. *Kleine Schriften.* Stuttgart: Ebner, 1875.

Wackenroder, Wilhelm Heinrich. *Confessions and Fantasies.* Ed. Mary Hurst Schubert. University Park, Pa: Penn State University Press, 1971.

Waetzoldt, Stephan. "Museumspolitik—Richard Schöne und Wilhelm von Bode." In Mai and Waetzoldt, eds., *Kunstverwaltung* (1980), pp. 481–90.

————. "Wilhelm von Bode und die innere Struktur der Preussischen Museen zu Berlin." *JbBM* 38 (1996): 7–14.

Waetzoldt, Wilhelm. "Die staatlichen Museen zu Berlin, 1830–1930." *JbPKS* 51 (1930): 189–204.

————. "Trilogie der Museumsleidenschaft (Bode-Tschudi-Lichtwark)." *ZKG* 1 (1932): 5–12.

————. "Preussische Kunstpolitik und Kunstverwaltung, 1817–1932." *Reichsverwaltungsblatt* 54, no. 5 (1933): 81–85.

————. *Deutsche Kunsthistoriker.* 2 vols. 2d ed. Berlin: Hessling, 1965.

Wagner, Cornelia. *Arbeitsweisen und Anschauungen in der Gemälderestaurierung um 1800.* Munich: Callwey, 1988.

Wagner, Heinrich. "Museen." In *Handbuch der Architektur*, 2d ed. pt. 4, 6 (4): 219–488. Stuttgart: Kroner, 1906.

Wagner-Rieger, Renate, ed. *Die Wiener Ringstrasse. Bild einer Epoche.* 11 vols. Vienna: Böhlaus, 1969–.

Warnke, Martin. *Hofkünstler. Zur Vorgeschichte des modernen Künstlers.* Cologne: Du Mont, 1985.

Watkin, David, and Tilman Mellinghoff. *German Architecture and the Classical Ideal.* Cambridge, Mass.: MIT Press, 1987.

Weber, Hermann. "Die Bedeutung der Dynastien für die europäische Geschichte der frühen Neuzeit." *Zeitschrift für bayerische Landesgeschichte* 44, no. 1 (1981): 5–32.

Weber, Jürgen. *Entmündigung der Künstler. Geschichte und Funktionsweise der bürgerlichen Kunsteinrichtungen.* Cologne: Pahl-Rugenstein, 1987.

Wegner, Reinhard. "Die Einrichtung des Alten Museums in Berlin. Anmerkungen zu einem neu endeckten Schinkel Dokument." *JbBM* 31 (1989): 265–87.

Weisbach, Werner. "Kunstgenuss und Kunstwissenschaft (Zur Museumsreform)." *PJbb* 134, no. 1 (1908): 148–58.

———. *"Und alles ist zerstoben": Erinnerungen aus der Jahrhundertwende.* Vienna: Reichner, 1937.

———. *Geist und Gewalt.* Ed. L. Scherdt. Vienna: Schroll, 1956.

Werkbecker, Wilhelm Freiherr von. "Die Museen unter verwaltungstechnischen Gesichtspunkte." *Mk* 7 (1911): 146–55; 8 (1912): 27–44, 115–21.

Werner, Anton von. *Jugenderinnerungen, 1843–1870.* Berlin: Deutscher Verlag für Kunstwissenschaft, 1994.

Werner, Karl Ferdinand, ed. *Hof, Kultur und Politik im 19. Jahrhundert.* Bonn: Röhrscheid, 1985.

Wescher, Paul. *Kunstraub unter Napoleon.* Berlin: Mann, 1976.

Wesenberg, Angelika. "Impressionismus und the Deutsche Jahrhundert-Ausstellung Berlin 1906." In Hohenzollern and Schuster, eds., *Manet* (1996), pp. 364–70.

West, Robert. "Hugo von Tschudi." *PJbb* 151, no. 1 (1913): 15–21.

———. "Zwei Denkschriften des Direktors der Berliner Nationalgalerie." *PJbb* 153, no. 2 (1913): 245–52.

Wienfort, Monika. *Monarchie in der bürgerlichen Gesellschaft. Deutschland und England von 1640 bis 1848.* Göttingen: Vandenhoeck & Ruprecht, 1993.

Wilhelm II. "Die wahre Kunst. 18. Dezember 1901." In *Die Reden Kaiser Wilhelms II*, ed. J. Pengler, pt. 3. Leipzig: Reclam, n.d.

Wilhelmi, Rudolf. *Die Fresken Karl Friedrich Schinkels in den Vorhallen des Museums zu Berlin.* Berlin: Selbstverlag, 1882.

Wilhelm von Bode. Museumsdirektor und Mäzen. Berlin: Staatliche Museen zu Berlin, 1995.

Winckelmann, Johann Joachim. *Die Geschichte der Kunst des Altertums.* Weimar: Böhlau, 1964.

———. *Werke in einem Band.* Berlin: Aufbau, 1969.

Windsor, Alan. *Peter Behrens: Architect and Designer.* London: Architectural Press, 1981.

Winkler, Friedrich. "Max J. Friedländer 5.6.1867–11.10.58." *JbBM* 1 (1959): 161–67.

Winkler, Kurt. "Ludwig Justi—Der konservative Revolutionär." In Junge, ed., *Avantgarde* (1992): 173–85.

Winterling, Aloys. *Der Hof der Kurfürsten von Köln, 1688–1794. Eine Fallstudie zur Bedeutung 'absolutischer' Hofhaltung.* Bonn: Röhrscheid, 1986.

With, Christopher. *The Prussian Landeskunstkommission, 1862–1911: A Study in State Subvention of the Arts*. Berlin: Mann, 1986.

Wittlin, Alma. *The Museum: Its History and Its Tasks in Education*. London: Routledge, 1949.

Woermann, Karl. "Anfang und Ende einer Gemäldegalerie des vorigen Jahrhunderts." *Gb* 40, no. 1 (1881): 147–61.

———. "Goethe in der Dresdener Galerie." In Woermann, *Von Apelles zu Böcklin*, (1912), 2:264–77.

———. "Die Neuerwerbungen älterer Gemälde für die Dresdner Galerie seit der Mitte des 19. Jahrhunderts." In Woermann, *Von Apelles zu Böcklin*, vol. 2 (1912): 289–98.

———. "Die Raumfrage in der Dresdener Gemäldegalerie." In Woermann, *Von Apelles zu Böcklin*, (1912), 2:299–312.

———. *Von Apelles zu Böcklin und weiter. Gesammelte kunstgeschichtliche Aufsätze, Vorträge und Besprechungen*. 2 vols. Esslingen: Neff, 1912.

———. *Lebenserinnerungen eines Achtzigjährigen*. 2 vols. Leipzig: Biographisches Institut, 1924.

Wolbring, Barbara. "'Auch ich in Arkadien!' Die bürgerliche Kunst- und Bildungsreise im 19. Jahrhundert." In Hein and Schulz, eds., *Bürgerkultur* (1996), pp. 82–101.

Wölfflin, Heinrich. *Autobiographie. Tagebücher und Briefe*. Ed. Joseph Gantner. Basel: Schwabe, 1982.

Woltmann, Alfred. *Baugeschichte Berlins bis auf die Gegenwart*. Berlin: Paetel, 1872.

Woodmansee, Martha. "'Art' as a Weapon in Cultural Politics: Rereading Schiller's Aesthetic Letters," In *Eighteenth-Century Aesthetics and the Reconstruction of Art*, ed. Paul Mattick, pp. 178–209. Cambridge: Cambridge University Press, 1993.

———. *The Author, Art, and the Market: Rereading the History of Aesthetics*. New York: Columbia University Press, 1996.

Worringer, Wilhelm. *Abstraktion und Einfühlung. Ein Beitrag zur Stil-psychologie*. Munich: Piper, 1908.

———. *Abstraction and Empathy. A Contribution to the Psychology of Style*. New York: International Universities Press, 1953.

Wünsche, Raimund. "Kronprinz Ludwig als Antikensammler." In Glaser, ed., *Krone* (1980), pp. 439–47.

———. "Ludwigs Skulpturenerwerbungen für die Glyptothek." In Viermeisel and Leinz, eds., *Glyptothek* (1980), pp. 23–83.

Wüthrich, Lukas Heinrich. *Christian von Mechel. Leben und Werk eines Basler Kupferstechers und Kunsthändlers (1737–1817)*. Basel: Helbing & Lichterhahn, 1956.

Wyss, Beat. "Klassizismus und Geschichtsphilosophie im Konflikt. Aloys Hirt und Hegel." In Pöggeler and Gethmann-Siefert, eds., *Kunsterfahrung* (1983), pp. 115–30.

———. *Trauer der Vollendung. Von der Ästhetik des deutschen Idealismus*. 2nd ed. Munich: Matthes und Seitz, 1989.

———. "Das Museum-Konstruktion von Kunst und Geschichte." *Neue Züricher Zeitung* 7, no. 8 (December 1991): 67.

———. *Der Wille zur Kunst. Zur ästhetischen Mentalität der Moderne*. Cologne: Dumont, 1996.

Zacharias, Thomas. *Tradition und Widerspruch, 175 Jahre Kunstakademie*. Munich: Prestel, 1985.

Zammito, John. *The Genesis of Kant's Critique of Judgment*. Chicago: University of Chicago Press, 1992.

Zentralinstitut für Kunstgeschichte, ed. *Berlins Museen. Geschichte und Zukunft*. Munich: Deutscher Kunstverlag, 1994.

Ziemke, Hans Joachim. *Das Städelsche Kunstinstitut—die Geschichte einer Stiftung*. Frankfurt: Städel, 1980.

Ziolkowski, Theodore. *German Romanticism and Its Institutions*. Princeton: Princeton University Press, 1990.

Zirk, Otto. *Zur Geschichte der Karlsruher Kunsthalle*. Karlsruhe: Adolf Dups, 1954.

Zolberg, Vera L. *Constructing a Sociology of the Arts*. Cambridge: Cambridge University Press, 1990.

Zuchold, Gerd. "Olfers kontra Bunsen. Ein Beitrag zur Berliner Museumsgeschichte." *JbPKB* 26 (1989): 355–99.

INDEX